English art 1860–1914

Modern artists and identity

EDITED BY

DAVID PETERS CORBETT AND LARA PERRY

Manchester University Press

Published by Manchester University Press
Oxford Road, Manchester M13 9NR, UK
http://www.manchesteruniversitypress.co.uk

British Library Cataloguing-in-Publication Data
A catalogue record for this book is available from the British Library

ISBN 0 7190 5519 9 *hardback*
 0 7190 5520 2 *paperback*

First published 2000

06 05 04 03 02 01 00 10 9 8 7 6 5 4 3 2 1

10026 34327

Typeset by
D R Bungay Associates, Burghfield, Berks

Printed in Great Britain
by Alden Press, Oxford

Contents

Illustrations

Plates

The plates appear between pages 2 and 3

Figures

Contributors

Paul Barlow is a Lecturer in History of Art at the University of Northumbria. He is the author of many articles on English art of the nineteenth century and, with Colin Trodd and David Amigoni, the co-editor of *Victorian Culture and the Idea of the Grotesque* (1999). He is currently working on Holman Hunt.

Tim Barringer is Assistant Professor in the Department of the History of Art, Yale University. He has written widely on Victorian visual culture and is the author of *Reading the Pre-Raphaelites* (1998). He is co-editor, with Tom Flynn, of *Colonialism and the Object: Empire, Material Culture and the Museum* (1998) and, with Elizabeth Prettejohn, of *Frederic Leighton: Antiquity, Renaissance, Modernity* (1999).

Jane Beckett is Senior Lecturer in History of Art at the University of East Anglia. She has written extensively on modernism and its histories including contributions to *Gaudier-Brzeska* (1983), *British Sculpture in the twentieth century* (1986) and, with Deborah Cherry, *The Edwardian Era* (1987) and *Blast! Vortizismus die erste Avantgarde in England, 1914–1918* (1996). She is completing a book on the urban history of Amsterdam in the twentieth century.

David Peters Corbett is Senior Lecturer in History of Art at the University of York. He has written widely on English art of the period 1850 to 1940, including *The Modernity of English Art, 1914–30* (1997) and, as co-editor with Ysanne Holt and Fiona Russell, *The Geography of Englishness: English Art and National Identity, 1880–1940* (2000).

Pamela M. Fletcher recently completed her Ph.D. on the problem picture at Columbia University and is now Assistant Professor of Women's Studies and Art History at The Ohio State University.

Alicia Foster is a freelance art historian. She wrote her Ph.D. on Gwen John at the University of Manchester and is the author of *Gwen John* (1999) and of a number of articles and essays on the painter. She is currently writing a book on women artists in the Tate Collections.

Kenneth McConkey is Professor of Art History and Dean of the Faculty of Art and Design at the University of Northumbria. He has published widely on British art of the Edwardian era, including *British Impressionism* (second edition, 1998), *Edwardian Portraits: Images of an Age of Opulence* (1987) and *Impressionism in Britain* (1995).

Lara Perry is a freelance art historian currently teaching for the Faculty of Continuing Education at Birkbeck College, London. She recently completed her D.Phil. on women in the National Portrait Gallery at the University of York and is the author of a number of forthcoming articles and essays.

Elizabeth Prettejohn is Associate Senior Lecturer in Art History at the University of Plymouth. She is the author of a number of contributions to exhibition catalogues, *Rossetti and his Circle* (1997) and *Interpreting Sargent* (1998), and, with Tim Barringer, co-editor of *Frederic Leighton: Antiquity, Renaissance, Modernity* (1999). She is also the editor of *After the Pre-Raphaelites: Art and Aestheticism in Victorian Britain* (1999).

Andrew Stephenson teaches in the Art, Design and Film History department at the University of East London. He has published extensively on British art of the nineteenth and twentieth centuries and is co-editor, with Amelia Jones, of *Performing the Body/Performing the Text* (1999).

Lisa Tickner is Professor of Art History at Middlesex University. She is the author of *The Spectacle of Women: Imagery of the Suffrage Campaign, 1907–14* (1988) and *Modern Life and Modern Subjects: British Art in the Early Twentieth Century* (2000).

Janet Wolff is Professor of Visual and Cultural Studies at the University of Rochester. She is the author of many books including *The Sociology of Art* (revised edition, 1993), *Feminine Sentences* (1990) and *Resident Alien* (1995). She is completing a book on the sociology of Modernism in Britain and the United States.

Acknowledgements

The editors would like to thank the many individuals and institutions who contributed to the completion of this volume. In particular we would like to acknowledge the encouraging and lively interest of the participants at the conference 'Rethinking Englishness: English Art 1880–1940', held at the University of York in July 1997, and our co-conveners of that conference, Ysanne Holt and Fiona Russell. Their enthusiasm and the attentive help of our editors at the Barber Institute and Manchester University Press – Tim Barringer and Shearer West, Vanessa Graham, Louise Edwards, Alison Whittle – and of our copyeditor Judith Ravenscroft, brought this book to fruition.

We were helped greatly to illustrate this volume by a grant from the Arts and Humanities Research Board. Their contribution and generous assistance from Professor Kenneth McConkey and the Faculty of Arts at the University of Northumbria, and from the School of Art, Design and Performance Arts at Middlesex University, allowed us to obtain and reproduce rather more images than would otherwise have been the case. The patient assistance of individual copyright holders and the staffs of various picture libraries in Britain and abroad – in particular Jennifer Booth, Dinora Davies-Rees, Adrian Glew, Susanna Greenwood, Adam Grummitt, Veronique Gunner, Bernard Horrocks, Michael Mitzman, Barbara Thompson, Jonathan Vickers, Christopher Webster and Lucy Wright – allowed us to complete the work. Gillian Forrester helped way beyond the call of friendship at a crucial moment.

A rather different version of chapter 9 (by David Peters Corbett) appeared in *Modernism/Modernity*, 7: 2 (April 2000), and we are grateful to the editors and to the Johns Hopkins University Press for permission to reproduce the relevant sections.

Introduction

David Peters Corbett and Lara Perry

In a 1995 chapter entitled 'England's climate' Charles Harrison concluded by asking how the facts of modernity and the facts of English culture relate to each other: 'how the predicate "modern" is to be defined in the light of the predicate "British"'[1]. In a later paper he argued that the category of the modern in fact does not pertain to the art of England and that English art has little claim on our attention, either as an expression of modern experience or for aesthetic reasons.[2] Harrison's attack on any claims for the modernity of English art is only the latest of a long series of dismissals which deny the importance of English art to any history of modernism. This type of argument claims that though England itself, with its highly developed commerce, transport and empire may have been 'modern', English artists never engaged adequately with that fact. The art they produced was vapid, timorous or aesthetically backward, without the aggressive confidence that we associate with modernism.[3] Behind such assertions lurks the ideal of French modernism after Manet as the normative form of the modern. Compared to the French canon, England's art has been deemed to be bloodless and disengaged, its practices those which worked to evade, rather than confront, its culture's modernity. The conspicuous failure of English artists to sustain high abstraction within their own traditions has reinforced this sense of a bungled history.[4]

It is true that English art made between, say, 1860 and 1914 does not strongly resemble the most celebrated examples of French modernist painting and sculpture. But why should we expect it to? How could cultures with different histories, which inherited different languages of representation and were possessed of different audiences, produce comparable work? There is no reason to assume that an account derived from the circumstances of one culture will adequately describe the conditions of another. Judging the achievements of one culture according to the norms of another is a certain recipe for missing what is characteristic and significant in the culture that you intend to explain. This is, however, the recipe which has been generally followed in histories of English art. In so far as there has been an enquiry into modern art in England, it has concentrated on trying to find homologues of the French experience. But English modernity differed from those which obtained in France, Canada or Russia, and the forms and character of the world

which arose from it are different also. That does not make the art any the less, or more, modern. But because of the continuing conviction that modernism is what the French did, and that anything different can only be a failure to live up to the true imperatives of modern life, historians of English art have inherited a restricted sense of what its modernity might be.

Charles Harrison's question about the connection between aesthetic modernity and English art is, then, a real one. How is 'modern' to be understood when we speak of English art?[5] The terminology requires clarification before we can proceed. We have been using 'modern art' and 'modernism' as if these terms were interchangeable, and we need to explain why this is so. Our use of these terms in this way reflects our allegiance to one of two competing readings of the art of the nineteenth and twentieth centuries now current in art history. On the one hand, the literature of art history has inherited an understanding of modernism which sees it largely as a series of formal developments, beginning in the closing years of the nineteenth century and running at least to Abstract Expressionism. Dominated by a quest towards abstraction, modernism in this reading interests itself purely in the evolution of new forms of visual expression.[6] By this definition, nineteenth-century art which is realist or symbolist or which takes Impressionism as its motivating influence cannot be modernist. The restrictions inherent in such an account limit its usefulness for the historiography of French art; it is almost entirely useless as an explanatory tool for the English case.

These pitfalls are avoided by a different, but now widespread usage which defines modernism more broadly, in a way that includes much of what we have learnt to value in nineteenth-century painting regardless of its position on the formal road to abstraction. In this interpretation, modernism means the art which begins with Manet and Baudelaire and which takes as its subject matter the transformations of nineteenth-century society in the cities, suburban and sub-rural spaces and contested areas of representation thrown up by the new conditions of experience in modernity.[7] This modernism is, on the whole, socially progressive or oppositional, mounting a critical account of those conditions and seeking to reveal or disguise the realities which lie behind the spectacular surface of modern life. From this perspective, modernism refers to art which grows out of and responds to modern conditions, whether it is formally innovative or not.[8] In choosing to use both 'modern art' and 'modernism', then, we are not playing fast and loose with terminology, but electing for the second of these definitions. Modernist art – of England as elsewhere – we define as art which responds to the evolving conditions of modern life prevalent in the late nineteenth and early twentieth centuries. The formal appearance of these works is less significant for their status than for their connections to their historical and cultural context.

This brings us to a second series of terms which require clarification, the words 'modern', 'modernity' and 'modernisation' which are used to describe the social and cultural conditions with which modern art was engaged. We use 'modern' here to refer to the rapidity and pervasiveness of European technological advances and the

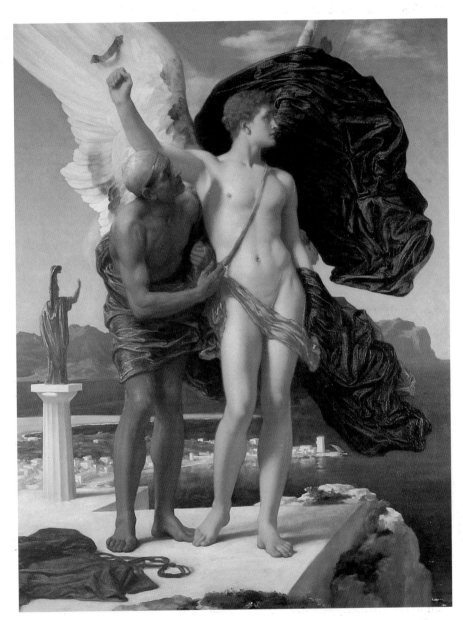

1 Frederic Leighton, *Daedalus and Icarus*, 1869.

2 John Everett Millais, *The Ruling Passion (The Ornithologist)*, 1885.

3 John Byam Liston Shaw, *Boer War 1900*, 1901.

4 James Guthrie, *Midsummer*, 1892.

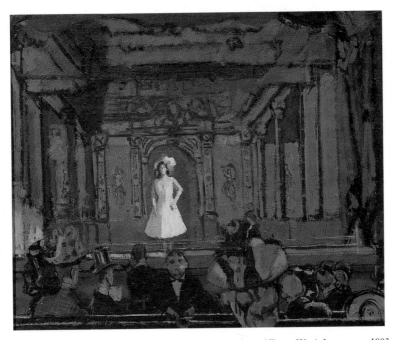

5 Walter Richard Sickert, *Gatti's Hungerford Palace of Varieties: Second Turn of Katie Lawrence*, c. 1903–4.

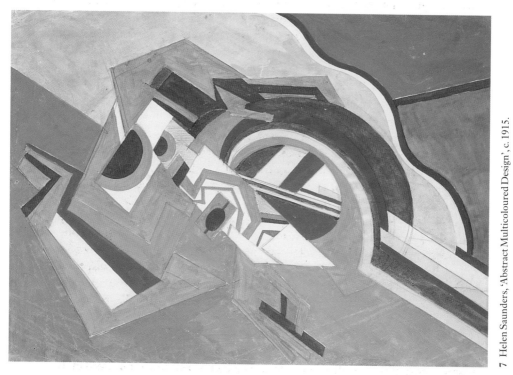

7 Helen Saunders, 'Abstract Multicoloured Design', c. 1915.

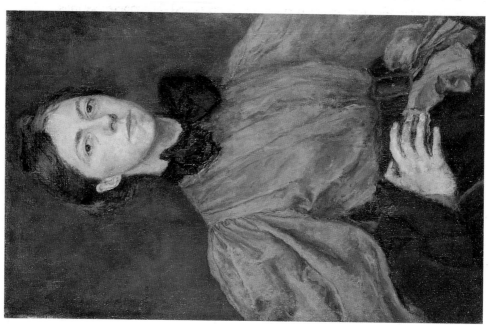

6 Gwen John, *Self-Portrait*, 1898–99.

consequent profound changes in the social world.[9] This usage reflects the tendency in accounts of European history to identify the period after the mid-nineteenth century with an acute phase of 'modernisation', a term used to describe the processes of change which bring about conditions which are perceived as new: industrialisation, urbanisation, the assumption of new gender roles, the bureaucratisation of everyday life. These processes weighed very heavily on the lives of modern citizens, and the final term 'modernity' refers to the experience of the processes and conditions of modernisation as the lived circumstances of modern life.[10]

In the history of modernisation, England, and the British Isles generally, played an important role. The grand narratives of the industrial 'revolution' are now contested, but not in any way that undermines our understanding of Britain as a nation which was profoundly altered over the course of the nineteenth century by new technologies and the social changes which arose in their wake.[11] The sense of innovation and lively engagement which evidently characterised British participation in the modernisation of commerce, manufacture and government does not, however, extend to accounts of the involvement of its artists with the changing conditions of nineteenth-century life. What has been lacking in the art-historical literature is any developed understanding of the ways in which English art, as part of that culture, was involved in the processes of modernisation and the immediate facts of modernity as they became evident to individual and collective experience. This is not an argument for any inherent 'specialness' in the English experience, or for being English as a transcendent ahistorical condition.[12] On the contrary, it is precisely a sense of the specificity of historical moments that we are interested in. If we are to recover the connections between Englishness and the modern, we must clarify the ways in which English art was woven into the cultural history of which it was a part, how it contributed to the expression of contemporary concerns, and how it referred to and set itself against the processes out of which it grew.

We are arguing, then, for a view of the relationship between the modern and English art which sees those relationships as specific to English cultural and historical circumstances. But reopening the question of English artistic modernity in this way might seem to incur a potential hazard. When the modern in art is unanchored from specific formal characteristics, and set to sail freely in the vast channels of its entire social and cultural environment, we may lose sight of it. The danger is that of defining the modernity of art so broadly that the term loses its descriptive power. That we wish to avoid. Our view of the modern in English art as tied in with broader historical themes is intended to ensure that 'modern' achieves a precise range of meanings in this context. At this stage such precision is out of reach. We now need studies which will refine and articulate for us the relationships between modern English art and cultural modernity. We need to describe those relationships in pointed, effective ways which allow us to identify and then investigate the significant features of the art it produced. To begin to explore and expand our sense of the relationships between history and art in the context of modern England is the purpose of this book.

Current scholarship has got us to the point where it has become possible to demand, and to begin to find ways of delivering, these enquiries. The contributors to the conference from which this book is largely derived, 'Rethinking Englishness: English Art 1880–1940', held at the University of York in the summer of 1997, engaged with the need to rethink the nature of English art in its 'field' – the term Lisa Tickner borrows from Pierre Bourdieu to describe the specific social, institutional and political conditions in which art is produced and participates.[13] The resulting discussion foregrounded the need to define what a new determination of English, modern and modern art might actually look like. We are not claiming this book as a general answer to this larger question. Generalities can only be properly broached once the detailed work has been done, and it is work of this detailed kind which is undertaken in the following chapters. *English art 1860–1914: Modern Artists and Identity* offers a diverse and interlinked system of micro-historical enquiries which push forward the process of identifying the modernity of English art. This is not to say that we have no purchase at all on the slippery cliff of generality at this stage. 'Rethinking Englishness' revealed a number of areas around which these enquiries revolved, including nationalism, gender, landscape, nature and the city, and aesthetic and other identities.[14] This book approaches the question of the modernity of English art from a single one of these areas by focusing on themes that emerge out of problems of identity.

By identity (the plural is implied) we mean the construction of individuality within a wider cultural history. An identity embraces both the particular and the general; it can refer to both the unique historical conditions of any given producer of art, and also suggest a sense of repetition or congruence.[15] In terms of the historiographical problem which we have outlined, this focus has the specific virtue of offering a means through which to investigate the individual's relationship to society, a way of charting the impact of the wider culture on any of its members. Far from dissociating any particular artist from the social, exploring her identity is a way of attending to the historical conditions of practice. Identities are individual but they are shared by groups, and identity is one of the principal means through which the relationships between artists, their practice and their reception into institutions of art were articulated. Those relationships shaped the work and careers of artists, and have subsequently helped to shape the histories of the modern and of modern art which we have formed to explain them. In making 'identities' the focus of our investigations we are putting pressure on one of the lynch-pins in the construction of the history of modernity.

The issues and subjects which the concept of identity introduces for study are wide and various. Between them, the chapters that follow explore personages from princely academicians to struggling students, paintings that range from ethereal landscapes to domestic drama, and issues of perception and visuality expressed in music-hall scenes and ancient portraits. Certain themes emerge from these diverse enquiries: the problems of a new professionalism and the significance of its gendered institutions; the tensions evoked by the new manners and mores of Aestheticism,

and the demands made of artists by a fragmenting art world. This volume is unified because it comprises a series of investigations of the ways that individuals concerned with the practice of fine art encountered the modern in the course of their professional lives. Each of the chapters examines the effect of such encounters in the experience of the protagonists, and in total they allow us to begin to define what we mean by modernity and what its relationship to English art might be.

Modernities

Lisa Tickner's opening chapter 'English modernism in the cultural field' offers some methodological guidelines for thinking about how artists and their practice intersected with more widely shared social and political conditions. Trying to understand the artist and art object as elements of the vast network of the 'social' can, if followed to what appears to be its logical conclusion, result in a lack of specificity which is ultimately unhelpful. Tickner's deliberations on this problem suggest some directions for the historian's task. Recognising that 'we can't have a sociology of art without agents', she identifies a supporting cast of people and institutions which 'need to be understood as in some way constituting the art – constituting, at least, the horizon of expectations in which it is made'. The ways that specific individuals are positioned in relation to that horizon and how they respond to it, shapes both the production of art and its success in entering the contemporary (and retrospective) field of work recognised as fine art, and recognised as modern.

Tickner surveys some aspects of English art in the early twentieth century with these problems in mind, pointing out the kinds of re-evaluation of the relationship between modernity and art which might take place in the period. Such re-evaluation is also pursued in the next three chapters which, having eschewed the proposition that modernity must look like 'x', focus on some well- and lesser-known English painters to examine the evidence for their engagement with the modern. They offer close readings of the oeuvres of individual artists who have generally been excluded from accounts of the modernisation of art. Recognising that questions of 'value' are at stake in the designation of the term modern, the chapters by Prettejohn on Frederic Leighton (2), Barlow on John Everett Millais (3) and Barringer on Byam Shaw (4) review the work of these artists through investigations which alert us to the ways in which they engage with modern life and experience. In each case, the authors conclude that their subjects were profoundly involved with questions about the relationship between artistic tradition and the circumstances and subjects of modern life and art practice.

Elizabeth Prettejohn begins this sequence of chapters by meditating on the general questions of modernism and value in the context of the academic artist, Frederic Leighton. Prettejohn's subtle discussion evaluates the arguments for Leighton's importance against the persisting standards and protocols of modernism, and concludes that to rehabilitate Leighton's scholarly reputation, to elevate academic artists of his type to the status of important modern practitioners, is

necessarily to question modernist accounts of modern art at a fundamental level. Against the values of ascetic clarity she identifies as modernist, Prettejohn places the sensuality and richness of Leighton's art, revealing how this set of choices, too, has every claim to be considered modern. Leighton's artistic decisions emerge from the chapter as responsive, precise and relevant engagements with modern experience.

The possibility of a conservative engagement with the modern – one which is celebratory and affirmative rather than resistant to or critical of the conventions of 'bourgeois' society – is dealt with directly by Paul Barlow in his chapter on John Everett Millais.[6] Barlow observes the juxtaposition of both modern technique and modern subject in the œuvre of Millais, a painter whose work, particularly from the latter part of his career, is standardly characterised as bland and uninteresting. Barlow suggests that it is not the nature or quality of Millais's painting but his complicity with contemporary 'bourgeois' social values which has given rise to the misleading assessment of his later painting as conservative and uninspired. Among other implications, this means that what Barlow calls 'the Manichaeism of the academic/avant-garde split' endemic to conventional accounts of modernism needs to be rethought in the context of an acknowledgement of 'multiple modernities'. Barlow poses a pointed challenge to the art-historical convention which associates the avant-garde with social criticism. His chapter shows clearly the need for studies of the use of formally innovative techniques in the work of academic and conservative artists as exemplary of a pervasive but little recognised modernity.

Continuing this concern with revisionism, Tim Barringer makes the rewarding choice of the little-studied painter John Byam Liston Shaw as the subject of his chapter. Regarded now and during his career as conservative to the point of backwardness in manner and method, through Barringer's reading we discover Shaw as a painter whose primary concerns of subject matter were both English and distinctively modern. The conventions and legacies of England as an imperial nation show themselves in Shaw's work, not through the exotic oriental subjects, but in the celebration of the colonising culture and its values. The heroes of imperial England and the patriarchal masculinity they embodied were Shaw's featured subjects, respectfully rendered in a clarity of detail frequently described as Pre-Raphaelite, and associated with what was understood as the eccentric but quintessentially English love of mimesis. Barringer's chapter evaluates the nature of Shaw's art in relation to this intimate response to the modernity of his social circumstances.

These authors' recognition of the absence of social criticism in much canonical painting of the period is significant for our understanding of the relationship between art and English culture during these years. The reluctance of English painters to engage critically with the modern is a circumstance which can be accounted for by the specific historical context in which they practised. One of the significant features of the 'field' of artistic endeavour at this time identified by Tickner is the 'shift from an art market still dominated by the international Salon

system to one controlled by commercial galleries'. Success within this changing context for art's circulation was linked in England with a privileged social existence, enjoyed by individuals who had other kinds of commercial successes as well as by a traditional elite. The successful English artist of the nineteenth century was not marginal to but rather was absorbed into an existing and powerful but essentially conservative culture – a distinctively English kind of 'modern' artistic existence.[17]

The social identity of the successful artist in England in the later nineteenth century comprised an artistic life and practice which was not oppositional to, but complicit with, the social values of the dominant cultures. Reviewing the cases of Leighton, Millais and Byam Shaw, all of whom participated in that social sphere in their own ways, suggests that their social positions strongly informed how they engaged with both modern subjects and contemporary developments in fine-art technique. This returns us to Lisa Tickner's observation that artistic agency (with respect to the modern or anything else) is 'a matter of the social and psychic formation of subjects with their own skills, agendas and pathologies' within the social environment. The implications of the appearance of the individual careers and bodies of work of ambitious and talented painters are the subject of another group of chapters collected in this book.

Identity

If Millais and Leighton, and in his own fashion Byam Shaw, are textbook cases of later nineteenth-century professional artistic identity, the kinds of identifications and themes that their careers hinged on emerge in different ways in the investigations of other chapters in the book. The careers which are the subjects of chapters 2 to 4 exemplify a normative identity and practice because of the artists' privileged relationship to the institutions in which artistic value was enshrined, but they do not represent the only option available to individuals working in the artistic sphere. Professionalism, its relationship to gender and the ways in which these informed the evaluation of art manifested themselves differently in the lives of other artists of the period. Chapters 5, 8 and 10 investigate the ways that these features of modern life were evinced in the practice and lives of artists who worked in other contexts and from other positions than those Millais or Leighton occupied.

An alternative professional artistic identity which was defined in the play between English and French models is the subject of Andrew Stephenson's chapter on James McNeill Whistler (8), a painter who is prominent in virtually all accounts of the modernisation of English art. Stephenson traces the ways in which Whistler defined and negotiated his own identity within the new art worlds of late nineteenth-century London and Paris. It argues for Whistler as a self-conscious manipulator of his own image, and for the need which drove Whistler to this, the imperative to set English painting against the French tradition, as a defining moment of English modernity. In this history, gender and the definition

of gender roles played an important part both in the nature of Whistler's work and in its reception by critics and other painters. Whistler was seen as effeminate, a dandy and poseur whose character powerfully signalled contemporary debates about the body, sexuality and cultural decadence.

The power of shifting and contested gendered identities to signify aspects of modern life appears again in the discussion of masculinity in Pamela Fletcher's chapter (5), which reads John Collier's failing problem picture of 1908, *The Sentence of Death*, as a registration of changing views of manliness as well as of the relationship of art to its culture. Alicia Foster, too, places Gwen John within this modernisation of gender roles (chapter 10). John's *Self-Portrait* of the late 1890s is read in her chapter within the shifting contexts inhabited by women artists at the Slade School around 1900. Foster shows the way in which the urgency of self-definition spills over from the field of social action within the art world (as in the case of Whistler) to the making of specific images of the artist under new circumstances. In this light, the *Self-Portrait* becomes an acknowledgement of the need to assert artistic identity successfully in ways that responded to and resisted the modernised pressures of experience which structured the way in which artists could frame and operate their own identities.

These three chapters demonstrate the ways in which a modernising of the art world and the experience of artists working within it led for many practitioners to a very different relationship to English institutions from those enjoyed by Leighton, Millais or Byam Shaw. This relationship is more oppositional, less comfortable and easy with the assumptions and protocols which the institutions existed to perpetuate. The Slade and art training generally altered under the pressure of new constituencies of students whose selves as artists were defined, as with John, both within and against the circumstances of their training and institutionalisation. Their engagement with their own identities as artists, with their peers, and with the models for working and living offered by successful Royal Academicians was made difficult by their alien status in the worlds of art practice and reception. Their work demands different terms of evaluation and investigation from those we apply to Millais or Byam Shaw if we are to identify their particular, modern, concerns.

Janet Wolff and Jane Beckett pursue these issues as they emerged into the twentieth century. Wolff (chapter 11) shows how Jewish artists were drawn into processes related to the management of competing ethnic and national identities. The production of a modern English identity was intimately dependent on the exclusion of 'foreign' identities, and this situation obtained in the art world as fully as elsewhere in the culture. In the course of a very wide-ranging discussion, Wolff performs a rigorous analysis of the historical status of identities within the field of art practice. She makes clear that Jewish artists working within England redefined complex cultural identities in their careers and art, and clarifies how that redefinition is significant for our understanding of the range of possibilities which art and the artist in England encompassed. Beckett (chapter 12) explores the limits presented by another set of distinctive conditions when she reassesses the question of

the war experience of women and women artists during the First World War to produce a revisionist reading and assessment of the art of Dorothy Shakespear, Jessica Dismorr and other women Vorticists after 1914. Vorticism has been seen as England's major contender for the role of avant-garde modernist movement and protagonist in the evolution of abstract art. Beckett's reading reorientates our understanding by dislocating it from a history of exclusively formal concerns. Both of these chapters map the ways in which specific historical and social experiences shaped artists' approaches to their subject matter and technique, and link a position on the margins of the art world with their innovations in practice.

The contribution which questions of identity make to our understanding of the relationship between English art and modernism, now becomes clearer. Investigating identity allows us to see the moment when individual agents come up against, enter into or resist, the institutions within which their professional lives take place. The pressures which shaped institutions, whether the formal organisation of the art world or informal conventions of gender and authority, also shaped the opportunities and constraints under which individuals lived and operated. Art practice begins to appear as an accumulated set of specificities and individualities, unfolding under more general social and cultural changes. Recognising the plurality of the positions those conditions entail contributes to an understanding of modernism which is, in Lisa Tickner's words, no longer a 'genealogical history of successive international "isms"'. We cannot privilege any one version of modern artistic identity, or art produced, over any other. The point is to see that the variety of forms which identity and art production take participate equally in the historical circumstances of modernity.

Value

If artistic practices can be understood as responses to the positioning of different individuals by some of the institutions which worked to define art and artists as contributors to the contemporary scene, the historical contingency and evolution of those institutions are further features of the development and practice of English modernism. The institutions which established the parameters within which artistic careers were conducted and assessed were themselves subject to historical change. The themes of gender and professionalism carry over as significant concerns in the chapters below which deal specifically with questions of changing forms of evaluation and appreciation in later nineteenth-century visual culture. These chapters explore the institutionalisation of new conventions of visuality which influenced the ways in which artists and audiences responded to the art of their contemporaries. Each in a different way suggests that the standards of accomplishment and professionalism in art were increasingly invested in a heightened awareness of the sensuous, that is, in the aesthetic rather than the narrative qualities of the visual.

The evolution of the view of art taken by one such institution is examined in Lara Perry's chapter on the National Portrait Gallery (chapter 7). Perry explores

the ways in which this national institution, established in 1856 as a repository and standard-bearer for one important aspect of English visual culture, formalised new kinds of evaluation and appreciation of artworks within its institutional structures. Charting a shift in its protocols of art evaluation and appreciation, Perry links the change to the gendered concepts of the professional which surfaced in the Gallery's administration and view of its purpose during the 1870s. Aestheticism appears in the Gallery's history in a new understanding of the artworks in its care which surveyed portraits as objects to be evaluated for their aesthetic accomplishment rather than as documents through which an established history could be recovered. Although the Portrait Gallery remained fundamentally historical and conservative in its objectives, changes in personnel and its physical development worked to integrate modern aesthetic values into its institutional concerns.

Pamela Fletcher (chapter 5) also investigates the modernising of aesthetics and its effect on the institutions of art. In this case, it is the problem picture, a staple of the Royal Academy exhibitions, which is placed in a different light under the impact of modernising views of gender and the rise of the new mass media. Fletcher's argument is that the withering of the content-led appeal of the problem picture prepared audiences for a formalist reading of high art, a reading which sharply differentiated it from the attempts at transparent and persuasive communication which characterised illustration and advertising in the periodical press. In contrast to the commodified meanings which were to be gleaned from the text of advertisements, high art offered itself within the new modernist protocols of the visual, the formal and the otherworldly, and forms of art which were unable or unwilling to adapt themselves to that transformation suffered a decline in accessibility and popularity accordingly.

Kenneth McConkey (chapter 6) shows the ways in which these processes led to new understandings of the relationship between memory, meaning, and the interchange between art and the material world. The intense interest in the rococo and eighteenth-century French culture which spread through English painters and their critics in the 1890s merged with the contemporary fascination for Bergson's philosophy to produce an aesthetics of interiority, sensuousness and the fictive creations of memory which dominated painting. McConkey takes the case of landscape, usually a literal motif, to explore the ways that painters inhabited and reported on this otherworldly universe. The identities of painters like Charles Conder, Philip Wilson Steer and other English landscapists, or of a critic like George Moore, are revealed as constructed through the alternative spaces of sensibility and recourse to interior states which this art created. Like Perry and Fletcher, McConkey deals with the rise of the new Aestheticism and its appearance within the cultural institutions within which English art was made and painters worked.

Finally, David Peters Corbett's chapter on Sickert (chapter 9) investigates the ways in which a major English artist of the period deals in his work with the demands on representation which these changes made. Corbett argues that Sickert's intention was precisely to reveal the nature of the modern in England, but

the route he took in order to achieve this is one in which the twin inheritances of Aestheticism and Realism are combined in order to produce a new, self-conscious, visual language to meet and register the new conditions. Sickert's own identity as a practitioner who needed to define his own role within the modernising art world as heir to Whistler is intimately connected with this. Mobilised in the embodied metaphor of paint, Sickert's identity and authority as a painter become prime actors in the work he produces. His music-hall scenes occupy themselves with the status of the painter and the adequacy of paint as a means to register modern experience and know the modern world. Sickert's paintings serve as explorations of what a modern art meeting English conditions might be.

By the time of Sickert's music-hall paintings, the aesthetic and its changing significance were registering powerfully in painting and in the institutions which evaluated and sanctioned their work. From one perspective, it might seem as if the rise of the aesthetic marks the moment when the artist and the practice of art define themselves outside the established institutions of the culture, when the making (and selling) of art becomes a potentially oppositional, alternative or resistant activity. Put like that, of course, this is a conventional modernist reading of the evolution of modern art. The Aestheticist concerns of the 1890s seem to prepare the way for the advent of a fully oppositional modernism after 1910. The English experience takes on, if ever so hesitatingly and briefly, the lineaments of the French. But the effect of reading through the discussions below is to show that such a narrative, French-influenced and teleologically modernist, has to be rethought. One of the discoveries made in assembling this series of chapters has been a much more expansive, much more complex array of responses to the modern than those evoked by the history of the French avant-garde. In the account of the modernity of English art which is begun in this book, the roles played by Leighton and Millais, Byam Shaw and the National Portrait Gallery must also be acknowledged. The privileging of the aesthetic as the defining sign of art grows within the institutional spaces of art practice as much as within the oppositional or marginal. The works produced by Leighton, Sickert, Millais or John are legitimately the objects of our attention, not because they are 'English' but because they are artworks of their time, produced on the cusp of one of the Western world's periods of great artistic innovation which reveal the experience of that process in stimulating and effective ways.

None of this amounts to an argument for modern English art as isolated or parochial. Rather it is to argue that the conventions of art-historical readings of the modern do not do justice to the diversity and breadth of the modern imperative in English art. Lisa Tickner speaks at the end of her chapter of the 'double vision' she feels art historians need to tackle the art they study, both focused on the social and cultural determinants which structure its appearance, and alert to the particularity of individual aesthetic objects. If one object of this book has been to reinsert English art into its wider histories, the other has been to attend more carefully to the analysis and description of particular paintings, and to observe the subtleties of

representation which differentiate one 'realist' or 'narrative' painting from
another. A number of chapters in this volume take up the challenge of making a
close and sensitive reading of the artworks themselves. In the process, they reveal
their subjects as capable of sustaining our most attentive scrutiny, the best of them
fittingly taking their place within the canon of European and North American
modernism.

This volume does not claim to reveal the whole extent of the impact of the
modern on English art or to finally describe that process or its implications. Rather
it is a series of views that are openings for a new map of English modernism. We
have in these chapters the beginnings of a survey of English art in its complex rela-
tions to its culture, bound into its changes and responsive to them. If that map is
here only sketched in, its implications are clearer: that the historically unique cir-
cumstances of English modernity produced for its artists an array of representa-
tional problems and solutions which we have only begun to be able to recognise in
the works themselves. If the glimpses offered by this volume stimulate a more
searching investigation of the artists and circumstances of modern English art it
will have achieved its purpose.

English modernism in the cultural field[1]

Lisa Tickner

A beginning, as Edward Said remarks, is both a point of departure (from the already-written) and a point of entry (into the material, and into a position from which to write). It is harder to begin with the fluidity of processes, relations and ideas than with the (by convention) more stable and bounded categories of artist, artwork, genre and style. I have taken my cue from Said – 'a beginning might as well be a necessary fiction' – and my agenda from this assemblage of images and quotations that is not quite a fiction, a corpus or an archive, but a way in.[2]

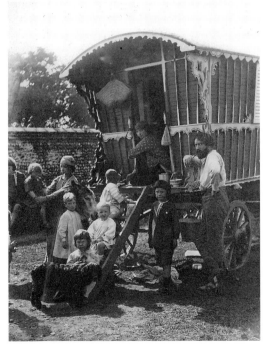

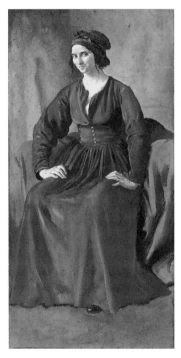

1 'Augustus John with Caravan', c. 1905.

2 Augustus John, *The Smiling Woman*, 1908–9.

Wyndham Lewis to his mother (from Paris, having visited Gwen John), c. 1905:

> [John is] going to camp on Dartmoor, with a numerous retinue, or a formidable staff
> ... or any polite phrase that occurs to you that might include his patriarchal menage.[3]

Augustus John to Dorelia, 1903:

> How would you like yourself as a Romany lady?[4]

C. J. Holmes on *The Smiling Woman*, in the *Burlington Magazine* 1909:

> the vitality of this gypsy Gioconda is fierce, disquieting, emphatic [and enhanced by]
> the summary strokes with which the swift play of the features and the defiant poise of
> the hands are suggested.[5]

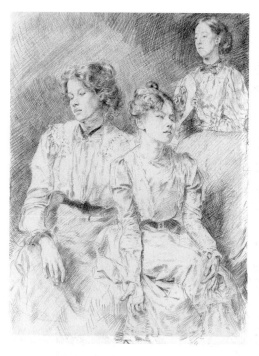

3 Augustus John, *Portrait of Ida Nettleship,* 4 Gwen John, *A Corner of the Artist's Room in Paris,*
Gwen John and Ursula Tyrwhitt, c. 1907. 1907–9.

Augustus John, in Gwen Salmond's obituary, 1958:

> The Grand Epoch of the Slade School ... [included] a remarkably brilliant group of
> women students ... Edna Waugh, Ursula Tyrwhitt, my sister Gwen John, and Ida
> Nettleship ... the male students cut a poor figure; in fact they can hardly be said to
> have existed ... But these advantages for the most part came to nought under the bur-
> dens of domesticity.[6]

Ida John back in London and swamped with Augustus's children:

> I feel so stifled and oppressed ... I can imagine going to the Louvre and then back to a small room over a restaurant or something. Think of all the salads and the sun, and blue dresses and waiters. And the smell of butter and cheese in the small streets.[7]

Clive Holland in the *Studio*, 1903:

> Lady artists of the present day are going to Paris in increasing numbers ... it is sufficiently Bohemian for the most enterprising feminine searcher after novelty. If she be very independent she will eschew the *pension* ... in favour of an *appartement au deux-ième* or *au troisième*, working upwards towards the sky ... according to her worldly wealth ... Some excellent rooms are obtainable in or near the Rue du Cherche-Midi [Gwen John's room is on the attic floor, 87 Rue du Cherche-Midi].[8]

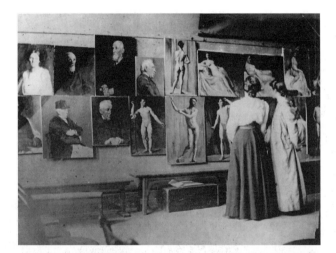

5 'Women at the Slade', 1910s.

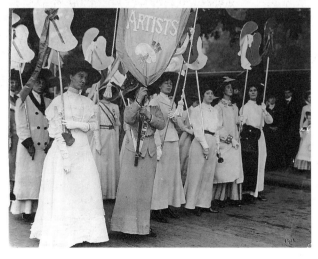

6 'Suffrage Atelier', 1910.

Wyndham Lewis:

> [John] had had the scholarship at the Slade, and the walls bore witness to the triumphs of this 'Michelangelo' … fronting the stairs that lead upwards where the ladies were learning to be Michelangelos, hung a big painting of Moses and the Brazen Serpent … Professor Tonks … had one great canon of draughtsmanship, and that was the giants of the Renaissance. Everyone was attempting to be a giant and please Tonks. None pleased Tonks – none, in their work, bore the least resemblance to Michelangelo. The ladies upstairs wept when he sneered at their efforts to become Giantesses.[9]

Vanessa Bell:

> Professor Tonks … was a most depressing master.[10]

Mary Lowndes, Chairman of the Artists' Suffrage League, 1914:

> How many times have women been reminded … that their sex has produced no Michael Angelo, and that Raphael was a man? These facts are indisputable; and they are supposed, as a rule, to demonstrate clearly to the meanest capacity that creatures so poorly endowed collectively with creative genius should have no voice in … Parliament.[11]

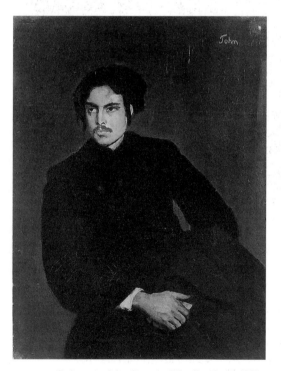

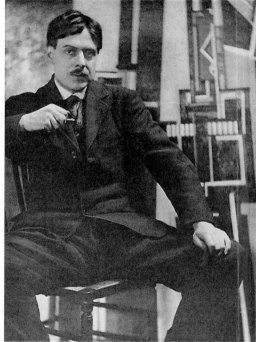

7 Augustus John, *Portrait of Wyndham Lewis*, 1905.

8 Alvin Langdon Coburn, 'Wyndham Lewis in his Studio', 1916.

Augustus John on Wyndham Lewis:

> In the cosmopolitan world of Montparnasse, P. Wyndham Lewis played the part of an incarnate Loki, bearing news and sowing discord with it. He conceived the world as an arena, where various insurrectionary forces struggled to outwit each other in the game of artistic power politics.[12]

Lewis on Lewis:

> By August 1914 no newspaper was complete without news about 'vorticism' and its arch-exponent Mr Lewis … might have been at the head of a social revolution, instead of merely being the prophet of a new fashion in art … The Press in 1914 had no Cinema, no Radio, and no Politics: so the painter could really become a 'star' … no illustrated paper worth its salt but carried a photograph of some picture of mine or of my 'school' … or one of myself, smiling insinuatingly from its pages … I saw a great deal of what is called 'society' … Coroneted envelopes showered into my letter-box[13].

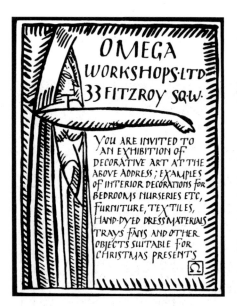

9 Omega Invitation Card, 1913(?). 10 'The Rebel Art Centre', *Daily Mirror*, 30 March 1914.

Lewis *et al.* on Fry's Omega Workshops, October 1913:

> This family party of strayed and Dissenting Aesthetes, however, were compelled to call in as much modern talent as they could find, to do the rough and masculine work without which they knew their efforts would not rise above the level of a pleasant tea-party … The Idol is still Prettiness, with its mid-Victorian languish of the neck, and its skin is 'greenery-yallery', despite the Post-What-Not fashionableness of its draperies.[14]

Lewis, *Blast* manifestos, 1914:

> We are Primitive Mercenaries of the Modern World ... The artist of the modern movement is a savage (in no sense an 'advanced', perfected, democratic, Futurist individual of Mr Marinetti's limited imagination).[15]

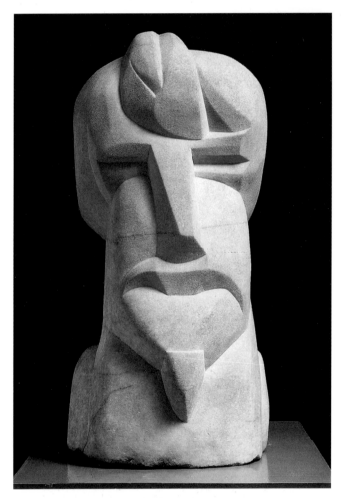

11 Henri Gaudier-Brzeska, *Head of Ezra Pound*, 1914.

Lewis on the *Head of Ezra Pound*:

> Ezra in the form of a marble phallus.[16]

Pound on Lewis, to John Quinn:

> The vitality, the fullness of the man ... Every kind of geyser from jism bursting up white as ivory, to hate or a storm at sea. Spermatozoon, enough to repopulate the island with active and vigorous animals. Wit, satire, tragedy.[17]

Nevinson and Marinetti's futurist manifesto on 'Vital English Art', 1914:

> AGAINST ... The English notion that Art is a useless pastime, only fit for women and schoolgirls ... WE WANT ... To have an English Art that is strong, virile and anti-sentimental ... [with] a heroic instinct of discovery, a worship of strength and a physical and moral courage, all sturdy virtues of the English race.[18]

12 'Vanessa Bell, Duncan Grant and Roger Fry painting Lytton Strachey', 1913.

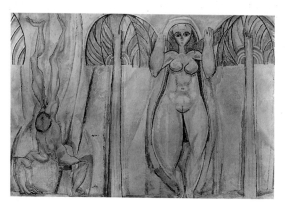

13 Duncan Grant, *Adam and Eve*, 1913.

Virginia Woolf:

> It was a spring evening [c. 1908]. Vanessa and I were sitting in the drawing room …
> Suddenly the door opened and the long and sinister figure of Mr Lytton Strachey
> stood on the threshold. He pointed his finger at a stain on Vanessa's white dress.
> 'Semen?' he said. Can one really say it? I thought and we burst out laughing. With
> that one word all the barriers of reticence and reserve went down. A flood of the
> sacred fluid seemed to overwhelm us. Sex permeated our conversation. The word
> bugger was never far from our lips.[19]

Vanessa Bell to Duncan Grant, January 1914:

> There have been lots of notices [of the first Grafton Group exhibition] mostly quite
> good. Of course your Adam and Eve is a good deal objected to, simply on account of
> the distortion and Adam's standing on his head … I believe distortion is like Sodomy.
> People are simply blindly prejudiced against it because they think it abnormal.[20]

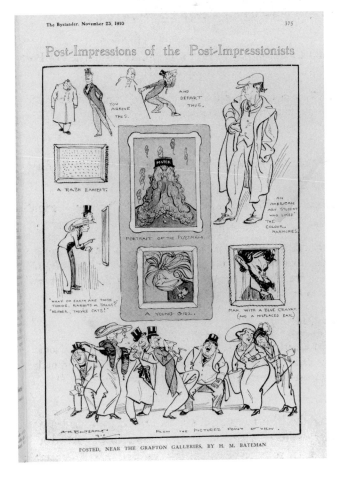

14 H. M. Bateman,
'Post-Impressions of the
Post-Impressionists',
1910, *Bystander*,
23 November 1910.

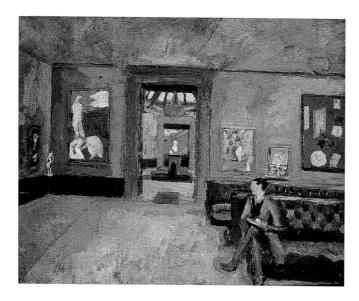

15 Vanessa Bell(?),[21] *A Room at the Second Post-Impressionist Exhibition*, 1912.

Frank Rutter's dedication to *Revolution in Art*, a pamphlet in defence of Post-Impressionism, 1910:

> To Rebels of either sex all the world over who in any way are fighting for freedom of any kind I dedicate this study of their painter-comrades.[22]

Vanessa Bell:

> It was as if one might say things one had always felt instead of trying to say things that other people told one to feel.[23]

Sir William Richmond, in the *Morning Post*, on the 1910 Post-Impressionist exhibition:

> For a moment there came a fierce feeling of terror lest the youth of England, young promising fellows, might be contaminated here. On reflection I was reassured that the youth of England, being healthy, mind and body, is far too virile to be moved save in resentment against the providers of this unmanly show.[24]

Charles Ricketts, March 1914:

> A sense of fear... is, I believe, fairly widespread among thinking men, who dread some sort of decivilising change, latent about us, which expresses itself especially in uncouth sabotage, Suffragette and post-Impressionism, Cubist and Futurist tendencies.[25]

I could go on. On one level this is just a game of pictures and captions, anchor and relay. But my argument is that the paintings look different when this is leached out of them. Not necessarily worse – in some respects 'better' if we like them like vegetables

topped and tailed and cleaned for the table. But in some sense amputated. Severed from the cultural field – to use Bourdieu's term – cut out of the web of social inter-course that fed them and shaped the circumstances in which they were read. Or to put it in period terms, I reject absolutely Clive Bell's assertion that to appreciate a work of art 'we need bring with us nothing from life, no knowledge of its ideas and affairs, no familiarity with its emotions'.[26]

I want to follow Charles Harrison's reference to the possibility of a study 'not subject to the traditional closures on art historical writing' with the pages on 'Of' that he wrote in a piece on 'Art history, art criticism and explanation', with Michael Baldwin and Mel Ramsden.[27] Here they insist that the substantial questions to address in art history are: what is it? to whom was (is) it addressed? what does it look like? what is it of? (or what does it represent?) what does it express? (or what is its meaning?) is it any good?

'Of' is a more substantial issue than 'like', demanding an inquiry into the causes of a picture being as it is – 'those features of the world, things, people, events, ideas, practices or other works of art, to which the picture is causally connected'. All works of art (because all occurrences) are multiply caused, 'which means that they exist as and in open systems'.[28] Paintings are overdetermined – that is, a range of technical, social, pictorial, institutional, discursive and autobiographical urges and constraints propels and shapes them. These will always be in some measure unde-cidable. But what Michael Baxandall said of fifteenth-century Italy is true, if in a different and more diffuse sense, of British painting between 1860 and 1914: 'a ... painting is the deposit of a social relationship'.[29]

From my 'archive' of images and quotations a cluster of issues emerges that is scarcely addressed in the standard accounts. In these (modernist) narratives pre-war painting is a series of staging posts en route to abstraction. Sickert displaces John, Bloomsbury is briefly triumphant around 1910–12, but Vorticism alone emerges as a movement that bears comparison with the continental avant-gardes. The fact that there is some truth in this makes it all the harder to see beyond it to what these paint-ings were 'of'; that is, to how their particularity emerges from the *British* cultural field (in which continental influence plays a part), and indeed to how radical experi-ments in form and technique were related to the defining experiences of modern life (which weren't always or only those of industrialisation). This cluster of issues, evi-dent in the commentary but *also* I want to insist, in the paintings, includes:

- the Englishness of English art (which a radical aesthetics will wrest from its basis in rural landscape and Arthurian subject matter and root in the virile, the urban, the industrial, the 'primitive' and the (quasi) abstract);[30]
- the association of avant-garde practices with radical social and sexual politics (by supporters like Rutter and Bell, and detractors like Richmond and Ricketts);[31]
- the social constraints on (especially) women artists, together with the value attached to creativity as the guarantee of masculine authority in the political sphere (though as Nicholas Pevsner pointed out the English have no Michelangelo anyway, so we may be dealing with a *national* anxiety displaced onto gender);[32]

- unease both within and beyond the art world as to the fragility of that authority, given what were perceived as the debilitating effects of 'civilised' life and the degenerative or anarchic influences of women and homosexuals;[33]
- transformations in the market and the fashionability of the avant-garde ('avant-garde' and 'fashion', like 'abstraction' and 'decoration', are terms between which there has to be a kind of *cordon sanitaire*: Lewis is unusual, and provocative, in admitting them into the same sentence).[34]

This isn't to say, of course, that works of art are directly 'of' these things with quite the same immediacy that they are 'of' their raw materials or their manifest subject matter. But 'of' them they are. An adequate art history, of British or any other art, of this or any other century, has to be a history of the cultural field. That is, it has to be – cumulatively – we can't all do everything at once – a history embracing the web of relations that enmeshes institutions, agents and audiences, discourses and practices, and at the same time an account of the mechanisms of that field, attentive to the kind of terms that have only recently found their way into the discipline: Sign, Meaning, Narrative, Primitive, Fetish, Gaze, Gender, Commodity, Value (to borrow from Nelson and Schiff's *Critical Terms for Art History*).[35]

If we think that the received account of (English) art in this period is suffering from fatigue – and I think it is – then it is precisely because of Harrison's 'traditional closures on art historical writing'. These 'closures' I take to be the limits on its traditional concepts of form and meaning, value and agency; and the framing of these concepts by, first, the rhetoric of an embattled avant-garde (Roger Fry's 'heroic Ishmaelites' versus 'the pseudo-artists'), a trope that casts the British permanently into the shade of the French; and, second, the plot of an inexorable progress from Victorian narrative painting to an art of pure abstraction or, at least, of purely formal values.[36] With this in mind I want to look briefly at questions of agency, sexuality and value. They command our attention in this period but they're not exclusive to it. They have a local relevance to 'rethinking Englishness' in the cultural field between 1860 and 1914, but they're also among the major problems in writing a history for 'art' more generally.

Agency

By agency I don't mean biography. The artist isn't the punctual source of meaning and value in the work. On the other hand one has to be a very stern structuralist indeed to see cultural products as effectively agentless, to reduce the author or artist to the status of a funnel through which social effects are poured unmediated onto the surface of the canvas, or emerge like an image on paper in the darkroom.[37] We can't have a sociology of art without agents and with nothing to say about the pictures *qua* pictures. And we can't have an art history of fetishised objects that stops short at the frame.

This is where I have found very helpful Pierre Bourdieu's account of 'the field of cultural production'.[38] Bourdieu advances concepts like 'field' and 'habitus' to

account for the structure of relatively autonomous fields of aesthetic activity, and
the positions and dispositions of agents within them. A field is 'a space in which a
game takes place, a field of objective relations between individuals or institutions
who are competing for the same stake'.[39] The cultural field embraces the works
themselves, related within a (historically developing) space of possibilities; the pro-
ducers of works (whose strategies and trajectories derive from their positions and
dispositions as agents); and all those instances of legitimation by which cultural
products are recognised and ranked (by audiences, publishers, curators, academies
and critics), in public and personal economies of meaning and value. All these fac-
tors need to be understood as in some way constituting the art – constituting, at
least, the horizon of expectations in which it is made.

Three things are important here. First, it's a question of the shape of the field,
and of the shaping of agents in it and on it. It's not a question of the 'expression' of
autonomous identities, in language new-minted for the purpose. It's a matter of the
social and psychic formation of subjects with their own skills, agendas and patholo-
gies, entered into what Bourdieu calls the *habitus*, roughly equivalent to the rules of
the game [of the field]. This is Lewis promising to do the 'rough and masculine
work', to stiffen a 'mid-Victorian languish of the neck', a promise of radical aes-
thetic endeavour couched in terms of heterosexual masculine supremacy because
it's also a bid for dominance in a highly competitive (increasingly proletarianised
and feminised) field.

Second, it isn't all one way, the work makes the artist in a reciprocal gesture, just
as the audience makes the work and the works modify the field. The field is a field of
possibilities, it doesn't determine each utterance. (Fields change, of course, which
is why the meanings and values of paintings are lost and found.) This is Lewis the
arch-exponent of Vorticism, posing for Alvin Langdon Coburn, living up to the
angular frown in his *Self-Portrait* (Figure 16) or 'smiling insinuatingly' in his *Blast*
persona.[40] (The work plays a role in his projective identifications, in other words.)

Third, each field is situated within the broader field of power, which is where
Bourdieu meets ideology-critique (although he's closer to Foucault's concept of
the capillary flows of power than to a Marxist model of class antagonisms). This is
where fields intersect (Bourdieu is a little hazy as to how), and *Blast* or Lewis's
Kermesse (1912), become instances in a force field of sexual politics rather than
simply artefacts in a modernist history of English art.[41]

So agency is at issue among 'the causes of the picture being as it is'. But this
includes the agency of its patrons, critics and 'conversational community'. How
could Rossetti afford not to exhibit at the Royal Academy, or rather what motivated
those who enabled him not to? Was it crucial or – by the late nineteenth century –
irrelevant that women won what Virginia Woolf called 'the battle of the Royal
Academy'?[42] Who paid for avant-garde artists to stand proudly aloof from the
market place? Patrons with avant-garde tastes of course like John Quinn and
Michael Sadler, but also Lewis's mother with her regular advances, Sophie Brzeska
who supported Gaudier, the Jewish philanthropists who sent Mark Gertler and

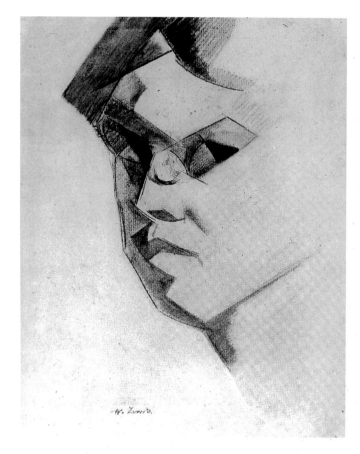

16 Wyndham Lewis, *Self-Portrait*, 1911.

Isaac Rosenberg to the Slade, Fry's Omega Workshops with its 30 shillings for artists a week.[43]

As Robert Jensen has pointed out, 'aesthetic modernism ... produced not only a body of work, the "isms" that stretched from realism to suprematism, but also a body of institutions, a matrix of practices that, unlike the art, was absorbed almost without resistance by the European and American public for art'.[44] These interlocking 'symbolic systems' included the refashioning of the commercial gallery from something like a book dealer's or an antiquarian's to something closer to the modern museum;[45] the rise of the promotional dealer (like Paul Durand-Ruel);[46] a rhetoric of independence and group identity (rooted in the example of the 'Impressionist' exhibitions of the 1870s); an avant-garde narrative of exclusion or neglect and subsequent vindication; and the rise of the monograph and the retrospective exhibition as the principal means of canonising artists and brokering relations between historiography and the market place.

Together these developments marked the shift from an art market still dominated by the international Salon system to one controlled by commercial galleries.

The first was understood in terms of national and regional diversity, the second was promoted by a new genealogical history of successive international 'isms'.[47] It wasn't a conspiracy. It isn't an answer to the question: how good is it? It's not that the economic and the ideological wholly determine the field. Rather that *these* become the relations in which agents acted (and writers wrote and viewers viewed), and we've marginalised them in an account of an alienated, heroic, embattled, uncommodified, unfashionable modernism, derived unquestioned from exactly this moment.

Sexuality

I was once accused of 'camouflaged tabloid feminism'. I assume that this was meant as a parallel to 'vulgar Marxism': something crudely reductive and thus inadequate to all those nuances that make a picture what it is and not some other thing. (As Sickert said of the little patch of blue, the shirt of a thatcher on the roof of a cottage, no bigger than a postage stamp, in a picture by Millet: 'if it could be described in words there had been no need to paint it').[48]

There are several things to say about this. The first is that well, yes, crudely reductive things have happened. On the other hand, an exclusively formalist or aestheticising discourse is crudely reductive in its own fastidious way. With all his stress on the collective development of a particular modern *facture* ('technically we have evolved ... a method of painting with a clean and solid mosaic of paint in a light key'), Sickert was a self-proclaimed realist with a taste for 'sordid' subject matter.[49] Seeing something like formal values as the real subject matter of *The Camden Town Murder* (c. 1908) is not only a kind of violence in itself, but a kind of blindness to the real complexity of the picture. This is quite a different thing from moralising about Sickert as an individual or about violence or voyeuristic masculinities in general.

Michèle Barrett has pointed out that we often fail to distinguish between three concepts of sexual difference (they are in fact only hypothetically distinct).[50] First, there is 'experiential' difference. Second, there is 'positional' or 'discursive' difference. Third, there is sexual difference as psychoanalysis understands it, as the Oedipal structuring of desire. Looking at the Camden Town pictures in terms of 'experiential' difference we ask about men and women as social beings in the spaces of the modern city, about their inter-relations and how these furnish subjects for pictures, about whether the gender of the viewer inflects their response. In terms of 'positional' difference the emphasis is on systems of representation, on gender as a semiotic category, on a critical discourse that genders genres (like the nude), on forms of painting that naturalise or disrupt the social attributes we gather up as 'femininity' or 'masculinity'. In terms derived from psychoanalysis we look at pleasure, anxiety and desire, at voyeurism or fetishism for instance, or abjection, as these are mobilised by the painting in the structures of looking. Sickert's self-conscious facticity is not at odds with this but part of it. And words are not at odds with

the recognition that we will never finally capture this picture in words, but a necessary part of the process of negotiating a more or less coherent response to it.

Feminism began for understandable reasons by taking femininity as its object of study. It was more concerned with the achievements of women, 'hidden from history', or with the social construction of femininity as a form of restraint, than with making men speak their masculinity. This has long since changed. For an adequate history we need analyses of the structuring effects of sexual difference (of anxiety and desire), in all the senses sketched by Barrett, and for English art. Some canonical masterpieces have come to look properly different (I think of Anthea Callen's account of the primitivising physiognomy of Degas's *Little Dancer of 14 Years*).[51] Some more marginal, 'feminine' or 'sentimental' images have come to be seen as speaking to the formative moments of human subjectivity (I think of Griselda Pollock on Mary Cassatt).[52] Some new investments have been, and will be, made and some old projections – some tired old sexualised scripts – torn up and discarded.

If we are looking for models we could turn to Anne Wagner's book, *Three Artists (Three Women)*.[53] It is a model of subtlety in broaching the vexed questions of making art from a female position (a position 'particularly unfixed but closely regulated') and of the importance of modernism to women ('consider the alternative'). 'Femininity', she points out, 'can be assigned as well as claimed, avoided as well as celebrated … Or an individual's relation to feminine gender may definitively escape her control.' Women, too, could be in flight from 'femininity'. Broader social developments ensured both the hostility towards women's work and a particular avidity for it before and after 1914. Stieglitz's 'at last, a woman on paper' and 'the Woman receives the World through her Womb' – conflating the feminine with the body, the intuitive and the primitive as a counter to American materialism – deserves as much scepticism as the popular complaint that women couldn't paint at all. There is much more. But there are two ways in which Wagner leads us into the question of value. First, she cites Arthur Danto's slighting review of Lee Krasner, not because in some simple sense he is 'wrong', but because he 'does not suspect that a different audience for Krasner's art might … come to exist': that like Domenichino – Danto has borrowed the example from Henry James – she might find her Poussin.[54] Second, she argues that: 'we have failed to find the terms in which to *see* women's art, failed to point to it in ways that make enough cultural or aesthetic sense' (and the same is true, perhaps, of English art).[55]

Value

Definitions of value embrace concepts of *intrinsic* value or worth; the value of something *for* someone or some purpose (use value); and the value at which something is estimated for sale or exchange. Art history – at least in its anglophone variants – has been largely a discourse of connoisseurship insisting on the *intrinsic* value of a specially valued class of artefacts.

When we talk about aesthetic value, we are talking (and have been since the eigh-
teenth century) about a realm of supposedly disinterested value *distinguished* from
vulgar considerations of use and market exchange. A Rembrandt isn't for 'use', like a
teaspoon, and it is 'priceless', its value is not reducible to the cash nexus even if it is
sold at auction. Everyone of taste and discernment knows that. Which is, of course,
as Bourdieu points out, precisely the use – and exchange – value of aesthetic value. It
serves to mark out social groups with varying degrees of educational and cultural
capital on apparently neutral criteria of 'taste' rather than emphatically social or
political criteria to do with relations to capital and the means of production.[56]
Symbolic capital transforms and disguises – that is it 'launders' – material capital.

Can we do anything with the question: how good is it? Well, we're short-
circuiting the issues too quickly if we assign questions of (aesthetic) value lock,
stock and barrel to Kant or Bourdieu, the aestheticians or the sociologists. First,
because Kantian aesthetics, though it moves away from the body into a realm of
pure taste, is rooted in what Terry Eagleton calls 'the whole of our sensate life
together – the business of affections and aversions, of how the world strikes the
body on its sensory surfaces, of that which takes root in the gaze and the guts and all
that arises from our most banal, biological insertion into the world'.[57] It is a 'primi-
tive materialism', in other words, and one relevant to the question of why we are
moved by art (and music) in other than purely rational ways. Second, because we
could concede much of Bourdieu's argument without conceding the claim that the
sociology of taste *displaces* aesthetics. Works of art are never entirely exhausted by
their deployment as social markers. There may still be grounds on which to argue
that *The Well-Tempered Clavier* is a better piece of music than *The Blue Danube*.[58]
Or to consider whether the rich complexity of some works doesn't contain a critical
edge or a utopian element that escapes their ideological functions.

Feminist art historians shared in the general evacuation of evaluative criticism
from post-structuralist theory. The question became not 'how good is it?' but 'what
does it mean?' Since 'bourgeois aesthetics' was largely premised on the intrinsic
value of high cultural artefacts for discerning but otherwise undifferentiated sub-
jects, and since value judgements regularly diminished women's work and capaci-
ties, this was a relief. But the question of value doesn't go away because the emphasis
shifts from value to meaning. We all make private judgements all the time. And the
question of value, as Barbara Herrnstein Smith points out, begins *in the studio*, with
'the thousand individual acts of approval and rejection, preference and assessment,
trial and revision that constitute the entire process of [artistic] composition'.[59]

Smith offers an agenda for a materialist (and feminist) theory of value where
value is 'radically contingent': neither immanent in the work, nor absolute, nor
arbitrary. She argues for an *economics* of literary and aesthetic value. She refuses the
clear-cut distinction between exchange value and use value:

> Like its price in the market place, the value of an entity to an individual subject is
> *also* the product of the dynamics of an economic system, specifically the personal
> economy constituted by the subject's needs, interests, and resources – biological,

> psychological, material, and experiential. Like any other economy, moreover, this too is a continuously fluctuating or shifting system … The two systems [i.e. of the market place and the subject] are not only analogous but also interactive and inter-dependent.

Literary value (in her example) is reproduced and transmitted in innumerable implicit acts of publication, purchase, display, citation, translation, allusion, etc. – each representing a set of individual economic decisions by critics, anthologists, small-town librarians or individual readers – so that the survival of a work or its elevation into the canon is the consequence neither of conspiracy nor of its own intrinsic value, but of 'a series of continuous interactions among a variably constituted object, emergent conditions, and mechanisms of cultural selection and transmission'. A work that has ceased to be valued (books out of print, paintings in basements) may be rediscovered and rescued when its original functions are again desired or 'when different of its properties and possible functions become foregrounded by a new set of subjects with emergent interests and purposes'.[60] Exactly – the impact of feminism – the rise of Virago – the development of a feminist art history with a new set of investments and new tools of analysis (semiotics, psychoanalysis): the field shifts. Krasner finds her Poussin (or rather her Anne Wagner). Degas's *The Little Dancer*, Cassatt's *Mother About to Wash her Sleepy Child*, Lewis's *Kermesse*, O'Keeffe's *Black Iris III*, all come to look different. Charles Harrison turns from Ben Nicholson to reconsider Gwen John.[61]

So it's with value that I want to conclude, in the recommendation – if I have anything as clear and prescriptive as a recommendation – of a doubled focus. First, we need to map 'the contingencies of value' – the use values of art, the gambits of artists, dealers, writers and patrons – in a social history of the English cultural field. For example, at the same time as artists like Lewis reacted to what they perceived as the 'feminisation' and 'bourgeoisification' of art – and perhaps for this reason – they were seeking a living from wealthy aristocratic female patrons, some of them not averse to a certain butch allure, who wanted dining-rooms, fancy dresses and party favours in avant-garde styles. Contrary to the popular trope of the embattled avant-garde, the avant-garde was briefly and, on certain terms, it's true, fashionable. Lewis referred to the years when coroneted envelopes showered through his letter box.[62] 'Futurism' – an elastic term in 1912 – offered newspapers and entertainers a new topic for popular satire, the avant-garde a newly bombastic self-image, and a few aristocratic patrons (chiefly women) a celebrity based not on birth or wealth or attainment but on consumption and taste: an identity *derived* from association with the avant-garde and from *being seen* as a consumer of *outré* commodities in the illustrated press. For those who chose to respond to it, from principle or expediency, this was a new if compromised space in which to operate.

But second, we need informed, attentive, nuanced, compelling and self-reflexive accounts of works of art and our own investments in them. There are already many of these, but few of them in the field of English art between 1860 and 1914. Meanwhile we have (more than) *12 Views of Manet's Bar*.[63] Histories of

English art are riven by the tension between two opposing narratives. One is a modernist account of the avant-gardes (which puts English artists into a continental shadow – literally, in the poster for the Barbican exhibition of *Modern Art in Britain 1910–1914*).[64] The other constructs an eccentric genealogy of Englishness – Blake, Burne-Jones, Spencer, Bacon, Freud – but one guaranteed, implicitly, by the centrality of European modernism. The terms of the first narrative are largely formalist and cosmopolitan. It stresses sameness and is embarrassed by difference, which can only be a falling short. The second is largely regionalist and biographical. It stakes everything on difference and is embarrassed by connections, which can only compromise the idiosyncrasies of its maverick heroes.[65] The point is that local modernisms are *different*, despite their debts, because there are local inflections to the web of relations that makes up the cultural field.[66] The 'causes of a picture being as it is' are not everywhere the same, even in the rapidly homogenising field of Western Europe.

Art is a social practice, variously defined and pursued in particular contexts. It is a matter of debate how far those contexts are different from our own and, if different, recoverable, and, if recoverable, of real explanatory value in the analysis of particular works. Charles Harrison, suspecting that the social history of English art may well be 'an endemically unpromising project', points out that 'social-historical exegesis has the capacity to render any work apparently vivid' while burying it in anecdote.[67] But there are ways of reconciling the insights of a properly social history with the attentiveness of close readings, of focusing simultaneously on the shaping of the work itself, and on the conditions of possibility that bear down on it and its effects. This 'double vision' sets a tall agenda (but one with a pedigree: Erwin Panofsky was apparently very proud of having one far-sighted and one near-sighted eye.)[68] Here in lieu of a conclusion are some lines from Elizabeth Barrett Browning's *Aurora Leigh*. Substitute 'historians' for 'poets'.

> But poets should
> Exert a double vision; should have eyes
> To see near things as comprehensively
> As if afar they took their point of sight,
> And distant things as intimately deep
> As if they touched them.
> Let us strive for this.[69]

The modernism of Frederic Leighton

Elizabeth Prettejohn

How can we write Frederic Leighton into the history of modern art? At first thought the question may appear simply ridiculous. Whether we speak of 'modernism' as a style or of 'modernity' as a cultural problematic, we readily find their opposites in Leighton's work. Stylistically his art is not modernist but 'academic'; the 'licked surface', that quintessential feature of academic style, is evident at a glance either in a painting such as *Daedalus and Icarus* (Plate 1) or in a sculpture such as *Athlete Wrestling with a Python* (Figure 17).[1] Leighton accordingly figures in the list of arch-enemies of modern art, the academic painters who represented an 'all-time low' according to modernism's most notorious apologist, Clement Greenberg.[2] Moreover, Leighton fares little better according to recent criteria for replacing Greenbergian modernism with a more inclusive notion of modernity, one that stresses engagement with the cultural and social changes of the recent past.[3] Leighton's work ignores such changes in favour of a thoroughgoing commitment to classicism, not only in subject matter (the Ovidian myth of *Daedalus and Icarus* or the Pindaric and Virgilian associations of the *Athlete*) but also in its broader frames of reference – to Praxitelean notions of the sensualised body in the painting or to the complex of debates around the image of the *Laocoön* in the sculpture.[4]

To accommodate Leighton, the boundaries of our history would need to expand still farther, beyond the confines of 'modernity' as well as those of 'modernism' – so far, indeed, as to raise the question of whether this could still be called a history of modern art at all. Yet all three of the key terms in that question – 'history', 'modern', and 'art' – are in dispute, not only in the localised debate about Greenbergian modernism but in wider interdisciplinary contexts as well. The counter-intuitiveness of including Leighton in a history of modern art may put the question into a more radical form than revisions of the modernist history of art have yet envisaged.

In an essay of 1969, Paul de Man noted 'logical absurdities' in the commonplace categories of literary modernity and literary history:

> The spontaneity of being modern conflicts with the claim to think and write about modernity; it is not at all certain that literature and modernity are in any way

17 Frederic Leighton, *Athlete Wrestling with a Python*, 1877.

compatible concepts. Yet we all speak readily about modern literature and even use this term as a device for historical periodization, with the same apparent unawareness that history and modernity may well be even more incompatible than literature and modernity.[5]

For de Man, as for many historians of modern art, a key text for exploring such issues is Baudelaire's essay of 1863, 'The Painter of modern life'. De Man reads Baudelaire as acknowledging the paradox of a modern art, by constantly qualifying the evocation of 'present-ness' with expressions that concede duration or reflection, such as 'the representation of the present'. Modernity might mean forgetting the past, but the alternative for the artist is to capture 'the memory of the present'. The working procedure of Constantin Guys, as Baudelaire describes it, comes close to translating memory into spontaneous action; according to Baudelaire a drawing by Guys is complete at any moment in the process of its making. But that must entail arresting the process whenever the drawing is contemplated as a complete work of art. The moment of the work's invention, its pure

modernity, continually passes into a moment of reflection that calls into question the possibility of modernity.[6]

Leighton's work might be described as approaching the paradox from the opposite direction, taking the impossibility of modernity as the starting point rather than the entailment of the artistic process. Certain disconnected jottings in his Notebooks, as well as the entire scheme of his Presidential Addresses to the Royal Academy, perhaps define the modern artist as one for whom modernity is impossible: 'in one respect we can never be like the ancients – we can no longer be the *unconscious* voice of our times – we are introspective analytic, doubts + selfconsciousness beset and hamper us'.[7] He tries to console the young artist who may feel overwhelmed by the sheer mass of precedents, 'the infinite variety of examples which Time has set before him'.[8] In his own work he makes no attempt to repress the memory of the art-historical past. On the contrary, he multiplies and overlaps reminiscences of earlier texts, sculptures, and paintings as if to present the modern work as an anthology of past works of art. Thus *Daedalus and Icarus* not only represents the story told in Ovid's *Metamorphoses* but hints at the art-historical texts, ancient and modern, that characterise Daedalus as the inventor of sculpture,[9] and perhaps also at those that interpret the flight of Icarus as an allegory of artistic inspiration.[10] The figure of Icarus has reminded scholars variously of the *Apollo Belvedere*, the ancient sculpture group known as *Castor and Pollux*, Canova's *Icarus*, and the Praxitelean *Hermes*; the extravagant arabesque of drapery might recall Hellenistic or Baroque prototypes.[11] These disparate references are pulled together with the taut precision of academic finish, incorporating the technical refinements of centuries of research into perspective, anatomy, modelling, and the physical properties of pigments. The subject, the visual quotations, and the technical thoroughness of the academic style all suggest a meditation on the history of art. More specifically the picture reflects on the relations between the ancient art of sculpture and the modern art of painting, relations that culminate in the beautiful sculpturesque body of the painted Icarus.

An eclecticism so excessive dramatises the predicament of the modern artist as Leighton described it in his Academy Addresses. But can we see it as transforming the project, leaving behind the impossibility of modernity in order to open up an enquiry into the possibility of modern art itself? In that case an interpretation of Leighton's work might loop back, surprisingly, to what seemed at first its antithesis, modernism in the sense Greenberg defined it in 1960:

> The essence of Modernism lies, as I see it, in the use of characteristic methods of a discipline to criticize the discipline itself, not in order to subvert it but in order to entrench it more firmly in its area of competence.[12]

On further reflection this is not so surprising after all. Both Victorian Aestheticism and Greenbergian modernism have often been attacked for their introversion, for concentrating on problems internal to the discipline of art at the expense of wider social, cultural, and historical issues. In that sense Leighton's classicism and

modernist abstraction could be described as alternative approaches to the problem of aesthetic 'purity' – the possibility that, whether by choice or compulsion, art limits itself to its own internal concerns under the conditions of modernity.

By juxtaposing Leighton, the academic artist, with Greenbergian modernism I am engaging in the kind of art-historical strategy that has been controversial in recent years under the label 'revisionism'.[13] In fact I shall propose two simultaneous revisions, revisions of both Leighton and modernism that emerge from their apparent collision. This exercise might be justified on historicist grounds, because it reintegrates art-historical events within the modern period that have been sundered by modernist ideology. But it may also be justified on the grounds of aesthetic theory, for I want to argue that the notion of aesthetic purity is central to the paradox of a modern art.

Towards a revision of Leighton

Greenberg's reference to Leighton occurs in his *Partisan Review* essay of 1940, 'Towards a Newer Laocoön'. In a schematic history of Western art since the seventeenth century, Greenberg inveighed against the subservience of other art forms, in particular academic painting, to the dominant art of literature. From the mid-nineteenth century onwards, the project of avant-garde art (Greenberg was not yet using the term 'modernism') was to free each of the art forms from their dependence on literature through an assertion of the unique qualities of their own media.[14] At this early stage in his career, Greenberg's anti-'literary' conception of 'pure' art was very close to that of Victorian texts such as Whistler's 'Ten o'clock' lecture or Walter Pater's 'The School of Giorgione'. Indeed Greenberg acknowledged his debt to Pater in a footnote. But he did not recognise Leighton's important role in the same revolt against the sway of 'literary' values, the revolt associated in the Victorian period with the labels 'art for art's sake' and 'Aestheticism'. In fact, it would not be difficult to situate Leighton's art somewhere in a historical trajectory from mid-Victorian narrative plenitude to modernist abstraction. As Anna Gruetzner Robins has demonstrated, Walter Sickert accorded some such role to Leighton, repeatedly praising the purely 'decorative' qualities of his work in antithesis to the 'literary' characteristics of Victorian narrative painting.[15]

It might be argued, then, that Greenberg simply misinterpreted Leighton's work. On the other hand, Leighton's painting style is instantly recognisable as 'academic', and was consistently branded as such from the 1860s onwards.[16] It revels in the illusionistic skill that Greenberg characterised in 1940 as a dishonourable occlusion of the medium, oil paint on a flat support.[17] This kind of denunciation of academic style has proved remarkably resilient. The account of Charles Rosen and Henri Zerner, first published in the 1970s, is particularly vivid:

> The *fini* of the Academy paintings is ... an estrangement, an alienation, not only from the reality that is represented, but from the reality of art. ... It cleans up, rubs out the

traces of any real work, erases the evidence of brushstrokes, glosses over the rough ·
edges of the forms, fills in the broken lines, hides the fact that the picture is a real
object made out of paint. Art, now become the slave of the rendering of textures and
surfaces, turns itself into a transparent medium for an imaginary world.[18]

Daedalus and Icarus fits that description well, not only in the overall glossiness of
the surface and the suppression of the marks of the brush, but also in the uncanny
smoothness of the modelling; the eye follows the roundness of Icarus's limbs but
cannot detect the fine gradations of tone that seem magically to conjure three-
dimensionality. The ideological entailments of such a technique may appear to
follow inexorably.[19] The academic style is read as physically and literally the style of
bourgeois complacency, of imperial rule and colonial administration, a style of
hygiene and bureaucratic efficiency, legislated in every detail, yet nonetheless man-
aging to smooth over any difficulties in a seamless veil of glossy paint. Leighton was
certainly the principal English representative of this style. As President of the
Royal Academy he was also the chief administrator of English art in the period
between 1878 and 1896.

This account of academic style is now so orthodox that it may seem unchal-
lengeable, but it is not the only view. For Victorian critics of *Daedalus and Icarus*,
the effect of the 'licked surface' was not at all to suggest the transparency of the
medium to the represented scene. They saw only artifice, from the stylised juxta-
position of the skin tones to the flamboyant swirls of the drapery: 'The wind never
twisted any drapery ever woven into the infinity of little zigzag convolutions with
which Mr. Leighton has broken up the robes'.[20] Far from being mesmerised by an
illusion, critics were compulsively reminded of other works of art: 'the surface is
smooth as a highly finished bas-relief'; 'he attains a purity of line and a generic ide-
ality of form comparable to the style of a Greek cameo'.[21] These responses are quite
unlike most critical writing of this date, which ordinarily concentrated on
describing the represented scene rather than the manner of the representation.[22]
Most distinctive in the criticism of Leighton are the frequent references to the
quality of the picture surface, variously described as smooth, waxy, polished, or
glossy. The surface could even be reprehended as luscious or voluptuous, which
suggests a different kind of ideological entailment from the ones we now find in
academic style.[23]

It has, then, been possible for some observers to see in Leighton's work not the
conventional academic occlusion of the medium, but a flaunting of it. It depends, of
course, which physical properties of the medium are stressed. The oiliness of oil
paint and the capacity of pigments to mix in endless gradations are not in any
obvious way less central to the medium than the viscousness often emphasised by
Courbet or the blatant tonal juxtapositions of Manet. Greenberg was aware of such
difficulties, for he narrowed down his criteria to one essential quality, the flatness of
the support.[24] Even here, he had to admit that the possibility of suggesting three
dimensions on a two-dimensional surface continued to fascinate in the work of an
artist such as Mondrian; he took refuge in positing a third dimension that was

'strictly pictorial, strictly optical', and therefore truer to the two-dimensional nature of painting than an illusion of space that the spectator might imagine walking into or touching.[25] As early as 1894, Roger Fry had advanced a similar argument in an unpublished article on 'The Philosophy of Impressionism'.[26] Here he attacked academic modelling because its suggestion of the tactile was untrue to the purely visual quality of painting; for Fry the Impressionist disavowal of modelling was more faithful to optical sensation. Fry's argument attempts a grounding in the science of perception, but it also betrays a debt to Renaissance theories about the hierarchy of the senses – to privilege the sense of sight over that of touch suggests a moral preference for distanced or intellectualised perception over physical contact. Fry's attack on academic style thus has clear affinities with earlier criticisms of Leighton's 'voluptuous' painted surfaces. Leighton's exploration of the medium is less purely pictorial on such terms; rather by admitting the tactile it expands the capabilities of the medium to encompass the imagined pleasures both of touching the glossy paint surface and of caressing a rounded fleshly form.

In Fry's and Greenberg's arguments there is of course a more rigorous underlying idea, that the spectator's experience of the optical or visual in painting is more direct than that of the tactile or three-dimensional, which must be imagined or inferred, and that therefore the optical is truer to painting's basic nature than the tactile. This relates to an axiom that already had a long history in art theory: that excellence in an art form should be defined according to what is unique to that art form, and not shared with any other. Already in Hegel's *Lectures on Aesthetics* (first published posthumously, 1835–38), painting was characterised by a 'quality of visibility' and restriction to a 'plane surface', as opposed to the three-dimensionality of sculpture: 'The spirit which sculpture represents is that which is solid in itself … [it] appears under this one aspect only, as the abstraction of space in the whole of its dimensions'.[27]

On such terms Leighton's painting might be accused of departing from the purely pictorial to trespass on the domain of sculpture. As we have seen, Victorian critics likened *Daedalus and Icarus* to ancient bas-relief or cameo cutting; moreover the body of Icarus is sculptural not only in the general sense of evoking tactile pleasure but in the particular one of reminding the observer of classical sculptures of the male nude. Conversely, Leighton's practice in sculpture trespasses on the domain of the pictorial. His first sculpture, *Athlete Wrestling with a Python*, seems effortlessly to translate the 'licked surface' of academic painting into bronze, not only by exploiting the play of light on highly polished metal but by refining surface detail to a degree that startled Victorian critics accustomed to the more generalised surfaces of the neo-classical sculptural tradition. Critics of the *Athlete* on its first appearance, at the Royal Academy in 1877, dwelt on details such as the straining, distended vein on the left foot, the rippling scales of the serpent, the sinews of the powerful arms.[28] With justice they marvelled at Leighton's skill at manipulating finish in a medium he had never tried before – one, moreover, that had traditionally been defined by the inflexibility and rigidity of its materials, distinguishable from

painting precisely by its resistance to elaboration of surface detail. England's major academic art theorist, Sir Joshua Reynolds, had insisted that sculpture must abjure 'whatever ... goes under the denomination of Picturesque'. Reynolds had assumed that the sculptor's basic material was marble. The bronze medium of the *Athlete* permitted a significant revision of Reynolds's notion of sculpture, not only in the elaboration of surface detail, but also in the flexibility and elasticity of the massing. The extension of one unsupported arm, the separation of the legs, and the complicated torsion of the body all exploit the suppleness of bronze in contrast to the 'uniformity and simplicity' of massing that Reynolds expected of sculpture in marble.[29]

That transgression of the traditional boundary between sculpture and painting led contemporary critics to see Leighton's *Athlete* as initiating the movement among younger English sculptors, such as Alfred Gilbert and Hamo Thornycroft, that came to be called the 'New Sculpture'. In sculpture, then, Leighton seemed for a time a prophet of modernity, even though his painting was already regarded as traditionalist.[30] M. H. Spielmann's book of 1901, *British Sculpture and Sculptors of To-Day*, displays considerable unease about the attention in recent sculpture to surface detail, realism in modelling, the addition of picturesque accessories, and above all the importation of non-traditional materials such as coloured metals, stones, and gems. For Spielmann such characteristics were unequivocally modern, but the result was to confuse the distinction between painting and sculpture central to the academic theory of the respective art forms.[31]

There is a case, then, for regarding Leighton's practice, in sculpture and painting alike, as a prime example of the 'confusion of the arts' that Greenberg, in 1940, saw as afflicting Western art since the seventeenth century and necessitating the modernist project of reasserting the uniqueness of each medium.[32] On this view, the modernist notion of the purity of the art forms, rooted in the physical characteristics of their respective media, has clear affinities with the academic theory of sculpture as it appears in Reynolds's Tenth Discourse. That is not as surprising as it appears at first thought. One of Fry's early projects was a critical edition of the *Discourses*, published in 1905, in which he strongly endorsed Reynolds's contention that (in Fry's words) 'sculpture should aim, more exclusively than painting needs to do, at the essential generalities of form'.[33] From a modernist point of view, Reynolds's art theory, and particularly the Discourse on sculpture, can be read as a precursor of formalism: 'we are sure from experience, that the beauty of form alone, without the assistance of any other quality, makes of itself a great work, and justly claims our esteem and admiration'.[34]

Leighton's sculpture might be called a different re-reading of Reynolds, a translation of his notion of marble sculpture into the fluidity and suppleness of bronze. But there is a more obvious sense in which the *Athlete* intervenes in the debate about the 'confusion of the arts'. Greenberg's article of 1940 relates the modernist version of the debate to an important German text on the uniqueness of the art forms, G. E. Lessing's *Laocoön* of 1766, acknowledged in Greenberg's title, 'Towards a Newer

Laocoön'.[35] But Lessing's text must also be implicated in Leighton's sculpture, overtly a modern meditation on the same ancient sculpture of a nude man struggling with serpents, the celebrated *Laocoön* of the Vatican Museum (Figure 18).[36] If Leighton was initiating a new movement in English sculpture, it makes an intriguing parallel with the art-historical role of the *Laocoön*, famous for its impact on Michelangelo and others when it was unearthed in 1506. The familiar anecdote suggests a striking historical precedent for an encounter with the classical that initiates possibilities for the modern.

The canonical status of the *Laocoön* was well established before the eighteenth century, but it was Lessing's text that identified it irrevocably with the theoretical distinction between art forms arrayed in space, which Lessing designates under the generic term 'painting', and art forms proceeding in time, which Lessing calls 'poetry', but which in Victorian and modernist parlance might be identified with the 'literary'.[37] That suggests a rather different interpretation of Leighton's sculpture, in which it proves after all to explore the aesthetic of purity, in terms of Lessing's notion of the spatial arts. The apparent 'confusion' between painting and sculpture in Leighton's work might then be part of a wider exploration, in which painting and sculpture are allied in opposition to the temporal or 'literary' arts. It is true that a number of Victorian critics permitted themselves to wonder whether the man or the snake would emerge victorious, thus supplying a kind of temporal

18 *Laocoön*, Vatican, Rome.

narrative for the sculpture (most critics opted for the man, despite the manifest improbability of a human victory over so powerful a brute).[38] But the predominant impression was that the sculpture was an exploration of the body in space, not of a moralisable action extending into time. As H. H. Statham observed in the *Fortnightly Review*: 'we find no trace in it of ... moral grandeur of aim. ... We could hardly say that there is anything about it to "incline us to take life seriously." It must be judged simply as a representation of that grand machine, the human figure.'[39] Henry James concurred in more approving vein: 'Whenever I have been to the Academy I have found a certain relief in looking for a while at this representation of the naked human body, the whole story of which begins and ends with the beautiful play of its muscles and limbs'.[40]

James's wording is precise: the 'story' that a Victorian art critic might expect to find in the work 'begins and ends' in the presentation of the body in space. The beginning and the ending occur simultaneously, as if to realise Lessing's category of spatial 'painting' as opposed to temporal 'poetry'. Moreover, this denial of temporality helps to account for Statham's contention that no moral could be drawn consequentially from the representation. Leighton's reinterpretation of the classical prototype emphasises the shift from temporal to spatial. The *Laocoön* is tied to a significant classical narrative, and indeed owed its prominence in Lessing's text to its putative association with the story of the Trojan priest and his sons enveloped by sea-serpents in Virgil's *Aeneid*. Leighton eliminates the narrative context, including the two subsidiary figures, and concentrates the contest of man and snake into one moment of equilibrium. The extension of the body into three-dimensional space is much more dramatic than in the classical prototype, which arrays the bodies across a frieze-like plane ideally viewed from the front only. Leighton's sculpture instead encourages the spectator to circle endlessly around it, to delight in various views of the interpenetrations of human limbs, coiling snake and open space, kept in magical balance by the complex development of classical contrapposto. The figures of the *Laocoön* are rooted to the massive marble base and trammelled by the coils of the enormous serpents. In Leighton's revision the limitations of marble are left behind for the freer plasticity of bronze. The sculpture liberates itself from the block, swivelling into space to become the autonomous object of modern aesthetics. In a Victorian context such a shift from temporal narrative to spatial form is ordinarily associated with the term Aestheticism, and divorced from the standard Franco-centric history of modernism. Yet the search for aesthetic purity in the spatial arts shares something important with the Baudelairean notion of modernity: a concentration on the 'present-ness' of the work of art that negates any imaginative extension into past or future.

Greenberg used a formulation reminiscent of James's 'story', beginning and ending in itself, when he spoke of aesthetic purity in avant-garde art: 'The picture or statue exhausts itself in the visual sensation it produces'.[41] This in turn recalls a passage in Walter Pater's early essay 'Winckelmann' (1867), where he describes a Greek sculpture of high status, the Venus de Milo of the Louvre:

That is in no sense a symbol, a suggestion, of anything beyond its own victorious fairness. The mind begins and ends with the finite image, yet loses no part of the spiritual motive. This motive is not lightly and loosely attached to the sensuous form, as its meaning to an allegory, but saturates and is identical with it.[42]

As we have seen, Greenberg acknowledged his debt to Pater in a footnote to 'Towards a Newer Laocoön'.[43] Recent literary criticism has increasingly emphasised the importance of Pater's writings to modernist literature and literary criticism.[44] The point can easily be extended to demonstrate the significance to the modernist project not only of Pater's writings but of art such as Leighton's, associated with the terms 'art for art's sake' and 'Aestheticism'. Leighton's *Athlete* explores in bronze the aesthetic completeness, the saturation or exhaustion of associated meanings in the concrete presentment of the body in space that Pater attributed to Greek sculpture, his paradigm for a pure art. We might, then, write Pater and Leighton into the modernist canon in a founding position analogous to that usually accorded to Baudelaire and Manet.[45]

This revision perhaps recovers a lost historical link between Victorian Aestheticism and Greenbergian modernism; in the process it finds a place for Leighton in the history of modern art. A similar reinterpretation might be applied to other academic artists, such as William Bouguereau or Alexandre Cabanel, whose elaboration of technical skill might also be interpreted as a move away from the 'literary' and towards a self-sufficient art. But there is a significant objection to this kind of revisionist procedure. It leaves intact the progressivist thrust of the modernist story-line, augmenting its cast of characters but continuing to presume a historical trajectory from the dominance of the 'literary' to a notion of aesthetic purity that can reach its logical endpoint only in abstraction. Another objection might be that this revision fails to account for the backward-looking aspect not only of the academic artists' classicising works, but of Pater's concentration on the art of the past. Yet that loose end might suggest a further revision, not only of the modernist aesthetic of purity, but also of its logical corollary, the inexorable trajectory towards abstraction.

Towards a revision of modernism

Greenberg's footnote to Pater refers to the discussion of the uniqueness of the art forms in Pater's essay of 1877, 'The School of Giorgione'. Pater too had grounded his notion on differences of medium: 'Each art, therefore, having its own peculiar and untranslatable sensuous charm, has its own special mode of reaching the imagination, its own special responsibilities to its material'.[46] Moreover, he immediately invokes Lessing's *Laocoön* as a founding text for this idea.[47] But he goes on to qualify his initial position in what almost seems a reversal:

But although each art has thus its own specific order of impressions, and an untranslatable charm, while a just apprehension of the ultimate differences of the arts is the

beginning of aesthetic criticism; yet it is noticeable that, in its special mode of han-
dling its given material, each art may be observed to pass into the condition of some
other art, by what German critics term an *Anders-streben* – a partial alienation from
its own limitations, through which the arts are able, not indeed to supply the place of
each other, but reciprocally to lend each other new forces.[48]

Having begun with an emphasis on the 'limitations' of the various arts (a kind of
phrasing particularly favoured by Greenberg), Pater then proceeds to authorise a
transgression, or transcendence, of those limitations; the apparent contraction
metamorphoses into a startling expansion of the potential domain of the arts.
Pater's exceptionally nuanced prose style accomplishes this transition as if it were
simply a logical next step in the argument. However, the result is a thoroughgoing
reconfiguration; what seemed at first to foreshadow the modernist aesthetic of
purity proves to critique it before the fact.

In Pater's writing a new interpretation of Greek sculpture plays a crucial role in
this transformation. In an essay of 1880 on 'The Beginnings of Greek sculpture',
he offered an explicit critique of traditional conceptions of sculpture's special
purity, writing that 'Greek sculpture has come to be regarded as the product of a
peculiarly limited art, dealing with a specially abstracted range of subjects; and the
Greek sculptor as a workman almost exclusively intellectual'.[49] Sculpture remains
the paradigm for a notion of aesthetic purity, still rooted in the physical characteris-
tics of the medium, but Pater exchanges the old emphases on limitation and gener-
ality for a new celebration of diversity and sensuous particularity. He reinterprets
the media of Greek sculpture as rich, sensuous, complex, and colourful; instead of
white marble he stresses chryselephantine, metalwork, and woodwork.

Already in the early passage on the Venus de Milo, there is the suggestion that
sculptural limitation may metamorphose into plenitude; the image is 'finite', yet it is
saturated by its 'spiritual motive'. The phrasing draws overtly on Hegel's account of
sculpture, the art form characterised by a special equilibrium between the spiritual
content of art and its sensuous embodiment; as Hegel put it, 'the sensuous element
itself has here no expression which could not be that of the spiritual element, just as,
conversely, sculpture can represent no spiritual content which does not admit
throughout of being adequately presented to perception in bodily form'. In this
account, the special nature of sculpture is inseparable from its embodiment in the
human figure. Indeed, sculpture comes into being as a dramatic incarnation: into the
temple, relic of the previous architectural phase in Hegel's scheme, 'the God enters
in the lightning-flash of individuality, which strikes and permeates the inert mass,
while the infinite and no longer merely symmetrical form belonging to mind itself
concentrates and gives shape to the corresponding bodily existence'.[50]

The immediate context for Pater's reference to the Venus de Milo was Pater's
reading of Johann Jacob Winckelmann, the eighteenth-century German historian
of Greek art. Winckelmann's close observation of such ancient sculptures as were
available to him brought startling complexity and nuance to the description of
sculptural surfaces. Of the *Laocoön* he wrote:

> Though the outer skin of this statue when compared with a smooth and polished surface appears somewhat rough, rough as a soft velvet contrasted with a lustrous satin, yet it is, as it were, like the skin of the ancient Greeks, which had neither been relaxed by the constant use of warm baths ... nor rubbed smooth by a scraper, but on which lay a healthy moisture, resembling the first appearance of down upon the chin.[51]

This attention to the sensuous and tactile qualities of the material's surface, as well as the sense of the critic's intense and potentially erotic response to the work of art, shifts the emphasis decisively away from the generality and austerity that formerly seemed to guarantee sculpture's special purity as an art form. The purely aesthetic seems here to imply not 'abstraction', either formal or intellectual, but concreteness and intense subjective engagement. In his essay of 1867, Pater underlined Winckelmann's reinterpretation of the *Laocoön*, using terms that seem to prefigure those used later about the 'New Sculpture': 'The *Laocoön*, with all that patient science through which it has triumphed over an almost unmanageable subject, marks a period in which sculpture has begun to aim at effects legitimate, because delightful, only in painting.'[52]

Leighton's *Athlete* might be described as exploring the Winckelmannian and Paterian characterisation of the *Laocoön*, with its emphasis on surface texture as well as its pleasurable exploration of the bodily forms of the male nude. If the sculpture is an exploration of free form in space, it does not search for abstraction; the pleasure of its spatial extension is inseparable from the flexibility of human limbs stretched to their utmost elasticity, as well as the supple contours of the musculature. Having abandoned the story of Laocoön, Leighton retains the heroism of the figure in the purely physical terms of the muscled body. That many critics thought the man's victory possible suggests an optimistic reinterpretation of the old theme, a glorification of the strength of the mature male body.

The bronze medium enables the malleability of the corporeal forms, but it also suggests a revival of the lost Greek art of bronze statuary. In the standard classical source for the history of art, Pliny's *Natural History*, art forms are classified according to the material in which they are made, so that sculpture is divided into two books on bronze and marble respectively. However, the bronzes eulogised as great works in Pliny's account were not extant in the modern world; they were known principally through later copies in marble. Leighton's *Athlete* imaginatively translates the marble classicism of the surviving copies back into the original medium of bronze. In 1886 Leighton exhibited a second bronze sculpture of a male nude, *The Sluggard* (Figure 19), his only other life-size work in the medium. The discarded laurel wreath on the pedestal indicates that this too is an athlete, perhaps a Greek victor like the ones praised in Pindar's odes for their physical beauty as well as their athletic prowess. This time, though, the figure appears in a moment of rest, stretching himself luxuriously. The slimmer forms and softer musculature are still those of a trained athlete, but they recall the sensuousness associated with Praxitelean sculpture rather than the more heroic, perhaps Pheidian, forms of the *Athlete*.

Together the *Athlete* and *The Sluggard* seem not only to complement each other in the expressive characterisation of the male nude, in stress and at ease, but to summarise the history of Greek sculpture codified by Winckelmann: the *Athlete* would seem to epitomise Winckelmann's 'high' style (associated with Pheidias), while *The Sluggard* represents the 'beautiful' (associated with Praxiteles).[53] In his essay of 1890 on the Greek bronzes, 'The Age of athletic prizemen', Pater too emphasised the notion of two contrasting phases, although he chose different prototypes:

> the *Discobolus* or quoit-player, of Myron, the *beau idéal* (we may use that term for once justly) of athletic motion; and the *Diadumenus* of Polycleitus, as, binding the fillet or crown of victory upon his head, he presents the *beau idéal* of athletic repose, and almost begins to think.[54]

Pater's essay can be interpreted in part as a response to the 'New Sculpture', in particular the male nudes in the work of such sculptors as Gilbert and Thornycroft; it may or may not be a coincidence that his two principal examples correspond so closely to Leighton's two sculptures.

More important is the new aesthetic Pater was proposing through his reinterpretation of the Greek bronzes, one that gathered in older notions of aesthetic purity only to expand them dramatically into the realms of sensuous and erotic pleasure. The phrase '*beau idéal*', which Pater stresses both by repetition and with a parenthetical gloss, suggests that this new/ ancient aesthetic can encompass the academic conception of ideal beauty. Indeed, Pater notes the 'academic' credentials of both the Greek sculptors he emphasises: Myron's bronze statue of a cow and Polycleitus' canon of proportions for the human figure were both cited in ancient texts as exemplary models for students.[55] In Kant's *Critique of Judgement* the same two sculptors figure as the quintessential examples of the 'academically correct'.[56] For Kant this differentiates the works of Myron and Polycleitus from the purely aesthetic; their obedience to rules of proportion ties them to a means–end rationality that disqualifies them from 'free' beauty. But Pater's more inclusive notion of the aesthetic can accommodate the academically correct. Startlingly, he identifies the sensuous pleasures of bronze with a notion of finish that

19 Frederic Leighton, *The Sluggard*, 1886.

transforms Winckelmann's fascination with surface texture into something closer
to late nineteenth-century notions of academic style:

> In any passable representation of the Greek *discobolus*, as in any passable representa-
> tion of an English cricketer, there can be no successful evasion of the natural diffi-
> culties of the thing to be done – the difficulties of competing with nature itself, or its
> maker, in that marvellous combination of motion and rest, of inward mechanism
> with the so smoothly finished surface and outline – finished *ad unguem* – which
> enfold it.[57]

The phrase '*ad unguem*', 'down to the finger-nails', vividly expresses the extreme
finish that by the date of this essay was indissolubly associated with academic style.
In his essay of 1894, 'The Philosophy of Impressionism', Fry described academic
finish in the same terms: 'the rosy finger nails remained clear and precise'.[58] But in
Pater's account detailed finish does not represent an occlusion of the medium.
Instead it is a legitimate expression of the malleability of bronze; simultaneously it
is a source of tactile and even erotic pleasure.

Pater's account of Myron is closely based on Pliny's *Natural History*. In particular
Pater dwells on Pliny's final sentence, summing up Myron's achievement: 'Still he
too only cared for the physical form [*corporum tenus curiosus*], and did not express the
sensations of the mind [*animi sensus non expressisse*]'.[59] Yet Pater's re-reading of
Pliny's epigrammatic summary recalls (and reverses) earlier critical reservations
about Leighton's preference for the bodies over the moral characters of his figures.
For Pater, Myron's emphasis on the body is his special virtue:

> just there, in fact, precisely in such limitation, we find what authenticates Myron's
> peculiar value in the evolution of Greek art. It is of the essence of the athletic
> prizemen, involved in the very ideal of the quoit-player, the cricketer, not to give
> expression to mind, in any antagonism to, or invasion of, the body; to mind as any-
> thing more than a function of the body, whose healthful balance of functions it may so
> easily perturb; – to disavow that insidious enemy of the fairness of the bodily soul as
> such.[60]

Pater goes on to reiterate the importance of the bronze medium in this project: 'it
was as if a blast of cool wind had congealed the metal, or the living youth, fixed him
imperishably in that moment of rest which lies between two opposed motions'.[61] In
this account Myron seems to capture the moment with the spontaneity of
Constantin Guys in Baudelaire's essay. At the same time he realises Lessing's ideal
of a purely spatial art. Moreover, Leighton as Myron, in Pater's expansion of the
Plinian account, informed by Lessing, is both a modernist and an academic: an
artist who unites consummate technical skill with extreme sensitivity to the
medium, one who discards 'literary' associations ('the sensations of the mind') to
concentrate not on abstract form, but on the human body in space.

Pater's erotic engagement with the *Discobolus*, or rather with its imagined
bronze prototype, seems obvious to the late twentieth-century reader. Moreover,

the frequent references to English cricketers suggest the contemporary relevance of Pater's homoerotic reading of the Greek sculptures. Linda Dowling and other scholars have demonstrated the importance of Hellenism to constructions of male same-sex desire in the later Victorian world.[62] Thus the Greek male nude turns out to involve 'modernity', in the sense of engagement with social and cultural change, after all, and this must apply also to Leighton's sculptures. His two sculptures, as well as paintings such as *Daedalus and Icarus*, demonstrate his fascination with the male body – a fascination expressed in the melting modelling and luscious surface of his paint, or in the lustrous polish and detail *ad unguem* of his bronze.

Leighton's personal sexuality is of course undocumented, and there is no reason to interpret his depictions of the male nude as intentional interventions into con-temporary debates on male same-sex desire; his pictures of female figures and of children no doubt engage with 'modern' debates on sexuality in different ways. But the issue is not merely one of personal sexual predilection. As Jonathan Loesberg has observed, twentieth-century critical disdain for Aestheticism has a conspic-uous homophobic edge; this may help to explain the modernist critics' repudiation of Aestheticism as a precursor to their own project.[63] In Leighton's case the homo-phobic response has been particularly pronounced, as evident in the critical response to the Royal Academy's Leighton retrospective of 1996.[64]

The antithesis between the modernist aesthetic of purity and the sensualised aesthetic of Leighton and Pater is a gendered one. Greenberg saw the modernist engagement with the medium as a kind of struggle, bringing out the resistance of the material; this returns to the emphasis of Reynolds or Hegel on the hardness and inflexibility of sculptural materials. By contrast Pater and Leighton stress the sup-pleness, the ductility, the malleability of the medium and indeed of the sensualised human body. The gendered implications of the modernist heroic struggle, versus the aestheticist yielding to the material, are obvious. Indeed a whole series of gen-dered antitheses is involved: resistance versus yielding, modernist versus academic, modern versus ancient. If the academic theory of sculpture was an important source for the modernist doctrine of aesthetic purity, the reinterpretation of Greek sculpture in Pater and Leighton provides a significant alternative to that doctrine, and one that is more expansive, encompassing minute finish as well as large-scale design, tactile contact as well as optical distance, the erotic as well as the abstract. This is also an alternative to the patriarchal. Bringing Leighton and Pater into the canon may thus bring ideological benefits appealing in our post-modern world, as well as opening up a dramatically wider range of aesthetic pleasures.[65]

Yet there is an important objection to this kind of revision. Arguably it remains tied to the modernist value system, simply tinkering with its judgements. In place of the elegance of limitation in modernism we have the richness of diversity and the pleasures of the senses. But the revision still assumes that the aesthetic of purity is a valid, or even a principal, aim for modern art. In an important article of 1989, signifi-cantly entitled 'Limited revisions', Neil McWilliam offered a trenchant critique of revisionist strategies that remain in thrall to the modernist discourse they purport to

oppose.[66] Both of the revisions I have proposed here are vulnerable to that charge, the first by accepting the historical trajectory of the modernist grand narrative, the second by accepting the importance of the aesthetic of purity. Yet McWilliam's own preference for 'serious historical investigation', purged of modernist value judgements, merely substitutes a rhetoric of historical purity for that of aesthetic purity.[67] By differentiating historical enquiry so decisively from aesthetic judgement McWilliam paradoxically concedes not only the existence of the latter but also its claim to occupy an autonomous sphere. This is simply a larger reversal of the modernist system of values. Indeed McWilliam's isolation of the aesthetic from the historical is more thoroughgoing than that of many modernist critics, including Greenberg, who was at considerable pains to stress the historical contingency of his own aesthetic criteria.

The very word 'revisionism' suggests that we are not writing a new history of modern art, but rewriting an old one. McWilliam calls for 'a whole-scale rewriting of nineteenth-century art history, a drastic reassessment of values which fundamentally questions the consecrated narrative of formal experimentation and progressive development'.[68] But terms such as 'rewriting' and 'reassessment', like Baudelaire's language in de Man's reading, covertly acknowledge that there is no 'pure' history, magically liberated from earlier historical narratives. Our desire for a *tabula rasa*, for a history of modern art that can forget previous histories, is akin to the desire for a modern art. We crave a more authentically modern account of modernity, a spontaneous gesture free from a 'modernism' which is no longer modern. But the paradoxes multiply. Such a spontaneous account could never be a 'history', since it would voluntarily abandon the retrospective viewpoint without which history is inconceivable. Nor could it ground its claim to call its object 'modern' art, for such a designation presupposes a periodisation that can only be historiographical. Perhaps that helps to account for the fascination, whether admiring or derogatory, with the aesthetic of purity. It is only in some realm 'outside history' that we can imagine modernity at all. The aesthetic as theorised in Western philosophy since Kant is such a realm, even if it appears to be an illusion when subjected to 'serious historical investigation'. We are, then, in the position of Leighton, forced to begin with an acknowledgement that a truly modern history of modern art is impossible for us. We can only rewrite or revise. But that need not be a melancholy prospect, for revision can become a way to open new possibilities – to move forward in a historiographical age that, like Leighton's perception of his artistic age, seems overburdened by precedents.

Our own academic conventions permit us to unmask the ulterior motives of writers such as Fry and Greenberg but they do not necessarily require us to reveal our own. Perhaps, though, I ought to rephrase the question with which I began: Why do I wish to write Frederic Leighton into the history of modern art?

For Rosen and Zerner, the absence of passion in the championship of academic art marks the failure of the revisionist project: 'In all of his hundreds of thousands

of words on Couture, Boime cannot bring himself to say that Couture was won-
derful. His inability to work up much interest in his hero except as a historical
influence is disarming, but this lukewarmness is typical of the present revival' of
the French academic painters.[69] They go on to ask why current revisionist scholars
do not display the same 'enthusiasm' as the revivalists of the nineteenth century:
'When Gothic architecture was taken up by Romantic critics, they declared boldly
that the great cathedrals were sublime, inimitable, far surpassing the buildings of
the classical Renaissance'.[70] In their view, the absence of this polemical and com-
bative edge from recent revisionist histories proves that academic art is not in the
end worth championing except on what Pater called antiquarian, rather than aes-
thetic, grounds. As Pater put it:

> There are a few great painters, like Michelangelo or Leonardo, whose work has become
> a force in general culture, partly for this very reason that they have absorbed into them-
> selves all such workmen as Sandro Botticelli; and, over and above mere technical or
> antiquarian criticism, general criticism may be very well employed in that sort of inter-
> pretation which adjusts the position of these men to general culture, whereas smaller
> men can be the proper subjects only of technical or antiquarian treatment.[71]

As I have argued, Leighton's work deserves incorporation into the history of
modern art on antiquarian or historicist grounds. Moreover, I do not hesitate to say
that I think Leighton is 'wonderful'. But should I go further, as Rosen and Zerner
seem to require, to claim that Leighton's art 'surpasses' the art of the modernist
heroes – Manet, Cézanne, and the like – as Pugin and Ruskin claimed that the
Gothic surpassed the Renaissance? Pater's writing is so wily that we cannot be quite
sure what kind of claim he is making, in the end, for Botticelli, but the example
shows that what we do matters. At the time Pater was writing, Botticelli was indeed
a minor master, but few would now deny him a place among the greatest artists. In
that dramatic canonical shift Pater's brief article of 1870 played a key role.

Yet Pater's criticism differed fundamentally from Ruskin's or Pugin's, for his
championship of Botticelli, however far he meant it to go, did not work at the
expense of Michelangelo or Leonardo. Pater's criterion for artistic excellence made
no exclusions; each judgement was singular, a matter of isolating the 'virtue' of the
particular work under observation, not of measuring it against other works, and
still less of comparing it to a standard.[72] Thus Pater's method was truly 'aesthetic'
in Kant's sense; his statements were of the aesthetic kind, 'the rose at which I am
looking [is] beautiful', not of the logical kind, 'roses in general are beautiful'.[73] By
contrast the methods of Ruskin and Pugin, or of Fry and Greenberg, were funda-
mentally antipathetic to Kant's notion of a free judgement of taste. Whether the
comparison is to a standard or to other works, a judgement based on comparison
requires the intervention of a concept such as the 'optical' nature of painting as an
art form or its essential flatness. Perhaps, then, the crucial problem with the mod-
ernist aesthetic is that it is not aesthetic at all, but a logical and/or moral position
masquerading as an aesthetic one.

Where, then, does that leave Leighton and academic painting? To be fair to Greenberg, he did not assert his aesthetic concepts as absolute, but explicitly presented them as contingent:

My own experience of art has forced me to accept most of the standards of taste from which abstract art has derived, but I do not maintain that they are the only valid standards through eternity. I find them simply the most valid ones at this given moment.[74]

I might, then, temporise along similar lines. Leaving aside the question of eternity, it seems to me that at this given moment it is important to shift our attention away from the modernist heroes, not merely in the service of post-modernist pluralism, but in order to avoid the bad faith of a 'limited revision' that pretends to critique modernism without questioning its particular aesthetic judgements. For now, I can claim that Leighton is more important to our history of modern art than Manet or Cézanne. That may sound shocking in the context of academic art history at the turn of the twenty-first century, but it is not more so than Fry's advocacy of Post-Impressionism in 1910 or Greenberg's of 'non-objective' art in 1940. Indeed our respect for modernist projects such as Fry's and Greenberg's might increase if we were willing to contemplate a similarly drastic revision to the values we have been accustomed to hold dear under their tutelage.

Yet that is only a first step, a clearing away of the debris before the mouth of the cave. Kant himself would surely have baulked at the thought of a free aesthetic judgement of Leighton. We cannot simply eliminate logical and moral considerations from our contemplation of male nudes painted or sculpted in the later nineteenth century, or more generally from any works by an academic classicist (for reasons of this kind, Kant preferred such things as birds of paradise and crustacea as objects for the judgement of taste, rather than anything involving the human figure).[75] One aim of this chapter has been to unsettle prevailing assumptions about how those considerations might work in the criticism of Leighton's work – to unmask, for example, the homophobic implications of what may be presented as a purely aesthetic distaste for Leighton's work. But I willingly confess to an ulterior motive. Leighton's work seems to me 'wonderful' in the way that many works in the modernist canon also do: as explorations of what 'free' beauty (or the 'pure' aesthetic) might look like, if we could see it. As in Kant's *Critique of Judgement*, that does not mean that such beauty is realised. More significantly, it does not even presuppose that there is such a thing. Kant's notion of the aesthetic allows us to explore what we cannot conceptualise with integrity or perform with impunity. Abstraction and the Grecian body are alternative heuristic devices for beginning such an exploration. There are many logical and moral reasons for preferring either one to the other, but no aesthetic sanction for such a choice. In that sense a radical revision of modernism, one that does not merely tinker with its logical and moral presuppositions, can only be an aesthetic one.

Millais, Manet, modernity

Paul Barlow

Il fault d'être de son temps.

<div align="right">Edouard Manet</div>

I maintain that a man must hold up the mirror to his own time.

<div align="right">John Everett Millais</div>

What is the problem with John Everett Millais? He is probably the most denigrated of Victorian artists, the figure who best seems to epitomise the failure of British art to develop its own independent qualities during the nineteenth century, necessitating the half-hearted importation of avant-garde ideas from France. True, his early Pre-Raphaelite paintings have been accorded some degree of critical respect, though Pre-Raphaelitism is still only tolerated rather than admired by many critics within the Greenbergian tradition of modernist criticism – which sees all forms of modern art as emerging from the French Impressionist and Realist schools, with Manet as the talismanic representative of avant-garde authenticity. Critical judgement on the work produced by Millais after his abandonment of Pre-Raphaelitism during the 1860s is, however, clear. The stuff is dismal. The standard view is most clearly summed up by Julian Treuherz, writing in 1994, who describes what happened to Millais after his election as a Royal Academician in 1863:

> As with so many Victorian artists, this [academic success] led to the pursuit of easy popularity with a conservative picture-buying public which had plenty of money but little taste. Ruskin criticised Millais's change of style, so much the worse after his early promise, as 'not merely fall, but catastrophe.' His late works were painted quickly and loosely, without the exquisite inventiveness and control that had marked his early work.[1]

While some recent critical literature has begun to discuss the later work without such an explicit claim that Millais 'sold out', the imputation remains that the change of style implies a loss of the qualities of which modern viewers can approve. Thus Kate Flint, writing in the catalogue to the 1999 exhibition of Millais's portraits, concludes her discussion of his late portraits of women with this ringing endorsement,

These works, however conventional some of them may now appear, function so inter-
estingly as documents of a period when the role of women was under transition. If
recent critical attention to the culture of this time has tended to emphasise the pio-
neering woman, the individualist, the 'new woman', Millais' portraits help us to place
such social rebellion in the context of the stifling expectations it was seeking to look
beyond.[2]

So Millais's paintings, it appears, are of interest only as historical 'documents'.
Worse, they support an oppressive ('stifling') social experience from which modern
culture seeks to liberate itself. Their pictorially 'conventional' nature, and their
alleged repressive social function are conflated. They fail as art *and* act as agents of
oppression. They are both boring and corrupt.

What exactly is going on here? Both Flint and Treuherz identify Millais's failure
in moral terms: the former as a capitulation to the demands of a tasteless public, the
latter as 'collusion' – a term she actually uses – with an oppressive regime.[3] But this
moral failing is *realised* in pictorial form – in Millais's weakness as an artist. For
Treuherz, it is enough to assert Millais's tastelessness and imply that his painting
'quickly and loosely' is evidence of sloppiness. Flint, though, is more specific. To
illustrate her argument she contrasts Millais's portrait of the three Armstrong sis-
ters (Figure 20), with John Singer Sargent's later depiction of the Vickers sisters
(Figure 21). In both paintings two women look outwards, while a third sits in

20 John Everett Millais, *Hearts are Trumps*, 1872.

21 John Singer Sargent, *The Vickers Sisters*, 1884.

absorbed contemplation. Millais painted the Armstrongs as they made their
society debut. The triple portrait, exhibited in 1872 as *Hearts are Trumps*, served to
draw attention to the girls as marriageable commodities. They sit at a table playing
cards, symbolic of the game of hearts they enter as they seek to secure the attentions
of suitable young men. This conservative social function is mirrored by the
painting's style. Millais depicts his sitters forming 'an invisible bond with their
highly decorative environment'. Sargent's painting, however, has a more 'relaxed
composition'. While Millais celebrates the 'artificial milieu inhabited by his sub-
jects', Sargent is modern and progressive because 'the bright openness' and 'intro-
spection' of the girls indicate that 'they are in charge of their own external and
internal lives'.[4]

Despite the vagueness of this argument and the absence of evidence that the
Vickers portrait was ever construed as an expression of 'social rebellion', Flint is
clearly presenting this parable of oppression and liberation through the distinction
between conventional 'academic' art and avant-garde 'modern' art – a distinction
which has for so long bedevilled discussion of this period.[5] Flint's comments make
clear the essential character of this distinction: an equation of stylistic differences
with moral worth. Sargent's modern style is allied to a modern sensibility. It articu-
lates modern values, including a belief in female emancipation. Millais is entrenched
in the Victorian, defined in terms of repression, 'bourgeois' expectations and so on.

Such Manichaeism is always arguable, but what is most problematic here is the assumption that the claimed difference between these social values is inevitably allied to judgements of artistic quality – that Millais's collusion in social convention negates the worth of his art, turning it into mere historical document. This claim is unique to the discussion of the nineteenth century, and is pervasive in critical commentary on the period.[6] Velázquez's *Las Meninas* is not denigrated within the critical tradition because it colludes with social hierarchies, nor is the portraiture of Van Dyck. These artists are not expected to question the culture in which they find themselves, nor are they accused, as Treuherz accuses Millais, of chasing success and popularity, despite the wealth and social prestige they both pursued and acquired. What is even more remarkable is the fact that this insistent dismissal of 'stifling' conventionality does not apply to comparable literature. Like Millais's Armstrong sisters, Jane Austen's characters are entirely devoted to the task of securing suitable husbands, but this has never led critics to equate the 'conventional' social values of the novels with an impoverished condition as literature. Likewise, the alleged tastelessness of the Victorian public is rarely used to dismiss outright its most popular novelist, Dickens.

These considerations are relevant here precisely because of the mythic structures into which Millais's late works have been inserted. It is these structures which are so important to the consideration of his art. More generally, however, it is also crucial to the articulation of 'modernity' within British art. During the late nineteenth century itself Millais was widely esteemed the most powerfully modern and most characteristically British of all living artists. By contrast, recent critical convention has denied the very possibility of 'British modernity' in art. British-based painters such as Sargent, Whistler or Sickert are modern because they reject the native traditions of British art which we now call 'Victorian'. They take their inspiration from Impressionism. British nineteenth-century art cannot *contain* modernity. It is defined by its very resistance to it.

Here, then, is another problem. The distinction between academic and avant-garde becomes conflated with that between the Victorian (© Britain) and Modern (© France). For British art to become modern it has to deny itself, or at best to reach back to a pre-Victorian moment: to the proto-Impressionist surfaces of Gainsborough, or the semi-abstraction of late Turner.[7] But what of these claims? Is Millais's late art impoverished? Certainly it is not avant-garde in character. It differs dramatically from his early Pre-Raphaelite work, which adopted a confrontational and experimental position defined by the assumption that accepted ('Raphaelite') academic methods and values were to be challenged. If the early Millais constructed his pictorial identity through an act of cultural *alienation*, then his position was at that time 'avant-garde'. Of course, as I suggested earlier, twentieth-century critics have considered this form of avant-garde identity to have been relatively feeble in comparison to contemporary developments in France. But it is important to emphasise the distinction between an 'avant-garde' position and stylistic characteristics which belong to Impressionism. This is another of the problematic blurrings

characteristic of recent criticism, one which has led to much confusion and evasion in discussion of the development of 'modernity' in art.

So it seems there are several problems here. There have been conflations of value judgement ('modern' art = good art) with style (modernity = Impressionism and after) and with social 'progressiveness' (modernity = liberation). The interpenetration of these judgements is complex and continually shifting. While there is much room for manoeuvre, this pattern of conflations is clearly evident in much criticism, including Flint's. Its result is to marginalise art which fails to conform to this scheme and to block consideration of stylistic connections which disturb it.

How is this relevant to Millais? Well, his work draws attention to the paradox in the avant-garde position – the implication that in order fully to express modern cultural experience it is necessary to be alienated from it. There is no doubt that Millais rejected just such an alienated and experimental avant-garde identity in his later work. His fellow Pre-Raphaelite Holman Hunt records conversations in which Millais is supposed to have expressed perplexity at Hunt's belief that sincere artists should ignore social expectations. Millais points out that this was not true of the great artists of the past. It is impossible to predict future taste, he argues. In order to be a modern artist it is necessary to participate in and articulate the culture of the moment in which one finds oneself.[8] Here, then, Millais identifies himself as 'modern' by defining himself in *opposition* to avant-garde identity, and to its claim on an authenticity – Hunt's (and Manet's) 'sincerity' – continually threatened by the demands of a given cultural moment.

In fact Millais rejected both the academic classicist position – that permanent formal and representational structures transcend historical specificity – *and* the avant-garde claim to authenticity. He sought a non-avant-garde modernity. It is this which makes his work so interesting. It allows us to look hard at those conventions which I indicated above, in which the equation of both aesthetic and moral worth with an avant-garde position is pervasive. Of course, Millais's period of 'avant-garde' activity pre-dates Impressionism.[9] His abandonment of avant-garde identity is, however, coincidental with the emergence of Impressionist art in France. In itself this fact is insignificant. What makes it important is the remarkable similarity between Millais's post-avant-garde style and the work of the most important innovators of Impressionist technique, most notably of Manet himself, commonly identified, as we have seen, as the first truly 'modern' painter and icon of avant-garde identity.[10]

Millais's *Hearts are Trumps,* his portrait of the Armstrong sisters so severely criticised by Kate Flint for its reactionary tendencies, is a case in point. Like Manet, Millais fragments the image into gestural strokes of paint which create a complex network of overlapping marks across the surface of the image. The figure at the left is integrated into an area of interlaced stripes and bands of pink, black and white. The two other figures are isolated against a black oriental screen. The cards, with their flat, stylised patterns, epitomise this emphasis on two-dimensionality, while also providing the model for the dominant hues of the image. Just as the patterns on the cards

are isolated marks of colour, so the painting as a whole extends into increasingly complex surfaces – inlay, lacquer, ribbons, oriental calligraphy. All of these flat patterns are placed on objects which occupy a constructed perspectival space, but which are continually pulled back to the surface by the fragmentation of the brushstrokes and by the blocking of pictorial depth by the use of black. This is an image which is constantly stressing the border between solidity and fragmentation. The pot plant in the 'decorative' part of the painting is constructed of a few linear strokes which suddenly stop in an unresolved condition between mark-making and the description of a physical object. Millais plays with the question of whether it is the black area (screen) or the pot and flowers at the left that constitute 'real' space (could the flowers be wallpaper – another piece of chinoiserie?). Likewise the women's figures are constantly moving between solid modelling and surface. Their three dresses merge into a labyrinth of surface marks. The figure at the left wears a black neckband against the black background, both isolating her head and emphasising its three-dimensionality in contrast.

These devices are evidently related to the theme of the painting – the deception and rivalry of the card game, and the question of psychological truth as opposed to constructed personas 'put on' for others. Flint is right, of course, to point out that the game stands in for the young women's romantic rivalries. The invisible figure of the viewer might be interpreted either as another woman, eyed up suspiciously – just as the central figure looks at her sister – or as a potential suitor. The women look and are looked at; they both display themselves (reveal their cards) and hide behind conventions. Just as the painting concerns this double process of gazing – revealing and concealing, self-possession and spectacle – so it also plays with the viewer's proximity and alienation. The fourth side of the gaming-table is 'open' for the viewer, but blocked by the small decorative tea table. The viewer is both invited to participate and kept at a distance.

This issue is related to the fact that the sisters are presented as differing moments of self-consciousness. The one who is absorbed by the image – integrated into decorative pattern behind her – is also psychologically absorbed; her eyes are downcast as she looks at her cards. The two remaining figures, dramatised against the black background, are by differing degrees responding to other presences. The process of concealing and displaying one's cards, then, is connected to this concern with levels of consciousness. This is correlated to the issue of pictorial surface and form, in particular the play on the distinction between decoration and modelling.

Millais's models for these devices are Reynolds and Velázquez, a fact that was not lost on contemporary critics. Like Reynolds, he is concerned to dramatise the construction of personas for his sitters. However, like Velázquez, Millais seeks also to analyse and narrate the relationship between the acts of looking and painting, connecting this with a circuit of consciousness and unconsciousness in the figures portrayed. *Hearts are Trumps* is specifically 'Velázquezian' in this respect. The hierarchies of absorption, consciousness, pictorial convention and visual description found in paintings such as *The Spinners*, *The Topers* and *Las Meninas* are transferred to a contemporary social context.

However, in other respects Millais's approach resembles Manet rather more than Velázquez. Manet himself was, of course, profoundly influenced by Velázquez. Like Millais, he identified in the Spanish master a model for the equation of realism with an assertively 'unfinished' pictorial surface. As is well known, Manet's portrait of Zola (1868, Paris, Musée d'Orsay) includes a reproduction of *The Topers* alongside a Japanese print and a photograph of Manet's own *Olympia*. Like Manet, Millais deploys his references to oriental art in order to stress the mechanics of image-making. The prominently rigid line where the black screen meets the floral pattern, the assertive use of black, the emphasis on calligraphic gesture: all these devices can be found in *Olympia* itself.

Now, I'm not trying to defend this painting by claiming that it is really avant-garde. On the contrary, I am pointing to the ways in which critical discourse chooses to block out connections which disturb the mythical oppositions by which Flint, Treuherz and others function. *Olympia* is indeed profoundly different from *Hearts are Trumps*. Manet's approach here is specifically critical and confrontational. The painting alienates the viewer, as, in different ways, did Millais' own early work. However, many of Manet's other works are not so different from some of Millais' of the same period. If Millais's 1879 portrait of *Louise Jopling* (Figure 22) were exhibited alongside Manet's of *Lola de Valence* (1862, Figure 23) it would not look out of place. Both artists minimise modelling, defining patterns on the women's flat black dresses in disconnected strokes and spots of colour. Of course, when Manet uses these devices they work to assert the 'ineluctable flatness of the picture plane', or his liberation from the academic demand for finish, or the fact that social identity is an unstable construct. Such claims, at least, are commonly made within the tradition of twentieth-century critical commentary stemming from Clement Greenberg.[11] When Millais uses these devices they are, in this critical discourse, meaningless. It is impossible to *see* them. Julian Treuherz, quoted above, even manages to describe Millais's shift towards painting 'quickly and loosely' as a capitulation to academicism. Impressionist sketch-like technique is, of course, normally coded as anti-academic. Treuherz also quotes Ruskin's condemnation of Millais's new style as if Ruskin's judgement were authoritative. Needless to say, the very similar language used by Ruskin to condemn Whistler's quickly and loosely painted work is normally considered evidence of the former's failure to understand the avant-garde.[12]

The complex relation between theme, composition and style in *Hearts are Trumps* certainly seems invisible to Flint. She cannot construe this painting in other than negative terms. Its acceptance of the social conventions to which it refers makes the painting *itself* 'conventional' – void of visual interest or density. The reasons for this blindness towards the complex visuality of a painting such as *Hearts are Trumps* are varied. But the most powerful, as we have seen, is the need to deny value to images that fail to mark themselves as 'progressive', combined with a wish to equate political with stylistic radicalism.

In order to explore the implications of this critical blindness it will be useful to look in more detail at one of Millais's most ambitious late paintings. In 1885 he

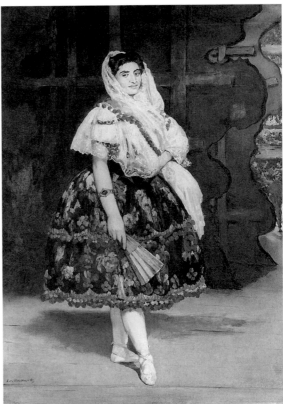

22 John Everett Millais, *Louise Jopling*, 1879. **23** Edouard Manet, *Lola de Valence*, 1862.

exhibited a large multi-figure composition under the title *The Ruling Passion*, though it is now known as *The Ornithologist* (Plate 2). It shows an old man lying on a couch, showing stuffed specimens of exotic birds to a group of children. According to his first biographer, M. H. Spielmann, Millais had originally intended to call the painting by the name under which it is now exhibited, but changed his mind, worried that some gallery-goers might not know the meaning of the word 'ornithologist'.[13] The story seems to epitomise Millais's reputation as a crowd-pleaser, desperate to avoid the merest hint of 'difficulty'. The painting itself certainly seems to the modern viewer to betray all the signs of kitsch Victorian sentimentality of the kind so frequently derided by modern critics. Even the gallery that owns it, Kelvingrove in Glasgow, seems uncertain whether it is quite art at all. It is displayed rather awkwardly on the staircase on the way up to the official art gallery. I suspect it may only be on display because Kelvingrove has a collection of stuffed birds on the floor below.[14] Nevertheless it is obviously popular, because the gallery sells postcards of it, though the official guidebook to the collection does not acknowledge its existence.

The family is depicted gathered around the old man's couch. He seems to be infirm, as the couch has a blanket across it. He is showing a King Bird of Paradise to the children, pointing out an ornithological feature. The youngest look wide-eyed with excitement at the bright-red colour of the bird. Beside them on the blanket are other specimens, lying on top of one another in a confused mass of feathers and primary colours. The children's mother leans over them protectively and indulgently. A slightly older boy and girl at the right and a teenage girl at the left are by differing degrees separated from the central group.

It is a painting about a unified family, the motherliness of mothers, the cuteness of children and the intellectual authority of older men. If it also seems to depict some of the alienation and boredom of teenagers, this only makes it even more readily recognisable. Certainly, it is a long way from the complex stuffiness and tension of paintings such as Manet's *Le Balcon* (1869), or Degas's 1862 *Bellelli Family* (Figure 24). The painting as a whole *affirms* the merits of the middle-class family and, crucially, depicts the mother at the centre of the painting in a way that defines her identity entirely in terms of her motherhood. Kate Flint is unlikely to be impressed. Ruskin, trenchant critic of Millais's fall from artistic grace according to Treuherz, must surely have condemned the picture. This is what he wrote: 'I have not seen any work of Modern art with more delight than this.' In a letter he added

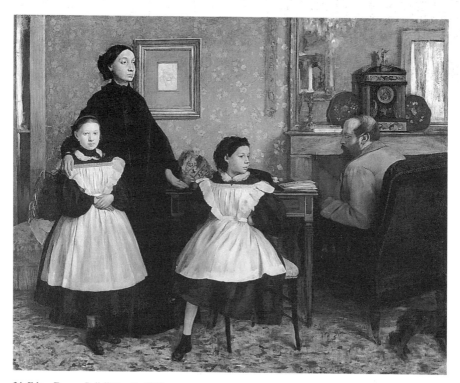

24 Edgar Degas, *Bellelli Family*, 1862.

that he was deeply impressed by the 'noble' figures of the teenage girl at the left and the old man.[15]

Why did he say this? There are several reasons why Ruskin may have been particularly affected by this image. He had become increasingly fascinated by birds, once expressing the wish that he had devoted his scientific efforts to ornithology rather than geology. One of his oddest late books, *Love's Meinie*, (1873/81) is about the spiritual meaning of birds. Much of this soul-searching had been brought on by the libel trial occasioned by his intemperate criticisms of Whistler, in comparison to whose pot-of-paint flinging style Millais's work may have come to seem much less 'sloppy'. Following this, Ruskin had also suffered several times from periods of mental and physical collapse. He may well have identified with the invalid ornithologist depicted by Millais.

So am I suggesting that Ruskin was deceived into admiring this kitsch painting by a combination of personal experiences? Other critics held similar views. A. L. Baldry writes that the painting's 'deep significance' and 'wonderful vitality' mark it as one of Millais's masterpieces.[16] What were Ruskin and Baldry seeing here? If we look in more detail at the way this image works we can see what it may have been that they so admired, and why Ruskin claimed that the teenage girl and the old man were 'noble'.

As in *Hearts are Trumps*, Millais seems interested in the relation between colour and form. This pictorial problem comes to be given particular significance by the narrative and composition as a whole. The dull brown dress of the girl at the left is set against the spots of greens and reds of the Resplendent Quetzal bird she holds. Likewise the yellowish brown of the blanket and the ornithologist's jacket are placed against the bright blues, blacks, yellows, reds and greens of the other birds.[17] In the background the dramatic curving blue and red brush marks constituting the body of a kingfisher are superimposed over a slightly foreshortened grey-brown goose, which is visible through the 'body' of the kingfisher. The goose itself emerges, modelled, from the green-brown wall. Alongside, hanging from the wall, is a silhouette, a black square of pigment with a flat black head-shaped mark inside it. The paint marking the wall is likewise visible through it.

In each case we have bright, swiftly brushed pigment set against more subdued colours and prosaic objects, constantly pulling between surface and form. More clearly than in *Hearts are Trumps*, Millais sets up a form of pictorial *conflict* within the image, layering forms over one another, constantly shifting his methods of modelling. The swirls of blurred paint, obscured bodies, and slashes of primary colour in the centre epitomise this process of spatial and formal confusion, the central articulation of which occurs as the old man points to the Bird of Paradise. The stuffed bird is isolated against the black of the mother's dress as she leans forward. This creates some spatial ambiguities. The mother is set against a dark background, the profile of her right arm cut off by the bright band of the boy's straw hat. Her other arm is blocked by the old man's black cap. The mother, in effect, appears to float free from her own body, hovering over the central group,

her white muslin shawl almost, but not quite, touching the figures. The red bird is thrust into that gap.

The mother's disembodied figure suggests the so-called 'angel in the house' cliché of Victorian femininity. It is possible to find comparable images elsewhere.[18] But, of course, my argument us not that the painting is sophisticated because it constitutes a 'critique' of contemporary cultural values, but that it generates pictorial complexity from within them. It seems to me that Millais is interested in the idea of visual intensity, evidenced in the bird, of Monet-like uncontained brushwork in the portrayal of the feathers, but sets this always against contained forms. This picture is about a relation between the prosaic and exotic which is correlated to one between pictorial surface and the construction of form. The birds are signs of freedom and transcendence, both because they are Birds of Paradise, and because they are marks of colour liberated from the repressive constraints of form. They are connected to the wide-eyed excitement of the children, while the other figures are increasingly locked into the 'stuffy' restraints of the old man's dingy room, epitomised by the coffin-like boxes from which stuffed birds grotesquely pop out, or the frozen imitations of life, like the barn owl in the glass bowl, or the apparently bodiless kingfisher stuck to a wooden stand.

This is, above all, a painting about death and decay. The old man is ill, probably dying, the family gather round, ushered together by the mother. They are all surrounded by death, by stuffed things, symbols of freedom, trapped. The sense of strain, of slightly forced interest among the older children, is, I think, an extension of this theme of entrapment and repression. More subtly than in *Hearts are Trumps*, Millais makes the expressions of the children ambivalent. The teenage girl at the left and her younger sister, leaning forward from behind the old man's head, seem slightly pained. This deliberate suggestion of psychological complexity or ambiguity is to be found throughout Millais's later work.[19]

The use of caged birds to signify the domestication of natural exuberance and innocence is common enough in Victorian art, and of course the imagery of the bird as visible spirit was familiar from Shelley and Keats. The Birds of Paradise themselves were, according to legend, never seen alive. They dropped out of heaven when they died.[20] Ruskin's own book *Love's Meinie* had sought to counter what he considered reductive Darwinian accounts of bird behaviour, attempting to revive natural theology by stressing instead the ethical and spiritual significance of bird life. He presents birds as signs of both plenitude and humility (the obsolete word 'meinie' is apparently the origin of the modern words 'many' and 'menial').[21]

All this is certainly relevant to the image, but what is most notable is Millais's rejection of Romantic conventions in favour of the deliberately banal, stifling interior. This too would have had contemporary resonance. The overuse of stuffed birds and birds' feathers in decorations, hats and jewellery was much debated during the 1880s. Shelagh Wilson has recently discussed this preoccupation with animal bodies in terms of a tension between 'abstract ornament' and grotesque physicality. Describing stuffed and mounted humming-birds made into earrings,

she writes of a contemporary ambivalence towards such designs, in which 'the actual body, desecrated, disembowelled and then reconstructed as ornament' forces 'a direct confrontation with the fact that this beautiful decorative object is a dead animal'.[22] Millais's fascination with the tension between abstraction, dead bodies, solidity and dissolution is, then, bound up with a much wider debate about taste, decoration and realism.

These points bring me back to the central theme of the image: the contrast of the intensity of life – signalled by the colours of the birds – with the 'shades of the prison house' that increasingly entrap the figures as they grow towards maturity. The immediate visual source for the composition and iconography is likely to be Wright's *An Experiment with an Air Pump* (1769, Figure 25) in which a group of figures at different stages in their lives watch while a scientist creates a vacuum in a glass jar. Deprived of oxygen, the trapped, dying bird inside the jar is about to be revived by the experimenter and returned to its cage. As he prepares to lift the lid to let in fresh air, the other characters react according to their age and sex. Wright's use of a white bird at the centre of the narrative and composition suggests the traditional imagery of the Holy Spirit. The experiment itself, of course, probes the sources of life, the proximity of death and the prospect of liberation, or transcendence.[23]

This central problem is articulated in Millais' painting by the figure of the teenager at the left, posed as 'the thinker', cradling the Resplendent Quetzal. She,

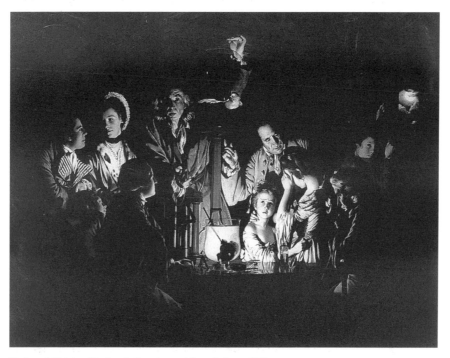

25 Joseph Wright of Derby, *An Experiment with an Air Pump*, 1769.

the dead bird in her lap, identifies the cycle of life which the painting reveals – seeing the old, dying man, the eager young children, her younger brother and sister, and the mature figure of her mother, all organised in a circle around the Bird of Paradise. The bird itself, bursting from the black space, is the heart of the image – quite literally, I think, as Millais seems to refer to the iconographical tradition of the Sacred Heart here. The spatial ambivalence generates a sense of the disruption of the physical: the mother's body opened up by the bird, brought to the surface and placed on display. I think this is probably the real reason why Millais retitled the painting *The Ruling Passion*. In the 'ages of man' tradition, it is about the dominant emotional experience in the lives of the characters – from unthinking childhood excitement, through budding adult awareness, to mature absorption in life, ending with the death-associated hobbyism of the old man. The teenage girl, poised on the threshold of adulthood, preparing for parenthood, sees the cycle as a whole, just before she enters into it, to replace the mother in her own generation.

Like its characters, *The Ruling Passion* is a painting which suggests a multiplicity of possible responses to the same object. Just as the King Bird of Paradise means different things to its different viewers within the painting, so the painting itself allows for both 'naive' and complex responses from its audience. If avant-garde identity implies a deliberate alienation of the viewer – through pictorial experiment or confrontation – *The Ruling Passion* is deliberately *accommodating*. Like the family depicted within it, it accepts multiple levels of consciousness, intellectuality and emotional engagement. The problem, for modern critics, has been this very accommodating character. Few bother to penetrate beyond its 'naive' level as an anecdotal or sentimental image. The iconographical significance of the King Bird of Paradise and the Resplendent Quetzal is not insisted upon by Millais, though viewers familiar with popular natural history would be likely to recognise the birds' association with redemption.[24] The story that Aztecs held the Quetzal to be sacred was well known. Mormons and others believed that the worship of Quetzalcoatl was a garbled recollection of the actual appearance of Christ to ancient American tribes.[25] The name of the King Bird of Paradise implies similar associations, but the closest parallel to Millais's use of the motif is to be found in Alfred Russel Wallace's famous musings on the bird in *The Malay Archipelago* (1869). Finding a dead specimen, Wallace marvels at its intricate beauties, pondering at the tragedy of endless life-cycles in a wilderness without meaning: 'I thought of the long ages of the past, during which the successive generations had run their course – being born, and living and dying amid these dark and gloomy woods, with no intelligent eye to gaze upon their loveliness.'[26]

The connection of this iconography to contemporary art and literature concerning faith, doubt and science is clear enough, and entirely consistent with Millais's earlier explorations of the life-cycle in *Autumn Leaves*, *Spring* and *The Vale of Rest*.[27] *The Ruling Passion*, however, in common with other of his late works, makes far more varied use of pictorial technique. The figure of the mother,

simultaneously foreshortened and dissolving as she leans forward, visualises the tensions of materiality and spirit, liberation and constraint, surface and form.

So how, and to what extent, is this painting 'modern'? For Millais and his admirers its modernity was not in question. It addressed contemporary social experience in a manner in which current debates concerning taste, science and religion were articulated. It sought 'the heroism of modern life', in Baudelaire's famous phrase, finding it in the tensions and devotions of the family: both stuffy and coherent, forced and harmonious. For Ruskin, this was 'the most pathetic painting of modern times'.[28] It dealt with the central paradox of symbolic realism, the struggle of claims to significance (and 'heroism') with the banality of the everyday. The characters are all caught between articulation and passivity. The ornithologist points to the bird, but the 'knowledge' he conveys about it cannot be read. Millais suggests iconographical *possibilities* but identifies through his characters multiple readings of the motif, and of the situation in which they find themselves.

For more recent critics, however, this painting cannot be modern. It is a history painting reduced to the 'bourgeois' domestic context. It rejects or ignores the emergent avant-garde tradition which would soon generate modernism. Such critics do have a point. If Millais is attempting to modernise Velázquez – which he is – it is in a manner quite different from Manet, though he does use some comparable devices, and is concerned with the same problems of realism, pictorial surface and the decay of legible meaning. True, Millais differs from Impressionism in his concern with form rather than light. *The Ruling Passion* uses light to dramatise ambiguities of form, not to mark the *process* of looking itself, its fragmentation of matter into colour. In this Millais's use of Velázquez is closer to his model than is Manet's. What Millais seeks to do is to construct a *Las Meninas* for modern social conditions. If Velázquez had produced the 'theology of painting', examining the interrelated hierarchies of pictorial form, social status and intellectual insight, Millais rejects his model's 'theological' assumption that such an order is manifest in the patterns of deference shown to divinely ordained monarchy. Instead, a more ambiguous order centring on the family is offered as the modern shape in which these problems are articulated.[29]

It might be claimed that I am reading far too much into this image, that I am ascribing a significance to it which it cannot bear. I would suggest that such a view indicates more about the prejudices of modern critics than about the painting itself. There is no reason why this painting should not be taken seriously. The problem is that the equation of avant-garde identity with cultural authenticity, and of so-called 'academicism' with triviality, has become so entrenched that it seems to some almost absurd to grant seriousness to a figure such as Millais, or to imply that his work can be engaged with the same cultural issues as Manet's. As we have seen, this problem is unique to art. The 'modernity' of Millais is in fact comparable to that of his contemporaries in literature, or even to figures of a later generation such as Kipling, Hardy and Conrad, all of whom are accepted as important modern

writers, but who nevertheless cannot be described as avant-garde. While the fact that such writers participate in many conventional (for want of a better word) cultural assumptions of their day is acknowledged, with Millais this fact is used as a reason to consign him to aesthetic oblivion.

The Ruling Passion certainly articulates many 'Victorian' ideas, as we should expect of a picture painted in 1885. But the painting is not simply to be reduced to the claim that it articulates a series of reactionary positions, which arise from Millais's rejection of avant-garde experimentalism. Millais's art is fully engaged with the debates of his day concerning the practice of painting and its social role. We know that Millais admired Whistler, but that he also engaged in pictorial 'debates' with him – responding to the latter's work with his own, an approach he also adopted with Leighton.[30] Only the assumption that, while Whistler is a legitimate artist, Millais and Leighton are not has obscured these complex pictorial engagements.

The notion that Millais wanted to produce art which met with approval from his contemporaries is partly true. His accommodating art seeks to include rather than to exclude. This inclusiveness may even be said to be manifest at the level of subject matter. *The Ruling Passion* depicts women both as loving mothers and as philosophers. The painting is neither 'progressive' nor 'reactionary', in any meaningful sense. Flint insists that Millais oppresses his sitters through the artifice of his style – despite the fact that comparable emphasis on pictorial artifice is valorised in artists such as Manet. Whether the equation of social and aesthetic positions is really very helpful is, in any case, doubtful. What is certainly wrong is the attempt to insist on the concept of progressiveness as a value judgement. This has never been a serious problem in literature and music, but has taken far too strong a hold in the study of art, leading to the tendency to reduce the complexity of both history and art to banal moral parables of the kind offered by both Flint and Treuherz.

We need now to explore the mechanisms through which modernity was visualised in a way which avoids the Manichaeism of the academic/avant-garde split. We should look for multiple modernities, avoiding the equation of pictorial radicalism with socio-aesthetic virtue. We should also acknowledge that devices of the kind adopted by Manet are not necessarily avant-garde, that they can be co-opted for other projects quite independently at the same historical moment. Millais's position as an artist fully engaged with these debates is long overdue for re-evaluation.

4

'Not a "modern" as the word is now understood'? Byam Shaw, imperialism and the poetics of professional society

Tim Barringer

does not belong in period.

In his obituary notice of 1919, the critic Frank Rutter, a significant figure in the reception of modernism in Britain,[1] effectively consigned John Byam Liston Shaw (1872–1919) to 'dreamland', that atemporal art-historical gulag, quaint but fatal to serious historical enquiry, where Burne-Jones, among many others, languishes to this day.[2] Rutter insisted that Byam Shaw (as he was known) 'was not a "modern" as the word is now understood, but belonged by temperament and taste to the Pre-Raphaelite period'.[3] For Rutter, employing one of the structuring tropes of the modernist historiography, Byam Shaw's tragedy was simply that he was an anachronism, a man whose sensibilities were those of the 1850s and not the early twentieth century: 'It was not the fault of Byam Shaw that his contemporaries were more concerned with flats than churches, and in considering his art, we must always think of him as a decorative painter who was born a little too late to find his milieu.'[4] By 1933, when a lavishly illustrated biography of Byam Shaw by his friend and colleague Rex Vicat Cole was reviewed, the perception of Shaw's work as the antithesis of the significant contemporary art of his own day had become more sharply defined:

> The larger pictures were crammed with ideas and symbolism, and at times had to be read like a rebus; but atmosphere, tone values, and plastic volumes were no concern of his. The problems which occupy the modern painter left him undisturbed. He lived in the past and was out of touch with his own time.[5]

Although it has been largely ignored since 1933, Byam Shaw's work features in Charles Harrison's recent general account of the history of art during the early twentieth century. However, his appearance is not symptomatic of a revision or broadening of the canon: rather, Byam Shaw takes the paradigmatic role of a foil to significant developments:

> in the early twentieth century artists, critics and spectators of a Modernist persuasion began to express strong preference for those works they could see as emphasizing

formal aspects, and as embodying what they took to be a 'primitive' or a 'direct' vision
... over those which exhibited skill and sophistication in the achievement of literal
likeness, such as Byam Shaw's *1900 The Boer War* [sic].[6]

Byam Shaw, in this modernist reading, stands accused of those traits of insincerity,
illusionism and deception which are conventionally associated in the literature of
Impressionism with French academic painters like Adolphe-William Bouguereau
and Jean-Léon Gerôme:

> Generally speaking, preference for works of the first type was justified on the ground
> that they were richer 'in feeling' than works of the second. By contrast, skill in the
> achievement of a likeness became associated with lack of emotional content, or with
> insincerity – which is to say with a form of *mis*-representation.

While this remains a fair summary of attitudes typical of modernist artists in the
early twentieth century, it remains unchallenged, and thus implicitly endorsed, in
Harrison's, as in almost every art-historical account of this period.

The few recent attempts to revive interest in the art of Byam Shaw and the
group of artists with whom he can loosely be associated – such as Eleanor
Fortescue-Brickdale (1872–1945) and Frank Cadogan Cowper (1877–1958) – have
accepted the notion of Byam Shaw being somehow displaced in time, belonging to
an earlier era than that in which he lived. The work of these artists appears most
frequently in books on the Pre-Raphaelitism,[7] a movement which flourished
twenty years before their birth. More significant is the reactionary inflection of the
modernist teleology by which to be 'out of touch with one's time' acquires a posi-
tive rather than a negative value. It was this celebratory version of 'dreamland' as
an anti-modernist utopia, an art-historical nowhere, which featured in the capa-
cious and important 1989 Barbican exhibition, *The Last Romantics*.[8] The selectors
excluded the works of Frank Brangwyn, which engage with themes like industrial-
isation, imperialism and war, 'because they would have disrupted the dream-like
surface of the show'.[9]

It is my intention in this chapter to disrupt the modernist trope whereby a teleo-
logical rewriting of history evacuates a historical period of figures not conforming
to a particular (and allegedly hegemonic) stylistic tendency. In one among many
parallels between modernism and imperialism (both of which reached their zenith
in the early twentieth century), this claim echoes the assertion of the coloniser,
described by Johannes Fabian, that colonial subjects belong to a past era outside the
matrix of time, and present a static, unchanging, contrast to the march of progress
which marks the dominant culture.[10] Histories of the British Empire, like histories
of modernism, have traditionally had little to say about the subject peoples whom
progress supposedly left behind: yet without these histories the record is mis-
leading and incomplete. It may seem preposterous to appropriate the notion of
'writing back' from post-colonial studies in order to reconsider an establishment
artist of the Edwardian era, especially one who (as I shall demonstrate) enthusiasti-
cally espoused the ideology of British imperialism. None the less, in this chapter I

shall suggest that serious consideration of such a figure as Byam Shaw (written off as 'endemically unpromising' by Charles Harrison at the conference from which this book derives) demands that we question and perhaps even abandon the existing master narrative of the development of modernism in Britain, and rewrite the history of British art.[11]

In particular I wish to address the idea that Byam Shaw was wholly anachronistic in his concerns, and unable to relate to the modernity of early twentieth-century Britain. I shall suggest that, although he was not principally interested in formal experimentation, his work nonetheless engages with key social and ideological issues of his era, and furthermore that his acute dilemmas as an artist were symptomatic of the crisis in representation and artistic practice which accompanied, and indeed which resulted in, the emergence of modernism in Britain. My revisionist claim is not to replace a modernist, stylistic teleology with another one – placing Byam Shaw on a royal (and reactionary) road, say from Romanticism to neo-Romanticism, or anti-modernism to post-modernism – but rather to reinsert his work into the eclectic, vital and complex British visual culture of the years before the First World War. In this context, Byam Shaw's recourse to stylistic revivalism and retrospection *was*, I contend, part of a strategy calculated to resolve what he conceived of as the 'problems which occupy the modern painter', rather than to avoid them.

A key issue here is that of the artist's relationship to modernity, a term which has been defined (at least in art-historical writing) largely in relation to Paris, a definition premised on texts by Charles Baudelaire and Walter Benjamin. The modernity of London has been less fully explored, though in recent work on the 'imperial city', the new politics, new social order and new imperialism of London in the 1890s has come more sharply into focus. This was a crucial moment for the renegotiation of the politics of gender, class and ethnicity in British culture. A central development, in many ways the key to British and imperial modernity, is what Harold Perkin has called 'the rise of professional society' from 1880, the emergence of a new upper-middle-class elite.[12] This phenomenon, of which Byam Shaw was self-consciously a spokesman, was closely associated with the administration of the British Empire, at its greatest extent from 1900 to 1920. A reading of Shaw's work with these problematics in mind can re-establish his relevance to his own time. Furthermore, through the analysis of Byam Shaw's works, I shall argue, the insecurities and fissures within the culture of 'professional society', notably its construction of sexual difference, and more broadly the paradoxical and compromised nature of the imperial project, come clearly into focus.

The artist in professional society

John Byam Liston Shaw was born in 1872 in a large house in Madras named Ferndale, which was later to become the Anglican Bishop's Palace; his father, John Shaw, was registrar of the High Court of Madras and had numerous relations in the

Indian Army. The Kiplingesque opening vignette of Rex Vicat Cole's biography (itself a nostalgic elegy for the late-Victorian and Edwardian art world) relates 'the first recorded incident of the little Byam' in India. 'Being missed and a search organised, the child was found riding a pony at the head of a native procession'. Cole included this hint of a colourful imperial tableau because it prefigures the subject matter of the colourful and eclectic processional paintings of Byam Shaw's maturity.[13] Too frail to attend school, he was taught by his mother and a governess, a procedure which continued after the family's return to London in 1878, where the father became a solicitor in Bedford Row, the family settling in fashionable Kensington at 103 Holland Row. Byam Shaw was to live within half a mile of this spot for most of his life, enjoying the proximity to the homes of his youthful idols, Frederic Leighton and George Frederic Watts, and surrounded by the highly structured rituals of upper-middle-class life, rituals which provided material for many of his most perceptive and provocative works.

Harold Perkin defines the professional ideal, which emerged in the late nineteenth century, as 'emphasizing human capital rather than passive or active property, highly skilled and differentiated labour rather than the simple labour theory of value, and selection by merit defined as trained and certified expertise'.[14] Byam Shaw acquired these skills and distinctions through a laborious training at the St John's Wood Art Schools and later the Royal Academy Schools, and a commitment to this new ideal of professionalism is apparent throughout a massively productive career as a book-illustrator, designer and cartoonist, and as a painter aspiring towards election to the Royal Academy. Fashioning his identity and his art in opposition to conventions of the bohemian and the aesthete, Byam Shaw chose to construct himself according to the archetype of the man-about-town in the heyday of imperial manliness.[15] His clothing and manner bore no trace of the 'artistic' as popularly understood at the time (Figure 26). Indeed, Lillian Faithful, Principal of the Women's Department of King's College, London, where Byam Shaw taught from 1904, recalled that 'while staid professors wandered about in cap and gown, Byam Shaw often appeared in a suit of loud checks, looking more like a bookie on a racecourse than an art master'. Any hint of moral dissipation is immediately disavowed, however, through a description which, again, associates Byam Shaw more closely with professional stereotypes which would not be out of place in describing a young imperial administrator: 'he was desperately earnest about everything he touched, and his simplicity, sincerity, enthusiasm and humour made him an enchanting companion'.[16]

The type of manliness which, despite his physical frailty, shyness and tendency to depression, Byam Shaw presented to the world was also celebrated in many of his works; indeed it is a *leitmotif* throughout his oeuvre.[17] If, as Lisa Tickner has noted, British modernism was dominated by a specific notion of masculinity, so too was Byam Shaw's artistic identity and production.[18] In an early Royal Academy exhibit, the *Christ the Comforter* of 1897 (Figure 27), we appear to be confronting a gloomy Victorian deathbed scene, along the lines of Thomas Hood's poem 'The Death Bed'

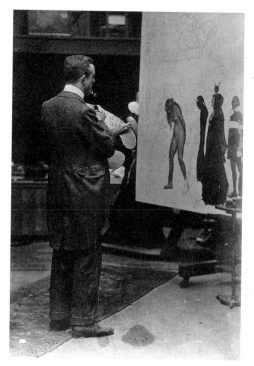

26 'Byam Shaw painting *Love the Conqueror*', 1899.

(1831) or W. I. Walton's ubiquitous lithograph, 'The Last Moments of H.R.H. the Prince Consort' (1862)[19]. In a gambit typical of late nineteenth-century academic painting, Shaw places the vivid and all-too-physical presence of a manly Christ alongside the despairing muscular Christian protagonist in order to comfort him for the impending loss of either a wife or a mother.[20] Yet, called upon to explain the painting, the artist offered an alternative scenario:

> My idea … was to bring before people the fact that Christ was as much the Comforter of the rich as of the poor, and to show that he is the Comforter of the ordinary healthy man who can ride and shoot with the best. It is quite possible for a man to be fond of a good horse and to dress decently, and still have Christ for a friend.[21]

While the figures in the painting are clearly wealthy, it is not possible to produce this reading from the image alone. The verbal

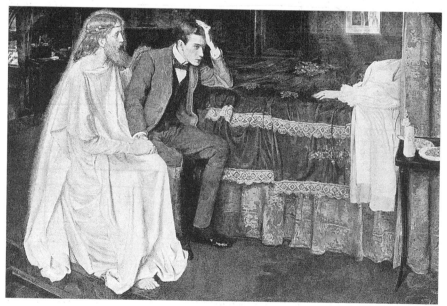

27 John Byam Liston Shaw, *Christ the Comforter*, 1897.

gloss tells us not only that the painting enshrines Byam Shaw's ideal of Edwardian manliness, but also that it positions itself in relation to an absent and unspoken opposite, Christian Socialism and the idea of Christ as the friend of the working man, an idea which underpinned such key works in the Pre-Raphaelite canon as Holman Hunt's *The Shadow of Death* (1873, Manchester City Art Gallery). Emphasising the paternalist merits of Shaw's Tory-imperialist politics by demonstrating the 'vertical friendships' linking the new professional elite with the urban masses, Cole notes that when exhibited at the Whitechapel Art Gallery 'the visitors – the poor of East London – by vote placed it first of the pictures that pleased them'.[22]

The ideal of the upper-middle-class family, with its apparatus of servants and possessions, was itself the subject of Byam Shaw's most autobiographical work, the strikingly decorative *My Wife, My Bairns and My Wee Dog John* (Figure 28). The painting clearly celebrates domesticity and the elegant, though not unduly opulent, circumstances of his own home and family. While the affectionate bonds of mother and child are lovingly chronicled, even Cole noticed that 'the title does not include the maids, who, as you would expect, he also depicted'.[23] This casual verbal denial of the significance of the domestic staff in his household, and disregard for female labour, is clearly undermined by the image itself in which his youngest son Glencairn is held aloft by a nurse.[24] Often the emotional bond between middle-class children and their nurses was closer than that with their parents at this time, and this was possibly the case for Byam Shaw himself.[25] For years after he left his

28 John Byam Liston Shaw, *My Wife, My Bairns and My Wee Dog John*, 1903.

parental home, 'his old nurse, Mary, used to bring his frugal lunch from his mother's house' to his nearby studio in Kensington.[26] Critical opinion of 1903 may well have considered the subject matter of *My Wife, My Bairns and My Wee Dog John* to be excessively domestic and thus the province of the woman artist, a possibility accentuated by the use of pastel, traditionally associated with female practitioners, rather than oil paint.[27] Furthermore, though the folksy use of Scottish terminology – 'wee' and 'bairns' – may have derived from Shaw's family connections in Scotland, its overtones were sentimental, even unmanly, in terms of the work's original audience. Yet such a reading of the painting as 'feminised' is countered by the artist's repeated and assertively patriarchal use of the possessive in the title: the wife, children, dog and (it goes without saying) servants are 'mine'. Shaw's controlling presence is established through a self-portrait, wreathed in pipesmoke in the mirror. This apparently ironic positioning of the paterfamilias at the margin of family may reflect his discomfort in the feminine environment of the nursery, but it may also reflect a deeper anxiety about the male role typical of the Edwardian era, as the suffragette campaign and more general agitation for women's rights placed Victorian conceptions of gender roles under scrutiny. Typically, inscribed within Byam Shaw's assertively orthodox image of the family are insecurities undercutting the very certainties which the work seems to be promoting.

The artistic profession itself provided a microcosm of this debate, as women artists became more vocal, and more successful in their struggle for recognition. Byam Shaw's wife, born Evelyn Pyke-Nott, was an accomplished miniature-painter, trained like Shaw at the Royal Academy Schools, though no hint of this identity can be found in *My Wife, My Bairns and My Wee Dog John* where she is figured as a producer only of children. Although she took a professional role in the art school founded by Byam Shaw and Rex Vicat Cole in 1910, where she taught the miniature-class, any single-minded pursuit of her professional activities would have disrupted the domestic idyll constructed in *My Wife, My Bairns and My Wee Dog John*. There is no suggestion that she wished to do so, and indeed Cole portrays the marriage as conforming to the conventions of professional society, as described by Perkins:

> He, by incessant diligence, fulfilled his aim of providing her with the comforts she had been accustomed to, as well as the means for bringing up and educating their children, to the best advantage. She, content in his love and that of the children, and busy in the management of the home, still found time to give him practical help in his pictures, as the many portraits of her in his subjects bear witness, as well as to carry on her art of which he was so proud.[28]

Yet Evelyn Byam Shaw's identity wavers in the final sentence between that of subject of art, model and muse, and producer of art; between 'her art' and his art. If his wife's artistic career could be normalised, or neutralised, as a genteel accomplishment, that of Byam Shaw's colleague and collaborator, Eleanor Fortescue-Brickdale, raises other questions. Herself the upper-middle-class daughter of a successful lawyer (a

typical exemplar, therefore of 'professional society'), she was a forceful and unorthodox character, who remained unmarried possibly in order to preserve the freedom to pursue a professional career. She was trained at the Royal Academy Schools, lived in Kensington, and her later career closely parallels Shaw's as an academy painter of allegorical subjects, a regular exhibitor at Dowdeswell's Gallery and a book-illustrator. She also taught at the Byam Shaw and Vicat Cole School of Art and was at the time widely assumed to have been – in Cole's words – 'influenced in her own beautiful work by him'.[29] However, her work has in recent years been reassessed more enthusiastically than his, both by scholars and the art market. While her inclusion in the *Pre-Raphaelite Woman Artists* exhibition of 1997-98 seemingly confined her to a female enclave of 'dreamland', the catalogue by Pamela Gerrish Nunn and Jan Marsh provided a first scholarly account of Brickdale's career, an account in which Byam Shaw's name was not mentioned in relation to her work.[30] Brickdale's prominence in the 1990s indicates that her oeuvre can no longer be subsumed under the rhetoric of Byam Shaw's 'influence'.

The academic painter and the imperial stage

The scenario of his Royal Academy exhibit of 1899, *Love the Conqueror* (Figure 29), a 10-foot canvas considered by Shaw to be his masterpiece, was described by Cole as follows:

> The World, represented by a walled city, has capitulated to Love the Conqueror astride his horse. His soldiers – Youth and Beauty – who won his battles; those who had been wounded, those who had been captured, and those who had died in the fight with him. Little Cupid may well be more powerful than the great ones in history.[31]

29 John Byam Liston Shaw, *Love the Conqueror*, 1899, lost, photogravure.

Historical figures – Beethoven, Shakespeare, Henry VIII – mingle with characters from drama and fiction – Siegfried, Ophelia – relating to the theme of Love's conquests, presided over by the bizarre figure of Cupid mounted on horseback. The painting's overloaded surface texture and brilliant coloration are reminiscent of Symbolist paintings of the period in France and Belgium but the techniques by which they were achieved allude to a different tradition.[32] *Love the Conqueror* was intended as a masterpiece in the medieval sense, a virtuoso demonstration of Byam Shaw's own professional credentials, and it does indeed raise central questions about his artistic practice. The process of completing this painting is documented in a series of photographs which indicate an adherence to the Leightonian academic conventions which Shaw absorbed as a student at the Royal Academy Schools in the 1890s. Following the working out of the composition in small-scale drawings, a full-size compositional sketch was prepared on brown paper the size of the canvas, then redrawn onto the canvas; next models were first drawn and then painted onto the canvas nude in the poses he had decided upon (such as the female figure, a naked Botticellian Venus confronting Byam Shaw in his tailcoat, in Figure 26); elaborate studies were made on paper of each figure costumed, and finally the clothing was added over the nude figures on the final canvas. The existence of photographs of each stage of these elaborate, Leightonian procedures demonstrates Shaw's wish to record and presumably publicise the whole performance as an implicit contrast to the Frenchified *plein-air* and *alla prima* techniques of the New English Art Club or the painterly bravura of the early work of Augustus John or William Orpen. There are several ironies in this; first, Leighton's importation of continental academic techniques had been a historical aberration in British art, and second, the highly decorative surfaces of *Love the Conqueror*, replete with gilding and brilliant patches of local colour, juxtaposed (as one critic remarked) like the tesserae of a mosaic, could not be further from the carefully-balanced overall effect of a Leighton canvas.[33] This eclectic wish to uphold as many contradictory traditions as possible within a single image, through a near-hysterical level of productive energy (he strictly timetabled his work on each figure), is surely underpinned by a *fin-de-siècle* anxiety about the exhaustion of tradition, just as the excessive labour of reference to a myriad of historical sources ultimately clouds the legibility of the finished image. Cole devotes an entire chapter of his biography of Byam Shaw to the critical response to this painting, revealing not (as he intended) the incompetence of the modern critic, but rather the bafflingly overworked and overdetermined nature of the image. While many critics were prepared to laud the painting, only one seems to have formulated a critique of Shaw as unaware of key concerns of the modern painter. *Hearth and Home* noted that *Love the Conqueror*:

> will be approached with astonishment, studied with overwhelming irritation, and quitted with despair … it is an acre of scorching confusion … canvas covered with the discordant savagery of aniline colours, without attempts at values, harmony, atmosphere or drawing.[34]

Even here the painting's paradoxical modernity is allowed – for the 'aniline' dyes and colours which result in the 'scorching' effects of the canvas are a product of industrialisation. The painting's eclecticism found critics prepared to identify it as 'only an imitation of Italian art'; 'conceived after the Flemish School'; 'recall[ing] the work of Mr Frith and Mr Maclise' and 'unmistakably under Mr Abbey's influence'. None of these is a foolish or exaggerated remark. The critics were merely attempting to find a response to Shaw's seemingly desperate eclecticism.

Less incoherent stylistically, but more blatant in its promotion of a particular construction of masculinity, is another 10-foot Academy canvas, titled with a quotation from Thomas Carlyle, *The Greatest of All Heroes is One*, exhibited in 1905. Carlyle's phrase is found in his lectures *On Heroes, Hero-Worship and the Heroic in History* (1840), a founding text for the late Victorian cult of imperial soldiers and explorers. As Graham Dawson notes, 'during the growth of popular imperialism in the mid-to-late nineteenth century, heroic masculinity became fused in an especially potent configuration with representations of British imperial identity'.[35] The finished work is lost, but a drawing of the composition (Figure 30) indicates a web of references to such staples of the academic tradition as Raphael's *School of Athens* (c. 1508, Rome, Vatican), Ingres's *Apotheosis of Homer* (1827–33, Paris, Louvre) and Leighton's fresco *The Arts of Industry as Applied to Peace* (1884–6, London, Victoria and Albert Museum). These affiliations could not more strongly assert Byam Shaw's wish to produce a history painting. Ranged in front of a classical backdrop in the drawing are an eclectic group of figures reinterpreting Carlyle's

30 John Byam Liston Shaw, 'The Greatest of All Heroes is One', 1905, preparatory drawing.

typology of the Great Man. Carlyle had found in the admiration of the powerful a religious and perhaps even an erotic charge:

> Worship of a hero is transcendent admiration of a Great Man. Hero-worship, heart-felt prostrate admiration, submission, burning, boundless for a noblest godlike Form of Man, – is not that the germ of Christianity itself? The greatest of all Heroes is One – whom we do not name here.[36]

Byam Shaw's composition gives physical form to Carlyle's suggestion that the Great Men who make up history are all typologically linked to Christ. However, the heroes in the Valhalla of 1905 are radically different in identity from Carlyle's of 1840; Odin, Mahomet, Cromwell and Luther are replaced by a more imperial line-up, beginning on the left with the figure of General Gordon (only vaguely indicated in the study), whose 'martyrdom' at Khartoum 'was invested as the ideal type of Christian forbearance in the face of suffering and death'.[37] Next is John Nicholson, who played a major role in the suppression of the Indian 'Mutiny' of 1857-58, and was understood as the first of a new breed of professional soldier heroes. Along with Major-General Henry Havelock, hero of the relief of Lucknow, Nicholson was lauded by *The Times* in the following terms:

> The middle classes of this country may well be proud of such men as these, born and bred in their ranks – proud of such representatives … men who were noble without high birth, without the pride of connexions … and without a single drop of Norman blood in their veins. The middle classes now produce the type of mind which may be called the governing one – that character which … gives life to a nation.[38]

Such figures appealed especially to Byam Shaw, as epitome of the professional middle-class artist. Alongside them he set Alexander the Great, conqueror of a vast Mediterranean and Asian empire, and the Indian Mogul Emperor Akbar (reigned 1556–1605), who was acknowledged as a cultural and military precursor of the British Raj. Lord Curzon, in particular, was to take Akbar's ceremonial durbars and the magnificence of his court at Fatehpur Sikri as a model for the invented traditions of the British Empire. It is of course a tacit act of colonialism to line up these non-Christian heroes alongside St Michael and Sir Galahad to pay homage to Christ whom (according to Carlyle) their deeds merely echo. A highly successful work, *The Greatest of All Heroes is One* sold from the Royal Academy for £800; yet despite his forceful, and indeed rather forced, allusions to great history paintings, Byam Shaw's treatment of the theme and space seem undeniably stagey, and reminiscent of his many smaller historical genre paintings such as *This is a Heart the Queen has Leant On* (1908).

The composition found a more appropriate recapitulation in his 1914 design for the act drop for the London Coliseum, where Shakespeare, in a small rotunda at the centre, presides over 101 figures as diverse as Thomas Gainsborough and Sir Edward Elgar, Dan Leno and Ellen Terry (Figure 31). Here, Byam Shaw's ability to command a range of high-cultural references (the composition is borrowed from Veronese's *The Marriage at Cana*, Paris, Louvre), while also drawing in references to

31 John Byam Liston Shaw, *Act Drop for the London Coliseum*, 1914, destroyed.

popular culture, provided a perfect visual expression of the project of the Coliseum and its founder, Sir Osbert Stoll. The Coliseum represents a significant development in the history of popular entertainment in Britain. Opened in 1904, it was intended to transform the music hall into a respectable form of entertainment for professional men and their families. Where the earlier music halls thrived on double entendre and salaciousness, attracted prostitutes and their clients and relied on the sale of alcohol for their profits, music–hall acts at the Coliseum were banned even from using the word 'damn', and alcohol was not served. The new theatre was the epitome of modernity, with its electrically illuminated globe visible across the West End, and its central Information Bureau where telegrams could be received and dictated, typed and sent. The celebrity of the Coliseum was, as Archibald Haddon recalled, compounded by Byam Shaw's 'famous picture act-drop'.[39] The Coliseum epitomised the 'theatre of variety' and was, par excellence, the place of entertainment of the new professional society. The management particularly stressed that the Information Bureau could convey telegram or telephone messages to lawyers, doctors and politicians in the audience if they identified themselves before the performance. Seats were bookable from two guineas down to sixpence. In the upper circles of the huge theatre, the highest (and thus cheapest) balconies being reached by separate doors in a side alley, Stoll hoped to attract a mass audience with a range of socially improving theatrical entertainments which included plays and pageants as well as

variety acts. Music-hall artists, therefore, are relegated to secondary status in Byam Shaw's cavalcade, with only the diminutive figure of Harry Lauder appearing to the far left of the front row and Dan Leno virtually invisible behind. High-cultural figures from theatre history – Mrs Siddons, Herbert Tree, Ellen Terry and Sarah Bernhardt – take pride of place. Even the figure of Toby, a famous performing dog who appears in the foreground, is symptomatic of this attempt to transform music hall to standards of West End respectability. Toby appeared in a double bill at the Garrick Theatre over the Christmas of 1904–5. The main item on the bill was 'Little Black Sambo and Little White Barbara', a musical based on the 'Dumpy' books by Russell Barrington set 'at the edge of the jungle'.[40] An imperial fantasy of a type guaranteed to appeal to the professional audience, it none the less also played on popular traditions of blacking up and minstrelsy. It was preceded by what seems to have been a spoof Jacobean entertainment, possibly akin to a pantomime, by Tom Gallon, 'Lady Jane's Christmas Party: An Old Fashioned Episode', which was principally memorable for the antics of 'the Dog Toby' dressed with a ruff and hat. Byam Shaw must have seen and enjoyed this performance enough to incorporate the dog prominently in the composition.

Byam Shaw's act drop responds to precisely the opposite elements in popular culture to those which attracted Walter Richard Sickert at the same time. Where Sickert relished the links between the music hall, prostitution, alcohol, low life and the underworld, and drew out these elements in his interiors of the Old Bedford and other halls, Byam Shaw celebrated the cleaning up and commercialisation of music hall, and its relocation within a highly capitalised and sanitised middlebrow forum. The Coliseum became a key site for the mass culture of imperialism: Edward Elgar provided the music for a grandiose and hugely successful 'Imperial Masque', *The Crown of India*, for example, which was produced there to celebrate the Indian Coronation of King George V in 1912. The mustachioed figure of Elgar himself appears in the act drop, and his *March of the Moghul Emperors* echoes Byam Shaw's heroic treatment of Akbar in *The Greatest of all Heroes is One*. In an interesting parallel with Byam Shaw, while Elgar's popular works articulate a brash and self-confident imperialism, his serious compositions are complex meditations shot through with doubt and melancholy.[41] These connections with the respectable end of music hall and popular culture link Byam Shaw's work into the developing popular imperialism of the Edwardian period.[42]

Pre-Raphaelitism and imperial crisis

Parallel to Byam Shaw's revival of Leightonian methods and the vocabulary of history painting in the search for a pictorial equivalent to imperial modernity was his deliberate deployment of a recognisably Pre-Raphaelite style. This strategy of revival, too, intersects in significant ways with discourses of empire. In one of those scenes of symbolic endorsement across generations which abound in monographic art history, the drawings of the fifteen-year-old Byam Shaw were shown to the aged

John Everett Millais, who predictably supported the youth's choice of career with professional advice impressive enough to convince Shaw's parents.[43] This anecdote weaves Byam Shaw into the fabric of 'Pre-Raphaelitism', the term of affiliation which, despite its obvious inaccuracy, was to overpower all others in every text discussing his work. The implications of 'Pre-Raphaelitism' were different by the time of Shaw's maturity from what they had been in the 1850s and the publication in 1905 of William Holman Hunt's *Pre-Raphaelitism and the Pre-Raphaelite Brotherhood* offered a powerful retrospective account of Pre-Raphaelitism as the cornerstone of the English School. The radicalism of Pre-Raphaelitism as a disruptive element in the traditions of English academic painting, a brief anti-Reynoldsian protest, seemed less significant in the light of later avant-garde challenges, mainly based in French practice. Instead of assuming an oppositional identity, Pre-Raphaelitism could be seen by the end of the century as an authentically, even uniquely English vernacular art form. The early Hogarthian and naturalistic elements in the movement could be emphasised and the later links with Aestheticism and decadence downplayed. As Julie Codell has recently argued, by 1900:

> art history reinforced [discourses of] nationalism by codifying supposed national and racial traits into stylistic traits, modelling artistic production on a heroizing ideology and systematizing and masculinizing networks of origins and influences.[44]

Hunt seems to have imagined that Pre-Raphaelitism (and especially the hard-edged realism of the Hunt–Millais axis) constituted no less than 'the hand-writing of the nation',[45] and offered an authentically English corrective both to the French practices – variously *alla prima* painting, heavy impasto and the 'square-brush' style – entering through the New English Art Club, and to more assertive forms of modernism which came to prominence in and after 1910.[46] As early as 1884 Ruskin had warned, in his introduction to Ernest Chesneau's *The English School of Painting*, that the British schools of painting were in danger 'of losing their national character in their endeavour to become sentimentally German, dramatically Parisian or decoratively Asiatic'.[47] It is worth recording that the young painters who formed the New English Art Club in 1886 described themselves as 'Anglo-French', representing an alternative to Hunt's isolationist Englishness.[48] A commitment to laborious, precise observation and recording of the natural world is presented by Hunt as a national imperative rather than a stylistic choice. Similar arguments advanced at the time of the Ruskin–Whistler trial in 1878, when the gestural and sketchy quality of Whistler's work was contrasted with the workmanlike virtues of 'finish'.[49] The 'Englishness' enshrined in such a practice is, furthermore, that of an England which lies at the heart of the British Empire. Marcia Pointon has demonstrated that Hunt's verbal accounts of his travels in Egypt and Palestine in the mid-1850s, published in their definitive form in 1905, provide a key example of the impact of imperialism on artistic practice, producing works which were, paradoxically, both based on exhaustive observation of Middle Eastern life and (in the words of one reviewer) 'thoroughly English and Protestant'.[50]

Shaw's choice of Pre-Raphaelitism was undoubtedly conditioned by this for-
mulation around which ideas of national and imperial identity, masculinity and
authenticity coalesced, and it was to the earlier works of Holman Hunt, Millais
and Ford Madox Brown that he looked for stylistic and iconographic precedents.
In 1894, as a student, Byam Shaw wrote admiringly to his friend Gerald Metacalfe
of seeing Madox Brown's *Christ Washing Peter's Feet* (1852, London, Tate
Gallery), 'with which I am perfectly enraptured ... Oh, I think it's lovely. I mean
literally lovely! I don't mean as a girl says lovely.'[51] Even if the Christian Socialist
message of this canvas seemed dated by the 1890s (and indeed was explicitly
rejected by Shaw in *Christ the Comforter*), Brown's image of a manly Christ with
bared forearms resonated with the bodily ideals of imperial manliness in the late
nineteenth century. Shaw's admiration for the work of the members of the Pre-
Raphaelite Brotherhood and their circle – bearers of the true flame – required him
to distance himself from the younger generation of painters, influenced by the
later work of Rossetti and often also loosely labelled 'Pre-Raphaelite'. Among
these might be counted Simeon Solomon, and particularly Edward Burne-Jones,
whose work was more decorative and less explicitly engaged with contemporary
life. Aestheticism could be read as both 'effeminate' and 'decadent', notions Byam
Shaw was keen to oppose. Even his *Love's Baubles* of 1897 (Liverpool, Walker Art
Gallery), an essay in decorative painting loosely derived from Rossetti's work of
the 1850s, brought forth the following response from Eleanor Fortescue-
Brickdale, positioning it against Burne-Jones and his followers: 'no one can
describe how fresh and delightful it looked at the Academy. Most of the subject
pictures at the time were a bit dreary, generally very "aesthetic" or "arty".'[52] The
painting's vivid coloration ('full of joy and fearlessness' for Brickdale) immedi-
ately reminded public and critics alike of the Pre-Raphaelite work of the 1850s: its
exuberant vulgarity contrasted with the extreme refinement of the later phases of
Aestheticism. Once again, gender is a central issue: Aestheticism had come to be
regarded as 'sensuous' rather than 'manly'. In a painting exhibited less than a year
after the trial of Oscar Wilde, Shaw's style rejected the painterly Symbolism of
Burne-Jones, whose exhausted and emasculated Perseus was eloquently portrayed
in near-monochrome pallor, in favour of a highly coloured and harshly stated reit-
eration of a style closer to the earlier works of William Holman Hunt and Ford
Madox Brown.[53]

In an image from contemporary life, *Boer War 1900*, exhibited at the Royal
Academy in 1901 [Plate 3], Byam Shaw wove together many of the themes which
run through his oeuvre, finding, for once, a wholly convincing formula which is
both revivalist and explicitly modern. The grieving widow, or fiancée, of a soldier
killed in action is seen standing transfixed by her memories, unable to perceive
what Cole called 'the lovely countryside, decked out in the brilliance of June'.[54]
Although the surface is in fact far freer and the paint applied far more thickly than
in the enamelled surfaces of early Pre-Raphaelitism, the brilliant effect of this
canvas, and the relationship between the oblivious, suffering female and the beauty

of the natural world clearly refers to Millais's *Ophelia* of 1851–52 (London, Tate Gallery). The Pre-Raphaelite affiliation of *Boer War 1900* is made explicit through a quotation from Christina Rossetti, which Shaw adopted as a sub-title:

> Last Summer green things were greener,
> Brambles fewer, the blue sky bluer.

But although the explicit subjects – a tragic female figure personifying vulnerability and grief; the beauty of the English countryside, nostalgia for lost happiness – are not unusual in late Victorian art, the title of the work and the context in which it was painted and exhibited insist on its contemporaneity.

Looking back on Byam Shaw's life in 1932, Rex Vicat Cole recalled '"Soldiers of the Queen" and Kipling's "Absent-Minded Beggar" being sung' in 1899,[55] the very epitome of jingoism, which found its most powerful expression in precisely the spaces of popular imperialism – the music hall and the Tory popular illustrated press – where we have already located Byam Shaw's work. Leslie Stuart's song 'Soldiers of the Queen' was written in 1881 (only three years after the song 'By Jingo' from which is derived the term 'jingoism') for Albert Christian to sing in the West End music halls. Its sentiments are bellicose, but it is the common foot soldier who takes the credit for England's greatness:

> So when we say that England's master
> Remember who has made her so ...
> It's the soldiers of the Queen, my lads,
> In the fight for England's glory, lads,
> Of its world wide glory let us sing.
> And when we say we've always won,
> And when they ask us how it's done
> We'll proudly point to ev'ryone
> Of England's soldiers of the Queen.[56]

As Penny Summerfield notes, this song was widely taken up during the Boer War. Kipling's 'Absent-Minded Beggar', written in 1899, with music by Sir Arthur Sullivan, took up the theme of the young soldier but aimed (somewhat implausibly) to flatten out class differences in the army:

> Cook's son – Duke's son – son of a belted Earl –
> Son of a Lambeth publican – it's all the same to-day!
> Each of 'em doing his country's work
> (and who's to look after the girl?)
> Pass the hat for your credit's sake,
> and pay – pay – pay![57]

As in Byam Shaw's painting, the social consequences of the Boer War are approached through the figure of a suffering woman. It could indeed be that Kipling's lyrics suggested the subject.

Cole's reminiscence continues with a sketch of the war from the point of view of the Londoner with a keen interest in imperial matters reading dispatches in the daily papers: 'our reverses at Talana, Stormberg, Nicholson's Nek and Magersfontein – grim realities set off by successes at Elandslaagte, and the holding and relief of Kimberley and Mafeking'.[58] The Boer War constituted both a crisis of imperial control, and a crisis of imperial masculinity. The military 'reverses' listed by Cole resulted in heavy casualties, notably Stormberg (where 696 British soldiers went missing or were captured), and Magersfontein (9–12 December 1899) where a Highland brigade marched straight towards Boer artillery concealed in a trench. There were 902 British dead, many of them shot in the back while fleeing the battle. Equally disastrous was the widely reported humiliation of the imperial troops at Nicholson's Nek on 29–30 October 1899, when Lt. Gen. Sir George White's reckless plan to send a column through enemy lines ended in the surrender of 954 officers and men. On 'Mournful Monday' (30 October) the rest of White's army was to be seen in full retreat, 'clubbed and broken' by the Boers, mainly untrained civilians, whose superior manoeuvrability and knowledge of the terrain had none the less allowed them to humiliate the imperial forces. In addition to these military losses, widely reported in the press, there were further anxieties over the potency and effectiveness of British masculinity, of which military prowess was a much vaunted symbol. During 1900 it became increasingly clear that recruitment of troops in Britain was impeded by the poor physical condition of working-class volunteers: British men were simply not fit for battle.[59]

In *Boer War 1900* the masculine is absent, but imperial manhood is nonetheless the ultimate subject of the image. The terrible human cost of war is figured through a feminine personification of loss, but a further loss is a symbolic one: under the conditions of 1899–1901 Byam Shaw withdrew from the challenge of producing a heroic image of the male body in a history or battle painting, the traditional forms of war imagery. Instead, the most English and manly of styles – Pre-Raphaelite realism – was deployed at a moment of national and imperial grief and calamity to restore faith in England itself, represented as so often by the landscape of the Thames Valley (in this case Dorchester), and personified by the dignified figure of an upper-middle-class woman whose husband or fiancé was most certainly of the officer class. Not giving voice to imperial violence, *Boer War 1900* instead presented the imperial through the domestic and the *haut-bourgeois*.

Shaw's painting is especially effective in constructing an image of 'home' even if that home cannot ever be complete for the young woman without her fiancé. Implicitly evoked by the opulent delineation of foliage and water is the otherness of the South African veldt, dry, hostile and dangerous, where we might imagine the body of the loved one to have been buried. This imagery was introduced into academic art through a number of heroic battle scenes, and works such as George William Joy's semi-allegorical *Dreams on the Veldt* (location unknown; painted in 1900 and exhibited at the Institute of Painters in Watercolours in 1901), which emphasised the 'burnt-up veldt, with its chill nightly vapours and the steep angle

of the rising hill ... suggestive of the campaigning difficulties of the country'.[60] Joy's lurid allegory visualised 'the Angel of Death in the form of [the soldier's] own beloved one',[61] but Byam Shaw was more interested in the psychological and social aspects of loss in the context of the upper-middle-class family at home. As in Ruskin's mid-Victorian delineation of the roles of man and wife in *Sesame and Lilies*, the woman is associated with garden imagery and home, the man with that of work and battle, implying frequent absence from the home.[62] The death of the imperial male marks the permanent disruption of the domestic idyll which Shaw was to depict in *My Wife, My Bairns and My Wee Dog John*: here, too, a family member is portrayed, since his sister posed for *Boer War 1900*. Signifying against the large corpus of battlefield reportage, verbal, graphic and photographic, which was published in the British press during 1900–1, *Boer War 1900* initially denies but ultimately reaffirms the violence of war. The juxtaposition of the bereaved woman with the water, coupled with the reference to Millais's *Ophelia*, opens the possibility of further violence: could perhaps the woman's contemplations extend to suicide?

The exclusivity of the domestic world, the 'home' celebrated by Shaw, may briefly be contrasted with the situation in South Africa, where a very different politics of the home was emerging as *Boer War 1900* was being painted. Byam Shaw's title explicitly refers to the year in which the British forces were able gradually to reassert control, partly through the use of concentration camps. In the second half of 1900 the British organised a massive campaign of destruction of farms thought to be harbouring Boer soldiers: between June and November 1900, for example, over 600 farms were burnt in the Orange Free State alone.[63] News of this campaign was quickly reported in the London press. Filson Young, a war reporter for the *Manchester Guardian*, for example, described how:

> In one melancholy case the wife of an insurgent who was lying sick in a friend's farm, watched from her sick husband's bedside the burning of her home 100 yards away. I cannot think that punishment need take this wild form: it seems as though a kind of domestic murder were being committed.[64]

Few in 1900 would have acknowledged the analogy which I am drawing here between the representation of domestic 'self' in Byam Shaw's work, and that of colonial 'other' in the news report. Yet in both cases the military engagement of the male is perceived through the suffering of the female. Perhaps the natural imagery in *Boer War 1900* attempts to reaffirm England's, Britain's and the British Empire's fundamental innocence: but as a strategy of denial of both British weakness and, simultaneously, imperial brutality in South Africa it is ultimately not effective. If 'Last Summer green things were greener/Brambles fewer, the blue sky bluer' then the loss is not merely a personal one: a young woman losing her prospective husband in fighting for Queen and country. Rather, the Boer War exposed the moral and political compromises, the incompetence and wastefulness of life which characterised the imperial project, and Byam Shaw's painting performs the same function.

A final example of Byam Shaw's referencing of Pre-Raphaelitism can be found in a watercolour exhibited during the First World War, *When Love Entered the House of the Respectable Citizen*.[65] In this painting Cupid (a figure seen in Shaw's allegories such as *Love's Baubles*, 1897, Liverpool, Walker Art Gallery) has entered and dis-arranged the parlour of a middle-class bachelor's suburban home. The obsessive domestic details, and, no doubt, the highly charged colour scheme, are reminiscent of a kind of disordered repainting of Holman Hunt's *Awakening Conscience* of 1853, a fallen birdcage and smashed oil-lamp operating like the cat and bird and dis-carded glove in Hunt's image, as symbolic underpinnings for the main action. This is a late Victorian domestic world vandalised and fragmented beyond repair, to the despair of the male protagonist. Here, in 1916, we experience another crisis of imperial manliness: the figure of the professional man rendered helpless by love. Yet the juxtaposition of a nude allegorical figure with a fully clothed modern one, a child with a man, makes this a disturbing image. Despite his wings, the figure of Cupid is no putto, but a naked pre-pubescent schoolboy: the possibility of same-sex desire or paedophilia is simultaneously denied and reaffirmed by the image. Such phenomena would indeed disarrange the comfortable domesticity of the upper-middle-class family. While the painting was probably read when first exhib-ited as merely another of Byam Shaw's many subject pictures on the theme of romantic love, its helpless, stymied hero can also be read as an unwitting, grotesque parody of Shaw's professional soldier-heroes, led as in the Boer War by Kitchener, but by 1916 rendered ineffectual in the stalemate of trench warfare.

Byam Shaw created enduring images which, through the informed manipula-tion of artistic traditions, speak poignantly of his own time. Perhaps more impor-tant is the fact that his works, and his biography, indicate the fractured and vulnerable nature of the late Victorian professional world – in the limited sense of the artistic profession, and in the broader idea of 'professional society' – which he represented. Furthermore, while Byam Shaw epitomised in his life and work the cult of imperial manliness, this identity is constantly undercut by his own physical and emotional frailty, and by the images hinting at crises of masculine confidence and competence to which I have drawn attention. The gender roles of the upper-middle-class family, the social and political structures of British society and the very fabric of the British Empire, all presented to the world as indestructible ideals, were in fact all strained to breaking point during Shaw's lifetime, and these frac-tures can be perceived even in his most celebratory images. His work is thus doubly modern: in giving a visual form to the ideologies of a modern empire and the pluto-cratic ideals of the new professional class, but also in tacitly demonstrating the hol-lowness and fragility of these same phenomena.

The First World War was to quicken these processes of change and expose the fragmented state of the culture of Britain's social elite. Perhaps, then, the chaos of *When Love Entered the House of the Respectable Citizen* reflects something of Byam Shaw's response in 1916 to modernism's challenge to his own artistic practice and the Great War's destruction of the sense of financial and social security – the world of

late Victorian professional society – which had nurtured it. Byam Shaw's exhibition pieces on war themes, such as *Hope*, a watercolour of 1916,[66] based on the allegorical figure of a female nude juxtaposed with a shaft of light representing dawning hope of victory, failed to achieve the timeliness and immediacy of *Boer War 1900*. During this period his output was dominated instead by a vast number of propagandistic cartoons and comic drawings, illustrations and advertisements, which manipulated a wide range of iconographic devices in the service of the patriotic cause. There were sound professional reasons for pursuing such a course, paramount among them being the need to provide an income to support his family, alongside the patriotic imperative which also impelled him first to join the United Arts Rifles, then resign to become a sergeant, and later an inspector, in the Special Constabulary of the London police force. It is possible that Byam Shaw might also have found in the popular press a context for his work where the challenge of modernism, felt vividly in London after the series of exhibitions from 1910 to 1914, was less immediate.

Writing in 1975, Peyton Skipwith provided another slant on the concept of historical inappropriacy with which I opened, claiming that Byam Shaw 'flits gaily across the stage during the last Empire-building days of Britain's greatness and expires neatly at the point when his art becomes redundant'.[67] For Skipwith, Byam Shaw is an emblematic figure of Edwardian England, who, far from living beyond his time, personified it and died with it. Despite its apparent flippancy, this is a more perceptive response than that of modernist critics who seek to displace the artist from his own time. Byam Shaw's work epitomises key elements in Edwardian culture, while bearing little resemblance to the art of the period of modernism's ascendancy from the First World War to the 1970s. But to read these later developments backwards in order to disparage or ignore Shaw's work from the Edwardian era, and to argue that he therefore does not 'belong' to that earlier period, is to perform precisely that retrospective, teleological act of history-making which has rendered the written history of British art, and the related displays of it in museums and galleries, unacceptably limited in scope. It is particularly important to dismiss this approach now that modernism's formal preoccupations – summed up by Rutter as 'atmosphere, tone values, and plastic volumes' – have long ceased to be the 'problems which occupy the modern painter'. But while Byam Shaw's strategies of eclectic reference and quotation, his focus on the human body, his brilliant, garish palette, and his occasional recourse to camp, all find echoes in post-modern artistic pluralism, little would be gained by falling into the trap of teleology and validating his work through such parallels. Post-modernity is, in any case, a nebulous *telos*, and few critics express a Whiggish contentment with the present state of things. Art-historical teleologies by definition impose an anachronistic pattern on the past: and in the case of the period 1890-1910 this has resulted in a diminution of the richness and diversity of artistic practice and visual culture. To consider the work of such artists seriously allows an enormously expanded field of enquiry and debate, a broad cultural history of the visual which can accommodate both celebration and critique.

Masculinity, money and modern art: *The Sentence of Death* by John Collier

Pamela M. Fletcher

Indeterminacy was one hallmark of the modernist project, as the unfixing of literal meaning functioned as a sign of the new aesthetic. As articulated by literary theorists such as Wolfgang Iser, indeterminacy is also the foundation of narrative, a concept often seen as the very opposite of the modern in the visual arts.[1] I'd like to use this overlap to explore what may seem at first an obvious question: why was narrative art not seen as modern in early twentieth-century England? If by now the distinction is so common as to seem self-evident, it wasn't necessarily so to early twentieth-century audiences. In fact, I will argue that the Edwardian 'problem picture' was one attempt to utilise the indeterminacy inherent in narrative to create a socially engaged form of public modern art. If the style was not one that we would recognise as modern *per se*, the subject matter – female sexuality and relations between the sexes – was. But this attempt ultimately failed, and the moment of that failure reveals much about how the opposition between 'narrative' and 'modern' was produced and learned as common sense, and how gender and class were implicated in that process.

Although almost forgotten today, the 'problem picture' was one of the most anticipated and publicised features of the late Victorian and Edwardian Royal Academy.[2] Problem pictures were deliberately ambiguous scenes of modern life, designed to invite multiple, equally plausible interpretations. Edwardian viewers responded enthusiastically, debating possible 'solutions' to the pictures' narrative and moral ambiguities at the Academy exhibition, in letters to the artists, and in newspaper competitions. The Hon. John Collier (1850–1934) was the most popular and prolific producer of this type of work, exhibiting the problem picture of the year at the Royal Academy most years between 1903 and 1908 and earning the dubious title of 'The Great Problem-Artist' from the *Illustrated London News* in 1908.[3]

Like the Victorian tradition of moralising narrative paintings from which they grew, problem pictures often depicted women in suspect situations, but the ambiguity of the later pictures forestalled any easy moral conclusions. Instead, the pictures posed a narrative question or questions which viewers struggled to answer.

One of John Collier's most popular problem pictures, *The Prodigal Daughter* of 1903 (Figure 32), draws on the theme of the fallen woman but with an unexpected twist: the young woman returning to her bourgeois home in fancy dress exhibits a notable lack of repentance, leading viewers to question whether she is leaving her home or returning to it, a repentant fallen woman or a modern New Woman. Lacking the inexorable narrative fall from seduction to suicide typical of earlier representations of the fallen woman, the moral message of the picture remained unfixed, and the picture generated widespread debate at the Academy and in the press.[4] As viewers invented their own narratives to complete and explain this painting and other problem pictures, they grappled with the new social terrain of the early twentieth century, in particular the changing roles available for modern women.

The periodical press was crucially important to this process, reproducing pictures, sponsoring competitions for the best 'solution', popularising the term and adding the 'problem picture' to the list of regularly expected works at the Royal Academy. The press thus plays a complex role for any analysis of the problem picture. On the one hand, the Edwardian periodical press is the single most important source of information about the pictures and their reception. On the other, the press was also a constitutive part of the phenomenon, as the coverage of individual pictures helped to shape and define the problems – artistic, narrative and psychological – that they presented. Thus, while necessarily incomplete, reports in the periodical

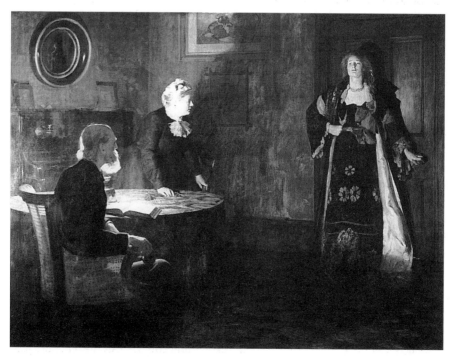

32 John Collier, *The Prodigal Daughter*, 1903.

press – ranging from popular halfpenny dailies to women's magazines and working-class Sunday papers – provide both a partial map of the various invented narratives generated by the pictures and a context for reading them as socially recognised, but still potentially subversive, representations of competing value systems.

In the early Edwardian era, problem pictures succeeded in generating public discussion of contemporary social issues, and were generally accorded a positive critical reception. 1908, however, marked a turning point in the history of the type. The popular problem picture at that year's Royal Academy was John Collier's painting *The Sentence of Death* (Figure 33) which depicts a young man seated in a doctor's office, apparently receiving an unfavourable diagnosis. The painting was simultaneously the last problem picture to be taken seriously and the first to be the subject of overwhelmingly negative critical commentary, a combination which both reveals the potential of narrative indeterminacy and suggests some reasons for its ultimate failure to provide a tenable version of modern art.

An early review suggests that the picture's subject was one reason for this changed response. Despite the fashionable popularity of the type, the art critic for *Truth* did not immediately recognise *The Sentence of Death* as a problem picture, complaining that Collier 'gives us no study of the Life of the Wicked Aristocracy … no study of gambling or marrying for money, no flashing eyes and yellow satin

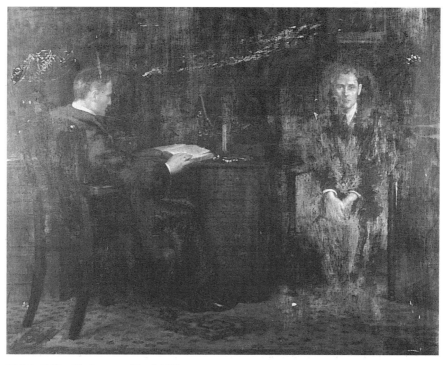

33 John Collier, *The Sentence of Death*, 1908.

dresses, nothing but a doctor, an ordinary middle-class professional man'.[5] The comparisons, referring to Collier's earlier problem pictures which generally took upper-class women as their subject, help pinpoint the source of the writer's confusion.[6] The critic does not recognise *The Sentence of Death* as a problem picture because it depicts middle-class people rather than the wicked aristocracy, and because it takes as its subject men and male roles rather than women. Although the critic later apologised for his mistake, his confusion is evidence of the expectations viewers brought to problem pictures, as critics and viewers explicitly framed their readings in terms of gender and class.

The Sentence of Death's disruption of gender expectations was also due to its use of Victorian narrative traditions. The subject of the doctor–patient relationship had important pictorial precedents in the preceding decade: Luke Fildes's hit picture *The Doctor* of 1891 (Figure 34) and Frank Dicksee's *The Crisis* (Figure 35) of the same year. Both represent an anxious man watching over a sick patient, although in *The Crisis* the identity of the man as doctor, husband or father is left ambiguous. As images of masculinity, however, the paintings are quite similar. Fildes's image represents the good doctor who cares for his young patient as a father would, while in the Dicksee the ambiguous identity of the man who watches over the sick woman creates a similar fusion of paternal and professional authority. In each, the caring doctor–father is the image of beneficent masculine authority defined in contrast to the child or female patient.[7]

Collier's painting differs from these earlier examples in several significant ways, each of which alters its representation of masculinity. First, the location has changed. The doctor–patient consultation takes place not within the home, but in a doctor's office, with the prominently displayed book and medical instruments emphasising the doctor's specialised knowledge, and the luxurious furnishings indicating his success. Second, because of the title, the doctor's opinion is no longer ambiguous; we know that the doctor has pronounced the young man's illness fatal. These changes transform the image of the doctor in the later picture, as he is firmly identified in his professional character. But this authority is potentially undermined by a third change: in the Collier painting, the patient looks directly out at us, meeting our gaze with his look of dumbfounded shock. The viewer thus confronts the patient face-on, standing in the diagnostic position of the doctor and invited to provide his (or her) own conclusion. Finally, the gender of the patient has changed. Illness and disease had long been considered defining characteristics of upper-class femininity and, as many scholars have demonstrated, the Edwardian ideal of manliness was increasingly equated with physical prowess and strength, making the reversal of gender roles in the picture a threatening one and the question of the diagnosis even more potent. In sum, then, the picture offered as a 'problem' at least two different models of masculinity in the figures of the potentially mistaken doctor and the effeminised male patient.

Thus, through its status as a problem picture, its references to pictorial tradition, and its visual structure, *The Sentence of Death* presented masculinity as a

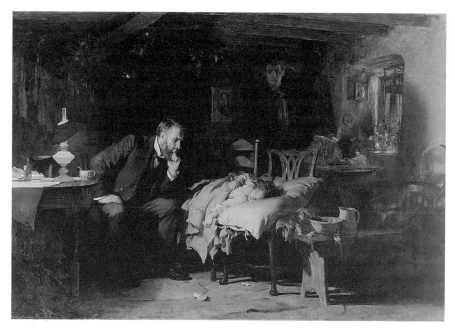

34 Luke Fildes, *The Doctor*, c. 1891.

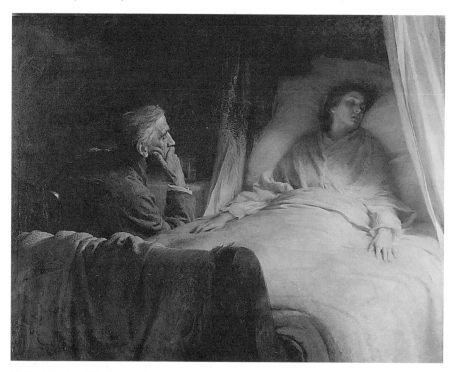

35 Frank Dicksee, *The Crisis*, 1891.

problem to its Edwardian audience. In some respects, this seems a complementary endeavour to earlier problem pictures which had successfully generated debate about modern femininity. As many recent studies have argued, 'masculinity' was also a contested category at the turn of the century.[8] The late Victorian and early Edwardian ideal of manliness was based on the model of separate spheres, as men were encouraged to develop the qualities needed for success in the public world, including 'courage, resolution, tenacity and self-government or "independence"'.[9] Strength – physical as well as moral – and control over emotion were seen as the defining characteristics of the manly man. Female challenges to male dominance in both the public and private spheres, as well as personal dissatisfaction with these constraints among some men, called into question these tenets of masculine power, creating what has been called a 'crisis' of masculinity.[10]

However, despite its topical subject matter, *The Sentence of Death* was neither as effective at generating coherent debate nor as well-received critically as earlier problem pictures had been, in large part, I believe, because of the implications of this focus on masculinity. First, the category of 'Man' was not already articulated as a problem in the way that the category 'Woman' had been. The concern over manliness (or its absence) in the British population was evidenced in Edwardian cultural discourse more often by measuring deviance from the ideal rather than by any questioning of the idea of 'masculinity' itself.[11] Second, as Lisa Tickner has argued, the concept 'masculinity' already had a different relation to the modern from femininity.[12] As artists and critics self-consciously invoked virility and manliness as the defining qualities of modern art (and artists), the picture's representation of masculinity as a problem worked against its acceptance as art. These two distinctions shaped the picture's curious reception, affecting both viewers' attempts to resolve the indeterminacy of the picture, and the representation of that indeterminacy in the press.

Unlike earlier problem pictures, *The Sentence of Death* does not seem to have posed a clear moral or social question to its viewers, as the problems posed by the questioning of 'masculinity' seem to have outstripped the available critical vocabulary. There is very little consistency in the response to the picture as to what the question is, let alone any consensus as to a solution. Multiple problems were articulated in the press, including: what is the illness from which the patient suffers? How long does he have to live? Should the doctor tell the patient of his fatal illness? Is the doctor even right?

Probably the most frequently posed question was the first: from what illness does the unfortunate young man suffer? Significantly, most papers did not venture a guess as to what the illness might be, unlike responses to the problem pictures of previous years in which the answer to the narrative problem was proposed frequently. The *Illustrated London News* pointed out that the instrument on the table was one used to test the heart, and might therefore be a clue, but this was the only suggestion offered in the large middle-class press.[13]

An unusual reading of the picture in *Reynolds's Newspaper*, a working-class Sunday paper, hints at one reason for this silence and calls attention to the

importance of class in interpretations of the picture. The reviewer identifies the illness as a 'slow inherited disease', a characterisation that taps into widespread contemporary fears about the deterioration and degeneration of British manhood but locates them in an unexpected place – the upper classes.[14] While a heightened concern with 'degeneration' as the dark side of progress had been part of European cultural discourse throughout the late nineteenth century, the humiliations of the Boer War acted as a catalyst for such concerns in early twentieth-century Britain and served to focus them specifically on men.[15] Both the length of time it took the British army to win out over the much smaller Boer forces and the widely reported statistic that 60 per cent of volunteers had been found unfit for service lead to the widespread perception that British masculinity was not up to the task of maintaining the Empire.[16] Such anxieties gave rise to various public commissions and reports on the physical deterioration of the population and the increasing numbers of feeble-minded persons. Under the influence of Darwinian theories of the survival of the 'fittest', this perceived deterioration was attributed to the genetic degeneration of the British population, in particular the urban working class. Within the context of such concerns about modern British masculinity, the insertion of a young man into the patient position which was usually reserved for a woman (or child) undermines his masculinity, and he can be seen as a type of degenerate and feeble male.

In this case, that characterisation is being utilised within a very specific class context. *Reynolds's Newspaper* was one of a number of Sunday papers which grew out of a Radical political tradition and were aimed at the working man. While much of the political purpose of these papers had been muted by the early twentieth century, there was still a decided working-class slant to their news coverage and they still served as significant sites for the consolidation of working-class identity.[17] Significantly, this paper aimed at working-class readers was one of the only places where the class of the patient was explicitly addressed. The bulk of the *Reynolds's* review focuses on the signs of the patient's 'gentle birth and breeding', thereby locating him – and his inherited disease – within the upper classes.

An article on the decline in British birth rates published two weeks later in *Reynolds's* provides a context for understanding this characterisation of the patient as both upper-class and prone to degenerative inherited disease. The author locates the decline in birth rates among the upper and middle classes but, rather than following this identification with the usual call for the genetically superior classes to reproduce at higher rates, he uses it as a justification for better living conditions for the labouring classes, as 'the fecundity of the race apparently depends wholly on the working classes'.[18] The paper's reading of *The Sentence of Death* thus begins to emerge as part of a larger argument presented to the working-class readers of *Reynolds's*, as a justification of their own importance in maintaining British pre-eminence as their virility and self-sacrifice come to 'the rescue of the race'.

The reading of the picture offered in this working-class paper suggests that one reason for the general silence around the question 'what is the illness?' was that the figure of the ill male was a potentially uncomfortable one. However, the *Reynolds's* reviewer's frank acknowledgement and use of this discomfort was unusual. Most viewers of the picture were of the class directly represented in it, and most commentary on the picture took place in papers and magazines aimed at middle-and upper-middle-class readers. In this context it is important to note that the rhetoric around health and masculinity was different from a middle-class perspective. While still informed by imperial interest and the fear of degeneration, it took shape in terms of an emphasis on physical fitness (or 'physical culture') and sport, and grew in part from fears that middle-class men, as they moved into office work and management, were becoming flabby and out of condition. In response to such concerns, the Edwardian era saw an increased emphasis on sports in public schools and an ideal of physical fitness as a sign of masculinity.[19] Thus, although the possible middle-class responses to an image of masculine ill-health were not identical to those of the working class, the image of unfit masculinity that the picture offered was still a threatening one.

Middle-class viewers of *The Sentence of Death* did not respond by positioning themselves in opposition to the represented masculinities, but by trying to *recuperate* those masculinities, a process the picture resisted. One strategy for resolving the uncomfortable image of masculinity offered by the figure of the patient was to deny that he was ill, refusing to read the picture as 'real' experience. Many reviews of the picture ignored the narrative content and focused on the supposedly visible health of the model, including the critic for the *Morning Post* who pointed out that the 'problem' was 'complicated by the fact that he has been painted from a model, conscientious no doubt, but obviously in robust health', and the critic for *The World* who called the model 'a perfectly healthy person'.[20] *The Times*, on the other hand, misread the picture as a young man being expelled from school, a reading which avoided the question of physical fitness altogether.[21]

This insistence on the health of the model may have been a means of circumventing the uncomfortable reading of unfit masculinity, and an attempt to redirect the discourse on the picture to the realm of the aesthetic, denying the reality of the scene by insisting on the artificiality of its representation. This strain of criticism continued and was carried in other directions, which I will follow later. For now, however, I want to make the point that the critical shift from reading pictures narratively to reading them formally was not nearly complete in 1908, and all of the critics who discussed the picture addressed its subject matter directly in at least some part of their commentary.

Given this critical interest in content, the identification of the patient-model as healthy posed another narrative problem: if the patient is not ill, is the doctor wrong? Has he wrongly pronounced the sentence of death? The very invitation to diagnose the illness carried with it the implication that the viewer might disagree with the doctor's assessment, as pointed out in a gossip column in *The Sketch*:

A Slight Mistake: Every visitor to the Royal Academy is concerned to know from
what disease the victim of the 'death sentence' is suffering in the Hon. John Collier's
picture. Nobody questions the finding of the doctor. Yet very likely he was wrong …
Doctors are as human as their patients, and apt to err.[22]

While this does not seem to have been a widespread reading of the picture, it was
clearly a possibility, and one that made it difficult to recuperate the ill male patient
altogether, as insisting on his health undermined the doctor's professional
authority.

Another strategy for recuperating the representations of masculinity which the
picture offered was to rewrite the question as an ethical dilemma. An item in the
Daily Mirror confronts the tension of the patient's gender directly and suggests an
alternative moral reading to justify it:

It has been suggested that, instead of the beautifully-dressed and eminently worthy
but slightly uninteresting young man, gazing blankly before him, as the eminent
medical man tells him there is no hope, Mr. Collier ought to have painted somebody
more sympathetic – a beautiful young girl, say, or a lovely married woman. That is, of
course, rubbish. No doctor, with so undisputed a practice as this one, would ever
think of briefly telling the truth about a fatal illness to a young girl.[23]

Recognising the discomfort of seeing a male as the patient, this review justifies the
sex of the patient by returning attention to the figure of the doctor. The 'problem'
the picture presents is thus transformed in several middle-class papers into a
debate on medical ethics: should the doctor tell the patient there is no hope?

Again, the form of the picture seems pointedly to raise the question. The young
man's appeal to the viewer focuses attention on his emotional reaction to the news,
variously described as 'hearing in tense quiet the unwelcome verdict', 'taking it
bravely', and 'blank despair'.[24] All of these readings focus on the emotional impact
of the diagnosis, and engage the viewer's sympathy, as implied in one empathetic
reading of the picture as 'a young man dazed at the doctor's fatal verdict. We hear
the sentence and the silence that follows is deafening.'[25] Only the doctor seems
unaffected by the patient's obvious distress. Separated from the patient by his desk,
the doctor leans back in his chair, gazing at the young man relatively dispassion-
ately, in sharp contrast to the doctors in *The Crisis* by Dicksee and *The Doctor* by
Fildes who each lean forward with chin in hand and furrowed brow in attitudes of
concern and professional attentiveness. In this regard, the *Times* critic's misreading
of the picture as a young man being sent down from school is instructive. While the
reviewer misidentifies the narrative content, his reading of the relationship
between the two figures is astute, as the man in authority behind the desk hands
down his verdict without mercy to the hapless young man.

Significantly, this dispassionate doctor was identified in many reviews as coming
from the upper ranks of the medical profession, referred to as a 'specialist' and an
'eminent medical man'.[26] By the early twentieth century the specialist or consultant
was firmly established at the top of the medical hierarchy, as the medical profession

consolidated its monopoly on healing. While there had been a national registration system for doctors since the passage of the Medical Act 1858, standards of education and training became increasingly well-regulated and science-oriented over the course of the century.[27] As Sir Arthur Conan Doyle recalled:

> I entered as a student in October, 1876, and I emerged as a Bachelor of Medicine in August, 1881. Between these two points lies one long weary grind at botany, chemistry, anatomy, physiology, and a whole list of compulsory subjects, many of which have a very indirect bearing upon the art of curing.[28]

By 1906, the average length of time for medical education was six and a half years, and the courses and training were focused on science and laboratory work, as the 'Germ Theory' of medicine became the dominant paradigm. To paraphrase Roger Boxill, the art of doctoring was becoming the science of medicine.[29] Among the many effects of this shift was a changed relationship between doctor and patient. The authority of science and new patterns of hospital treatment gave doctors a new level of control over patients, while the professionalisation of the field meant that doctors came from a higher social stratum than had been previously the case. As a result of these changes, the balance of power in the doctor–patient relationship shifted towards the doctor, leaving patients in the role of an 'examined' body rather than an active participant.[30]

The Sentence of Death depicts precisely this kind of relationship. The doctor–patient consultation is represented as a transaction; both men are in suits, in an office setting, with no evident emotional relationship or connection. The doctor has made his decision based on his scientific knowledge; he appears to have used the three medical instruments on the desk to examine the patient, and then looked up the symptoms in the book on which he rests his hand. In light of the changing expectations of medical care, the debate about whether or not the doctor should have told the patient of his prognosis seems to be a critique of doctors' treatment of patients under the new professionalism.

George Bernard Shaw's play *The Doctor's Dilemma*, which opened in London in 1906, offers a parallel to (and possible inspiration for) Collier's painting. The dilemma of Shaw's title is ostensibly which patient – a degenerate young artist or an honest and impoverished doctor – the celebrated physician Sir Colenso Ridgeon should save, but it is essentially a false dilemma as he later seems to have enough serum and time to have saved both. The real target of the satire is the doctor's assumption of god-like powers of infallibility, which lead him to commit the 'disinterested murder' of the young artist under the guise of medical ethics, although his true motivation is a considerably less lofty interest in the artist's beautiful wife. In his lengthy 'Preface', Shaw expanded his critique, attacking the system under which patients were made vulnerable to doctors in part because of the veneration in which doctors were held by the uninformed public.[31]

In the press coverage of *Sentence of Death* this kind of critique was muted almost as soon as it was expressed. A writer in *The World* complained:

> The elementary fact that 'circumstances alter cases' seems to have been curiously overlooked by most of those who have taken part in the rather grim discussions provoked by Mr. John Collier's Academy picture, 'Sentence of Death'. To some persons placed in the tragic position of the unfortunate patient in Mr. Collier's work, complete candour on the doctor's part would be the quintessence of cruelty; to others it would be far preferable to any attempted evasion or palliative of the truth. Everything depends, in fact, upon the individual character and temperament of the individual patient; and that being so, it would seem that the physician in such cases should be allowed a certain measure of discretion ... It is obviously unfair to hold him responsible for the possible effects of a 'sentence' which he is held to be bound, willy-nilly, to pronounce.[32]

While the defence of the doctor presented here is rather scattered, the focus seems to be a critique of the public's expectations that the doctor be both infallible scientist and carer; if he is 'held to be bound' to pronounce the medical sentence, he cannot be held responsible for the emotional impact. Taking a similar line, 'A Family Doctor' wrote of the picture that:

> two questions suggested themselves to the public mind. First, what is this malady from which the patient is suffering? This, unless the artist be willing to satisfy our curiosity, must remain unanswered, as it might be anything from consumption to sleeping sickness. Second, is it right for a doctor to tell a patient suffering from such a disease the truth about his condition? Everybody will answer this question from his own point of view but discussion of the subject is of use in making the public realise the daily difficulties which arise in a doctor's life.[33]

The article goes on to discuss the issue as well as other moral dilemmas faced by medical men and concludes with the advice that 'it is undoubtedly best for patients to leave themselves in the doctor's hands'. The writer thus achieves two important reorientations. First, he affirms the doctor's gaze as belonging only to the medically trained doctor; the viewer cannot possibly diagnose the patient. Second, he identifies the ethical responsibilities of the doctor as one of the difficulties of the profession, and thus a sign of the doctor's moral stature. With these two strategies, he reaffirms the authority of the professional man in control and the model of professional masculinity.

As the illness of the male patient disrupts the norms of ideal masculinity, the reassertion of the professional authority of the doctor works to confirm them, suggesting that one possible response to the unease generated by the picture was to reposition the middle-class male self as doctor, not patient. However, this argument was primarily textual and could not truly shut off the possibility for oppositional readings of the picture, as it relied on the assumption that the viewer's access to the picture as 'doctor' was impossible and that the doctor's behaviour was irreproachable, while the picture seems to insist on allowing other readings.

All of these responses circle around the nature of classed masculinity, a locus of instability, anxiety and potentially adventure. But they cannot fully make sense of

the picture or the problem it might pose. Unlike earlier problem pictures which sparked relatively coherent discussions of the changing definitions of 'womanliness', the discussion of masculinity the picture raises cannot be contained by its narrative structure. The sheer volume of attention the picture received attests to the fact that these issues were of widespread interest, but ultimately the picture cannot be judged a complete success as a modern narrative painting. It cannot really lead to moral or social re-evaluation of the issues it raises, as the terms of the discussion cannot be agreed upon, and so the indeterminacy overflows its bounds, becoming the dominant experience of viewing the picture.

I believe that this experience is a good part of the reason for the violently negative reaction the picture provoked in various critics, and may help explain why the problem picture ultimately failed to be received as high art. While there had always been an undercurrent of dismissal in the critical coverage of problem pictures, there is a noticeable difference in the response generated by *The Sentence of Death,* as periodicals aimed at all social classes and professions ripped the painting apart and dismissed it as a work of art.

I want now to look more closely at the terms in which this judgement was made in order to unpack what was at stake. Most attacks in the daily papers were based on the charge that the painting was too literary – a standard modernist response to subject pictures and one that pervaded even the most mainstream art criticism by 1908, albeit in a slightly altered form. As the theme is a familiar one, I'll note only one representative example, in which the critic concluded a long diatribe by emphatically stating that 'there is nothing in this picture that cannot be described in words, and therefore no good reason why it should have been painted'.[34] This rhetoric is, of course, part of a broad shift in art criticism and reception, towards appreciation of the formal properties of a work of art over its subject. In what develops as the modernist aesthetic, being non-literary – i.e. not reducible to words – is the very definition of high art, as true aesthetic response should draw upon the viewer's imaginative faculties through poetic ambiguity and, ultimately, significant form.

While the language is familiar, however, the vehemence with which it is applied to *The Sentence of Death* is unusual for the popular press. A second set of terms used to dismiss the picture suggest that this critical judgement was somehow insufficient, perhaps because there *was* something in the picture that could not be put into words: the answer or solution. Reviewers also attacked the picture as too commercial, repeatedly using the analogy of the advertisement to dismiss it from serious consideration. One critic called it an 'Academy advertisement', and another joked, 'if I were the proprietor of a patent pill I should make a strong effort to secure this picture in order to publish reproductions of it broadcast with this inscription "Pinkenthem's Pellets for Peculiar People"'.[35] Comparison to an advertisement was one way of refusing a picture the status of high art. But the charge is more specific, and reveals more about the discomfort critics felt with this picture and with the genre overall, especially when linked with a critique of the picture as too literary.

The problem picture and the advertisement were not just equivalent terms in an equation of bad taste; the problem picture actually resembled new forms of advertising in at least three ways.

First, they shared the imagery of upper-middle-class modern life, which advertisers were beginning to use to sell commodities through identification with 'lifestyle'. Until the late nineteenth century, advertisements were not primarily visual, but between 1880 and 1920, there was a remarkable change in how advertisements looked. Even a quick survey of magazines or newspapers from the years around 1900 reveals a dramatic change from small, textual advertisements set within the boundaries of column text to larger, more visual versions. As advertisers turned to imagery to sell their products, they adopted the visual codes and conventions of traditional narrative painting, filling advertisements with details and, eventually, mini-narratives. Advertisements and problem pictures – both scenes of modern life set in comfortable upper-middle-class interiors – came to look increasingly similar.

Second, advertisers were creating a new language of reading visual imagery, in which the relation between image, text and product had to be decoded – some even using the form of a puzzle – in a process quite similar to that of reading a problem picture. Actual puzzles were a popular method of advertising as they caught the consumer's attention, but 'decoding' images in a more general sense was also part of the new mode of reading advertisements. In his visual analysis of American advertisements from around 1900, Richard Ohmann argues that a new relation between image and text is charted in these years, one in which the text does not explain or even annotate the image or how the product relates to the consumer. Instead, 'readers had learned to supply connections, fill gaps, participate in the creation of meaning'.[36] This model of reading is precisely that initiated by the problem picture; removed from the textual support systems that underlay Victorian narrative paintings, the problem picture required the viewer to fill in the gaps to reconstruct the narrative.

Third, and in part as a result of this new language, a new relation with the viewer was being constructed in the spectacle of advertising, one which relied upon the creation and stimulation of desires that could never be completely fulfilled. By turning ambiguity into a game, the problem picture emphasised a negative component of indeterminacy: namely, its links to the increasing commodification of modern life. The endless chain of desire set in motion by the narrative indeterminacy of the problem picture lay uncomfortably close to the desire conjured up by department stores and advertisements.[37]

Significantly, this relationship between advertiser and consumer was a gendered one. Advertisements were generally aimed specifically at women, as they were the main consumers in the middle-class family. Department stores also catered to a female clientele, and the activity of shopping was (and still is) identified as a feminine one. This gendered position helps makes sense of the discomfort *Sentence of Death* aroused, as to be in the position of the consumer is to be in a feminine position.

What, then, can we make of the coexistence of the literary and the commercial as the twin poles on which the negative evaluation of *The Sentence of Death* centres?

The problem with art that is too literary is that it contains 'nothing which cannot be put into words'; it allows no room for the beholder's imaginative faculties, while critics call for *more* indeterminacy in the viewing experience. The problem with art that is too commercial (too like advertising) is that it has some indeterminacy, but of the wrong sort, directing the viewer to a specific end, and effecting a redefinition of meaning itself as a commodity which must be purchased.

In the experience of the problem picture as art, then, two kinds of indeterminacy were potentially in danger of being confused: the poetic ambiguity which should accrue to art, and its commercial opposite which threatened to make artistic meaning itself just another commodity. For critics anxious to certify the virility and autonomy of modern culture, the distinction was a crucial one, and thus the problem picture had to fall outside the boundaries of modern art.

I want to conclude by looking at a cartoon published in *Punch* in 1908 (Figure 36) which images this anxiety in a more comic form, and indicates how it was ultimately resolved. Predicting a future Academy overtaken by the problem picture, the cartoon depicts a 'problem room', its walls stacked with problem pictures captioned with questions and packed with people in various attitudes of bewilderment, confident guessing and shocked recognition as they gaze at the pictures and write up their solutions. The figures in the background congregate around a box marked 'Solutions: Enclose P.O. ... 6d Puzzle Picture Syndicate'. A gentleman in top hat and clerical collar writes out his entry, while a middle-aged woman with a heavy-set face peers into the box as she drops in her solution.

The idea of the contest is drawn from magazine puzzle pages where the 'best-worded solution' to a puzzle could win a prize, but it also suggests that the solution can be purchased from a syndicate which profits from the curiosity aroused by a picture. The confusion as to the exact nature of the contest is revealing of the two different but related targets of the joke. On the one hand, the cartoon satirises the idea that the meaning of art can be put into words, mocking the idea the 'best-worded' solution is actually the proper way to experience art. But the joke also relies on the breakdown of the proper dichotomy between the commercial and the artistic, as the problem picture's ambiguity stimulates a desire which can only be satisfied through purchasing the answer.

Although obviously meant as a joke, the cartoon helps makes sense of the critical response to *The Sentence of Death*. The insistence that the problem picture is not truly art is, I would argue, a way of maintaining the boundary between art and commerce, drawing a firm line between the free play of the imagination offered by true art, and the mechanical problem-solving initiated by the problem picture. The definition also works to patrol the boundary between images and words, between the transcendent unspeakable meaning inherent in true art, and that form of meaning which can be put into words and is therefore accessible to anyone. As long as the ambiguity of art cannot be spoken, it cannot be learned, it cannot be purchased, and it is hard work to figure out, thus serving as a marker of refined sensibility and elite status.

36 Lewis Bauner,
'Looking Forward –
A "Problem" Room
at the R. A.', *Punch*,
27 May 1908.

As the *Punch* cartoon implies, gender and class were crucial components in the construction of these borders. Art reviews of the period make increasingly sharp distinctions between subject pictures and art, and between the sensationalist taste of the 'shilling public' of suburban women, and the sophisticated appreciation of artists and critics who could distinguish between the 'gem' and the 'counterfeit', in a terminology laden with metaphors of commerce and femininity.[38] Problem pictures were invoked as the epitome of this degenerate taste, and after 1908 were no longer taken seriously in art reviews, but discussed in gossip columns and society-magazine editorials as suitable only for the frivolous female viewer.

As viewers learned to dismiss problem pictures, they learned to distinguish between commerce and culture, between consumerist and poetic ambiguity, and between art as a commodity and art as an experience: in short, between narrative and modern art. In the process, a new audience began to emerge, an audience

divided into categories of knowledgeable viewers who appreciated 'Art' and the so-called 'shilling public' of 'suburban' women who could not. More significantly, viewers were encouraged to split within themselves their categories of response to different kinds of art and subject matter. As the imaginary suburban lower-middle-class woman with her taste for the problem picture became a figure of fun, women and men learned to aspire to a private and imaginative aesthetic experience rather than a public and social conversation in front of a work of art.

The problem picture proved to be a dead end as a form of socially engaged modern art, as the anxieties and instabilities meant to be managed by the narrative ambiguity came to exceed its bounds and were even exacerbated by the implications of its structure. Instead, the problem picture and its representation in the press became one of modernism's many 'others', participating in the creation of a new audience by training viewers how to – and how not to – consume modern art.

A walk in the park:
memory and rococo revivalism in the 1890s

Kenneth McConkey

One Sunday in September 1893 at around 6.30 in the evening, George Moore decided to walk across St James's Park to find a place to eat. A coster woman was noisily chastising her daughter as he entered the park and he hurried on until all of a sudden his attention was grasped by 'landscape beauty more exquisite than any I had yet seen'.[1] In the pale sunlight, the trees, suspended over the 'green sward', seemed to 'speak like a memory'. Moore recognised the scene as a 'beautiful Watteau'. Without difficulty the glade was peopled with Watteau's characters – Pierrot seemed to lean over a lady 'twanging a guitar'. At that moment, the eighteenth century lurked beneath the surface of reality. What Moore saw was not the real trees of St James's but *Une Assemblée dans le parc*, a painting in the Louvre, he half remembered.[2] The picture was a memory of an object which existed elsewhere. In a London, often characterised in the 1890s for its grimness, this momentary glimpse of Elysium was not insignificant. The ghost of Watteau which continued to haunt the social elite of the *belle epoque*, had made a sudden appearance in St James's (Figure 37).

This chapter is concerned with the degree to which a coherent understanding of French eighteenth-century visual culture impacted upon British painting at the turn of the century. At a crude level it is about the consumption of an alternative, foreign visual code and the way in which consumption itself becomes a new form of production.[3] It takes as given the current debates about Englishness and the rural.[4] Central to this investigation is the shared understanding of the mind's process of moving between matter and memory – ideas which around the turn of the century would become popularly associated with Henri Bergson. The dialogue of realities, between the perception of the external world and the life of the mind, was essential to the conceptualisation of the art-making process. Henry Tonks recalled a fellow painter, Charles Wellington Furse, telling him around this time that imagination was memory.[5] Allied to this were ideas about style and modernity drawing upon a common visual repository, upon recollections which privileged pre-revolutionary France. 'La moderne', crucially dependant upon the fickle face of the manners and dress of the time, had its roots in a way of seeing, in

37 Jean-Antoine Watteau, *Gathering in the Park with a Flautist*, 1717.

social and philosophical attitudes which were fused initially, in Moore's mind, with Impressionism, although within a short time something more was demanded. The fashionable world performed a kind of *comédie*. It was not disorganised. It arranged itself in front of him as he walked through the park.[6] Moore's vision entailed the admission of sensual delight, of a landscape improved by artifice, a setting more readily found in St James's than in Hyde Park or Green Park, but which paled beside the Tuileries, the Luxembourg or Versailles.[7] In this transformed landscape he envisioned a world in which men were constrained by the rules of gallantry and courtship and women were permitted the exercise of caprice. Its surfaces, its 'satin and sunset … its ankles and epigrams', composed themselves agreeably within the frame of a picture.[8] To get there he must hurry past the coster, a clinging symbol of present reality.

Moore was not the first late nineteenth-century British writer to embark for Cythera. Six years earlier the fascination for rococo artifice had drawn Walter Pater into the world of Watteau, in the most ingenious of his *Imaginary Portraits*. Pater's special affinity with the society of the French Regency derived in part from the fanciful thought that he must be descended from Watteau's brother-in-law and principal pupil, Jean-Baptiste Pater.[9] Through the eyes of Jean-Baptiste's sister, he describes Watteau's transformation from talented provincial into court painter to the *beau monde*. Flemish virtue, the honest values of the country, are sacrificed to those 'coquetries, those vain and perishable graces' which, in order to fully

understand, Watteau must surely despise.[10] The narrator's portrait, in a gown of 'peculiar silken stuff', which pleased the painter, remained symbolically unfinished at the time of his death at thirty-seven, indicating that in spite of her love for him his attentions had been elsewhere. Nevertheless Watteau's painting reshaped the social scene – dress, make-up and manners were all affected.[11] By this aesthetes of the 1890s understood not simply that Watteau had created a new style, but more fundamentally that there lay in his work the claim for something more profound, some *tristesse*, some *delicatesse*, in the expression of a whole society.

Pater's imaginary portrait would undoubtedly have been conditioned by his reading of the recently published account of the artist by Jules and Edmond de Goncourt.[12] In the Watteau and Boucher chapters of *L'Art du dixhuitième siècle*, little changes of hue take the reader from the pomp of Louis XIV to the 'gay, amorous' social spectacle of Louis XV. Although the Goncourts claimed, and were popularly credited with the reinvention of eighteenth-century taste, the *goût dix-huitième* was a much more general phenomenon in the July Monarchy and the Second Empire and spread to London in the 1890s.[13] There were, for instance, reports of Whistler's embrace of the social values of the *faubourg* after his departure for Paris in 1892.[14] Two years later, William Rothenstein visited Edmond de Goncourt to produce a portrait lithograph for William Heinemann.[15] Rothenstein is likely to have reported extensively upon his visit to the *maison d'un artiste*. The brothers' research, particularly on Watteau and Boucher, dominated scholarship on these painters at the end of the century and they were frequently cited by Claude Phillips and M. H. Spielmann in surveys of the Wallace Collection.[16] However, to British writers who admired its literary artifice, Pater's was the preferred account of Watteau's personality. Lewis Hind, for instance, found in his 'imaginary por-trait', 'a deeper insight' than either of the analyses of the Goncourts and Camille Mauclair.[17] In pointing generally to the eighteenth century Pater, and Moore fol-lowing him, were proposing a direction for the end of the nineteenth.

Moore owed his introduction to the park landscapes of the eighteenth century to the Goncourt brothers, and to contemporary Impressionist painters who were extracting the charms of bourgeois life from the flickering sunlight of the *sous-bois*.[18] He was irresistibly attracted to images of a society the rococo design princi-ples of which were in stark contrast to the parochial rusticity of English Arts and Crafts. As a consequence, he was prepared to be generous to James Guthrie's *Midsummer*, 1892 (Plate 4), and to declare it 'summer's very moment of complete efflorescence … a delicate and yet full sensation of the beauty of modern life from which all grossness has been omitted'.[19] Moore now approved the more advanced methods of realisation in Guthrie's canvas, having earlier praised the celebration of middle-class *modernité* in his references to John Lavery's *The Tennis Party* at the Salon of 1888.[20] With *Midsummer*, there was a step-change. The figures flow into and fuse with the background; they are not drawn in the sense of being separately seen. This was what excited him. Crucially, what had been understood as plein-air painting was falling away in favour of the Impressionists' 'envelope'. For Moore

this term had a particular historical meaning, and he increasingly realised that the fit with Impressionist landscape was only partially successful.

As a concept, this envelope of space, light and atmosphere depended heavily upon Moore's reading of *L'Art du dixhuitième siècle*. In Guthrie, Moore had discovered the 1890s equivalent of Boucher's 'little plot of ground, singing and trembling with fresh colour full of bursting foliage, encumbered with complex tree forms ... the verdant alfresco chamber of which the eighteenth century dreamt in its moments of tender fancy and bucolic yearning'.[21] Elsewhere he was looking for 'enchantment', a code word for the qualities found in Watteau's and Boucher's landscapes, and, in the 1890s , less and less appropriate to those of Monet.[22] The charm of the eighteenth century lay in the fact that the painter did not permit a single organising intelligence to rule his hand, but risked unity for multi-layering. The flowers grow up from around the feet of the viewer who is obliged to look through and beyond them to a scene which will forever be a series of fragments.

This sense of the breaking into pieces of the visual field and its recomposition with the aid of the art of the past is suggested by an anonymous visitor to Whistler's house in Paris. Waiting for the painter to arrive, the writer looked out upon the garden for which the decorative scheme of the room had been designed, noted 'patches of daintiest green ... with masses of pink flowers' and then tried to remember if there was a latticed porch, a sundial or if the surrounding buildings were domestic or ecclesiastical: 'you cannot remember afterwards, for the effect is so complete that the impression which lingers comes back to your memory like a panel by Watteau ... a bit of nature trained to accord with the courtesy of urban need'.[23]

This alternative way of thinking hinted at in Guthrie, not directed towards mimesis or even the mere reading of surface *à la* Monet, had captured Moore's imagination. His enthusiasm for the prints of Utamaro was precisely because they were non-naturalistic.[24] He was now interested in a different kind of authenticity, in the search for those objects or fragments of an everyday experience which might initiate reverie or provoke imaginings. Through the memory of the configuration of the trees and the green sward, St James's Park becomes Watteau's *parc*. The visual correlative of this 'enchantment', frequently likened to Monticelli, Boucher and Watteau, and, occasionally in the same breath, to Gainsborough, is found in the later 1890s work of Henry Tonks, Philip Wilson Steer and Charles Conder. Looking back on Steer's work in 1909, C. H. Collins Baker's most frequent citation was that of Watteau.[25] The same author the following year remarked upon Tonks's reliance on Watteau in his teaching of drawing. This is supported by evidence not only from students but from Tonks's own strained efforts at 'park' subjects.[26] 'The Pastoral Play', 1899 (Figure 38), adds drapery, statuary and classical columns to Lavery's and Guthrie's props. Male *flâneurs* now engage the fashionable women in Wildean dialogue.[27]

For Steer's and Conder's patrons French eighteenth-century art was not simply a momentarily fashionable trend. The incipient nationalism which underwrote contemporary notions of Englishness and the fluctuations in Anglo-French relations at

38 Henry Tonks, 'The Pastoral Play', 1899, lost.

the time make it difficult to account for, on the surface at least. The diversity of late
Victorian and Edwardian attitudes to France from the Franco-Prussian War
onwards is indicated by the fact that the court at Windsor supported Germany while
that at Marlborough House was decidedly Francophile. Relations between France
and Britain had cooled during the Dreyfus affair, came to the point of sabre-rattling
as a result of the 'Fashoda' incident in 1898 and the Boer War, and warmed with the
entente cordiale in 1903. Despite international politicking, in manners, dress and
interior design there was a curious reciprocity.[28]

In the context of this fascination, the *ancien régime* was perceived in Britain as a
period of frivolity and over-indulgence which resulted deservedly in revolution.
Edwardian social commentators inherited their tone of moral disapproval for pre-
Revolutionary France from Thomas Carlyle. With Baroness Orczy's *The Scarlet
Pimpernel* topping the best-seller list in 1905, eighteenth-century aristocracy was
shamelessly caricatured in the context of familiar racial stereotypes, and the revolu-
tionaries of 1789 were portrayed as scoundrels. Revolution in Britain, despite the
growth of anarchist, suffragist and labour groups, coupled with the intemperance
of a vulgarian monarch after 1901, remained unthinkable to the ruling elite.

These social and political issues were disassociated from the discussion of
absolute aesthetic values. In the rarified world of aesthetic theory, which did not

consider the concept of stylistic change in relation to broader social and political cross-currents, Germanic thinking dominated.[29] Meier-Graefe, perhaps tainted by German chauvinism, commented upon the incapacity of France and Britain to produce general systems of aesthetics. Referring to French artists' lack of morality, with the exception of Zola's stand on the Dreyfus affair, he asserted a strong anti-intellectual current in French artistic discourse and concluded that:

> this is the reason why French art is great and French general aesthetics as a rule beneath contempt. The taste which displays its inimitable nobility and its inexorable logic in the works of the French School, becomes a sort of faint-hearted compromise the moment that it attempts to deal with anything but a work of art.[30]

These were, nevertheless, years which saw the ascendency of French taste among the new plutocracy in Britain, identified with the monarch. The King's Jewish friends, portrayed by Sargent, have collected the impedimenta of elegance. Thus for instance when the cultivated Aline de Rothschild married Edward Sassoon and eventually acquired 25 Park Lane as her London home, the house was remodelled with elegant rooms decked in *boiseries*, French furniture and Chinese porcelain.[31] Inevitably the architectural restrictions imposed by Regency mouldings led to fewer, smaller pictures being displayed and these, in the case of the nouveaux riches, were often selected to obscure dubious origins or suggest a distinguished patriarchy. From these accoutrements emerged a thoughtless confidence which their original eighteenth-century makers did not betray. Regarding the work of Wilfrid de Glehn, an artist of German background working in England, T. Martin Wood noted that the painter of the present had found a 'light-hearted note ... instead of the concealed depression which is the characteristic of the laughter and music in a Watteau'. He continued, 'eighteenth century people, trying to keep their illusions, feared everything; twentieth century people, having parted with all theirs fear nothing. Eighteenth century people seeking happiness found a revolution, twentieth century people giving up the search are found by happiness.'[32] Hedonists are justified providing they do not delude themselves. Artists like de Glehn saw no approaching storm.

The spectre of revolution or war did not cast a shadow over the Edwardian painters' world and, on the level of the visual, they tended not to segregate their sources systematically. Thus, for instance, George Clausen writing to MacColl in 1943 with information for his forthcoming biography of Steer, generalised about the influences of Watteau and Gainsborough.[33] Gainsborough was different from Watteau, but Steer might move easily between the two. Writing about Steer's first solo exhibition at the Goupil Gallery in 1894, Moore characterised the decision-making process as a matter of the artist making up his mind to 'use the trees, meadows, streams, and mountains before him as subject-matter for a decoration in the manner of the Japanese ... or for the expression of a human emotion in the manner of Wilson and Millet'.[34] The history of art was a style manual. At this point, the new guiding lights in Steer's work had not become clear. Within a few years he

came to identify with those social elites who admired eighteenth-century culture
and whose commissioning coincided with the *entente cordiale*. Evidence abounds
for this current fashion. When asked to supply decorations for the drawing-room
of Cyril Butler's house at Shrivenham, Steer produced a set of grisailles of girls
fishing, playing battledore and on a see-saw, to relieve wall panels of rose silk. The
overmantel, *Springtime* (Figure 39), a large canvas of 40 x 50 inches, was hailed as a
masterpiece when the room was dismembered and the decorations sold in the
1930s.[35] Oval overdoors and inserts were first started as oil sketches before being
worked up as *trompe l'oeil* re-creations of the delicate carvings of the eighteenth-
century interior (Figure 40).[36]

Steer was led in this direction by the example of Charles Conder, an artist who
had first impressed Moore within a couple of months of that revelation in
St James's Park.[37] Even in its early phase it was evident to Moore that Conder's
work required special attention. He had arrived as an exhibitor in the New
English Art Club at the very moment when public attention was diverted by the
sale and subsequent exhibition of Degas's *L'Absinthe*, and when, paradoxically,
Moore's artist contemporaries were turning away from visual appearances and
from working on the motif. Sickert, in a rare moment of aberration, infected by
Jacques-Emile Blanche's *dixhuitième* enthusiasms, had converted the populace,
strolling past *L'Hotel Royal, Dieppe* (c. 1900–1, Ferens Art Gallery, Hull), into
ladies with crinolines.[38] Even Moore, one of his few supporters, was not entirely
convinced by this, attempting lamely to justify these odd insertions as a way of
filling up the dark-green foreground.[39] Sickert's influences at this point were as
likely to have been drawn from eighteenth-century Venetian painting, from the
ridotto of Francesco Guardi, as from French sources.[40] Aubrey Beardsley, in his

39 Philip Wilson
Steer, *Springtime*, lost.

40 Philip Wilson Steer, sketch for an overdoor decoration in Cyril Butler's house, Shrivenham, 1890s.

only oil painting, *A Caprice*, done under Sickert's tutelage at this time, adopts similar visual artifices.[41]

Sickert was, nevertheless, not much detained in eighteenth-century reverie. When Moore had been nervous about his new departure, he had in the same breath hailed Conder's arrival as the quintessence of European decadence. 'It is the painting of chlorosis', he wrote, 'of consumption, of Bright's disease, of every liquid malady.'[42] These were the pictures which did not stop with nature; 'Mr Conder is very different from the gentlemen who paint Folkestone at low tide and Folkestone at high tide'.[43] Considering what was available to Moore in 1893, these are extraordinary assertions.[44] If he was looking for an artist who substituted the pleasures of artifice for the facts of nature and he was unconvinced by Sickert's solution Moore had found his answer in Conder. But over the next few years Conder's work became pale and substanceless. The enchantment of Chantemesle, which he first savoured as an Impressionist in the early 1890s , was revisited in a more nostalgic vein in 1898 when he compared the place to 'Watteau's happy island'.[45] The *Yellow Book* which first appeared in April 1894, and in which Conder

eventually published several drawings, put words alongside these visual tenden-
cies.[46] He retreated to Browning's Venice in *A Toccata of Galuppi's* and to Mozart
for the image of Donna Elvira. The choices were significant. Browning had alle-
gorised the end of the Venetian state and a Francophile like Conder, if he thought
about it, might well interpret the bungling and bad publicity of Fashoda and the
Boer War as an anticipation of the end of Empire. The futile geometry of the toc-
cata left nothing permanent 'when the kissing had to stop'. By this token, Conder's
maidens, in the late oils, washed up on Towan Beach should have been gone by the
end of the season.[47] Amazingly, they remained for six or seven years until excess of
drugs and alcohol stifled their creator.

Conder's patrons provoked him towards the recreation of rococo elegance.[48] In
1895 he was invited to decorate the boudoir in Siegfried Bing's Maison de l'Art
Nouveau, the results of which were apparently unsatisfactory because he was
working to a deadline.[49] When he supplied decorations for the villa of the sturdy
Norwegian painter, Fritz Thaulow, it was with loose, unstretched wall-hangings,
banners of silk and canvas which contained elegant ladies in floral hats and bil-
lowing dresses.[50] A small British coterie, now anxious to escape the claustrophobic
chintzes of the modern English interior, came to Conder with commissions. His
work, placed upon fashionable ephemera, upon fans and screens, had to be strenu-
ously justified. MacColl, in an extraordinarily evocative article, defended his
poetry against English philistinism: 'by people so stern to their own feelings, so shy
of the grace and vanity of life, it is improbable that Conder's art should be very
much liked'.[51] Conder demanded that patrons discard their old furniture and
refurbish their living-rooms, just as Pater's Watteau had done. One such was
Edmund Davis who invited Conder to supply decorations for a bedroom and
dressing-room in his house in Lansdowne Road, Holland Park.[52] The result was a
series of warm, golden roundels and oblong inserts depicting a lotus land of half-
clothed nymphs which, when they were unveiled in 1905, resulted in an adulatory
article by T. Martin Wood (Figure 41).

In Wood's article Conder was once again compared to Watteau, a painter who
'almost created the fashion of his time, so anxious was he to embody his fancies on
the surface of whatever came to hand'.[53] Wood's Bergsonian attitude to the imme-
diate surroundings of the patron was to claim that architecture, particularly
domestic architecture, was no more than a series of backdrops, 'set scenes in which
the drama of life is acted out'.[54] In essence, the interior fantasy was only completed
by its inhabitants, whose life, in turn, was to be distilled into a series of single
frames. The central task of Bergson's *Matière et Mémoire,* which appeared in Paris
in 1896, was to theorise the relationship between the mechanisms of perception in
the present and the pre-existent memory bank of images from the past – our own
past as well as that deeper cultural past which is appropriated from others through
works of art. As Debora Silverman has shown, in his initial attack on this theme in
Essai sur les données immediates de la conscience of 1889, the central core of his life's
work, Bergson took the artist as a paradigm case, as someone concerned to translate

ideas into images and to operate by means of suggestion and inference.[55] Conder's decorations did not need to refer to any particular history or legend, they were 'crowded with images, pictures and memories of faded things', they were no more than suggestions, cues or prompts to an enactment. Functioning in the private space of the boudoir, they were extensions to the life of interior spaces. As in Watteau, they brought the garden into the bedroom since both were secluded spaces reserved for dreams and love making. Conder's decorations worked subliminally, below the surface, placed partially as they were behind the furniture, hanging loose or falling into shadow. They thus became part of the background,

41 Charles Conder, decorations for Edmund Davis's house, Landsdowne Road, Holland Park, London, 1890s.

and, unlike conventional oil paintings, their reduced colouring, now even more faded, subordinated them to the *mise en scène*.[56] They had no independent existence outside the scheme.

In his return to the eighteenth century, Conder was seen by Wood to be looking to an age in which life was:

> lived as in itself an art – when the toilet was a high art, ministering to the beauty of fashion; when the pose taken up on a sofa, the gesture of saying goodbye, all formed part of an elaborate courteous science, when men and women lived not for any purpose, nor any duties or arts, except the art of giving themselves to a beautiful fantasy, as butterflies with gaiety float where the long sunbeams can play upon their coloured wings.[57]

Conder was attempting to achieve a general effect to which his patron could bring a multiplicity of readings. Where does that figure come from? That bridge vaguely

recalls the Ponte Vecchio; that vista may be the Bay of Naples. These decorative panels were an invitation to sensual delight, a debauch in rosy tones containing hints of Claude, of Monticelli, echoes of the art of the *Regence* and the rococo, dreamily confected with the worlds of Florence and Venice in an eclectic *mélange*.

As Conder's range reduced, Steer's expanded. A St James's Park revelation seems to occur every time he sits down to compose on the motif. Gainsborough, Turner, Constable, Watteau, Boucher, Monticelli, crowd around him and support the instinct of his painting arm. Robin Ironside saw these landscapes of the late 1890s and beyond as an out-pouring devoid of 'the encroachments of intellect'.[58] Ysanne Holt has taken the grand panoramic pictures, those most heavily reliant upon British sources, to underscore an argument about the Edwardian remaking of a mythic vision of rural England.[59] Steer's work is more densely structured than these imply. When he attempted to put figures into his landscapes, the grand swathes of countryside, of noble trees and ruined forts, evaporated. His people were flimsy, fashionable and slightly effete. Far from being robust refashionings of the *Déjeuner sur l'herbe*, the *Summer Afternoon* of 1899, and *The Picnic (Little Dean)* of 1909 (Figure 42), attempt to recreate the 'verdant alfresco chamber'.[60] They are

42 Philip Wilson Steer, *The Picnic (Little Dean)*, 1909.

prefigured in the Ludlow and Knaresborough landscapes of 1898. In considering *The Embarkment* of 1898, prosaic questions about time and place become irrelevant. Motif is subordinate to effect. In the heat of summer, under the lush heavy foliage at a clearing by the river, half a dozen revellers set off.

The sense of *dolce far niente* conjured up by the picture appealed to John Singer Sargent, its first owner, and must have reminded him of his and Steer's common enthusiasm for the work of Adolphe Monticelli. Instinctively in this artist they had isolated a strand of modern painting which bore the traces of the earlier era. Monticelli's teacher, Diaz de la Peña, of all the Barbizon School associates, was the definitive translator for his time of the *fête galante*. Monticelli's colours were woven in a tapestry-like effect which recalled the sketches made by painters of Boucher's generation for the royal factories at Beauvais. Although he died in obscurity in 1886, his work appealed to those Glasgow and London dealers who were astute enough to anticipate a trend and who cultivated Francophile collectors in Britain.[61] In 1895, writing in the *Art Journal*, Marion Hepworth Dixon noted Monticelli's popularity with Americans and Scots, describing his work as 'an enchanted garden' in which we might 'breathe airs blown as from heavy laden flowers or the robes of some exquisite woman'.[62] These were sentiments which were frequently repeated. AE (George Russell), for instance described Monticelli's paintings as containing 'no recognisable trees, but there is the rich dark of the forest. There is no definite figure, but through a flutter of moth-like colour we catch a glimpse of a lovely face, a white arm or neck, a gracious movement of a body. It is enough to set us dreaming, where a more complete realisation might have left us cold.'[63]

Steer's visual ambiance was thus richer than is occasionally implied. He collected eighteenth-century porcelain and chinoiserie. His dining-room was hung with engravings of the work of Watteau, Boucher, Lancret and Fragonard and he owned the recent publications about them.[64] Although the effects listed in his posthumous sale of 1942 have not been considered remarkable, taken with his legendary eccentricity and the tangled strands of his later work, they help to recreate a personality which partially parallels that of the Goncourts, and can be likened specifically to their characterisation of Boucher – someone who hesitated to leave his house and who was 'surrounded by his own possessions and bibelots, that bouquet of enchanted colour, the glow and splendour of which has so often infused into his canvases'.[65] For him, the Nidd flowing through Knaresborough was no ordinary river. It ran through the sunny pastures of northern France, out by a parched estuary on the southern shoreline and on to the happy island beyond the coast. As in Monticelli, there were no recognisable trees and no definite figures, but their shifting colour and fugitive, 'moth-like' movement left unmistakable traces. *Ludlow Walks* of 1898 was 'Watteau-like' and illustrates a procession to Cythera, and, according to Collins Baker, Steer brought to his room decorations 'a light and graceful inspiration, *dixhuitième* in mode, and in theme of what I might call the *fête champêtre* of today'.[66] In the later *Picnic*, 'enchantment' translates into a group of young women surrounded by a rocky outcrop covered with indeterminate foliage,

as though painted for the stage. Clad in flounces and carrying parasols, in the company of a single languorous male, they perform no ritual dance. Watteau's *commedia* has succumbed to Edwardian middle-class politeness. If the undergrowth could be cleared, food hampers would be discovered. Lived experience in Guthrie has been transformed into a congenial resolution of past and present in Steer.

Were these pictures merely pastiches – now of Watteau, now of Gainsborough? No, *Springtime* and *The Picnic* are not less authentic than *Midsummer.* They are the by-product of Steer's particular fusion of matter and memory. It is clear for instance that Moore tested present reality against past experiences in front of works of art, and that for him, as for other European intellectuals, memory was conceived of as a series of images, like lantern slides in a projector. These could be called up when, as in St James's, the occasion seemed to demand it. The artist of the 1890s and Steer in particular, pictured himself as functioning in the same way, as thinking that this matter upon which he gazed was already part of his experience, and that he had seen it before, even though it had been created by someone else, in that bygone privileged world which he admired.

Matter and memory were again brought to the point of fusion in works like *Springtime*, when through Moore and others Steer had access in a very general sense to shared opinions on the working of the human brain.[67] Bergson does not consider the presence in the mind of complete ready-made images supplied by the art of the past and accessible in museums, nor does he specifically address the degree to which this conditioning and the conscious cultivation of a visual memory in an art student might determine an artist's production on the motif.[68] However the general view of perception as constrained by, and responsive to, present reality, yet carrying the codes of past experience, clearly equates with the practice of a painter whose present is indissolubly fused with remembrances of things past. Bergson wrote:

> our perceptions are undoubtedly interlaced with memories, and inversely, a memory
> … only becomes actual by borrowing the body of some perception into which it slips.
> These two acts, perception and recollection, always interpenetrate each other, are
> always exchanging something of their substance as by a process of endosmosis.[69]

Steer's creative reaction was to work in a variety of manners, using thin fluid washes, scumbled impasto, scratching, bending and moulding the oil paint, each method understood and co-opted as he responded to the mental images which the landscape and its inhabitants suggested. He too might have walked through the park and his approximations in paint, his resolutions between what he saw and what he knew, revived and extended the phraseology of the gallant conversation.

Moore walked on through the park puzzling over Watteau, and further along the path he was again brought to a halt, this time by 'one of the loveliest Corots in the world'.[70] For the writer who had fled from rural Ireland to obtain his education in the city, in Paris and London, the Corotesque landscape had come to occupy an equally special place in his affections. Corot exemplified the artist imbued with the 'Greek' spirit, who desired his work to be 'merely beautiful' and Moore's passion

for his work came as the result of direct experience.[71] During his first year in France, the last year of Corot's life, he had chanced upon the old painter working in the woods near Paris. He records that, looking over his shoulder, he could not at first decipher what Corot was painting, until he was told that the foreground only began 200 yards away, in what for most landscapists would be the middle distance. Corot did not paint everything before his eyes, but carefully selected his composition from what was available. He was the master of rhythmic line and 'values'. An important distinction had to be made between his approach and those painters in the school of Monet who went for 'dazzling and iridescent tints' and who never learnt 'how to organize and control' values.[72] A walk through St James's was enough to confirm his prejudices.

In singling out Corot, Moore was referring to a territory which was already familiar to his audience. His name immediately signalled a certain generality. If Watteau was a specialist taste at the beginning of the 1890s, this painter was a known commodity and collectors were discriminating in their preference for the later work.[73] They stood with Sir Robert Chiltern in Oscar Wilde's *An Ideal Husband* of 1893, in their preference for paintings of 'silver twilights and rose-pink dawns'.[74] Corot and the Barbizon School were clearly implicated in rustic naturalism, the very thing which Moore abhorred, and his work had been an inspiration to the more poetic visitors to Barbizon, Marlotte and Grez-sur-Loing.[75] However when Sir Robert invites Mrs Cheveley to see his Corots, she refuses: she is not 'in the mood'. The visually literate were well familiar with his work and, for Moore, had to be resisted. The memories which Moore called to mind were of a particular character, and Corot's interpretation of nature had in effect overwritten them. He had supplied the definitive expression of a certain kind of reverie.

Aspects of Corot's sensibility were picked up and repeated by the new school of British landscapists which included the likes of David Murray and Alfred East. Writing about East in 1895, Walter Armstrong began by quoting at length from a letter, recently published by D. C. Thomson, which Corot had written to one of his British admirers.[76] It expressed the innocent joy of the landscapist working on the motif at sunrise and seeing the changes in nature as midday approached. 'After lunch', the painter wrote, 'I will dream my landscape and later on will paint it.' Armstrong noted these 'same procedures' in East, a painter who 'lay in wait for nature … accepting the impressions she gives, digesting them and then sallying forth to realise his dream, with the fact before him to prevent the dream becoming too dreamlike' (Figure 43).[77] He was edgy about direct comparisons. 'You may take your general notions of how a picture should look from someone else,' he wrote, 'but unless your work is literally traced from theirs, you must make a design for yourself which will stand or fall by its own coherence.'[78] Moore was edgy too, but he refrained from mounting a defence of East.[79] For the painter there were traps in a process which derived from observations recollected in tranquillity, 'after lunch'. In fairness, East was also aware of the traps and would conventionally advise ever closer engagement with nature as the universal truth.[80]

43 Alfred East, *A Pastoral*, c. 1900.

After seeing his 'vision' in St James's Park in September 1893, Moore did not wait long for a painter who, in his terms, fulfilled Corot's mission, in that he was looking at nature and beyond it. In the New English Art Club in the following November he saw what he described as the 'Corot Conder', in: 'a tint of green spread over the canvas in the shape of a bouquet of trees … Nature passes through his brain before it appears on canvas; only in doing so nature is so thoroughly exhausted that one feels there is very little hope of her ultimate recovery.'[81] East's nature was being challenged by a kind of Bergsonian relativism. Pictures were now as never before validated not by recourse to real hills and trees, but by selective use of the art of the past. The painter was locking into a collective mentality which permitted elements of pastiche in the cases of Steer, Conder, East and others. A scene encountered in daily life calls up a landscape derived from others and, as it forms in the mind, the original stimulus evaporates like morning mist in midday sun.

It was this composing and dissolving in the mind which Moore experienced in St James's. He itemized the ingredients; the broken branch, the rose sky and the lake. But these London trees were heavier than those in Corot's *By the Side of the Water* (Figure 44), the broken branch did not fall across the foreground in the same way as that in *Le Lac de Garde* and this sky lacked the 'refined concentration' of the sky in *Ravine*.[82] Momentary aesthetic pleasure in nature's gift did not compensate

for what was after all only 'a false Corot'. Distracting and disconcerting details began to appear. Children feeding a black swan were reproved by their mothers 'for reasons which must always seem obscure to the bachelor'. Buckingham Palace in the distance provided a 'good', but 'obvious' line, and as he walked on he noticed that 'the rose sky had turned to a cold crimson'. The Corot in St James's Park had been 'merely an abortive attempt on the part of Nature to rise to the great man's level'.[83] Whistler had taught Moore's generation that the natural world was never good enough.[84] Having slammed the followers of Bastien-Lepage for copying nature inch by inch, he was compelled to take the Whistlerian standpoint. Yet there was something more fundamental in this process by which Watteau and Corot were transformed and remade in St James's. Pictures, which may in themselves be approximations of the mentality which produced them, fall into, are consumed by and become part of the mental equipment of the writer or the painter. They become part of an involuntary recall, mediating between present experience and pleasures felt in the company of works of art. For the moment Moore was involved in a frantic process of decoding. This bit reminded him of *Ravine*; that bit recalled the *Lac de Garde*. As they became clearer the half-remembered paintings did not match the changing scene. The moment had passed. It was over.

This was what Moore experienced in September 1893, if we believe it. Present circumstances were no more real than those recollected in a picture. It is entirely possible that he did not actually walk through St James's, or if he did, that he did not think of Watteau or Corot at the time. This whole stream of connected images, the coster woman and child, the sylvan glade, the pathway, the black swan, might only ever have existed in the mind's eye as he wrote. It is possible that he was merely describing a group of pictures, linked in a series of superimpositions, and that a journey like this, a walk to an eating house, was merely a series of images which were in themselves only accessible to memory and desire.

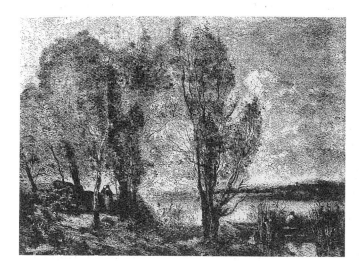

44 Camille Corot, *By the Side of the Water*, c. 1860

Looking like a woman: gender and modernity in the nineteenth-century National Portrait Gallery

Lara Perry

This chapter concerns the role of gender in the negotiation of modernity in the National Portrait Gallery, London, during the second half of the nineteenth century – formative decades for both the Portrait Gallery and modernity. It may seem perverse to study the impact of modernity in art through a collection of historical portraits, none of which evinced any of the usual features of modernism; indeed the founding intentions of the National Portrait Gallery can be said to have repudiated the modern in many ways.[1] But in spite of the Gallery's explicitly historicising interests, the modern was felt within the institution, in a way which exposes some of the less obvious mechanisms through which the modernisation of fine art practice was enacted. These mechanisms were linked not so much with the formal qualities of painting as with the manner of their appreciation, and the fashion in which painting was promoted to the spectator.[2] Spectators were positioned in relation to the collection through various institutional forms and social conventions which influenced their interpretation of the portraits as formal and informative objects. Gender was among the important categories through which spectators were positioned in relation to different forms of portrait interpretation; here it provides the focus for an investigation of the forms and conventions which worked to construct a modern connoisseur of (modern) portraiture.

The determination of an artwork's significant features – its form, its content, the relationship between the two – is largely the work of its critic. This (usually unrecognised) contribution to an artwork's value which is made by the spectator is visible in the history of the National Portrait Gallery because of the unique position that portraiture occupies in historiographical and other discourses of modernism. Portraiture appears not to be susceptible to aestheticising language because, as Paul Barlow has suggested, portraiture's status as fine art (i.e. as something which is self-consciously an art object) is 'compromised by its function as a historical document'.[3] Because portraiture is always by definition a historical document, it does

not invite claims for its formal value that exist entirely apart from its narrative or content or status as sign; that is, it does not invite the kind of claims that modernist criticism would like to be able to make for modernist artwork. But of course it is possible to describe a portrait in purely formalist terms, and any resistance that the work offers to that description only serves to highlight the desire of the critic to do so. It is the desire of the spectator to make those kinds of descriptions, and to adopt that kind of language, with which this chapter deals.

It is as a consequence of the spectator's desire to describe a portrait in a particular way that it can appear either as a work of pure formalism or as a historical document. Portraiture's status as a historical document is not itself a straightforward proposition, and in fact embraces the apparent opposition between a portrait as 'fine art' and a portrait as a mimetic representation of a subject. Any portrait is a documentation of at least two historical events: the presence of the sitter, and the work of the artist. A portrait, consequently, has two agents, and a doubled presence. While both agents (sitter and artist) might be held mutually responsible for the finished object, more commonly one agent is privileged as the producer of the image. If the agency of the sitter (as a visible form transcribed in the image) is privileged, the significance of the work appears to be invested in its content; if the agency of the artist is privileged, the work's significance appears to be invested in the form and manner of its representation, and the object itself then appears to be 'modern'. The formal qualities of an object might attract or repel either interpretation, but neither inhere in the portrait object itself: both are applied by the spectator.

The spectator's work in attaching meaning or agency to the portraits in the collection of the nineteenth-century National Portrait Gallery was of considerable interest to its administrators, who were concerned to develop the Portrait Gallery as an institution of instruction and education. Part of the work of the Gallery was thus to encourage visitors to 'see' its collection in an appropriately informative way. The precise nature of the National Portrait Gallery's 'claim upon the interest of the public' was, however, in tension, and under negotiation, from the moment of its founding until its move into its permanent gallery in 1896 (the period dealt with in this essay), and beyond. That tension devolved on how the spectator would register the two kinds of agency of portraiture: either she interested herself in the portraits as a collection of sitters, or she recognised the primary agency of artists and viewed the National Portrait Gallery as a collection of fine art. Whether the visitor approached the Gallery with historical interest in the sitters, or with the more modern sensibility of seeing it as a collection of aesthetic objects, was perceived by the Trustees to depend on their presentation of the collection. Their work was explicitly engaged with shaping the visitor's interpretation of the portraits, through different means as they were available at different periods.

This aspect of the Trustees' duties can be better understood as part of the shared problems of the newly founded, and rapidly developing, profession of museums administration. The efflorescence of national and regional exhibiting institutions in the second half of the nineteenth century demanded the innovation

of appropriate forms for the display and development of museum collections. Carol McKay has argued that for nineteenth-century museum directors the distinction between the museum visitor's gaze which superficially consumed exhibitions, and the serious gaze which considered and learned in the course of a visit, was of urgent concern. She writes that 'the new and developing technologies of museum display ... threatened to align museums with much less desirable institutions: places where material, not mental, impulses were stimulated and gratified'.[4] The identification and encouragement of a serious, interested museum visitor was one of the principal tasks which lay before the new administrators of these new institutions, a task which involved (as is frequently noted in museums histories) a measure of social regulation and control. McKay notes that one strategy for privileging the mental impulse was to associate it with the privileged partner in other opposed pairs of social identification, principally masculine/feminine and professional/amateur. These polarisations and pairings were the concerns and terms within which much of early museums management was conducted.

These concerns surface similarly in the history of the National Portrait Gallery and its encounters with modernity and modernism. The Portrait Gallery's pairing of gazes which distinguished, on the one hand, the sitter-as-agent, and on the other, the painter-as-agent, were also worked through the mechanism of associating those approaches with masculine/feminine, mental/material, and professional/amateur spectatorships. Those associations were not, however, stable, and responded to various pressures and events in its early history. A marked shift in the alliances of the various terms of identification is one of the most notable features in the nineteenth-century administrative history of the National Portrait Gallery, a shift which worked to incorporate the values of what can be described as those of modernism into its institutional culture. This shift seems clearly to have been related to the emergence and institutional recognition of a class of (male) arts professionals within the body of the Trustees, the Gallery's principal administrators. What follows is an elaboration of how dual modes of spectatorship, gender, and professional status were paired and aligned, how those alliances were enforced, and how they were revised in the course of the nineteenth-century history of the National Portrait Gallery.

Seeing the authentic portrait

When the National Portrait Gallery was formed in 1856, the privileged gaze was one which identified the sitter as the primary agent of the portrait. It was on the premise that a viewer could learn about and understand an individual from their portrait that the National Portrait Gallery was founded. Its brief was to collect 'sitters of historical importance', and it was in pursuit of sitters, rather than of paintings, that its collection was formed. That portraiture could function as an authoritative representation of character is one expression of the now alien belief that form and content are united (physiognomy is another similarly informed discourse of this period). The Trustees'

confidence that portraits represented the presence of sitters was expressed in a widely quoted passage by Thomas Carlyle, one of the first appointments to the Board of Trustees of the Portrait Gallery, who wrote:

> Often I have found a portrait superior in real instruction to half a dozen written biographies, as biographies are written; or rather, let me say, I have found that the portrait was a small and lighted candle, by which the biographies could for the first time be read, and some human interpretation be made of them.[5]

In the context of the National Portrait Gallery (and in other less formal contexts) the portrait stood literally and potently for the sitter, and served to acquaint the living with the characters of the past.

Portraits for the National Portrait Gallery, then, were judged on their capacity to represent the sitter. The portrait's capacity to function in this way was expressed as its *authenticity*. Authenticity was a quality granted to portraits which had been produced as a result of a direct encounter between the sitter and the artist, or the sitter and a contemporary studio or copyist: in other words, to any portrait which had been made during the life of the sitter, even where a single originary artist could not be identified.[6] Evidence of the specificity of the portrait encounter was in the nineteenth-century National Portrait Gallery one of the most prized elements of a portrait; for instance, the inscription on the portrait acquired as one of Mary Sidney, Countess of Pembroke (Figure 45) which reads 'No Spring Till now' and dates the canvas 12 March 1614.[7] A comment on the weather (the ultimate in banalities) was understood to testify to the precise historicity of the sitter and of her presence before the painter at that moment: the inscription and its meaning was discussed at length in the Gallery's catalogue as a fascinating and informative part of the image.[8] So long as internal or collateral testimony that a portrait had been painted from life could be produced, it was designated authentic and eligible for inclusion in the National Portrait Gallery as a true and useful representation of its main agent: the sitter.

In this construction of the portrait, the artist is subordinate to the sitter as the agent of the portrait, and functions in the capacity of record-maker rather than creator. This is not to say that there were not hierarchies of artistic achievement, but rather that in portraiture the nature of artistic achievement was interpreted as the artist's degree of success in transcribing the visual form of the sitter. For example, while Van Dyck was considered to be one of the premier portrait painters of the English school, his female portraits were considered the less successful of his oeuvre; and while later writers often attributed this lack of success to his creative capabilities as a painter, in 1844 William Carpenter (who was later appointed a Trustee of the Portrait Gallery) wrote that when it came to women Van Dyck 'had not a strong perception of the beautiful'.[9] It was Van Dyck's perception, rather than his skill or labour, which was understood to shape his contribution to the portrait, and his value as an artist was reduced to the fact of his historical presence (with paintbrush) at the moment which allowed him to record the image of the sitter.

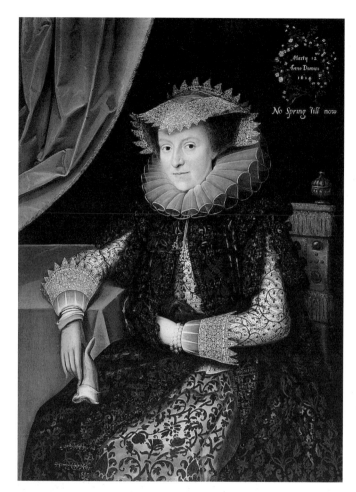

45 Marcus Gheeraerts the Younger, *Mary Scudamore* (acquired as 'Mary Sidney'), inscribed and dated 1614–15.

[Inscriptions within image: "Mary 12 / Anno Domini / 1614" and "No Spring till now"]

This interpretation of the portrait's presence was held to firmly by the administrators of the Portrait Gallery in spite of their constant encounters with portraits that blatantly registered the artist's interpretive function, for example, in the acquisition of multiple images of Elizabeth I which bear little resemblance to one another. Variations in the images of sitters were seen not as artist's choices but as effective or ineffective transcriptions of the individual: the Trustees rejected a perfectly plausible portrait of the Duchess of Portsmouth as inauthentic on the grounds that it did not represent the 'light meretricious look' which her character predicated.[10]

The duties of the Director devolved almost entirely on the development of the skills and knowledge required to identify and authenticate portraits, and to prevent errors in their identification on behalf of the Gallery and the wider world.[11] The appreciation of the authentic in portraiture demanded a certain approach to the portrait: the spectator needed to have interest in and knowledge of the sitter; to

observe with close attention the detail in the image; and to correlate those details with elements of the character it represented and with other kinds of documentary evidence that related the historical event of the portrait's production to the sitter's life. The presence in the portrait of texture, surface, compositional harmony, beauty of tone and of colour, were largely disregarded since these were aspects of painting which, if recognised as being independent of the sitter, might undermine the proposition that the sitter could be known through the portrait. The success of the National Portrait Gallery as an exhibiting institution thus depended on an extremely informed, disciplined, and regimented spectatorship.

This kind of spectatorship was not, however, overtly encouraged by the exhibition practices of the early National Portrait Gallery. Between 1858 and 1868 the collection was exhibited in three rooms of a house in Great George Street, Westminster. Literally a residential building, the gallery had a distinctly domestic atmosphere which did not express its status as an institution (Figure 46), or have the capacity to invite the visitors to make use of the portraits in the informed and disciplined fashion which appreciated the portrait's authenticity. The portraits were jumbled together on the walls in whatever way there was space for them, suggesting Royal Academy exhibitions more than the orderly chronological histories that were found in the widely printed volumes of illustrated biographies which were models for the Portrait Gallery's collection. The house was open to the public three days a week – on the other days the same rooms were used for the pursuits of the Secretary, the Trustees, and their friends who contributed to the work of the Gallery. In this context, where expert and casual uses of the gallery were physically inseparable, appropriate and inappropriate forms of spectatorship were difficult to distinguish, much less enforce.

46 George Scharf, 'Drawing of National Portrait Gallery at Great George Street', 1866.

If the quality of spectatorship could not be determined or directed in the early National Portrait Gallery, the qualities of the spectator could. Certain kinds of spectators were associated with certain kinds of spectatorship, and one way in which spectators (and their spectatorship) could be distinguished was by their sex. The contexts in which the alert gaze of authenticity was cultivated were elite, scholarly, and almost exclusively male: the Society of Antiquaries, the universities and the Anglican Church, and Parliamentary committees and commissions on the fine arts were some of the principal arenas in which the skills and information used in the identification and authentication of portraits were exchanged, arenas which were during this period open exclusively to male membership. The Board of the National Portrait Gallery was until the 1860s appointed from the male social and political elite, those who held parliamentary seats and interests in literary, historical or ecclesiastical enterprises; as a brief illustration of this point, consider that four of the men and the descendants of at least three others who are represented in John Partridge's study for 'The Fine Arts Commissioners' of 1846 (Figure 47) were later appointed to the Board of the National Portrait Gallery. The only woman 'included' in the study is Queen Victoria, who is represented (like the women in Zoffany's infamous portrait of the founding Royal Academicians) by her portrait bust. Participation in these kinds of national or other specialist organisations was the distinguishing mark of the informed and expert, although not yet professional, portrait spectator. The common denominator of persons capable of the fully appreciative and informed spectatorship of authentic portraits and their sitters was maleness; their practices were gendered male, and the gaze which failed to fully authenticate the portrait was open to feminisation.

In order to privilege the gaze of authenticity which rendered the sitter vivified and available to the viewer, the gaze which attended to the aesthetic qualities of a portrait

47 Partridge, 'Preparatory Sketch for The Fine Art Commissioners', 1846.

was feminised. The spectator who interested himself in the incidental features of the portrait (its composition, colours, and brushwork) was liable to charges of lack of interest or skill, and the degradation of this form of spectatorship was worked in part through feminisation. The feminisation of the aesthetic gaze turned on the familiar distinction between the flirtatious gaze of the consumer and the focused, concentrated gaze of the expert: following the logic that conflated the sitter with the representation, the feminised aesthetic conflated women's looking with the way women looked. Women's looking was supposed (in both senses) to be directed at the consumption and production of their own fashionable image, rather than being directed outwards in scholarly and serious appreciation.[12] This association appeared most prominently in the early National Portrait Gallery collection, which was proportionally heavy with obviously aestheticised portraits of women. Associated with the sartorial and superficial, the feminine look (and look of the feminine) could represent the failure to discern and appreciate the portrait's subject.

This rhetorical conflation of women's looking and the look of women was economically depicted by the ultra-conventional Royal Academician J. C. Horsley in his 1877 Academy exhibit, *Critics on Costume* (Figure 48).[13] The painting shows two women in the rooms of a man who is probably a picture dealer. The pictures that he deals in, or restores, or perhaps even forges, are portraits. The portraits that appear in the painting are all of women who were represented as difficult characters in nineteenth-century historiography. Queen Elizabeth I, Bess of Hardwick, and the notorious seductress Anna Maria, Duchess of Shrewsbury, were women who were known or painted as 'beauties', but whose lives were involved in events that were definitely not beautiful. Although these were well-known anti-heroines whose lives, actions, and characters provided much to discuss, it is evidently the dress, rather than the characters, represented in the portraits that have the women spectators' attention: the woman on the left gestures with her umbrella to the waist of Elizabeth's dress and figures its tiny circumference with her free hand. All of the women in this image – those represented as portraits and those represented as living – are shown engaged in the duplicitous play of the surface. A kind of looking at portraits which is dominated by superficial interests is here related to the concerns of female fashionability and gendered feminine.

These kinds of logical moves were used to effect in the Portrait Gallery's early collection. The portraits represented in *Critics* were all part of the Portrait Gallery's collection at the time the painting was exhibited, and the painting shows a representative selection of the Gallery's female portraits. It includes two Elizabethan portraits, representing the period during which some of the most notably powerful and most hated women in British history lived; and the period of portraiture which had the most intensely detailed and ornamented surfaces. Horsley also included a Restoration 'beauty', one of many collected by the National Portrait Gallery in the first twenty years of its existence. These portraits of important court figures, the majority by Sir Peter Lely or his studio, were idealised and aestheticised to such an extent that it is often difficult to tell the sitters apart, since

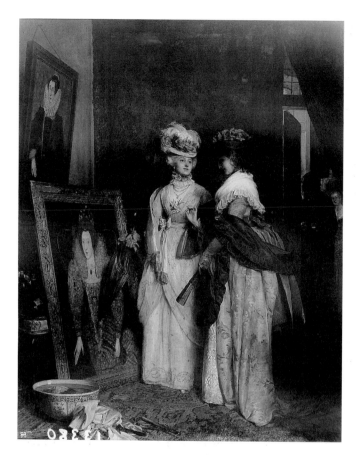

48 J. C. Horsley,
Critics on Costume,
1877.

each was endowed with the facial type popular in the period. These women did have historical importance, but (by one interpretation of the court of Charles II) it found its limits and its extent in their beauty. The collection representing the foppish court of Charles II was dominated in the Portrait Gallery by these idealised female portraits as a way of representing its enervation: Figure 49 illustrates this exhibition strategy. The play between the aesthetic and the feminine was used in a complex way to construct the Gallery's historical account of different periods, an account which reiterated the femininity of the aesthetic.

Horsley's *Critics*, and the collection of the nineteenth-century National Portrait Gallery, worked with a form of circular logic which signified the feminine with the superficial, based on femininity being signified by the aesthetic. The Portrait Gallery's early acquisitions of women's portraits were almost entirely from the periods when portraiture, especially female portraiture, was at its most idealised and decorative. These acquisitions were, with deliberation, concentrated in historical periods which were understood to be characterised by duplicity, immorality, or ineffectuality, and used aestheticisation as a description of those

undesirable biographical traits.[14] The idealised or aestheticised formal character-
istics of these portraits attract the viewer's attention to their contrived surfaces, to
their ontological status as representation. But the relative resistance of the aes-
theticised portrait to suggest an authentic encounter with the sitter (who appeared
to be more accessible when represented in a fully developed mimetic style) was
interpreted as substance rather than style. The apparent superficiality of a portrait
was thought to signify the superficiality, vanity, or duplicity of the sitter.
Femininity and aestheticisation were thus seen as mutually explanatory attributes
of the sitter, rather than as attributes of the portrait object.

In the context of mid-nineteenth-century portrait spectatorship, the aesthetic
represented inadequacy – either of the sitter herself or of the viewer's inability to
investigate that character – and that inadequacy was gendered feminine. Between
1858 and 1868, during the period when the Portrait Gallery was uncompromising
in the attribution of a portrait's significance to its sitter, gender was the most acces-
sible trope with which to distinguish between the different uses of portraiture.
Apart from the collection itself, institutional recognition of the difference between
amateur and professional, between the expert and the uncertain uses of portrait
exhibitions was little developed. They were (and are) difficult to distinguish, since
the processes employed in the expert assessment of portraits often resembled the
stylish musings of the ladies in *Critics*: attention to the detail of clothing and jew-
ellery in portraiture was, and remains, one of the major tools in portrait identifica-
tion and authentication. This ambiguity was aggravated by the undifferentiated
physical space which was occupied by the Portrait Gallery in its early years: the
Gallery itself worked to conflate its various (but not so different) uses. (Men)
trawling through history seeking the acquaintance of its significant characters
would not appear in great contrast to (women) scanning the portraits with a self-
consciously fashionable interest in details of dress and jewellery, unless those dif-
ferences were understood to be made explicit by the sex of the spectator.

Seeing the aesthetic portrait

In the late 1860s there were several events which led to an important sea change in
the way the National Portrait Gallery managed the relationship between the aes-
thetic and the authentic in portraiture, and their association with other paired
terms. These changes were primarily the result of new appointments to the
Portrait Gallery's Board of Trustees and of alterations in the arrangement of the
gallery itself, although these were supported by changes in contemporary art
practice, art-historical and critical writing, and the history of the management of
national galleries and museums. The modernising influences of this wider context
in the National Portrait Gallery created an opportunity to reconceive the relation-
ships between gender, spectatorship, and the agency of portraiture. The apprecia-
tion and enjoyment (as well as the production) of aesthetic beauty was
increasingly appropriated as a professional privilege of (male) artists and their

colleagues: this served simultaneously to masculinise the aesthetic, and to further invest the hierarchy of spectatorship in the implied categories of expert and amateur which had previously been figured primarily through gender. This shift was figured in a spatial reorganisation of the Gallery which took place when it moved from Great George Street to South Kensington in 1870, a move which created an opportunity for the Trustees to express their changing sense of their own masculine gaze.

In 1870, the Portrait Gallery reopened in larger, purpose-built galleries in South Kensington, which had several important effects on the ways that spectatorship in the Gallery was managed. One was that the Portrait Gallery was placed in the context of the other exhibiting institutions which occupied the South Kensington Estate, a locale which marked it out as a site for rational recreation. The galleries at South Kensington also put more space at the Portrait Gallery's disposal, a change in circumstance which had two important influences on its use. One was that separate space was assigned for the Gallery's business offices, effectively marking out the exclusiveness of the expert use of the Gallery and providing a physical means of distinguishing the expert from the amateur. The other was that the portraits could be hung in an orderly fashion. Each portrait was given more space and they were, importantly, hung in chronological order. The chronological order of the portraits placed both the portraits and the viewer under a disciplinary regime: signs hung over the portraits marked out the different periods, and directed the visitor in historical order through the Gallery (Figure 49). The potential for the consuming or aestheticising gaze in the National Portrait Gallery was dampened by the disciplining of the viewer, who was directed by the Gallery's layout and display to take a serious, concentrated, and historical view of the portraits.

49 'National Portrait Gallery at South Kensington', 1883.

This insistence on the viewer's taking a historical, authentic, view of the portraits on display made it less incumbent on the Board of Trustees to realise that principle through a gendered hierarchy of spectatorship. Rather than marginalising the aesthetic gaze as feminine in order to privilege the gaze which looked to the portrait's subject, the Portrait Gallery's new arrangement clearly produced it as a display of historical characters. The move to South Kensington shifted the burden of organising the gaze of the viewer from gender, and onto the physical arrangement of the collection. In shifting that burden, it provided the male Trustees with a greater degree of freedom in the exercise of their own expert and consuming gaze. The status of the Trustees as experts, and the general visitors' status as non-experts, had been affirmed by the new arrangement of the Gallery which created separate spaces for each. That newly affirmed expert status was one which, for a variety of reasons, could now begin to accommodate the aesthetic as part of its interests, ultimately resulting in a Portrait Gallery which was institutionally as interested in the form of the portrait as it was in its subject.

During its very early years, the Portrait Gallery's Board of Trustees was composed mainly of politicians and historians, men whose interests in the aesthetic importance of the collection was limited if not absent. Before 1865 two appointments to the Board of Trustees were made from the art establishment, in the persons of Charles Eastlake and Francis Grant; but their role in the Board appears to have been functionary at best. The aesthetic appraisal of portraits under consideration for acquisition was at least formally excluded from the Board's concerns, and no discussions of the artistic merit of portraits appear in the institutional records of the early history of the Gallery. Francis Grant evidently lost interest in the Gallery and, together with another member of the Trustees who was dissatisfied with the Gallery's lack of connoisseurial interests, lost his seat on the Board after he failed to attend a single meeting in two years.[15] Three consecutive appointments between 1866 and 1868 added men who began to change that anti-aesthetic culture: they were Alexander Beresford Hope, Sir Coutts Lindsay, and the second Viscount Hardinge.

The appointment of these three men marks the beginning of the incorporation of the aesthetic values of portraiture into the National Portrait Gallery. Their appointments were in most respects consistent with those of their Trustee peers – they easily belonged to the class of men from which the Board of Trustees was ordinarily culled. However, unlike most of their fellow Trustees none of these men were strictly part of the political establishment; rather, they found their main interests and activities in the art world. Beresford-Hope, son of a famous dilettante, was known as a connoisseur and promoter of gothic architecture; Coutts Lindsay made a career as an artist and (commercial) patron, notably as co-founder of the Grosvenor Gallery; and Hardinge was a published draughtsman and watercolourist.[16] Although none of them was, strictly speaking, a professional practitioner of the arts, all of them had artistic interests which shaped their activities and identities in ways which bordered on professionalism. Together they represented a new generation of public servants whose involvement in large museum or arts

institutions, and whose personal identities, were increasingly predicated on their specialised professional interests. Joseph Middleton Jopling's watercolour portrait of Coutts Lindsay (Figure 50), a dandified figure with his stylish monocle, framed in the doorway of the Grosvenor Gallery, endows this public servant with the confident, discerning persona of the aesthete.

It is generally agreed that one of the distinguishing characteristics of labour history during the second half of the nineteenth century was the growth and consolidation of the professions, characterised by the vehement assertion and defence of the specialist skills of the group (including, but not limited to, resistance to the entry of women into the professional bodies). For artists, one of the ways this was enacted was to create a new emphasis on their skills as manipulators of form. The arrival of this development was first signalled in the late 1860s, when for the first time in decades the received orthodoxy that English painters ought to strive for mimesis (preferred as a corrective to French idealisation) was being questioned, and the seeds of nineteenth-century neo-classicism were sown and growing.[17] It was cultivated through the use of an increasingly formalist critical language which was fashionable with a similarly professionalising community of art critics and, in this case, gallery administrators.[18] One way of understanding these developments is to see them as an assertion of the artist's mastery over his material and the object he produces, as an assertion of the artist's exclusive agency in the outcome of the artwork. In the case of portraiture, this was an assertion which was worked primarily through images of women.

50 Joseph Middleton Jopling, 'Sir Coutts Lindsay', 1883.

It is widely acknowledged that the painted nude – particularly the female nude – functions as a signifier of the artist's ability to manipulate and aestheticise form.[19] Female portraiture functioned in a similar role as the signifier of the artist's agency during the second half of the nineteenth century. This is most easily illustrated with reference to the literature on historical portraiture: Anna Jameson's early nineteenth-century *Beauties of the Court of Charles II* (1833) is a book about women; Andrew W. Tuer's late nineteenth-century *Bygone Beauties: A Select Series of Ten Portraits of Ladies of Rank and Fashion* (1883) is a book about Hoppner's portraits. In an 1872 volume which took as its subject

Thomas Lawrence's portraits of both sexes, the male portraits are accompanied by a biography of the sitter, but the female portraits are generally written up in terms which praise the painter.[20] By the third quarter of the nineteenth century women's portraits, particularly those which exhibited an obviously aestheticising tone, were understood to testify not to the character of the sitter (praiseworthy or otherwise), but to the skill of the painter. In the context of expert evaluation and connoisseurship of portraits, the aesthetic was recognised as a signifier of the agency of the artist.

This renewed interest in the portrait as an object began to register in the administration of the Portrait Gallery during the same period. Although the professionals named above had been appointed to the Portrait Gallery's Board by 1868, evidence of the existence of an aesthetically appreciative gaze began to be explicitly recorded after Viscount Hardinge took over the Chair in 1876. One senses that aesthetic appraisal of portraits was regarded as a specialist interest within the Board: that if there were certain Board members whose function continued to be the assessment of portrait subjects, there were others whose appointments reflected their ability to pronounce on the aesthetic merits of potential acquisitions. It was explicitly for this reason that during Hardinge's chairmanship the President of the Royal Academy was appointed *ex officio* to the Portrait Gallery's Board; Frederic Leighton proved a particularly active member, and sometimes delivered written assessments of the merits of pictures when he could not attend in person.[21] It was also during Hardinge's tenure as Chair that practising artists in addition to the President of the Royal Academy began to be appointed: these included John Everett Millais in 1882 and G. F. Watts in 1896. The influence of this specialist group of Trustees was increasingly felt in the gallery.

Without ever giving up its insistence on the importance of portrait subjects, after 1876 there are numerous events in the administrative history of the National Portrait Gallery which record the importance of the aesthetic appreciation of portraiture to the values of the institution. These include a rehang of the South Kensington Galleries in 1879 which placed some of the 'choicest and most interesting pictures' acquired by the Trustees in a prominent position; the informal introduction of the 'artistic merit' of a portrait as a criterion for acquisition; and complaints to the Treasury that the management of the Gallery's purchase grants, which had to be spent annually, was 'a direct inducement to the purchase of inferior pictures'.[22] Open assessments of the artistic merit of portraits and unabashed enthusiasm for the work of the 'masters' are frequent in the Gallery's records of the last two decades of the nineteenth century. A form of spectatorship which had been expressly excluded from the institutional values of the Portrait Gallery when it was founded was now promoted and legitimated amongst the Trustees.

That greater freedom to appropriate what had been feminised modes of portrait appreciation was probably a consequence of the Trustees' securing their masculine authority to appraise portraits through other discourses, specifically those of expertise or professionalism. The maturation of the institution as an authority on portraiture and the increasing association of aesthetic production with professional

production in contemporary art practice all helped to identify and authorise the expert gaze as one which included aesthetic appraisal.[23] These credentials, plus those conferred by wealth and titles, encouraged the Portrait Gallery's Trustees in a degree of artistic paternalism: Hardinge once wrote to Scharf that 'I don't see why we are to buy such pictures merely because the *vulgar public* like them – our aim should be rather to draw them away from their contemplation and instruct them to like better things.'[24] The expert gaze continued to be gendered male, but did not rely as completely on gender to identify its qualities: rather, it could be identified through the spectator's status as a viewer within the context of the categories professional/amateur. The relation between the consuming, aesthetic gaze and the considered, authentic gaze was held in tension in the Portrait Gallery at the end of the century, when in 1896 the collection was finally moved into the purpose-built Gallery it still occupies in St Martin's Place. The building was deliberately sited in such a way as to make it one of many spectacles of fine art like the National Gallery and Royal Academy that could be consumed in central London, set up in relation and in contrast to these other major exhibiting institutions. Director Scharf's plans for the utilisation of this custom-built space reveal an interesting departure from the Portrait Gallery's usual exhibiting practices. He circulated a plan to the Trustees which proposed that the pictures be divided according to their artistic merit, so that the best portraits could be placed on the third floor where the skylights provided the best light. 'Chronological order to be strictly observed', he insisted, 'but each floor will have its own independent chronological sequence.'[25] Perhaps Scharf and Viscount Hardinge had it in mind to cater for the aesthetically educated eyes of the Royal Academy students and patrons of the National Gallery under whose purview the national portraits would be placed.

The Board was, apparently, still alert to the danger that encouragement of an aesthetically consuming gaze invited a trivial use of a serious exhibition. The Portrait Gallery's move to St Martin's Place also brought it within the geographical scope of districts like Regent Street, Oxford Street, and New Bond Street, where fashionable shopping was complemented by fashionable display, and art galleries (particularly the Royal Academy exhibition and the Grosvenor Gallery) served equally as venues for the performances of social competence – performances which were still largely attributed to and associated with women. Scharf and Hardinge died before the new gallery was hung, and rather than follow their original plan for an aesthetically differentiated hang, the Trustees directed:

> that the arrangement should be as far as possible strictly chronological without reference to the artistic merit of the paintings or sculpture. This decision was made in consequence of their opinion that it is as a historical collection, rather than as a collection of works of art, that the National Portrait Gallery has a claim upon the interest of the public.[26]

The National Portrait Gallery's exhibition regime of chronological order and modest surroundings was preserved in order to resist association with the

spectacular display of the department store, and indeed the Royal Academy and National Gallery. The flirtatious gaze of the (female) consumer – dangerously close to the flirtatious gaze of the (male) aesthete – still required to be held in check.

Looking like a man

Even in the highly developed and established state attained by the National Portrait Gallery in 1896, the organisation and identification of the spectator's gaze continued to exploit the hierarchy of sexual difference. The fascination of the history of that exploitation is the way that it changed while remaining the same. While the masculine gaze was always accorded a higher status, what was understood to constitute that masculine gaze was significantly renegotiated – indeed reversed – during the course of the latter half of the nineteenth century. In mid-century an aestheticising gaze was understood to defeat the intended function of the National Portrait Gallery, and was gendered feminine. That feminised aestheticising gaze was subsequently absorbed by masculine cultures of professional art practice and appreciation, and became an acceptable part of the administrative practices of the Gallery: its exercise was, however, appropriated to the meeting rooms of the Trustees, whose portals were defended by the (masculine) claims of professionalism. What changed during the latter half of the nineteenth century were not the possible forms of art appreciation, but the ways that they were regulated and appropriated to different groups of viewers.

The privileging of one form of spectatorship (and its associated partners) in the National Portrait Gallery at the end of the nineteenth century has clear interconnections with the (gendered) advent of modernist practice. Administered by men whose own identities were at least partly shaped by their roles as arts professionals and artists, the kinds of portrait evaluation that the Trustees' practised was consistent with the values of an emergent modernist aesthetic. By the 1890s, the National Portrait Gallery recognised the artist as the principal author of the object. By granting the artist primary responsibility for the finished object, it affirmed one of the central tenets of modernism, namely that the form, rather than the content, of the finished object is its most significant feature. In this theory of the relationship between the artist and the artwork, the artist is an agent of the aesthetic who works independently of his subject matter. The agency of the artist in this respect was frequently linked to a kind of social and economic independence which was gendered masculine (any of the various claims that women were less competent as artists would suffice as an example of this link – for instance, the custom of training women artists separately).[27] Modernist artistic practice and the modern artist are recognisably, and well-recognised as, gendered male; the same can be said of the modern spectator.[28]

What is less well recognised is that the presence of forms of artistic spectatorship and appreciation which produced or at least accommodated masculinised

modernist practice can be identified long before any recognisably 'modern' art was made in England, as alleged attributes of femininity. In the early National Portrait Gallery, women and femininity were often represented through the decorative and aestheticised; these qualities were understood to express or represent the superficial, or the absence of substance or meaning. Through the latter half of the nineteenth century, substance was returned to those formal qualities, but it was returned to them as a product of professional, masculine artistic production. The modernisation of portraiture and its appreciation did not involve the invention of the new: it merely required the privileging of what was previously regarded as marginal, notably through professionalisation and masculinisation.

The collection of the National Portrait Gallery was (and is) a historical one, and until the twentieth century contained few portraits produced during the period when modernist practice (as it is conventionally read) began to make inroads on English art. But the Gallery did confront and negotiate the claims of modernity during the nineteenth century. The possibility of seeing the national portraits in a modern sense – the sense in which the portraits were aesthetic objects, representing nothing but themselves – has never been foreclosed. Its emergence as the privileged mode of viewing portraits, or at least as a legitimate one, is tied up with specific historical events such as the advanced development of exhibiting institutions and the (masculinised) professionalisation of art production and criticism. Modernity evinced itself in the history of viewing as much or more than it did in the history of painting: the modernity of the National Portrait Gallery (and perhaps other modernities as well) was not present in the images, but was invested in, and conferred by, the spectator's legitimised forms of artistic enquiry.

Refashioning modern masculinity: Whistler, aestheticism and national identity

Andrew Stephenson

> Here ... is the work of a man born American with all our forces of confusion within him ... Within him were drawbacks and hindrances at which no European can do more than guess.
>
> Ezra Pound[1]

Recent writing has highlighted how in the second half of the nineteenth century, as part of the impact of modernisation in urban Western Europe and North America, there was a destabilisation of traditional sexual and gender identities and an urgent sense of a realignment of masculine-feminine divides within public life.[2] One consequence was that just as heterosexuality (and homosexuality) became the increasing focus of medico-scientific attention, and more stringent forms of the public regulation of sex were legally put in place, the 'normative' conventions of male sexual behaviour and manly identity were perceived to be breaking down.[3] For many English commentators, the mobility and mutability of modern manliness with its often confusing inflections of the markers of race, class and gender was a symptom of a pervasive consumerism aided by a burgeoning advertising industry and a rapidly expanding mass media. Approached as a dynamic site for a new and thoroughly modern cosmopolitanism, this refashioning of male individualism alert to the opportunities for self-advertisement and celebrity was exemplified, perhaps at its most extreme, by the showmanly codes and sartorial excesses of the aesthete and the dandy.[4]

Given these circumstances, it became particularly important to distinguish between English and other constructions of 'masculinity',[5] with their distinct structures of bourgeois respectability, and to uphold domestic, 'natural' and genteel inflections of gentlemanliness (as opposed to foreign, 'artificial' and vulgar attributes with their differing racial exemplars and often non-primogenitary, less aristocratic modes of cultural authority). In the face of such an array of alternative

manly models and a proliferation of sexual cultural discourses, the most urgent question, according to *The World* in 1878 was 'What is a gentleman?' It concluded somewhat despairingly that the term:

> is as washed out as some of the fashionable aesthetic hues. It wears as many and as swiftly changing tints as the chameleon ... It has been lightly tossed from lips to lips and class to class, and the consequence is that, as might have been expected, all flavour of moral attributes has evaporated in the process.[6]

And as if to highlight that this disintegration of masculine norms was linked to the emergence of 'New Aestheticism' with its very different, flamboyant modes of male self-display and theatrical dress management, *The World* published in the same issue a personality profile in its series 'Celebrities at home' of the artist James McNeill Whistler.[7]

What I want to argue is that as a consequence of these complex social, cultural and sexual transformations, Aestheticism from its emergence in the 1860s through to the early 1890s spawned competing tropings of artistic masculinity and national identity.[8] In so far as these stylings recontextualised the male body and destabilised the regulatory frameworks of normative mid-Victorian English masculinity, they did so in terms that had previously been considered 'un-English', 'unnatural' and perverse.[9]

What for many artists, art critics and writers stood at the core of the problem was what *The World* termed the aesthete's chameleon-like ability for self-reinvention and his pleasurable exhibitionism. Aestheticism, by drawing attention to the fluid distinctions between anatomical sex, sexual identity and gender performance, provided a compelling and far-reaching revision of earlier understandings of the male body's social semiotics as 'truthful' and 'authentic'.[10] This sense that modern masculinity was a fabricated corporeal style – a cultivated 'look' or pose understood as a socially mediated 'act' – raised the subversive possibility that manliness did not emanate 'naturally' from within the body (from a central essence or soul). Nor did it follow that inbred rank, class and racial distinctions were unconditionally reproduced on the surface of the male body, in his speech, his deportment and his dress.[11] Rather, in acknowledging that masculinity was the outcome of a variable, multivalent and rhetorical transaction between subjects, these reworkings revealed a suspect, artificial and *modern* subjectivity in process and what we might call a transgressive *performativity* at play.[12]

At the heart of such a public performance, however, there stood an in-built and anxious paradox, namely that the necessity to attract attention and to generate publicity (so crucial to the cult of artistic celebrity, brand-name packaging and international art-market success) was subject to conflicting interpretations by shifting consumer groups (with their own class positions, localised traditions, and moral, cultural, religious, ethnic and sexual regimes). Thus contemporary masculinity – 'learned' with the aid of fashion and etiquette guides, refined through self-help and 'how to' manuals, and achieved with the aid of corsets, cosmetics and speech therapy – was better approached as a strategy enacted under duress. The

fraught and sometimes unsure signifiers of a manly style 'performed' in public depended for its success (or failure) on the eyes and cultural-sexual norms of others.[13]

Furthermore, any refashioning of modern masculinity demanded an awareness that reinvention is, in Judith Butler's words, 'never fully self-styled, for styles have a history, and those histories condition and limit the possibilities'.[14] Whether or not these associations registered as persuasive depended upon their reference to a recognisable structure of impersonation (which involved negotiating shifting homo/heterosexual definitions and understanding discrete codes of respectability in currency amongst different bourgeois groups). Therefore, any flashy parade required caution since the self-conscious nature of the aesthete's posing might for particular audiences readily draw it into the province of the 'feminine', carrying with it overtones of exhibitionism and narcissism, thereby initiating a suspicion of unhealthy inter-male spectatorial desire at play.[15]

With these local variations in mind three factors require particular acknowledgement in any analysis of how these changes in approach to masculinity affected the artistic field in England in the second half of the nineteenth century, and how Aestheticism afforded new opportunities for artists to assume up-dated typologies. First, during the period from the 1860s to the 1890s male artists in England were faced with altering patterns of artistic patronage; with a developing and dynamic critic–dealer system; with increasing economic insecurity; and with growing public competition from the expanding number of women artists.[16] Artists were confronted by calls for greater professionalism and more specialised male-dominated career hierarchies in order to maintain professional standards in the face of the growing number of often unregulated art schools, which as Frederic Leighton recorded in 1888 'multiply, one might almost say, swarm, over the face of the land'.[17]

Second, the situation demanded that artists (like art critics and dealers) were aware of the proliferation of alternative and phantasmatic representations of artistic bohemianism prominent within popular journalism and circulating within the illustrated press.[18] Choreographed in semi-fictional narratives in artistic biography, 'personality profiling', gossip columns and *Kunstlerromans*, such tropings generated heightened fears about the English artist's social status within the public imaginary. Visibility (so necessary to securing a personality profile and aided by increasingly sophisticated print and photographic reproduction techniques) carried with it the risk of sensationalism and scandal, even blackmail (as both Whistler and Wilde found out).[19]

Third, as earlier domestic repertoires of artistic masculinity were precariously refurbished in response to greater exposure to continental models, French, especially Parisian, role models offered more potent, more emancipatory, masculinist tropings.[20] For artists (as readers and consumers of such widely disseminated, internationally syndicated, mass media representations), these up-dated models posed alternatives to previously held, familiar configurations of masculinity, 'Englishness' and modernity.[21] Consequently, whilst the articulation of new kinds

of cosmopolitan identity succeeded in encouraging many men, artists and others, to aspire to and to fashion alternative ways of being 'masculine', for contemporary 'English male artists displaying the signs of a contemporary, yet appropriately English', manliness in their public profile (and having it register as convincing in their work) was complicated.

One area of particular difficulty was that flamboyant or ostentatious ornamentation in male dress threatened to subvert English middle-class standards of respectability and decorum, thereby risking the stigma of impropriety. With reserve so highly valued by the English middle class as a signifier of manly self-confidence in character and sober protestant taste in dress management, the anglicisation of continental models was fraught with difficulty.[22] As Théodore Duret noted on the dress distinctions between France and England:

> in France where the 'artist's style' permits every fancy in the way of a get up, no body ever pays any attention to the way in which a painter dresses himself, but in England where artists are not allowed to transgress the common correct form, Whistler's mixture of the manners of a gentleman with the pose and fantastic get up of the artist was astonishing.[23]

Two sets of letters between France and Britain dating from 1873 and 1883 expose the difficulties attendant upon performing artistic masculinity within divergent socio-cultural contexts and managing appropriate social behaviour and dress according to shifting national regulatory frameworks. They record the disjunction between the 'French' and 'English' performances of Whistler and stress the necessity of paying attention to how localised cultural conditions affected the consumption patterns of artistic stereotypes and inflected their meanings through existing gender norms. They also underscore the crucial importance that the artwork had in reaffirming any assumed artistic identity, bohemian allegiance and sub-group positioning. Furthermore, through the evidence of its themes, formal and stylistic vocabularies, and its facture, the artwork was also called upon to demonstrate signs of the processes of social and sexual modernisation at work and thereby to legitimate the conviction of the artist's performance.

On 23 January 1873, Henri Fantin-Latour wrote to Otto Scholderer from Paris about Durand-Ruel's recent exhibition of work by Whistler, then resident in London, and noted the artist's recently assumed flashy, arriviste manner: 'I've seen the pictures [Whistler] has just sent at Durand-Ruel's. It was a big surprise for me, I don't understand anything there; it's bizarre how one changes. I don't recognize him any more.'[24] Fantin, still puzzled by Whistler, responds on 10 March 1873: 'I am left with my first impressions ... the reason is that everyone follows his own path; one no longer understands another; it's a law of Art. Everyday I'm troubled by that: I no longer understand, I almost no longer like what I see by my old comrades.'[25] In June 1873, Fantin-Latour encountered Whistler in Paris and demanded an explanation. He reported to Scholderer in a letter dated 22 June, 'there was a coolness between us ... [Whistler] appeared enchanted with himself, persuaded

that he is moving forward whilst we others stick with the old painting ... I'm no longer in a mood to discuss it.'[26] The rift between them must have been finally underlined when, in contrast to the failure of the Paris show, Scholderer reported Whistler's phenomenal success on the London art market in a letter of 19 May 1876: 'harmonies, symphonies à la Whistler are all the rage at the moment ... every imbecile talks about harmonies, colours symphonies in white or other colours or thinks himself very advanced in modern art.'[27]

The second correspondence dated 28 February 1883 is from Camille Pissarro to his son, Lucien, then working in England, about Whistler's controversial third exhibition of 'Venice etchings and drypoints' held at the Fine Art Society in February 1883. The installation had attracted international press coverage because of its co-ordinated white-and-yellow decor and the private view's status as a London social event. Pissarro *père* lamented that Whistler as 'showman' had orchestrated the gallery space into an aggressively stylised, commercialised, self-promotional stage and had succumbed to the English tendency (in Pissarro's eyes) to see the aesthetic artwork as a demeaned, decorative accoutrement and subsidiary to the celebrity performance. Pissarro concluded:

> Whistler is even a bit too *pretentious* for me ... I wouldn't want to be an aesthete, at least like those across the Channel. *Aestheticism* is a kind of romanticism more or less combined with trickery, it means breaking for oneself a crooked road. They would have liked to have made something like that out of impressionism.[28]

These letters reveal the anxieties felt by French artists about the ways that mobile artistic repertoires circulating within an increasingly international art world displaced earlier, localised, cultural tropings and disrupted pre-existing homosocial patterns. They emphasise how the recycling of artistic identity and commodity across national boundaries and through the dealer–critic system occurred at such an accelerated pace in the rapidly expanding late nineteenth-century art economy that a friend's paintings seemed quickly 'bizarre', and the shared, manly tropings of 'old comrade' painters and their attendant avant-garde politics were soon re-cast as a marketing device (resulting in Fantin's 'bad moods').[29] They also highlight how the anglicisation of continental theory involved careful transformation, not least if the demise of avant-gardism into a publicity ploy was to be avoided. For Pissarro, Whistler's dandyism reeked of just such a compromise, intimating an easy-going if 'crooked' compatibility between Aestheticism and the art market, between politics and performance.

To adequately appreciate these concerns we need to recognise how established artistic role models and professional ideals in Britain and abroad (especially France) were unevenly refashioned under the impact of modernity and cosmopolitanism.[30] And tied to this how the difficulties of enacting relevant masculine codings across diverging contexts from an already 'feminised' position of display could cause the artistic performance to collapse into a commercialised and pretentious exhibitionism.

According to Théodore Duret, Whistler travelled 'like a shuttlecock' backwards and forwards between London and Paris from his arrival in Europe from the United States in 1855,[31] establishing a dialogue between them by successfully merchandising what Walter Sickert termed 'his kind of dandyism' in a bi-focal way through their expanding cultural systems.[32] Whistler's strategy necessitated at the very least two distinctive career trajectories and masculine identities which were responsive to the alternative currencies of avant-gardism as they operated within each metropolis.[33]

At the same time, it required an awareness of how such tropings were disseminated by the mass-distribution popular press. From the late 1850s, the rapid expansion of a highly technologised, international mass media provided better-informed urban and suburban readerships – especially middle-class women – with up-dated typologies.[34] One way these fictional repertoires could be monitored was by employing the professional services of international press-clipping agencies, a strategy Whistler adopted from the late 1860s or 1870s.[35]

Another way was by reference to an already validated avant-garde role model. Initially, Gustave Courbet appears to have fulfilled this 'mitigating' paternal function. Although not his pupil, Whistler in *Wapping* of 1860–64 (Figure 51), and in his 1859 *Thames* series, rehearsed Courbet's 'Realist' legacies on 'poetic' London-life subjects (such as *Black Lion Wharf* (1859) and *Rotherhithe* (1860). The themes of these works echo Courbet's work and employ French 'Realism' as

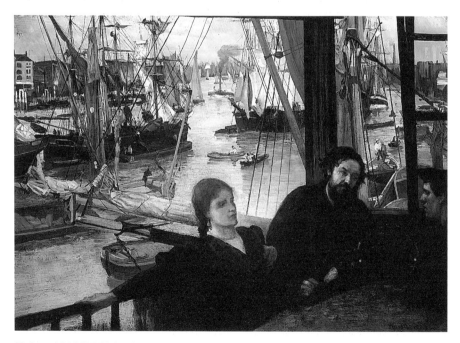

51 James McNeill Whistler, *Wapping*, 1860–64.

it was understood by English art groups from Courbet's 1859 French Galleries show in London.[36]

Yet the orchestrating of an assumed identity by deference to a foreign mentor demanded a close check upon how the assumption of a particular class, racial and gendered viewpoint in currency in one country intersected with shifting national moralities and sexual-ethical regimes when displayed in another. For example, whilst Baudelaire praised Whistler's *Thames* etchings in 1862 as 'improvisations' that suggested 'the profound and intricate poetry of a vast capital',[37] and Philippe Burty commended his *Thames* works in 1863 as 'the purest English',[38] the failure of the set to find a substantial market in England in 1871 highlighted how such diffusion across borders was fraught with difficulty and not independent of localised conditions.

Approached from a Baudelairean perspective and as part of a 'Realist' lineage, Whistler's representation of East End wharves was seen by certain English critics as a 'virile' troping of the urban labyrinthine complete with a highly charged, *flâneur* mystique. 'Let us welcome Whistler in the rudest of his works', wrote one critic after viewing *Wapping*, 'and hail him as one more manly artist who exists to correct the upholsterers and the decorators and the servile *connoisseur* conception of art.'[39]

Yet for other London audiences, such morally dubious narratives carried promiscuous connotations that suggested an excess of male sexual mobility (frequently identified with a continental European male stereotype). First, the East End docklands were increasingly associated with urban squalor, destitution and depravation, and the Thames identified with industrial pollution, miasma and contagion (especially during the 'Great Stink' of 1858–59).[40] And second, the figures of prostitutes, watermen and sailors in the vicarious narratives of middle-class slumming had become implicated in the spread of syphilis and sexual disease.[41]

Whistler's *Wapping* in its explicit sexual theme, which positioned the spectator as a voyeur watching a prostitute out-manoeuvring two cruising sailors, risked offending the social proprieties observed by conservative English audiences, as Whistler's friend Thomas Armstrong warned him.[42] It imagines a camaraderie in which the artist rubs shoulders with a nomadic under-class; a trophy of Realism perhaps, but one which for English audiences was associated with overinscribed Parisian poetics, and its explicit sexual narrative reeked of a jaded, moral bankruptcy. By the mid-1860s, such sexually dissolute, military promiscuity had become glossed in English middle-class perceptions with degenerate associations. Prostitution alongside crime and alcoholism was scapegoated as a social pathology endangering the nation's moral hygiene, not least because the alarmist Contagious Diseases Prevention Acts of the 1860s had homed in on the navy, dockland vagabonds and prostitutes as transmitters of sexual infection.[43]

When the work was exhibited at the Royal Academy in 1864, whilst many English critics praised the technical skill and colour virtuosity with which Whistler represented the Thames and its shipping, the trio of figures attracted a less than favourable response. The *Realm* reviewer declared that 'the representation of the pool is very truthful and especially the colour like that of the Thames, but the effect

is so marred by the intrusion of the hideous figures in the foreground that we are glad to turn away to more agreeable if less able work'.[44] *The Times* critic, Tom Taylor, echoed this view, stating that 'it is a pity that this masterly background should be marred by a trio of grim and mean figures. There are noble looking merchant sailors and fair women even among the crowd of Ratcliffe-highway.' Interpreting *Wapping*'s characters in terms of 'repulsive' urban physiognomies, the reviewer concluded that 'even such powers as Mr. Whistler's do not excuse his defiance of taste and propriety'.[45]

Alert to these variable reinscriptions, Whistler's anxiety about discrepancies between his social status, artistic reputation and masculine self-styling in France and England was acute by the early 1860s. In response, he seems to have become adept at trying out and discarding a whole range of possible male communities by enacting what his patron, Frederick Leyland, termed the charades of 'an artistic Barnum',[46] and becoming what Théodore Duret called an 'en-Frenchified American'.[47] Furthermore, Whistler also appears to have become well-versed in judging just how far to go too far, thereby attracting press attention and generating publicity.[48]

Whistler met Dante Gabriel Rossetti in July 1862 and the English artist swiftly came to fulfil a similar function to Courbet, yet configured in a dissimilar national, class and masculine style.[49] By October, Whistler was 'as thick as thieves' with Rossetti and trying to arrange a group exhibition with Rossetti, Fantin-Latour and Legros.[50] By the early 1860s, Rossetti had acquired a cult status amongst a select coterie of English intellectuals (including Algernon Swinburne, Frederick Sandys and Edward Burne-Jones) and a group of wealthy patrons subscribing to a shared Anglo-Japanese taste and an eclectic Anglo-French Aestheticism. Rossetti embodied a distinctive English troping of bohemianism, one historically formed in an ambiguous relationship to urbanism and opposed in its virility to the ordered, disciplined 'manliness' urged in the writings of Matthew Arnold and Thomas Carlyle, though rooted within the earlier idealism of the Pre-Raphaelite Brotherhood.[51]

When both artists displayed work together, these differences in their manly natures and by implication in their moral and ethical stances as well as in their national backgrounds and avant-garde affiliations were interpreted from their work:

> Whistler's is a very different temperament from that of Rossetti. Rossetti is wilful, positive, thoughtful, painstaking. Whistler is wilful, lawless, bold and does what he pleases to do and does not take much pains with his work.[52]

Nevertheless, Whistler's work of the mid-1860s when viewed besides later works such as 'Sketch for *The Balcony*' of 1867–70 (Figure 52) demonstrated a desire to use 'pure' colour on subjects that privileged sensuous atmosphere and immediate sensation over explicit narrative content. This apparently eclectic stance subscribed to the developing tenets of an English Aestheticism as it was extolled within Rossetti's circles and as it was becoming theorised in the writings of

Swinburne.[53] It was an allegiance which for certain audiences carried with it effete connotations of a 'soft' aesthetic masculinity which was later denounced by Robert Browning: 'I hate the effeminacy of [Rossetti's] school – the men that dress up like women – that use obsolete forms and archaic accentuations to seem soft.'[54]

At the same time, Whistler maintained his relationship with Courbet by working alongside him in Trouville in October and November 1865 and producing paintings such as *Harmony in Blue and Silver: Trouville* (1865) that were derived from Courbet's *Seaside at Palavas* (1854) and attested his paternity.[55] Ultimately, Whistler's abandonment of Courbet's 'Realism' – explicitly declared in a letter to Fantin in August 1867 – concluded this phase of almost obsessive manoeuvring and reaffirmed Whistler's reorientation towards English Aestheticism.[56]

Approached in the light of these changing allegiances and emulations, Whistler's *Arrangement in Grey: Portrait of the Painter* (Figure 53), displayed at the Society of French Artists exhibition in November 1872, is revealing about the ambivalences perceived in his art (and by implication the contradictions in his masculine temperament). It posits portraiture as a modern and modernising mode. On the one hand, it signalled Whistler's aspirations to be seen as a portrait painter in the Grand European tradition through its references to the authoritative pose, sombre attire and serious tone of Rembrandt's *Self-Portrait* (1659) which had been

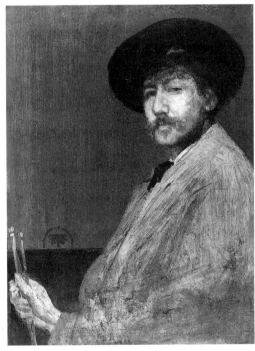

52 James McNeill Whistler, sketch for *The Balcony*, 1867–70.

53 James McNeill Whistler, *Arrangement in Grey: Portrait of the Painter*, 1872.

exhibited for the first time in London in 1871.[57] On the other, in its modern tech-
nique – its fragile, dissolving appearances, its conspicuous, surface brush strokes
and its aesthetic titling and contrived butterfly motif – it engaged with those
debates which English Aestheticism had brought to the fore. It dealt with discus-
sions about the relationship between modelling and flatness; about decoration and
artificiality; about the relative value of academic tradition versus the practices of
avant-gardism; about the validity of an art linked to morality and one purely aes-
thetic in its aspirations; and about the styling of an artistic identity referenced to
Great Masters of the Past as opposed to one self-consciously fashioned under the
dynamic conditions of modernity. In a complex and sophisticated way,
Arrangement in Grey: Portrait of the Painter staked Whistler's claim to his new aes-
thetic credentials as 'one of the leading contemporary "English" artists, if
American by birth', as one critic put it.[58]

Yet, the lack of sufficient empirical detail and the apparently minimal technical
effort involved in the painting, reaffirmed the comparison to Rossetti that under-
stood Whistler's 'lawless', capricious, un-English temperament as at the root of his
incapacity to follow his ideas through to completion. As *The Times* critic com-
plained, the final composition signalled an unsteady transaction from intention to
completion, with little sense of intellectual ambition or appropriately masculine
perseverance:

> This is but the laying in of a head, excellent in modelling and relations of tone and
> colour, as far as it goes, but only the beginning and suggestion of something, which
> the painter lacks either the power or the patience to carry out.[59]

Whistler's identification with English Aestheticism was publicly endorsed when
his first nocturnes, including *Nocturne: Blue and Silver – Chelsea* (Figure 54) were
displayed at the Dudley Gallery, London in November 1871. It was a repositioning
further confirmed by his first London solo show at the Flemish Gallery in June
1874, where his *Six Projects* of 1868 were exhibited in his first carefully harmonised
gallery installation.[60]

In their colour orchestration, the *Six Projects* and *Nocturnes* contravened the
dominant gender structure of stylistic and technical opposition developing in
English art theory in which drawing was perceived as 'masculine', rationally struc-
turing and ordering formal relationships, stabilising narrative and thereby sig-
nalling intellectual distance and moral control. Colour, on the other hand, was
coded as sensuous, decorative, superficial, 'treacherous and unstable', carrying
connotations of the subjective and the unreasoned, so that the aesthetic gaze could
be coded as 'unredeemably feminine'.[61]

Whistler, stating in a letter to Fantin-Latour in 1867 that 'drawing [was] the
"master" of the "whore" colour' and that colour without drawing was a 'vice',[62]
clearly rehearsed arguments originally set out in one of the most comprehensive
expositions of these principles, Charles Blanc's *Grammaire des arts du dessin, archi-
tecture, sculpture, peinture* (published in instalments in the *Gazette des Beaux Arts*

54 James McNeill Whistler, *Nocturne: Blue and Silver – Chelsea*, 1871.

between 1860 and 1867 and in a complete edition in 1867). The English reception to Blanc's proposals inflected these gendered constructs through national differences between Britain and France, invoking the relative strengths, aesthetic values, work ethics and moral proprieties of modern British versus modern French art and culture.[63]

Crucially, since these arguments appeared at the same time as fears about the relative inferiority of the English system of art education under the impact of the market economy, they were specifically indexed to differences in national training and to declining standards of competence in drawing and finish (seen as indicators of the over-commercialisation of art in England).[64] To cite one influential example, in his Slade School lectures given between October 1871 and October 1873, Edward Poynter, the first Professor of Fine Art, stated that 'the English are behind the rest of Europe in our knowledge of drawing' and 'our National School is enfeebled'.[65] Poynter, whilst in favour of replicating aspects of the French atelier system at the Slade School of Art, nevertheless warned of the dangers of wholesale copying of French methods, since 'French art has indeed of late years, enormously degenerated. Thanks to the continual and persistent efforts of the "realistic" school, it is descending lower and lower to a mere brutal materialism.'[66] Poynter argued that following the death of Ingres and the decline of the 'Great School of David', French art had 'seized on the disgusting and horrible … with a cynical pleasure' and with the lamentable outcome that 'every [French] artist vies with his fellows in the production of the most sensational result.'[67]

In 'Lecture V: the training of art students', Poynter turned to the delicate issue of the inter-relationship between form, tone, colour and composition. Paraphrasing some of Blanc's arguments, Poynter stressed that there was a need for English art students to acquire a 'workmanlike manner' and to demonstrate an advanced skill in drawing before being allowed to use colour. Echoing Blanc's fears about the corrupting potential of colour, he warned that drawing and colour should not be taught concurrently as the one might negatively affect the other and 'students are too hasty to progress to colour in England'. As a result, he concluded, any study of colour 'should not be undertaken too young'.[68]

In the light of these arguments, Whistler's attempts to align himself with a neo-classical revival in English art in the 1860s through a claimed genealogy with Ingres and an allegiance with Albert Moore, with whom he was friendly from May 1865, might be interpreted as yet another self-conscious manoeuvre intended to counter the perceived contradictory associations of his works. Nevertheless, what compromised this repositioning was that the *Nocturnes* and the *Cremorne Gardens* studies (completed c. 1871–77) remained ambivalent and unresolved in spite of his expressed desire to structure and systematise colour usage scientifically. For English critics, the 'pure colour' and 'poetic effects' of works such as *Nocturne: Blue and Silver – Chelsea* demonstrated an insistent pleasure in surface decoration and ephemeral light conditions that intimated the superficial 'anglicisation' of French aesthetic theories, a very modern and personal visual language, but one having little recall to the illusionistic conventions, legibility and moral effectiveness of English narrative painting. As the *Athenaeum* critic wrote in response to seeing *Nocturne: Blue and Silver – Chelsea*, such decorative flashiness carried a taint of vulgarity:

> In Mr. Whistler's production one might safely say that there is no culture … they are marvellously subtle symphonies of colour, so fine, so ineffably lovely that their obvious offences against convention, even their complete novelty … are forgotten in the fascination of exquisite colour.[69]

Such an unrigorous tonal and spatial vocabulary marked out a lack of intellectual ambition and a lamentable degeneration into the 'merely tricky and the meretricious'.[70]

Alternatively, when Whistler painted recognisable bohemian locales, like the notorious pleasure gardens in Chelsea in *Cremorne Gardens, No. 2* (Figure 55), his pictorial technique demonstrated a Francophile aesthetic gaze rather than an analytical, 'masculine' and suitably English enquiry at work on a London subject. These images were inevitably tainted by their association with promiscuity suggesting a moral laxity and male licentiousness at large on the Thames bankside.[71] As Sir John Holker observed in his address to the jury at the later Whistler–Ruskin trial in November 1878, 'I do not know what the ladies would say to [the *Cremorne* study] because it has a subject they would not understand – I hope they have never been to Cremorne – but men will know more about it.'[72] Any mitigating references

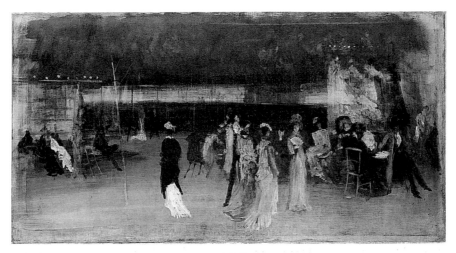

55 James McNeill Whistler, *Cremorne Gardens, No. 2*, 1872–77.

to Courbet were undermined by growing English prejudices against his work and by the 'degenerate style' and associations of 'brutal materialism' which French 'Realism' had come to evoke by the late 1870s.[73] As one critic explained, the problem was that the paternity of his work like 'Mr. Whistler's nationality is so mixed up that it would take an expert genealogist to solve the question'.[74]

Whistler's February 1883 exhibition of fifty-one etchings at the Fine Art Society provided yet another opportunity for his 'purely aesthetic', cosmopolitan approach to be evaluated by English art audiences. It also allowed him to import the lessons of recent Impressionist installations, using coloured walls, tinted frames and decorative accessories to redefine the inter-relationship between artwork and environment.[75] Yet in obsessively orchestrating every aspect of the encounter with the artwork and gallery space, in co-ordinating the showroom as a site for theatre and performance, in outfitting gallery attendants in complimentary colour-coded suits, in using the catalogue as a personalised mode of address, in employing the frames as customised devices for effective decorative display, and in deploying the butterfly as aesthetic trademark reproduced on invitations and worn as badges by visitors, Whistlerian showmanship appeared to many critics, even some of his supporters, to have gone too far.

It was not Whistler's adoption of the refined features of Aesthetic decoration and interior design in his environment that attracted comment since, as one critic put it, 'the true bent of Mr. Whistler's talent appears to be artistic furniture decoration ... It is not particularly original, for many of us have seen the same kind of idea carried out in houses of the nobility'. Rather, it was because this form of installation 'is quite something new for a public art gallery'.[76] The problem was not only the inappropriate use of the intimate, domestic ambience in a public

commercial space (one already successfully pioneered by the Grosvenor Gallery from its opening in May 1877), but that in deploying a co-ordinated colour scheme to launch a brand-name Whistlerian modernism, any respect for the art-work and the decorous protocols of viewing art appeared to have been lost. As *The World* summarised it: 'the decoration of the room ... and other aesthetic aberra-tions characteristic of the artist have rather the effect of detaching attention from his works. There is a danger sometimes of the picture being forgotten because of the eccentric glories of its environment.'[77]

It was just this calculated use of display devices that subordinated the artwork to the decorative totality of the whole which Pissarro had deprecated as the 'gim-mickry' of English Aestheticism: 'a kind of romanticism more or less combined with trickery'.[78] A similar disgust was expressed by Walter Sickert in his condem-nation of Whistler's installations in May 1915, when he condemned 'the Whistlerian *mis-en-scène*! Hangings and overpowering frames, frames, frames, out of all proportion to the matter enclosed in them, are more and more insufficient defence for the result of dissipation of effort and confusion of aim.'[79]

Put briefly, the dangers of Whistler's seductive ambience, like that of Aestheticism's radicalism, lay in its failure to distinguish between English 'private' and 'public' spatial protocols and in its promotion of new forms of spectatorship that sanctioned altered modes of viewing in public for a growing number of fash-ionable female spectators and modern young men. As art critics and writers sup-portive of Aestheticism argued, if the aesthetic encounter could offer, at least temporarily, the possibility of an 'out of self' spiritual experience by introjection into the potentially democratic and ideal 'unity' of 'pure beauty', then it might also provide for a highly eroticised, heady fantasy of cross-sexual identification in which gender boundaries were transgressed (transformative possibilities given intellectual credibility in recent writings by Swinburne and Walter Pater).[80]

A corollary of this – and perhaps one reason for the strength of critical reaction to the show itself – was that Whistler's installation in its eagerness to unify artwork, frame and environment through the 'intuitive' and 'feminine' use of colour co-ordination failed to sustain the 'authentic' signs of the 'intellectual' and 'masculine' as they were conventionally and tastefully inscribed in the private spaces of art col-lectors' homes or the smaller galleries dedicated to art connoisseurs or professional art groups, spaces that offered a haven for intimate communion with the artwork and opportunities for discrete aesthetic reflection. Thus, Whistler's work and its artistic credentials were already compromised through the exhibition's relentless colour co-ordination and its overblown theatricality (symbolising a suspect and pervasive 'effeminisation' at work).

In metaphors of dissolution, degeneration and disease, conservative English critics likened the disturbing experience of Whistler's 'Arrangement in White and Yellow' show to 'death by drowning in yellow fever'; to 'an attack of yellow jaun-dice'; and to falling into 'a perfect bog of chromatic bewilderment'. The overall effect was 'a sickly delirium of the senses' and an unruly loss of self-control in

which male composure could only be regained by returning to the London streets outside to recover.[81]

With these responses in mind, the inability of English critics to offer up convincing professional judgement on the show and to secure appropriately 'masculine' readings of the work was paralleled by their frustration at trying unsuccessfully to dislocate Whistler's manliness from its flamboyant and cosmetic fashionability. This frustration showed itself in a number of ways: in the despair felt at failing to rescue the etchings from their overpowering frames and elaborate installation, in the pressures to establish reasoned and moral critical judgement when faced with the pervasive exhibitionism of the event, and in their inability to restore decent English protocols of spectatorship to an art audience already knowledgeable about the potential freedoms, aesthetic or otherwise, that Aestheticism might offer. As *The Times* declared in relation to the previous year's Grosvenor Gallery show, 'criticism and admiration alike seem impossible and the mind vacillates between the feeling that the artist is playing a practical joke upon the spectator, or that the painter is suffering from some peculiar optical illusion'.[82] The anxieties generated by Whistler's public failure to respect and uphold decorous moral and sexual boundaries in public in the face of an engulfing 'feminised' culture were most acutely evidenced in the critics' urgent remonstrations to re-establish distance from the spectacle either by physically going outside the gallery space or by recourse to the symbolism of death.[83]

If, as George Gissing proclaimed, the 1880s and 1890s were 'decades of sexual anarchy',[84] then Whistler's 1883 exhibition drew attention to the processes of sexual modernisation at work and valorised the claim that 'Whistler is a sort of Wagner in painting'.[85] It also pointed up the pitfalls associated with the importation of continental Aestheticism without a full recognition of, and adequate attention to, the historical precedents and localised art practices current in England (and without due acknowledgement of the moral–aesthetic mappings prevalent within English art criticism). Located as a set of fantasies, fears and anxieties about the dismantling of patriarchal authority and a decline into a decorative abyss, Whistler's aestheticism, its extravagant *mise en scène* and its opportunities for pleasurable performance were seen in serious art criticism and popular culture alike as an offence to English propriety and as symbolising a threat to the normative conventions of manly disciplinary regimes.

As more stringent nationalist and conservative ideologies were put in place in the late 1880s and 1890s, shifts amongst English audiences in the signification of bohemianism and Aestheticism registered an altered approach to modern French art and to internationalism. Moreover, more virile, heterosexist and misogynist role models for male artists were reinstated. In such a climate, Aestheticism's universalising, potentially democratic empathetic unions and its sexual politics ran counter to the notion gaining currency of a 'naturally' invested, seamlessly reproduced, racially discrete, culturally conservative and resolutely heterosexual 'English' patriarchy befitting the nation's imperial destiny.

These far-reaching revisions recast Whistlerian performativity and the aesthetic installation as a sign of an effete and degenerate overcolonising of the 'feminine'; a legacy that was to belittle Whistler's work as shallow and 'based upon a series of compromises and evasion'.[86] Furthermore, such a view also castigated Whistler as a poseur and branded his sartorial displays as the hallmark of an 'effeminised' Wildean dandy – a cliché of popular culture – which embroiled him within debates about the male body's cultural signification and decadent sexual mores, especially male homosexuality.[87]

When in 1912 Ezra Pound wanted to signal his admiration for his fellow American and the 'life and intensity' – the *modernity* – that he saw in Whistler's work, he had himself photographed (now lost) in the pose of Whistler's portrait of Thomas Carlyle (Figure 56). It is revealing that Pound (portrayed by Henri Gaudier-Breszka in his 1914 *Head of Ezra Pound* (Figure 11) as the most virile and phallic of modernists)[88] should have selected Whistler's *Carlyle* as a means of registering his admiration. The work is an odd, idiosyncratic, choice when faced with the more flamboyant available male role models. Yet as I have suggested, by 1912 Whistler's

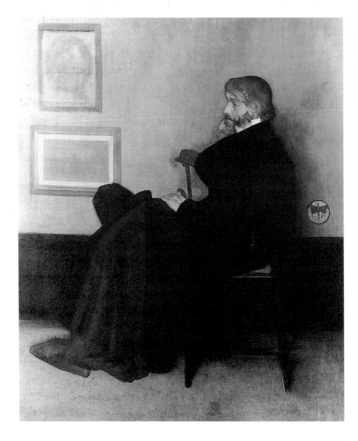

56 James McNeill Whistler, *Arrangement in Grey and Black, No. 2, Thomas Carlyle*, 1872–73.

dandyism and the artistic ideals it epitomised appeared to many younger artists and critics incapacitated and emasculated, especially when set against the 'normative' tropings of masculine heterosexuality that had come to dominate histories of modernism. Located within a more rigid dichotomy, Aestheticism in its most 'Francophile' manifestation, carried associations of the effete and decadent; connotations of an 'unmanliness' and homoeroticism that had come largely to be identified with a styling of masculinity and a homosexual promiscuity that was heavily censored, and after Wilde's trial in 1895 believed to be exiled abroad.

Nevertheless, the *Carlyle* was a considered choice on Pound's part since (as an earlier critic had noted) 'it is a striking and eloquent presentment ... [showing] a refreshing absence from that [colour] eccentricity in which Mr. Whistler seems habitually to take delight'.[89] For within the debates on masculinity and sexual identity that preoccupied late Victorian and Edwardian Britain, it was Carlyle's aggressive notion of manliness – his advocacy of the value of 'great men', heroes and hero-worship, the correctness of patriarchal authority, the celebration of the male will to power, and his emphatic assertion of the racial superiority of the Anglo-Saxon – that had been influential in his writings. Recycled to condone man's flight from domesticity, to offset the threats that the 'New Woman' and feminism posed to male dominance, and to underpin the racial authority of New Imperialism, Carlyle's active and 'muscular' masculinity provided the remasculinised framework within which (and out of which) Pound's phallic modernist repertoire would emerge. Pound's admiration for Whistler and his representation of Carlyle obscured any connotations of the 'effeminacy' and 'softness' which Whistlerian dandyism had acquired in the popular press. In its place, it proffered a virile model for the male intellectual, complete with a compelling male mystique and an aggressively heterosexual and misogynist masculinity.

Seeing into modernity:
Walter Sickert's music-hall scenes,
c. 1887–1907

David Peters Corbett

Walter Sickert has frequently been seen as a paradox. An artist who was profoundly concerned with the question of how to depict modern life, he was simultaneously committed to exploring the idea of a purely formal and autonomous painting. Much of the Sickert literature has felt the need to acknowledge the tension which this duality provokes in our understanding of his work.[1] It has been difficult to provide an account of his art which makes sense of both these aspects, of what Virginia Woolf famously acknowledged as 'the silent kingdom of paint', as well as of the 'painter of modern life' more recent commentators have discerned in him.[2] In this chapter I want to look closely at one section of Sickert's oeuvre, the music-hall subjects which he produced in three series between about 1887 and 1907. I will argue that these paintings, with their associated prints and drawings, provide us with a way of understanding Sickert's dual devotion to the formalist and the realist and that this duality goes to the heart of Sickert's modernism as a painter. It is one of the principal interests of this work that Sickert's explicit management of thematic issues through the medium of paintwork directs our attention towards the 'kingdom of paint' as well as to the social history of his works and to the profound connections between the two.

I suggest that seeing Sickert as working within a set of issues which revolve around the capacity of paint to achieve and communicate knowledge about lived experience helps to elucidate these connections. Sickert is an important figure in the development after 1850 of an art in Britain which took the circumstances of modern life for its subject matter. His ambition was to achieve a painting which contained and categorised the contemporary world for his viewers, and his art is, at one level, a taxonomy of the observed conditions of modernity in the urban environment of London. The question for Sickert, as for other artists in this period, was how successfully could a social project to define and understand modern life be conducted in what he called the 'grossly material' substance of paint?[3] Faced with

the defining modernist demand that painting meet the new conditions of modern experience, the capacity of paint itself to act as a medium for the investigation and diagnosis of modernity became of crucial interest. The identity of the painter, too, as the individual capable of presenting knowledge about experience, became linked to these questions. The authority of the reading of modern life in the work was seen ultimately to depend on the ability of the painter to understand and communicate experience in the world. In the end, any claim for Sickert as a 'modernist' must be bound up with the implications of this belief.

By looking closely at Sickert's music-hall scenes I believe we can observe both his attempts to enact the modernist imperative to depict the true nature of the contemporary world, and the articulation of a meditation on the difficulty of doing so in the medium of visual art. Sickert confronts the problem of the adequacy of paint as a form of knowledge and explores the implications of this question for the registration of contemporary experience.[4] In the process he both asserts and questions the grounds of his own identity as an artist.

The London Impressionists

In 1889 Walter Sickert wrote an introduction to the catalogue of the 'London Impressionists' show at the Goupil Gallery.[5] For anyone working with an analysis of modernity which sees the modernism of avant-garde works as impelled by a desire to register and describe modern life explicitly at the level of manifest content, what he said there seems to require explanation.[6] The problem with the 'London Impressionists' catalogue is that Sickert writes about a collection of paintings which manifestly share an aim to depict the contemporary scene as if they were perpetuating the protocols and concerns of 'Symbolism'. In the catalogue Sickert famously defined his Impressionism in this way:

> Essentially and firstly it is not realism. It has no wish to record anything merely because it exists. It is not occupied in a struggle to make intensely real and solid the sordid or superficial details of the subjects it selects. It accepts, as the aim of the picture, what Edgar Allen Poe asserts to be the sole legitimate province of the poem, beauty … It is, on the contrary, strong in the belief that for those who live in the most wonderful and complex city in the world, the most fruitful course of study lies in a persistent effort to render the magic and the poetry which they daily see around them.[7]

Sickert's repudiation of Realism has often seemed disconcerting to later readers.[8] In part this is because of its final words, which claim that the means to achieve this rendering of magic and poetry are to be found 'in all their perfection, not so much on the canvases that yearly line our official and unofficial shows … as on the walls of the National Gallery', an assertion which does not fit well into the conventional understanding of developments in nineteenth-century art.[9] But in part as well the statement seems odd because of the apparent disjunction between Sickert's

language and the perceived subject matter of the show. Sickert's justification for the 'London Impressionists' is not social realism or 'the painting of modern life'. It is couched in the language of 'Symbolism' – 'beauty', 'magic' and 'poetry' – and in invoking Poe it calls upon one of the arch-Symbolists of the English-language tradition. How are we to reconcile this account with the ambitions which seem to be embodied in works shown at the Goupil like Sidney Starr's *The City Atlas* (Figure 57) or Sickert's *The Butcher's Shop* (1884, York City Art Gallery), let alone with the music-hall paintings that Sickert also showed? The catalogue introduction seems to suggest a different and inappropriate principle of meaning for images which strike us as plainly about social realism.[10]

It is a mistake, in general, to accept Sickert's written or reported statements at face value. Nevertheless, in this case I think we would be wise to attend closely to what Sickert says. I want to begin to consider how we may do so by suggesting that Sickert's work can be understood as expressing a wider dialectic in English painting at the end of the nineteenth century, that between what we might call 'Symbolist' and 'Realist' modes of representation. It was, in the case of Sickert, the mutual influences and inheritances from these two intertwined strands in English

57 Sidney Starr, *The City Atlas*, 1889.

art which provided the material from which he constructed his own confrontation and analysis of modern experience.

Despite recent attempts to subsume a wide range of practice under the port-manteau term 'Symbolism', it remains the fact that English art in the late nine-teenth century was a very broad church.[11] The monolithic implications of 'Symbolism' are entirely misleading. By the end of the century, not only was there a wing of British painting composed of Aesthetes, Decadents, Pre-Raphaelites and others – artists concerned with the inherent or essential meaning of experience and hence loosely 'Symbolist' – but there was also a broad array of 'Realist' painters whose aim it was to describe the appearance of the world in their art, whether as plein-air painters, Impressionists or naturalists.[12] Both groups are divisible into a multitude of sub-groups, and many artists have characteristics that belong to apparently opposing camps, so that these options are in fact best understood as points on a continuous range of possibilities. Individual artists frequently had con-nections to both ends of the spectrum, and many produced work which is best understood as bringing together apparently opposing ambitions and strategies. It is certainly the case, for instance, that Whistler's apparently 'Symbolist' influence is also 'Realist', feeding into the desire of artists to achieve an optical registration of the motif. Whistler's memory techniques, expressed in the famous nocturnal trips to fix a scene in the mind prior to painting in the studio, reflect a desire to pin down the realities of the subject as well as to transform them within the space of the canvas.[13]

If English art offered a spectrum of positions along the Symbolist–Realist axis, so that we might wish to disallow these terms or treat them sceptically, it was also the case that there were genuinely different approaches to the question of how best to figure the character of reality in the work of art. I suggest that it is possible to use the terms 'Symbolism' and 'Realism' with some care in this strictly limited sense in order to define two influential positions on the question of representation (and, with this understood, I will drop the scare-quotes from now on). Both were of crucial importance for the development of Sickert's account of modern experience in his art, but as linked positions orientated towards the same goal rather than as opposing forces to be set against each other in an absolute way.

Whistler's *nocturnes* have been cited as 'central statements of the Symbolist position' because of their artificiality and frank distance from reality.[14] But although a painting like *Nocturne: Blue and Silver – Chelsea* (Figure 54) elides the contemporary elements of the scene in favour of a painterly self-sufficiency and the evocation of what Whistler called 'poetry' and 'palaces in the night', it nonetheless remains a contemporary scene, recognizable as a view across the Thames towards Chelsea.[15] The scene it depicts is an industrial, quintessentially modern, one.[16] In a parallel way, G. F. Watts is certainly exemplary of modes of Victorian painting which repudiated the claims of Realism, yet his works were conceived as in a direct relation to contemporary experience. In the case of a painting like *Mammon:*

Dedicated to his Worshippers (Figure 58), the reference is to what Watts saw as the central failure of modern society, the fact that 'prosperity has become our real god', and that it offers little consolation or spiritual solace.[17] His figure of Death, too, pressing remorselessly across the threshold of a Victorian household in *Love and Death* (c. 1874–77, Whitworth Art Gallery, Manchester), brings questions about the meaning of existence forcefully into the contemporary world.

These paintings all derive from a concern with the character of modern experience, but deal with it by attempting to find principles through which a more authentic meaning, a deeper truth, can be brought to bear. Symbolism seeks a representation which will access those aspects of existence and reality which it believes the dominant materialism of the nineteenth century covers over. Its most urgent impulses are those which aim to strip away the deceptive surface of experience and suggest or evoke a greater truth beneath. Modernity's surface, an account of its appearance and optical character, is repudiated in favour of the 'beauty' which may be found within it. But this act of revelation remains a way of responding to the contemporary. Watts's symbols of terror and sterility and Whistler's transformation of the London scene are equally ways of attributing significance to the contemporary themes and sites from which they begin. Symbolist representation in the sense I am using it here is committed to an analysis and understanding of modern experience, but distrusts a surface account of the visual world as a means of achieving it. Symbolism proposes a deeper investigation and revelation of the conditions of experience than the surface can provide.

58 George Frederic Watts, *Mammon: Dedicated to his Worshippers*, 1884–85.

The advent of an art explicitly concerned with contemporary life and subjects in Britain is in part the result of a shift from this Symbolist ambition to make sense of the contemporary world by uncovering abstract or generalised truths which can substitute for it, to an ambition to comprehend the modern on its own terms. In the history of that ambition artists like Sickert were also the heirs to a mode of painting opposed to Symbolism, one which attempted to transcribe and understand the character of modern life precisely by the cultivation of an art of the surface. Realist practice in all its variety proposed to pin down experience by

replaying its visual, often its optical, appearance rather than by attempting to con-
jure its essence. Realist attention was directed towards an account of the forms and
surfaces of the world, painting modern life through the kind of description the
analysis of appearance could offer.[18] A major figure in this tradition, Sickert con-
fronts head-on the task of understanding modern life. But, as the 'London
Impressionists' catalogue and the works it introduces imply, the character his solu-
tion assumed, his explicit interest in revealing the essential realities beneath
modernity's surface rather than its 'sordid and superficial details', is as deeply
indebted to the ambitions of English Symbolism to uncover the hidden truths of
experience as to the desire of British Impressionism and Realism to record and
define its surfaces and appearance.[19]

This apparent ambiguity in Sickert's artistic loyalties was the occasion of a
great deal of comment in the art press once he began to receive extended
reviews.[20] The critics see Sickert's work as a prime example of modernity in
English painting because they recognise a modern kind of puzzle, a very great
technical ability and sophistication put at the service of what seems unequivocally
sordid and ugly subject matter. On the one hand, for the critics Sickert is the pro-
ponent of an 'extremist Realism',[21] a recorder of the surface of reality, whose 'eye
is a purely mechanical contrivance for conveying images' which 'seems to strip his
subjects of all the[ir] aura';[22] on the other, he is a painter who 'like Mallarmé …
gives you a fragment here and a fragment there, enough to prove the reality of his
vision, but not enough to render it visible to the world',[23] or who shows 'how … a
subject may be beautified by the touch of mystery that results from a dextrous
suggestion of the unseen'.[24] The critics understand that Sickert has a visual pro-
ject, sustained over a number of years and a great many works, but are unable to
conceptualise it or articulate it in established terms.[25] They cannot understand the
content as anything but evidence of a perplexing desire to be 'modern' at all costs,
and they cannot see how Sickert's superb technical ability and subtlety of tone and
colour can be used to ends which are manifestly not about 'beauty' of subject
matter. Thus, the critic of the *Observer*, reviewing the New English Art Club show
in the autumn of 1909, praised Sickert's 'types and music-hall sketches for the
cruel truth of their brilliant impressionism', and had this to say about one of his
music-hall paintings:

> it is in … 'The New Bedford' that Mr Sickert, who so often devotes his distinguished
> talent to the cult of the ugly, achieves a degree of sumptuous beauty that only a true
> artist's eye can discover in the gilt and florid decorations of the hall, when the lights
> are lowered and only a gleam here and there alights upon some detail. I cannot
> remember another picture by Mr Sickert that shows so keen a sense of beauty, such
> absolute knowledge of where to stop, such consistent solidity of handling.[26]

The ambition which leads Sickert to combine both the investigation of interior
meanings and the surface appearances of modernity in the halls and elsewhere is
persistently troublesome to such commentators, who work, as the *Observer*'s critic

has here, to abolish one of the terms, reducing the surface, 'the cult of the ugly', to a known category of 'beauty' and technique. In fact, the tension generated by Sickert's collapsing of apparently opposed aesthetic strategies into a single endeavour is already in play in the 'London Impressionists' show, and in this Sickert and his co-exhibitors in 1889 are pivotal figures, engaged in creating out of the inheritances of English painting in the late nineteenth century the grounds and procedures on which the invention of a new art which could investigate and register modern experience could be conceived and taken forward.

The perception of the 'London Impressionists' show as centrally concerned with the requirements of representing modern experience is therefore accurate enough. But it is also the 'magic and poetry' and the 'beauty' of this material in the Symbolist sense which is to be evoked. The aim of these works is the articulation of the deep meaning of modernity, an analysis which would truly understand and communicate the character of its manifest subject matter by means of access to its profundities and essences. Leading exhibitors in 1889 like Philip Wilson Steer accordingly show a pattern of movement between the recording of surface and this delving for universal truth. *Girls Running, Walberswick Pier* (c. 1889–94, Tate Gallery) or *A Summer's Evening* (Figure 59) combine in their fabric the dual inheritance of Symbolism and Realism. *A Summer's Evening* yokes an overt reference to the universalised Symbolism of Puvis de Chavannes, to experimental paint marks which push forward the plein-air and recording ambitions of much English Impressionism.[27] Steer's most interesting works are hybrid, mixing techniques

59 Philip Wilson Steer, *A Summer's Evening*, c. 1887–88.

derived from Impressionist attention to the surface with the implication of hidden or indeterminate but significant meaning characteristic of Symbolism.

Like Steer, Sickert's thinking is saturated with this duality and he mobilises the characteristics of paint as a material practice in order to problematise and investigate its competing claims. He can do this because both Symbolism and Realism pursue their project to understand the world through the agency of the visual, although they interpret its character in very different ways. Ideas of the visual underlie both the optical realism of Impressionist and related practices and the investigation of the world as deep meaning which supports the project of Symbolist artists.[28] The visual describes both the understanding of the world as surface, as appearance, as what optically registers as its characteristics and organisation; and the visionary, the province of the seers and prophets so beloved of Symbolism: that which lies beneath the surface and in which reality inheres. Visuality bounces back from the surface, and it penetrates into the depths. It sees the reality of experience because it records what is really there; and it sees the reality of experience because it sees into and beyond what appears on the surface into the depths of meaning.

The question of the surface and of its fluid, contrasting meanings thus becomes a critical one for the representation of the world which Symbolist and Realist modes of understanding contest between them. Ideas about the visual can be understood to describe both an idea of the surface as the only authentic account of the world, and the alternative, the view that perception *beneath* the surface is what counts in the registration of reality. The possibility accordingly arises that paint, the substance of visuality itself, can serve as a vehicle which will accurately register surface reality or will uncover the depths of meaning in a revelatory transcription of essence onto the surface of the canvas. At a moment when the authority of language to register the world was increasingly in doubt, the promise of an unmediated access to reality through the visual media of paint and its graphic analogues became truly attractive.[29] But to say this is already to raise the principal difficulty, for paint is unquestionably material, a densely physical medium on its own account which inserts its own creation of the world into the ideal space of an unmediated presentation of reality.

This dual nature of paint allows it to match the opposition of Symbolism and Realism, depth and surface, with a third set of terms and to act, for Sickert, as a critical tool in opening up the implications of the modes of representation promulgated in the two positions. Sickert does this by problematising the signs which paint offers as a route to comprehension of the world. On the one hand, there is a neat sequence of connections to be posited which runs from the real via the visible forms and surfaces of the world to the surface of the painting which embodies the visual transcription of those forms and surfaces. On the other, there is the surface of the painting itself, a surface which intrudes into the fantasy of an unmediated transcription of reality a blatantly fictional skin of paint or cluster of marks which constantly threatens to reduce itself to its own materiality and to yield up its presumptive rights to *be* the world which it describes. The interplay between fictionality and reality which the

painted surface enacts allows the contest between a form of understanding which wishes to see truth in the visible forms and surfaces of the world and one which wishes to see truth only in what is *invisible*, beneath or behind those forms and surfaces, to be articulated and explored within the physical and material constitution of paintings themselves.[30]

Themes of visuality – looking, transcribing, the exigencies of the medium whether paint or some graphic process – all take the stage as important actors in Sickert's art because of their relationship to these issues and their power to express and articulate them within the works.[31] The visual seems to Sickert to be both the necessary medium of understanding and one which, by the very fact of its materiality, is compromised, or which carries inherent difficulties of analysis within it. This gives rise to a critical project within Sickert's oeuvre, one which both seeks to use the diagnostic possibilities of the visual to understand and determine the realities of contemporary experience, and attempts self-reflexively to understand the limitations and range of those possibilities. These preoccupations are discernable in the thematisation of visuality and the act of looking which occurs in Sickert's music-hall works. It is not just 'poetry and magic' which are derived in these works, the deep meaning of the modern, but also the adequacy of visuality as a tool for uncovering it, in effect the adequacy of painting as an investigative instrument for the apprehension of the realities of modern experience.

The music hall

Sickert's music-hall scenes fall into several distinct chronological periods.[32] They first appear in his oeuvre around 1887, and he produced a number of paintings and graphic works of the London halls in the years up to 1889, including some of the most important.[33] This first period includes the sequence of paintings which I shall discuss below, in which mirrors play an important compositional role. Returning to the theme from around 1894 to 1898, Sickert produced a number of studies, principally of the Bedford music-hall in Camden Town, the majority of which concentrate on descriptions of the audience. This phase of his work seems to have been brought to a close with Sickert's departure for Dieppe at the end of 1898. He was based abroad for seven years, returning to London to live and work only during 1905, a move which may have provoked his next sequence of music-hall subjects. In 1906–7, starting with *Noctes Ambrosianae* (1906, Nottingham Museum and Art Gallery), Sickert produced studies of the audiences seen in halls in London and Paris. Later, between 1919 and 1926, he produced several paintings with related themes, including *The Trapeze* of 1920 (Yale Center for British Art) and *That Old-Fashioned Mother of Mine* (c. 1920, private collection). After this, with the exception of one or two paintings like the well-known *The Plaza Tiller Girls* (1928, private collection), Sickert abandoned themes related to the halls. My interest here is in the work Sickert produced which takes music-halls proper (as opposed to theatrical or related subjects) for its theme, that is the work produced up to and including the 1906–7 series.[34]

This work uses the scenes of contemporary entertainment in the halls to stand for the character and meaning of the modern. It is, as elsewhere in Sickert, the very sordidness and déclassé quality of the rough-and-tumble music-halls, mainly located in outlying London districts, that suggests for Sickert an authenticity and reality as modern experience of the sort he wishes to transcribe and reveal to his audiences.[35] The theatricality – the literal falsity, dissembling and preoccupation with surfaces of the stage and the performances which take place on it – also allows Sickert to mount his dialectic between essence and reality through the depiction of music-hall scenes. The halls are, by their nature as performance, strong exemplars of surface. The stage and the performance, the involvement of the audience, and the question of its meanings for an art which has as its ambition the desire to transcribe and identify the realities of modern experience, are all ideal subjects for Sickert's working out of the issues of comprehension and knowledge his paintings take on so directly.

Sickert's music-hall scenes of the 1880s enact the injunction of the 'London Impressionists' catalogue to understand the modern world by revealing its essential meanings, by 'rendering' them to use Sickert's term, and he exhibited several in the 'London Impressionists' show.[36] When he was taken to task by a critic for imitating French Impressionist subject matter in his music-hall scenes, Sickert's reply was framed precisely to drive a wedge between the idea of a socially realistic content in painting and the imperatives which he wished to assert actually powered painting as a medium:

> At a given moment I was intensely impressed by the pictorial beauty of the scene, created from the coincidence of a number of fortuitous elements of form and colour . . . the fact that the painter sees in any scene the elements of pictorial beauty is the obvious and sufficient explanation of his motive for painting it.[37]

Here, as in the catalogue, the formal aspects of visual art can stand for the 'magic and poetry' of essential realities. As with Whistler's *Nocturnes*, it is the identification of the 'beauty' in modern life which defines its deepest truths. The social intentions of representation stand opposed to this. Instead of the depths within 'any scene' which define the Symbolist mode, Realist representation of the social is concerned with surface in the sense that its subject is the strict appearance of the world.[38]

The ramifying visual complexities and nested images of paintings like *Little Dot Hetherington at the Bedford music-hall* (Figure 60) or *Vesta Victoria at the Old Bedford* (Figure 61), are Sickert's meditations on this dialectic between the representation of the material surface of experience and what lies beneath, a dialectic which distills the dual inheritance of Realism's materialist observation and of Symbolism's desire to plumb the depths of inner meaning. In these works the tension between visual appearance and interior essence is thematised across the spatial and representational surfaces of Sickert's canvases by means of a systematic play on the status of representation.

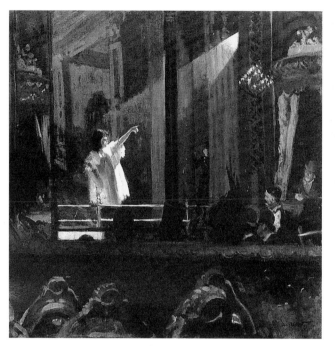

60 Walter Richard Sickert, *Little Dot Hetherington at the Bedford Music Hall*, c. 1888–89, private collection.

61 Walter Richard Sickert, *Vesta Victoria at the Old Bedford*, c. 1890.

In *Vesta Victoria* and *Little Dot Hetherington* space is deliberately presented as misleading: what we initially take to be the stage is revealed as a reflection, and the direction and attack of the singer's gestures have to be painfully reconstructed from the reversed information.[39] The first experience of encountering an image like *Vesta Victoria* is often one of pervasive and fundamental puzzlement. What is depicted here? And what are the relationships between the parts which we can make out? The eye persistently attempts to read the left-hand side of the picture as a hollow space which allows us to see into the hemisphere of the box. But the presence of the audience in the gods above therefore becomes inexplicable, a problem compounded by Sickert's abstraction and flattening of the vertical divider between the audience and the stage which here seems flush with the picture plane and parallel to it. Lower down, Sickert offsets the increasing clarity of this vertical element by juxtaposing it with an incoherent passage composed of fields of near-formless colour. It is only when we reach the very bottom of the canvas that the vertical element fully crystallises into the beaded frame of the mirror, at which point the spatial complexities of the painting at last become clear. Sickert, in short, assembles contrasts of represented space and flatness of picture surface in order to confuse and problematise our perceptions of the events he depicts.

Recession, too, challenges our understanding, as in *The Sisters Lloyd* (c. 1888–89, Government Art Collection), or *Little Dot*, where our perception of the

backdrop has to be laboriously wrestled clear of the perspective space. The surfaces of appearance are here made problematic for us. What we think we see is rendered uncertain both by the inherent theatricality, and hence unreality, of the performance and by the explicit play on representation and appearance which Sickert's use of mirrors, backdrops and theatrical devices facilitates.[40] *The P. S. Wings in the O. P. Mirror* (Figure 62) shows the performer reflected in the off-prompt mirror, behind the watching audience, whose fascinated attention to the stage therefore appears to us at first misdirected. We see the act of vision, of looking, of surrendered self-consciousness, as well as the performance which attracts it, but now the two are disjunctive and ill-matched. Appearance, analysis and display, the movements of the surface and of its meaning, come to us through Sickert's painting confused and in an alienated relationship to each other. It is as if the lines of relationship which connect appearance with the meaning of events are disrupted and difficult to access. Surface is revealed as inadequate and deceptive. 'Poetry and magic' arise from the observation of this disruption, and from the gap between the surface appearance, the act of looking and the reality of what is seen, imaged in the commercial halls where the essences of modern experience are played out through the surface of entertainment.

This might be regarded as stage one of Sickert's painted argument. In paintings like *Gatti's Hungerford Palace of Varieties: Second Turn of Katie Lawrence* (Plate 5), he advances it further through the extended use of facture and depicted space to

62 Walter Richard Sickert, *The P. S. Wings in the O. P. Mirror*, c. 1889.

problematise visual meaning.[41] In *Gatti's*, Katie Lawrence is standing full square in front of a backdrop curtain which has an elaborate architectural space painted on it.[42] There is none of the overt spatial obscurity which dominates *Vesta Victoria*. But, having set himself the challenge this poses, Sickert manipulates perception and space, surface and depth, in the picture by exploiting the ambiguities the backdrop curtain suggests.[43] As in *Little Dot* and *The Sisters Lloyd*, the *tromp l'oeil* effect of the backdrop confuses, since by the nature of painting itself it becomes difficult to decide whether what we are looking at is intended to represent real or painted depth. It appears moreover that the backdrop is depicted in such a way that the areas between the columns at the 'sides' are to be imagined as mirrors.[44] On the right, the distinction between the backdrop and the 'real' space is fairly sharply defined by the curtain (although this is only a darker

maroon compared to the lighter maroon, plum and dark pink dominant in much of the backdrop, a similarity which itself suggests more confusion or interblending of real and fictional spaces, perhaps even an identity). Although the pelmet of the curtain is visible across the whole of the top of the picture, it is much harder to make out what is happening on the left-hand side. The backdrop appears to extend beyond the edge of the canvas, but this does not really make visual sense as it becomes vertiginously difficult to disentangle real from fictional space. The thin strip of light colour at the bottom of the backdrop which marks the gap between it and the floor does not extend beyond the hats of the audience at the far left, so the final section lacks this key marker of difference. Immediately above the space on the left where this gap would be is a strictly illegible patch of paint in light and dark tan colours which has been simply scrubbed onto the surface of the canvas. This patch is strategically placed to allow the design of the backdrop to appear to be real space and to emphasise the effect of the perspective recession painted onto it. With this arrangement, it is almost impossible to read this left-hand section of the backdrop as flat. Only the hint of the swag of the curtain at top left allows us, if we notice it, to key in the proper relationships of depth and reality. At the far right, above the round plate-shaped hat of the watching woman, there is another similar area of illegibility which, although it doesn't have the same calculatedly disturbing effect as that on the left, also disrupts expectations of clearly differentiated space.

Sickert's technical procedures extend this play on real and fictional into other areas of the canvas. The yellow paint – applied very thin and liquid – which describes the low railings across the front of the stage is very clearly representation rather than mimesis, and functions as such. It is thin, wavery, it changes width with the pressure of the hand and the fullness of the brush. This is the mark of the medium, the declaration of the materiality of paint which asserts the impact of its physicality on the construction of an account of the world rather than its direct transcription. In a similar spirit, some of the heads at bottom right are outlined in a heavy black line. Sporadically across the surface (for instance in the woman's hat and hair in the foreground) there are lines of bright-red paint which seem at first to be the remnants of lines at right angles to each other like the grids used for squaring up. Some of the lines are tight and appear to be ruled, others are blotted. This gives a sort of random accent to the surface which provides visual interest, but it is certain that these grid lines were applied after the main stages of painting.[45] They are visible even where the main body of the paint is wet on wet, and it's clear that in some areas the red paint has been brushed dry over dried wet-on-wet paint.[46] Again, the woman's hat is liquid paint, and the thin drawn red lines can only have been added afterwards as overt reminiscences of the constructive capacities of squaring up in transferring the spontaneity of drawings into the more planned and considered arrangements of painting.[47] Like the patches of illegibility which paint itself, paint as material, is allowed to describe at the two sides of the canvas, these dialectical relationships of paint surface and descriptive technique function to draw attention to the character of paint as medium.[48] Paint in Sickert's music-hall

scenes is avowedly fictional, a medium of apprehension and understanding rather than a transparent transcription. It is precisely this fictionality, the metaphorical opacity of the medium, which is acknowledged through the literally opaque and declaratively material character of the paint itself.[49]

These are strategies designed to problematise the visual surfaces of these scenes. A mere description of contemporary life will not do. Not only the project of Impressionism to transcribe the surface appearance of modern life, but also the capacity of paint to image a deep, interior, reading of the material is explored here.[50] The music-hall becomes what W. J. T. Mitchell has called a 'hypericon', an image which works to raise and enquire into 'the act of picturing' or to 'imagine the activity of imagination, figure the practice of figuration'.[51] It serves as a workshop for Sickert's investigation of how painting might meet the desire for knowledge about the world. This investigation is focused on the question of the access to reality which paint affords. By exploiting the paradoxes and ambiguities which cluster around the representations the music-halls enact, Sickert raises and critically addresses the question of the possibility of a deep understanding of modernity and its communication in paint. Visuality functions as the critical tool of enquiry into this process.

The relationship to visuality also accounts for the interest so many of Sickert's music-hall paintings and drawings take in the audience. The various versions of *The Gallery of the Old Bedford* (Figure 63), or the 1906–9 series – which includes *Noctes Ambrosianae*, *The Old Middlesex* (c. 1906–7, The Beaverbrook Art Gallery, Fredericton, New Brunswick), with its bird's-eye view down onto the spectators in the stalls, and the *Gaîété Montparnasse* (c. 1907, private collection), which takes the opposite viewpoint, sharply upwards from the stalls into the gods – all dwell on the watching audience. In these works the loss of the self in the act of spectatorship is the sign of the direct involvement with the world, the absence of mediation which Realism might be thought to bring with it. The rapture of the audience as they watch, craning, leaning and gawping down, suggests the complete identity and involvement of the spectator with the spectacle through the transparent medium of transcription. But the observation of the audience in these works also allows Sickert to question and explore the adequacy of that account of visuality.

In one of the climatic paintings of the Camden Town period, *The Studio: Painting of a Nude* (Figure 64), Sickert brings the theme of visuality in this sense into the forefront of the canvas.[52] *Studio* places the nude figure which serves as the centre of attention in the Camden Town series into a more complex spatial setting and introduces the explicit figure of the painter observing his model in a mirror.[53] The multiplication of images of the nude here, both real and implied, together with her extreme passivity, suggest her function as the object of observation. The important action is the painter's translation of the nude body into the medium of paint. Likewise, the rapture of spectatorship, the loss and dissolution of the self in the parade of tawdry action on the music-hall stage can be brought back into the realm of comprehension by the pressure of the analysis the painter brings to bear

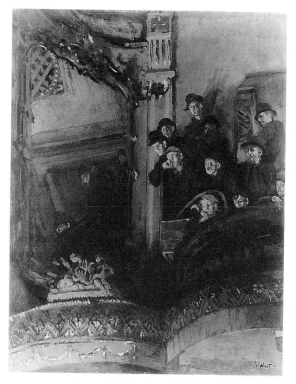

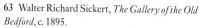

63 Walter Richard Sickert, *The Gallery of the Old Bedford*, c. 1895.

64 Walter Richard Sickert, *The Studio: Painting of a Nude*, 1906.

on it. It is the painter's vision which renders the nude and the audience, the music-hall and its performers, meaningful, and exemplary of modernity and reality. The music-hall audience, like the nude, is itself the object of observation by the painter's vision. The meaning of these events seems to be that they *are* observed and therefore brought into the context of knowledge. In both types of subject matter Sickert's painter's eye can assess, discriminate, classify and analyse the shifting social practices of modernity.

The audience of watchers is the defining sign of the loss of self-consciousness consequent on the abolition of the medium of understanding which vision is imagined to be. But it is also the opportunity for Sickert to create a conceptual laboratory which will allow him to investigate that situation and hence to assess the position of the painter as well as of paint. The painter sees not only the world, but also those who look at it; not only reality, but its watchers, too. This serves to assert the authority of the painter, as the finest example of visuality and its power, the purest vision, and the purest instance of visuality at work. But the fictionality of the music-hall performance acts as a sign of the potential inadequacy of the revelation which visuality, and hence the painter, claims to offer. Sickert's play with mirrors

and his insistence on the contested nature of visual knowledge in painting increase this effect and draw attention to it. Thus the audience is the image of the direct engagement with the world that visuality claims it can deliver, but the location of this example is within circumstances which are clearly fictional. The audience's rapture is provoked not by immediate reality but by theatrical performance, a fiction which deceives them and their fascinated observation. Depth frustrates surface here. The fact of the artist's own observation of the audience and their deception allows space for Sickert to consider the realities of the claims of the visual. The artist as observer still retains some authority, but the implication of the critique of visuality the audience allows is that he, too, is compromised.

The drawing Sickert made of the drop curtain at the Gaiété, Montparnasse sometime around 1906–7 displays this compromise in a summary form (Figure 65). The curtain is, first of all, a surface, its smooth fall obscuring the arrangement or rearrangement of objects and events behind it. The curtain here stands in for the flat surface of the canvas or paper and, like those surfaces, it is marked, scored with a multiplicity of signs, both visual and verbal, and both representational (the drawings and icons of the advertisements) and conventional (the linear elements which divide the screen into boxes and hence into discrete commercial spaces). But the marks which describe the curtain and the signs for which it is the material vehicle

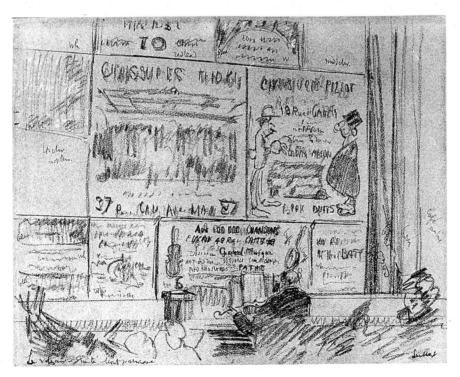

65 Walter Richard Sickert, 'The Drop Curtain at the Gaiété, Montparnasse', c. 1906–7.

are identical to those which describe the surrounding spaces in the drawing, suggesting that the semiotics of modernity which the curtain carries are not seen separately from the social space in which their meanings become dynamic and are consumed. Sickert's attention, despite this, is firmly focused on the curtain itself and the messages it flashes out at the audience beneath it.

This is a moment at which Sickert pays attention to surface as such and thematises it as a subject in its own right. Surface in paintings of the Camden Town period like *The Studio: Painting of a Nude* stands for the imposition of meaning on the world by the controlling mark of the painter's hand. Even the nugatory or trivial can be brought into meaning once a particular quality of attention is paid to it by the central self of the painter, wielding the brush or pencil as instruments of knowledge and definition of the world. The overt presence of the paintwork in Sickert's surfaces functions as a sign of this authorial knowledge. Surface is the place, the site, where that process of definition takes place. And here we have a surface on which particular sorts of modern meaning are very frankly declared. What is thematised is therefore the process or fact of surface as meaning. The sort of meaning it is, of course, is another matter. The modernity of the advertisements makes them also the *subject* of Sickert's attention. They are what he understands and renders comprehensible through the practice of his art. By the process of drawing them, the advertisements become known, are brought into the orbit of comprehension, but they also *are* that process, and their superficiality (in the literal sense), flatness, reduction of the signs of meaning to a few gestural formulations, suggests at the same time the problems attendant on knowing the world through representation. What is happening here is that Sickert's own practice, his own use of surface and materiality to render modern life in a form of knowledge, is seen as inadequate, as a reduction of the fullness of the world into a flattened surface, into *representation*. What presents itself as informational, as knowledge, as reportage about the world, is revealed as discourse, as invested or interested. The view of reality which the surface encapsulates and promotes is a partial rather than a full account. It is compromised and bound into the systems it seeks to explicate.

I have been arguing that Sickert's perception of the mediation of the painter and of paint itself as matter which stands between the reality of the subject and the transcription, that is the understanding and apprehension of that reality in the picture, serves as the motivating power of his modernism as a painter.[54] It accounts for his highly wrought and self-conscious paint surfaces and for the shifts and stratagems which he employed as a technician and which he constantly changed or altered, experimenting with their possibilities. It accounts as well for his interest in performance and in the audience, in the observers, and in the observation of observers which so many of the music-hall works conduct and meditate upon. All these are signs of mediation. Sickert's art at this time is, in the end, an art about the theme of mediation and the impact of mediation on our understanding of the world. These are fundamental questions about *how* visual art as a practice can understand and

communicate knowledge about the realities of experience and the world, whether through the meticulous transcription of the appearance and surfaces of the world, or through the transmission of an insight into its conditions and essence. In that account the identity of the painter is placed precariously within modernity, but the power to understand that situation arises precisely from that precariousness. The painter is a modern identity, contingent and indeterminate in ways which Sickert's critical reception before the First World War also reflects. Katie Lawrence or Vesta Victoria are homologues of this situation. They, too, are quintessentially modern identities which Sickert's paint seeks to transcribe and communicate, to see into and beneath, to their essences or essential truth. But they are also marks of paint on the surface of the canvas, things observed, seen, watched, subject to the observing presence of the painter and his distillation of knowledge in the physical constitution of the artwork.

This involvement in the adequacy of the painter's ability to investigate the world through the medium of paint, seems to me to carry important implications for our understanding of the history of English art during these years. Pigment and surface, observation and the fact of being observed, can carry meanings and these meanings are themselves historical, keyed to specific moments of social and cultural formation, including the formation of artistic identity. If we are to understand the development of modernism in England and the nature of the modernist painting Sickert and others produced, we need to attend to the role the materiality of paint played in that project and in the unfolding of that history.

Gwen John's *Self-Portrait*:
art, identity and women students at the Slade School

Alicia Foster

Gwen John's time at the Slade School of Fine Art, which lasted from the autumn of 1895 to the summer of 1898, is not well documented. Much of her work from this period is lost, and few of her papers have survived. However, a self-portrait which was made by the artist during the late 1890s is extant and is part of the National Portrait Gallery collection (Plate 6). The painting creates a strong and uncompromising image of the artist as a young woman. Gwen John represented herself as a dashing and assured figure, the confidence of her gaze and pose echoed by the flamboyant full sleeves of her blouse and the jaunty bow at her neck.

It is tempting to read *Self-Portrait* simply as a transparent record of the artist's appearance and character, as first-hand evidence of her taste in clothes and of her personality during her youth. However, I will argue against such an interpretation, not only on the grounds that *Self-Portrait* can be understood as constructing rather than reflecting identity, but also because such a straightforwardly evidential reading actually undermines the significance of the image. *Self-Portrait* is an important painting because it is one of the few works by a woman student at the Slade during the late 1890s to have survived. As such it is a reminder of a history which has often been overlooked completely, or subsumed within the much circulated stories of the male students of the period. I will attempt to sketch this different history, and will show how the women students' particular experiences of art-school training, working in the life room, travelling in the city and making sense of themselves as artists at the end of the nineteenth century shaped the creation of Gwen John's *Self-Portrait*.

Accounts of the importance of the Slade at the time when Gwen John was training there, and of the influence of its tutors, Frederick Brown, Henry Tonks and Philip Wilson Steer, continue to feature in writing on the students who became famous artists and in histories of British art education. The mythology surrounding the Slade during the 1890s began with the literature which it produced

itself. It was during this period that the Slade ran its own magazine, *The Quarto: A Volume Artistic Literary and Musical*, in order to chronicle the work and successes of tutors and students.[1] As early as 1907 a book was published on the alumni of the turn of the century, written by an ex-student, Fothergill.[2]

In much of the literature on the Slade during the late nineteenth century women students have been represented as a talented and decorative group, of less artistic importance than their male colleagues. There have been many descriptions of the work, appearance and life-styles of the men students, and particularly of Gwen John's brother, Augustus, who was portrayed by fellow student William Orpen in 1899 wearing the stylishly shabby clothes, hairstyle and beard which denoted the bohemian (Figure 66).[3] The late Victorian idea of bohemianism appeared in popular literary accounts of the Parisian left-bank art world, such as George du Maurier's novel, *Trilby*, which was published to great acclaim in 1894. That the book was known to Slade students is indicated in the diary of a student, Wyn George, for the academic year 1896–97: 'a girl named Gwen John asked me if my name was "Trilby", then sketched me gobbling on an apple'.[4] Du Maurier's novel tells the story of a group of male art students in Paris, and their female model, the eponymous Trilby. Trilby's position in the art world is defined within the text of the novel and its illustrations: she models for the men, cooks for them and mends their clothes. The image of the bohemian artist was in such ways predicated on masculine social and sexual privilege. In William Orpen's

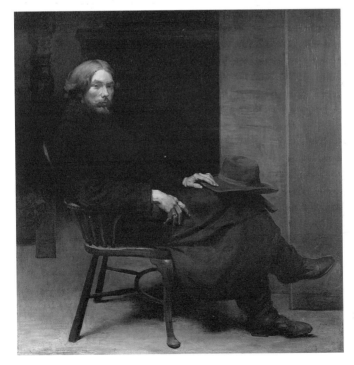

66 William Orpen, *Augustus John*, 1899.

portrait of Augustus John, the bohemian sits, suggestively, in front of a four-poster bed.

Critical emphasis on the colourful male students of the 1890s and the concurrent marginalisation of their female contemporaries began early. Although during the late 1890s approximately two-thirds of Slade students were women, they make up only a quarter of the artists mentioned in the 1907 publication by Fothergill.[5] The different treatment given to the two sexes can be traced back to the institution of the Slade, and its demarcation of male and female students and their spaces. The function of institutional architecture has been theorised by Foucault in terms of the technologies of power which are constituted and operated within buildings.[6] As Foucault argued in *Discipline and Punish*, institutional power relations work both through the ordering of space and through 'discipline', which combine to create a position for the individual through the location, organisation and surveillance of activities, and the division of time.[7] The difference of female students at the Slade was structured within both the space and the discipline of the School. Slade School floor plans of 1895–96 show separate women's rooms in the basement of the building, next to the lower life rooms, and they were placed in a different room for study from the life model, the most important part of Slade training.[8] Women were also listed separately and their names recorded differently from those of male students in registers and documents.[9]

The organisation of the Slade contributed to the wider enforcement of separate spheres for the sexes which had accommodated women in the art world since the mid-nineteenth-century, a strategy by which they could be allowed to practice (in increasingly large numbers) while at the same time being contained, supposedly, by the unchallenging denomination of 'lady artists'. This ideology is expounded in Wyn George's diary entry for May 1897, in which she wrote about a tutorial with Miss Elder, a teacher at the Slade who does not appear in the histories of the School.[10] According to Wyn George, Miss Elder advised her as follows:

> Man and woman are equal. But man stands on his own ground and a woman on hers – a woman cannot compete with a man on his ground – there has never been any very great woman painter, which goes to show that man has a greater creative, more imaginative force than a woman – and the woman has more intuitiveness of refinement, grace and beauty in drawing. So many women go on men's line and it is hopeless – woman must find out her ... groove in art and never attempt to do things as a man. Of course it is very difficult for women to do this because we have no great women painters to go by.[11]

Foucault issued the following proviso with his analysis of institutional space: 'there always remain the possibilities of resistance, disobedience, and oppositional groupings.'[12] For feminist critics this helps to theorise the position of women within patriarchy *or* assigned a specific space yet not necessarily contained by it. Teresa de Lauretis has analysed women's often unacknowledged agency 'in the margins ... of hegemonic discourses and in the interstices of institutions, in counter-practices

and new forms of community'.[13] Such a formulation opens up the possibility of looking again at the women students in the Slade during the 1890s. Although they have appeared pushed into the margins of the numerous histories of their male con-temporaries, and were unable to take up masculine artistic identities such as the bohemian, this does not mean that the large group of women students could not develop their own creative practices and definitions of themselves as artists.[14] The art and writing of these women can be interpreted as a space in which they were able to negotiate their own lives, work and artistic identities.[15]

For women students the Slade's location as part of University College, London was of particular significance. By the 1890s women had made progress in their struggle for equal rights to higher education, but continuing discrimination restricted what they were allowed to study and demeaned the status of their educa-tion. But not only was the Slade part of a university, the training it offered was per-ceived as advanced. As early as 1883 Charlotte Weeks described the school as modern and progressive and emphasised the fact that it offered both men and women alike a serious fine-art training.[16] By 1895 Tessa Mackenzie declared that the Slade had 'become one of the most important Art Schools in the kingdom'.[17] The system of study there, inspired by the French atelier system, was based on rig-orous work in the life room, to which women students were also given access.[18] By contrast the nearest rival to the Slade, the Royal Academy, still concentrated on working from antique casts and favoured the use of academic stippling tech-niques.[19] It also barred women students from its nude life rooms.[20]

The opportunity to train at a progressive and prestigious institution must have been a strong incentive for the women who registered at the Slade for the 1895–96 session alongside Gwen John. The relative informality of Slade admission proce-dures also encouraged them to apply. Prospective students were interviewed by the Professor, and their sketchbooks and drawings were examined. By contrast the Royal Academy required a candidate to have extensive previous training in order to pass the drawing examination and produce the standard of work required for an entrance portfolio.[21] Such preparatory study would have been unavailable to most women during the late nineteenth century, and this partially accounts for the popu-larity of the Slade for female students, even though it was fee-paying while the Academy Schools were free.[22] Nevertheless, during the Slade admission proce-dures prospective female students were treated differently from male applicants. In addition to the usual interview with the Professor, women candidates had to meet Miss Morison, the Lady Superintendent of University College, to whom they had to present a formal letter of introduction, implying that for women respectability was as important as artistic talent.[23]

Students at the Slade began their training in the antique room before pro-gressing to the life room as quickly as possible. Life-drawing skills were essential for professional artistic practice during this period and were the focal point of the Slade training. However, working from the life model was different for women stu-dents not only because they were housed in a separate room, but also because the

history of their access to the model and their relationship to contemporary debates on the viewing and representation of the female nude were also different from those of male students. There were discourses concerning the signification of the female nude in circulation at the Slade which were difficult for women to participate in because they were structured around sexual desire and the possession of the female body, and so privileged a male viewer.[24] Despite this, examination of the written and visual material produced by the women students suggests that rather than being prevented from working successfully in the life room, they were able to develop their own distinct yet diverse approaches to the female nude.

Although some ideas of respectable femininity still debarred women from life drawing, Slade students could ally themselves with the increasing numbers of women who were professional artists. Wyn George's diary suggests that, although she was aware that working from the nude could be frowned upon, the prospect of disapproval did not make her question the activity, neither did it hamper her work. She wrote that she adopted the strategy of not mentioning this aspect of her training to those she felt would not understand.[25] Moreover, Wyn George's accounts of visits to contemporary art exhibitions represent her emphatic rejection of some of the central discourses of the female nude in late-Victorian art. In the winter of 1896 she wrote that she had been to an exhibition of the New English Art Club (NEAC) and seen a painting by Henry Tonks entitled *A Lady Undressing* which she found 'a queer subject – not at all inspiring'.[26] Visiting another exhibition in early 1897, she described some of the work on show as 'beastly – Frenchy', commenting, 'I think it simply wicked to degrade art so.'[27] By questioning the suitability of Tonks's subject and categorising 'Frenchy' art as degrading and wicked, Wyn George distanced herself from the interpretations of modern French art which informed the work of the Slade tutors and the NEAC during this period. In doing so she allied herself with those British critics who perceived French art as decadent and unwholesome during the 1890s.[28] However, she also dismissed the neo-classicism of the first Slade Professor, writing, 'went to S. K. Museum with Daisy Fawcett … Poynter's I didn't like at all! So sick of Grecian girls and marble.'[29]

Throughout her diary Wyn George described herself as developing strategies which would allow her to view, represent and take pleasure in the female nude. She wrote of being overwhelmed by the beauty of a new model, yet the woman's 'graceful, gentle and ladylike' manner reminded George of some of her own friends, and she found it impossible to draw.[30] A belief in the class difference of the naked woman before her seems to have been essential for George. For women students at the Slade, who are likely to have been exclusively of the middle and upper classes, a working-class female model could have been perceived in similar terms to the working-class women servants who were employed in their family homes. Any sense of the disruption of the rigidity of class divisions within the life room may well have been unsettling because it forced an unwelcome identification between the female student and the posing woman. The approach which George seems to have found workable combined a reassuring awareness of the class divide which

separated her from the model with a belief that the purpose of life drawing was to celebrate beauty.[31] Other women students developed different ways of dealing with the female nude. Focal points of the Slade calendar were the regular student competitions, one of which was for the 'best composition from a given subject'.[32] In her memoir Edna Waugh wrote about spending a day at home in front of a bedroom mirror 'lying half dressed in awful positions, being raped', posing for her own watercolour 'The Rape of the Sabines', and also of modelling for Ida Nettleship's figure composition.[33] The respectability of these middle-class women students would have been jeopardised if they had acknowledged at the time that they had worked from studies of their own bodies rather than from those of anonymous working-class models.[34]

Despite the complexity of their relationship with the female nude women students had some success at the Slade. Edna Waugh's watercolour won a prize in 1897 and was reproduced in *The Quarto*.[35] Gwen John was herself awarded a certificate for figure drawing and a prize for figure composition.[36] And five of the seven Slade Scholarships awarded between 1895 and 1898 were given to women students, including Gwen John's friends Ida Nettleship and Edna Waugh.[37] Wyn George gave a vivid account of a fellow student receiving an award: 'at 3.30 the criticism took place. Such fun. Bone room was packed. Girls sitting and boys and men standing ... Miss Salmond got the prize when Pro gave it out she looked as cool as a cucumber. All the men clapping etc. Hurrah! for the girls!!'[38] Nevertheless women students embarking on careers as professional artists faced considerable discrimination from selecting juries and galleries. The Slade tutors held sway over the NEAC during the 1890s, which showcased their work, and those of artists who were felt to be in sympathy with their aims. Although the NEAC might, as a result, have been expected to promote the work of women artists who had trained at the Slade, they were excluded from its administration and were also a marginal presence among exhibitors.[39] There is evidence to suggest that women students at the turn of the century attempted to redress the balance. In 1902 *The Studio* magazine noted the formation of an organisation intended to provide both current and former women Slade students with a space in London for study and creative practice, and to hold exhibitions of their work.[40] At University College they were able to join the newly founded Women's Union Society, established in 1897.

Just as they were consolidating their hard-won position within higher education during the 1890s, women were also claiming new spaces within the city. For women students such as Gwen John, who came from the provinces, studying in London often meant leaving the family home to live independently. Art students also had to travel around the city to and from the Slade, and in order to visit and study in galleries and museums.[41] In November 1896 Wyn George wrote of the pleasures of a day in London:

> At 12.30 Miss Wilson and I walked down Tottenham Court Road to Oxford Street ...
> The shops were lovely ... Such beautiful things – enough to make your mouth water.

> Walked down New Bond Street. Splendid picture shops, Lovely diamonds. To Piccadilly had lunch in an ABC then on to the National Gallery. Went to the late Italian then had a look round the British and Turner water colour drawings ... Back to Gower St. Short poses.[42]

Edna Waugh reminisced about her experience of the city as a student:

> I always loved wandering in London which was also a city full of life and adventure. If I happened to miss my train home or whenever I had an hour to spare I went strolling about the streets, drawing and looking at all the wonderful things that were going on.[43]

Although both of these women wrote about their presence in the city being threatened or challenged, they represented themselves actively contradicting the image of frail femininity in need of protection from urban dangers. Edna Waugh's account of being harassed by a group of men when she lost her way in London concludes with a description of her composure and control 'in confronting them and receiving directions.'[44] Wyn George wrote dismissively about the advice of a guard at the National Gallery that she shouldn't make her visits alone.[45] Travelling in London was even the subject of a debate at University College in May 1896. Against a motion that 'The World is Degenerating' a Miss Oliver countered that 'she was very happy and pleased with life' because she could travel on railways and on the bus pursuing her studies. The ultimate progress would be, she continued, when women students smoked in their common rooms as male students did.[46] This desire of a woman student to smoke openly in the University signified more than a taste for tobacco. It was part of a wider challenge to male privilege symbolised by the 'New Woman', for the conventional late Victorian lady was not the only model of femininity available to women students at the Slade.

'New Woman' was a label attached to a type of female character who began to appear in novels by writers such as Sarah Grand during the 1890s. As a woman who sought an independent life and fulfilment through the development of her own talents, her potential attraction as a role model to women students is, therefore, very understandable. Viv Gardner has argued that, although the typical New Woman figure represented in the media, with her 'masculine dress and severe coiffe', who spent her time 'smoking, riding a bicycle, using bold language and taking the omnibus or train unescorted', was a caricature, she was also a 'composite product of the accelerating woman's movement'.[47] Her image, made up of various combinations of the recognisable components of cigarette, tailor-made separates, spectacles and the latchkey to her own house, was both a parody and a reflection of the appearance of many independent single women.[48]

During the 1890s the self-representation of some women art students shares marked characteristics with the image of the New Woman. On a travel scholarship to Florence, Ida Nettleship wrote to her sister and described herself smoking a cigarette before starting to draw.[49] As Dolores Mitchell has noted, some women artists at the end of the nineteenth century produced images of modern women smoking and even self-portraits with cigarettes, referring to the commonly held belief that

tobacco stimulated creativity. For the woman art student, smoking could signify both a pleasure and an artistic identity which had hitherto been seen as exclusively masculine.[50] Feminine appearance as an important signifier of creativity was a theme of Wyn George's diary. After her first day at the Slade she noted, 'the girl students are all very nice looking – artistic – most of them very tall and fine – after Venus of Milos types – big waists and figures – hair done very untidily'.[51] The women's unkempt hair flouted definitions of femininity as neat and decorous, and the reference to 'big waists' suggests that they had rejected the corsets which literally underpinned conventional fashions. George's mention of classical sculpture in this context implies that she was aware of current debates over dress. As Stella Newton has shown, the female figure in classical sculpture was perceived by late nineteenth-century advocates of dress reform as epitomising the beauty of the uncorseted female form.[52] Edna Waugh also wrote about her appearance at the Slade; according to her memoir she wore 'a belted overall of Holland, three rows of coral about my throat', combining a practical garment with artistic jewellery.[53]

Gwen John's interest in her own image is evident in *Self-Portrait*. Conservation work on the painting has revealed the stamp of a Parisian artists' colourman,[54] which suggests that it was made during, or soon after, the artist's first visit to the French capital in winter 1898–99 with two of her friends from the Slade, Ida Nettleship and Gwen Salmond. The visit was planned in order to further their art training in the Parisian ateliers. It coincided with the opening of Whistler's Académie Carmen, where Gwen John received painting tuition. Given the crucial role of appearance in creating and stating a new feminine artistic identity and presence, it is not surprising that all three women were reported as making self-portraits and portraits of each other during their stay in the French capital. Ida Nettleship wrote to her mother that 'Gwen S. and J. are painting me and we are all three painting Gwen John.'[55] Although the works by Gwen Salmond and Ida Nettleship referred to in the letter have not been located or reproduced, in addition to the *Self-Portrait*, a painting which Gwen John made of her two friends does survive.[56] The recorded work of their Slade contemporary Edna Waugh from this period includes three self-portraits and a double portrait of the artist with Grace Westray, another art student, underlining the importance that the women attached to representing themselves.[57]

The composition and pose of the figure in Gwen John's *Self-Portrait*, which creates such a striking image of spirited confidence, immediately suggests her awareness of the portraits of artists such as Van Dyck, Hals and Velázquez. The history of Gwen John's access to and interest in such works links the painting again to her studentship at the Slade during the late 1890s. Visiting art galleries and copying works in their collections was part of Slade training, and there are records of Gwen John's registration as a copyist in the National Gallery.[58] However, it was not only Slade students who were involved in the creative practice of working from the art of the past. There was widespread interest in artists such as Van Dyck and Hals, and numerous artists reworked old master portrait styles, including Sargent and Whistler. Sargent made use of the historical tradition of the full-length pose which

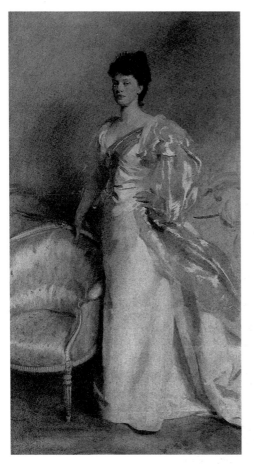

67 John Singer Sargent, *Mrs George Swinton*, 1897.

allowed detailed representation of the sumptuous dresses worn by society women, as in his 1897 *Portrait of Mrs George Swinton*, standing in an evening dress with her hand on her hip (Figure 67). As Margaret Maynard has shown, there were complex social and political investments in historical-revival portraiture during the 1890s.[59] The genre was largely used to represent women; male sitters featured far less frequently. Although, as Maynard points out, the female subjects of such portraits were just as likely to come from newly moneyed families as from the aristocracy, in either case the women were portrayed as spectacles of wealth and beauty, suggesting both a familial and cultural lineage and the social preservation of class and sexual difference.[60] Dress was crucial to the formation of these images of femininity. The lavish historical-revival costumes in which Sargent and his contemporaries represented many of their female sitters constructed a feminine identity at variance to the troubling and socially disruptive image of the New Woman in her practical clothes.

Gwen John's *Self-Portrait* clearly makes use of the conventions of old master portraits, but it creates an alternative femininity to the highly decorative images of women created by many other artists of the 1890s who were involved in reworking the genre. The most obvious difference is in the size of the portrait. While the scale of Sargent's work was in proportion to the grand rooms of his rich patrons, Gwen John's *Self-Portrait* seems to follow the trend among many of the NEAC artists who, *The Times* noted in 1901, were making 'portraits for which everybody has room and which do not look hopelessly out of place in the small houses with which most people have to content themselves'.[61] The composition which Gwen John used is also distinct from many other historical-revival images of femininity. Instead of representing herself as a full-length spectacle wearing an elaborate sweeping gown, the artist painted herself as a half-length figure with a level gaze, the position of her right arm, swathed in material, emphasising the full curve of her sleeve. Although this composition does not include the signs of artistic production, palette and brushes, it still signifies artistic identity as similar poses and formats

had been used by a long line of male artists to create their self-portraits – notably Rembrandt, in his *Self-Portrait aged Thirty-Four* of 1640 which Gwen John is likely to have seen in the National Gallery. From the 1870s to the 1890s this compositional format was being reworked by Whistler, the contemporary artist perhaps most admired by Slade tutors and students, in a series of self-portraits including *Gold and Brown* of c. 1896–98 (Figure 68, see also Figure 53).[62] Whistler's use of this composition specifically in order to signal his power and prestige as an artist is evident from the fact that he painted *Gold and Brown* for an exhibition of the International Society of Sculptors, Painters and Gravers, of which he was president, in London in 1898. In contrast to Sargent's dazzling paintings of women in opulent dress and surroundings, Whistler's reworking of the old master tradition of self-portraiture used close tonal harmony, subdued colour schemes and plain backgrounds to create an image of an artist of great stature and authority. It is this tradition of male artists' self-portraits which Gwen John's painting follows.

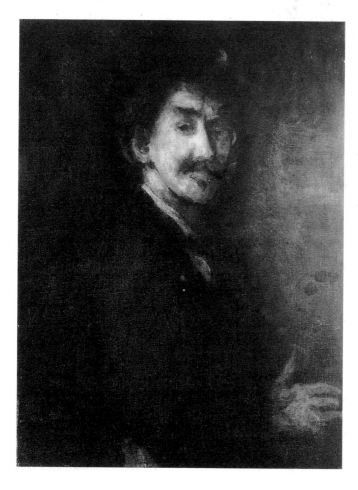

68 James McNeill Whistler, *Gold and Brown*, c. 1896–98.

Gwen John's use of the tradition of male artistic self-representation to make a self-portrait as a woman artist can be clarified by what has been termed the masquerade of womanliness. Masquerade was theorised by Joan Rivière in 1929 in a case study of a woman who, in order to mitigate the threat which her success in the 'masculine' role of successful public speaker posed to her male colleagues, presented an alternative image of femininity to them as unchallenging, frivolous and flirtatious.[63] Rivière concluded that womanliness could be strategically 'assumed and worn as a mask'.[64] In her article on the self-representation of the artist Marie Bashkirtseff, Tamar Garb deployed the psychoanalytic term in order to analyse Bashkirtseff's multiple and sometimes contradictory images of self in portraits, photographs and writing.[65] As Garb argues, it is in the gap between the representation of femininity and the historical individual woman that women have agency. The usefulness of masquerade in interpreting Gwen John's *Self-Portrait* lies in its capacity to analyse women's ability to take up and manipulate forms of self-representation, even those which gender roles should have prevented them from using.[66] Gwen John was not alone in deploying such a strategy. As we have seen, other students at the Slade were well aware of the possibilities for constructing identities through appearance.

Other women artists working during the late nineteenth century also made notable use of masquerade. The successful painter Thérèse Schwartze did so in her *Mlle Thérèse Schwartze faisant son portrait* of 1888, which was commissioned by the Uffizi Gallery. It shows the artist wearing modern costume but adopting a pose which clearly refers to a famous old master painting. Thérèse Schwartze's stance, her left hand shadowing her brow and her right holding palette and brushes, is a direct reworking of Reynolds's famous *Self-Portrait* of c. 1747 in the National Portrait Gallery, placing the woman artist in a composition which signified renowned masculine artistic identity. In a comparable way, women writers of the period also used masquerade in their novels. Ann Heilman has pointed out that this representational mechanism allowed these writers to 'stage a silent revolt against gender restrictions and invade male territory otherwise closed' through the representation of their heroines.[67]

Across the traditional bravura pose of artistic self-representation Gwen John overlaid a portrayal of her own face and also of a particular style of dress which is crucial to the identity constituted within *Self-Portrait*. The full sleeves of the blouse recall Rembrandt's costume in his *Self-Portrait aged Thirty-Four* but also locate the painting firmly within the mid-to late 1890s when such sleeves were again in vogue.[68] The fashion among women students was remarked upon in a verse which appeared in the *University College Gazette* in 1897:

> Who is this that comes to college
> Bent on the pursuit of knowledge
> Who is this that nature grieves
> with those two balloon like sleeves
> Who is this? but stop – be prudent –
> 'Tis the college Lady Student.[69]

Painting herself in this garment, Gwen John represented herself as a woman who knew about contemporary fashion and was aware of the significance of her own appearance. The large bow tie is bold, rather than delicate and pretty. The separate blouse and skirt, which would have been worn with a tailored and perhaps matching jacket, was a modern innovation in women's dress. The New Woman was often caricatured wearing such garments because they were seen as practical; the blouse and skirt, therefore, have an implication of women at work which is similar to Wyn George's corsetless classmates and Edna Waugh's holland overall. This type of costume was also used in other representations of women artists. Hélène Postlethwaite's article 'Some noted women painters' which appeared in the *Magazine of Art* of 1895 was illustrated with paintings of women artists, including Flora Reid's self-portrait wearing a large bow at her neck and full-sleeved tailored jacket over her blouse.[70] The clothes worn by Gwen John in this portrait imply a difference in class from that of Sargent's wealthy sitters in silk, lace and velvet. Although women's separates became a staple of late Victorian fashion, and luxurious haute-couture versions were created for the rich, the blouse and skirt in Gwen John's painting are clearly not of this quality.[71] The relationship between art, class and femininity is aligned in a specific way in Gwen John's small painting of herself wearing such clothes. Rather than the spectacular displays of their women other artists created for the wealthy, Gwen John's *Self-Portrait* offered to the people described by the *Times* reviewer as living in 'small houses', the natural audience for the work on show at the NEAC, an image of a woman artist of their own class.

If, as seems probable, Gwen John's *Self-Portrait* is the *Portrait of the Artist* with which she made her exhibiting debut at the NEAC in 1900, its significance as a compelling statement of feminine artistic identity becomes clear.[72] As was usual at the NEAC, works by women artists were greatly in the minority. Among the exhibits were two images of male artistic identity, Orpen's imposing painting of Augustus John (Figure 66) and William Holman Hunt's *Portrait of Dante Gabriel Rossetti*.[73] Exhibiting this *Portrait of the Artist* as a young woman who was both modern, yet firmly located within an illustrious tradition, made an exquisitely skilful and carefully judged intervention into an organisation which discriminated against women. It provided a much needed counterpoint to images and ideas of male artistic genius, and its presence is likely to have been appreciated by Gwen John's female contemporaries at art school who were also involved in the business of negotiating their appearance in the city and at the Slade.

The 'Jewish mark' in English painting: cultural identity and modern art

Janet Wolff

In her memoirs Lady Ottoline Morrell recalls a visit to Mark Gertler's studio in 1914, saying of his paintings 'in those early days there was still the Jewish tradition, the Jewish mark, which gave them a fine, intense, almost archaic quality'.[1] The notion that some 'Jewish' quality could be detected in a work was quite widespread in England in the early twentieth century, and could be found, too, among Jewish writers on art. In this chapter, I want to explore the question of 'Jewishness' in art, in relation to debates about the construction of 'Englishness' in the same period. As several scholars have recently shown, 'Englishness' is defined negatively in relation to its exclusions.[2] Social historians have demonstrated the centrality of Jews and Jewish identity in the production of this national ideology in the period before the First World War, suggesting that to be English was, amongst other things, to be not-Jewish. My intention is to examine the manifestation of this discursive strategy in the visual arts, in particular in the texts of art criticism. For the most part, discussion of the construction of 'Englishness' has been within the disciplines of history and literary criticism; the 'Englishness' of visual art is only now being taken as a topic of analysis (though it has a kind of pre-history in Pevsner's 1955 Reith Lectures and subsequent book, *The Englishness of English Art*).[3] Here I will consider examples of the work of certain Jewish artists in the period 1910–20 (Mark Gertler, Jacob Kramer, Jacob Epstein and David Bomberg), as well as the critical response to their work, in order to assess how much the 'Englishness' of modern art was seen to be dependent on the identification, and exclusion, of 'non-English' ('Jewish') visual style. I want to suggest that although it is important to understand this attribution as ideologically and discursively produced, there is also a sense in which we may still want to consider the relevance of ethnicity in relation to these works – in terms of their subject matter, style, and social conditions of production.

The premise of Robert Colls and Philip Dodd's seminal book on Englishness is that the period 1880 to 1920 was a crucial one in the formation of a new and important conception of Englishness, one which redefined the nation and its cultural attributes in specific ways which have had implications for twentieth-century

Britain up to the present moment.[4] Starting from the acknowledgement that there is no fixed meaning of 'Englishness', but rather that 'Englishness has had to be made and re-made in and through history, within available practices and relation-ships, and existing symbols and ideas',[5] they propose a focus on this crucial forty-year period at the turn of the twentieth century in order to examine the radical transformation of the conception of national identity which was linked with modernity, industrialisation and associated changes in social and political rela-tions (mainly domestic relations of class and gender, and to a lesser extent the international relations of colonialism).[6] Contributors to the volume explore aspects of politics, literature, music, the Irish and the discovery of rural England in relation to the central theme. The relevance of literature to the formation of a national identity at this particular historical moment is made clear in an important earlier essay by Tony Davies, which demonstrated the closely interconnected development in late nineteenth-century England of literary criticism, literary ide-ology, a particular definition of English literature and a national language known as 'standard English'.[7] Davies reads this composite set of standardisation practices as ideological responses to, and the imaginary resolution of, the social divisions of class and gender which were created and exacerbated by the progress of industrial capitalism in England in that period. Thus, standard English – and English litera-ture – operated as ideological constructs which produced unity in the face of divi-sion (and, of course, potential antagonism). The identification of a specific moment in the history of 'Englishness' does not imply uniqueness, however. Another major collection of essays from the late 1980s addresses 'the making and unmaking of British national identity' across a period of three centuries, tracking the changing meaning of the term in different circumstances.[8] The editor, Raphael Samuel, pays particular attention to Britain in the inter-war years and in the period after the Second World War, moving forward to his central concern (and the motivating factor behind the publication of the three-volume collection), namely the currency of new conceptions of 'Englishness' and 'Britishness' during the Thatcher administration. But contributions cover the seventeenth, eighteenth and nineteenth centuries, and collectively establish the fact that, as a reviewer puts it, 'since the eighteenth century the terrain of Englishness has been continually redefined'.[9] In the context of this acknowledgement of the always contingent nature of Englishness, I want to focus, like Colls and Dodd, on the critical period at the turn of the century in which the contemporary national ideology was first articulated.

It is interesting, in fact, that the *content* of the ideology of Englishness is not often specified. Davies stresses the emphasis on unity (as against class and other divisions). Samuel and others describe the inter-war version of the ideology known as 'Little Englandism', whose key features included the English countryside, the rise of gardening, rural and small town life, the charisma of authority and an active xenophobia, directed at Europeans and Americans alike.[10] David Lowenthal traces English xenophobia back to the thirteenth century, and its modern form to

eighteenth-century anti-French sentiment.[11] Philip Dodd, discussing late nineteenth-century English culture, considers the centrality of a particular conception of masculinity in that formation.[12] Apart from such abbreviated descriptions, 'Englishness' is usually distinguished less by its inherent characteristics than by its *exclusions*. Two groups in particular are considered by Dodd, each marginalised by, and at the same time invited to participate in, the national culture: the working class, and the Celts (Irish, Scots and Welsh). Their colonisation is necessarily founded on an initial positioning of members of those groups as 'other' to the dominant culture. And this feature, of the discursive construction of a collective identity by processes of exclusion, is absolutely central to the case of the construction of Englishness. As Philip Dodd says, 'the definition of the English is inseparable from that of the non-English; Englishness is not so much a category as a relationship'.[13] Raphael Samuel puts it like this: 'ideas of national character have typically been formed by processes of exclusion, where what it is to be British is defined in relations of opposition to enemies both without and within'.[14] In the period under discussion, the excluded other *par excellence* is the Jew.[15]

The 1905 Aliens Act was specifically designed to reduce the level of Jewish immigration. It was the first piece of legislation in nearly a century to limit free entry into the country. The impact of enormous numbers of Jewish immigrants from Eastern Europe to Britain between 1880 and 1914 has been well documented by David Feldman and other social historians of the period, as have the complex and conflicted responses of the more assimilated Jews already living and well established in London and other major cities.[16] Economic and other fears fuelled the hostility to this influx, and these manifested themselves in growing demands for immigration controls and, in some cases, for repatriation. Among Jews themselves, the additional fear was that the more visible, less 'respectable' Jews who were arriving from their villages and small towns in Eastern Europe would threaten their own status as assimilated English people. Accordingly, Jewish organisations were active in programmes of anglicisation for the newcomers, and also in schemes for repatriation. The 'alienness' of the immigrants was all too apparent, and was a primary cause of the widespread and growing anti-alien agitation which led to the 1905 Act. Feldman has asked the question, in this context, 'in what sense and to what extent was it possible for Jews and Jewish immigrants to become English in the late Victorian and Edwardian years?',[17] and his careful historical research of the debates of the period suggests an answer: if not for the new immigration, Jews might not so easily have served as the 'necessary other' in the construction of Englishness – might, indeed, have passed for English – but the definition of 'Jew' underwent a radical shift as a result of the particular historical circumstances, providing the ideal alien for the production of Englishness.[18]

As with most such phenomena, the discursive construction of Jewishness and Englishness was not confined to political and legislative debate. Literary scholar Bryan Cheyette has shown, through a close reading of the texts of Arnold, Trollope, George Eliot, T. S. Eliot, James Joyce and others, how English literature

participated in the construction of 'the Jew' in the late nineteenth and early twentieth centuries. In his nuanced reading, the figure of the Jew is never fixed, but manifests what he calls a 'protean instability' as a signifier.[19] This means that the relationship between Englishness and Jewishness is one which is constantly in flux, alternating between inclusivism and exclusivism. Like Feldman, though, Cheyette is clear that in the period before and after the First World War the project of inclusion was secondary to that of exclusion. G. K. Chesterton, for example, 'increasingly constructed "the Jew" as the opposite of both a familial Englishness and a homogeneous European Christendom'.[20] David Glover has discussed Joseph Conrad's *The Secret Agent* in relation to British anti-alienism and the Aliens Act, as a text which both responds to and participates in the discourses on racialised identities (though in this case not explicitly with reference to Jews).[21] The literary representation of the Jew has its own pre-history, paralleling the history of the discourse of the Jew in general, but my interest here, again, is in its specific articulation in the early decades of this century.[22] In an anthology of contemporary texts on 'Englishness' in the period 1900 to 1950 – literature, political speeches, diaries, journalism – the editors have illuminated in the very arrangement of the book the complex ways in which a variety of discourses intersect (and, very often, compete) in the cultural construction of a strategic category. They, too, stress the changing nature of the category of 'Englishness', but stress its regular dependence on discourses of exclusivity. Particularly suggestive is the inclusion, in the list they provide of media and social practices through which this ideology is produced, of one which has to date been little addressed: namely visual representations.[23] It is this that I take up in this chapter, in order to come back to Lady Ottoline's comment and to the question of what it might mean to talk about the 'Jewishness' of visual art. I shall be interested less in the question of the representation *of* Jews in art than in the art-critical discourse about Jewish artists and their work (whether or not the subject matter is the life and representation of Jews). It is not that the representation of Jews in this period is not of critical importance in relation to my main theme here – the Jew as non-English other. Indeed Kathleen Adler's interesting study of Sargent's portraits of the Wertheimer family is clear evidence to the contrary.[24] But the 'Jewish mark' is the presumed mark of work by Jews, and is not to be found, or sought, in a painting by Sargent or any other non-Jewish artist. My focus then is the narrower one of Jewish artists of the period and their work.

How is 'Englishness' manifest in the discourse(s) of the visual? This is, of course, the central topic of this book, and is addressed in various ways by most of the contributors. Until recently, the starting point for anyone attempting to address the question has been Nikolaus Pevsner's 1955 book, *The Englishness of English Art*, which famously (or perhaps notoriously) identifies both characteristics and cause.[25] For him, the essential characteristics of English art are naturalism, detachment, conservatism, linearity, the perpendicular and 'longness' in portraits (the contrast being, implicitly where not explicitly, not only the French and the European in general, but also the 'other', Celtic, domestic aesthetic[26]). For Pevsner, the explanation of these

characteristics is to be found in climate and language. Twenty years after Pevsner, we find the analytic framework not much changed. For example, in his introduction to a 1975 volume on the history of British painting, David Piper states: 'any account of the Englishness of English art must begin with geography, with the obvious fact that Britain is an island'. He, too, stresses the linear, rather than painterly, qualities of English art, and explains these in terms of the climate:

> The English climate, even when seeming crystal-clear to the natives, appears slightly hazy to those coming from, say, Italy. Mediterranean light has an extraordinary faculty of seeming to order, in the onlooker's eye, its component elements into interrelationships that have a visual logic and, inevitability, that is rarely glimpsed in England. And when Continental originals in art, imported into Britain, are copied, or used as source for inspiration, their painterly and monumental qualities tend to be transposed into linear values.[27]

Discussing the lack of large-scale painting in England, he adds, 'the English climate is here again partly to blame, for the island's persistent damp is noxious to large-scale painting, whether fresco or stretched on vast canvases'.[28] As John Barrell points out, the focus on climate in discussions of the peculiarities of English art pre-dated Pevsner by more than 150 years, and can be traced to the work of John Ruskin.[29] But since the mid-nineteenth century, the continuing interest in cause has been accompanied by a new definition of content, as the concept of 'Englishness' itself has undergone transformation. We should, of course, expect to find the fluidity of political conceptions of national identity matched by equally mobile definitions of the Englishness of art, since, as Philip Dodd points out, 'the Englishness of English art ... is not a "given", does not have a settled and continuous identity, but has been constituted and reconstituted at various historical moments – for very different purposes'.[30] For about the past hundred years, however, the Englishness of art has been seen to consist in its landscape painting, its representation of a particular type of rural scene, and its essentially southern English character.[31] This particular visual imaginary has its grounding in the urban realities which initially produced it, as well as in the particular anxieties associated with the progress of modernity at the turn of the century.[32] The work of 'new historians' of art who read English landscape painting critically has met with fierce resistance by those for whom art – and not coincidentally this supremely 'English' genre of art – transcends politics and ideology.[33] But for the past decade, the parameters in which we must understand the Englishness of English art have been mapped out in terms of an ideology of the rural scene, a visual ideology very much in accord with its equivalents in literature and in political discourse.

As in other discourses of Englishness, the discourse on visuality is entirely dependent on that process of exclusion which allows the national to emerge as a positive moment.[34] The discursive 'other' may be the French, the Celts or the northern English, but in the early twentieth century it was paradigmatically, in the visual as in literary and other fields, the Jew. The placing of Jews in art-critical

discourse and in institutional practice manifests a combination of the hostile (and the anti-Semitic) and the benign. In both cases, though, the apparently unquestioned identification of Jewish art and Jewish artists as separate and different from the main currents of English and British art is striking. This separation is justified sometimes in terms of style, sometimes in terms of theme and subject matter. It is difficult to read, and read about, these cultural practices in the late twentieth century without the unease which is founded on the suspicion of anti-Semitism in the very identification of difference. But it is important to recall that Jews as much as non-Jews colluded in this belief in ethnicity as a foundation for art-making. The effect of these discursive practices, as I hope I have shown with regard to the more general case of constructions of national identity, was to participate in the construction and maintenance of a conception of 'Englishness' in the visual field. Three examples of Jewish participation in, or at least acceptance of, such practices come to mind. The first is David Bomberg's willingness to curate a special room devoted to the work of Jewish artists at the 1914 exhibition at the Whitechapel Art Gallery in London.[35] The second is Mark Gertler's apparent acceptance of D. H. Lawrence's admiring statement about his painting, *The Merry-Go-Round*, of 1916: 'it would take a Jew to paint this picture'.[36] And the third is *The Jewish Chronicle*'s description of Jacob Epstein's sculpture as 'entirely Hebraic',[37] a characterisation which is particularly problematic given the tendency, recorded by Elizabeth Barker, for non-Jewish critics at the time to employ just this strategy in the service of a clearly anti-Semitic ideology.[38] (It is worth noting, too, that such unselfconscious reference to the Jewishness of art was still possible in the mid-1980s, when Frederick Gore, in the catalogue for the 1987 Royal Academy of Arts exhibition on twentieth-century British art, wrote: 'Mark Gertler's early work is closely related to his family and has an emotional power associated with the striving of a Jewish émigré community to achieve modest prosperity.'[39])

My own interest here is in those texts which position the Jewish artist (and his work) as 'other', as part of the project of (negatively) producing an English identity. The other side of this, though, is the (positive) 'quest for Jewish style', as it is referred to by Avram Kampf.[40] The context of Kampf's essay is the 1990 exhibition at the Barbican Art Gallery on the theme 'Chagall to Kitaj: Jewish Experience in 20th Century Art'. His discussion of the question of Jewish style, which serves as the introductory chapter of the catalogue, focuses on Russian writers in the nineteenth and early twentieth centuries, whose answer to the question shifted from a stress on aesthetic characteristics (for example, in the view of the nineteenth-century critic, Vladimir Stassof, the essential *realism* of Jewish art) to a focus on content and particularly the inclusion of Jewish folk themes in painting. Chagall, of course, epitomises 'Jewish' art of the latter type. An important 1919 essay on the theme, cited by Kampf, also considers the appearance of the Hebrew letter in art, and the preference by Jewish artists for 'deep, dark tones', grey and violet.[41] By the time of the Russian Revolution, the commitment to modernism and the avant-garde by Jewish artists as well as writers on Jewish art had

displaced the earlier emphasis on realism. But Kampf concludes that by 1922 the idea – and the possibility – of a national Jewish art had faded, and in his long and comprehensive survey of Jewish art in other countries and at later moments in the century, the notion that art might be somehow essentially 'Jewish' does not recur. A study of the Soyer brothers – three immigrant Jewish–American artists, active in the inter-war years – considers Irving Howe's suggestion that 'some tonality of "Jewishness"' inheres in a painting by Raphael Soyer, and reviews the more general question of the 'Jewishness' of the oeuvre of the brothers.[42] The authors' view is that we can only describe the work as Jewish in the particular sense that much of it contains themes related to Jewish life, including the complex representation of the artists' own ambivalence with regard to their heritage. I refer to these two essays, neither of which deals with British artists, because the idea of the 'Jewish mark' is generally premised on some universal Jewish quality or qualities; that is, the ideology of 'Jewishness' in English art is founded on a generic concept of Jewishness, so that the expectation is that what is 'Hebraic' in New York, Russia and London is more or less the same thing. Critical analysis, though, soon deconstructs this ideology, and insists that we make particular, and local, enquiries into the supposed Jewishness of specific works. On that basis, I want to look a little more closely at the art-critical language employed in the case of Jewish artists in England in the 1910s.

The two major reasons for describing art as 'Jewish' were its subject matter and its style; in the case of the latter, this was usually in terms either of a work's perceived 'primitivism' or in terms of its formal characteristics (notably its identification as 'modernist' and 'foreign'). I think it is clear that the question of style, addressed in these terms, is highly problematic, and I will come back to examples of that discourse. The matter of content is both more straightforward and (at least ostensibly) less ideologically weighted. There is no question that many of the immigrant Jewish artists in England in the early twentieth century, or those whose parents were immigrants though they themselves may have been born in Britain, took family life, and hence traditional Jewish themes, as their subject matter. Jacob Kramer (1892–1962) was born in the Ukraine, and came to Britain at the age of eight. The family settled in Leeds, and Kramer was accepted as a student at the Slade School of Fine Art in London. Eventually he returned to work and teach in Leeds.[43] Much of his work, and not only in his early years, depicted Jewish life, including religious aspects of this life. One of his best-known paintings is *Day of Atonement* of 1919, now in the Leeds City Art Gallery (Figure 69). This image of men at prayer on the holiest day of the Jewish year achieves its striking effect by its simplicity and starkness of both form and colour and its invocation of the rhythm of prayer in the repetition of the human figure. The work shows evidence of Kramer's involvement in modernist art practice in England, and in particular the influence of Vorticism. But although, as we will see, some critics did make the equation of modernism with Jewish art, the 'Jewishness' of this particular painting lies clearly, and, I think, unproblematically, in its subject matter. The same can be said for most of

69 Jacob Kramer, *Day of Atonement*, 1919.

Mark Gertler's early work. Gertler (1891–1939) was born in England of immigrant parents from Eastern Europe. The family returned to Galicia after his birth, and then settled in England when he was five. Gertler grew up in the Jewish community in the East End of London. Like Kramer, he studied at the Slade. Although he moved away from his family, and also away from his early interest in depicting traditional Jewish themes, his work in the period before the First World War was very much centred on those themes.[44] Lady Ottoline's comment about the 'Jewish mark' in his painting was made, though in retrospect many years later, about a visit to his studio in 1914 at a time when she might very well have seen works like *Jewish Family* of 1913 (Figure 70) and *The Rabbi and his Grandchild* of the same year (Figure 71).[45] We cannot be certain what she means by 'the Jewish mark', and her remark that this 'gave them a fine, intense, almost archaic quality' does support a reading that she was talking about style as much as content. Nevertheless, his studio in 1914 would have been very likely to contain a number of paintings with subject matter drawn from Jewish life. It was only in the

70 Mark Gertler, *Jewish Family*, 1913.

71 Mark Gertler, *The Rabbi and his Grandchild*, 1913.

following year that he more or less abandoned these themes.

D. H. Lawrence's remark ('It would take a Jew to paint this picture') about Gertler's work is more problematic. It appears in a long letter to Gertler, and refers to his 1916 painting, *The Merry-Go-Round* (now in the Tate Gallery), generally considered one of Gertler's most important works, and also one of his first *not* to deal with Jewish themes. The image, in Cubo-Futurist style, depicts a nightmarish scene of groups of people, including men in uniform, on a carousel, all open-mouthed in fear. The painting is a comment on the futility as well as the horror of war. What might Lawrence mean by saying that only a Jew could paint this picture? His letter is highly complimentary. (His comments were based on seeing a reproduction of the work: he writes, from Cornwall, to say 'your terrible and dreadful picture has just come … I'm not sure I wouldn't be too frightened to come and look at the original'.[46]) He says that this is the best modern picture he has ever seen, and that it is 'great, and true', as well as 'horrible and terrifying', and even 'obscene'. He goes on to reflect on the likelihood that Gertler's outer life and human relationships must be superficial, while his 'inner soul' must be a 'violent maelstrom of destruction and horror', as he is 'all absorbed in the violent and lurid process of inner decomposition'. Then comes the comment about the Jew, which is followed, by way of explanation, by these sentences:

> It would need your national history to get you here, without disintegrating you first. You are of an older race than I, and in these ultimate processes, you are beyond me, older than I am … At last your race is at an end – these pictures are its death-cry. And it will be left for the Jews to utter the final and great death-cry of this epoch: the Christians are not reduced sufficiently … You are twenty-five, and have painted this picture – I tell you, it takes three thousand years to get where this picture is – and we Christians haven't got two thousand years behind us yet.

Here we have a very different discourse – and of course a mystical, Lawrentian variant of it – which locates ethnicity in pseudo-historical, spiritual terms. Nor is it the kind of interpretation one can argue with, though it is easy enough to dismiss it as entirely unanalytic (and potentially anti-Semitic). But its emphasis on the archaic qualities of 'Jewishness' – here ostensibly presented in a positive way – is very similar to other characterisations of work by Jewish artists as 'primitive'. The most prominent example of this is the reception of the sculpture of Jacob

Epstein (1880–1959), documented by Elizabeth Barker.[47] Epstein, who was born in the United States, and spent his earliest years on the Lower East Side of New York City and later studied at the Art Students' League, immigrated to Britain in 1905 and spent the rest of his life in London. He was involved in the London Group and with the Vorticist movement, and contributed to Wyndham Lewis's periodical, *Blast*, of 1914–15. Epstein was a major innovator in sculpture, and the first truly modernist sculptor in Britain. His work invariably met with hostility, first because of the 'obscenity' of his nude figures, and later because of the uncompromising anti-naturalism of the work. As Barker shows, much of this hostility was phrased in terms of his ethnic identity – for example, a 1925 review of his work which asserts that his primitivist style was the outcome of an 'atavistic yearning of like for like', and his omission from a 1933 history of English sculpture on the grounds that 'Epstein's ancestry and early environment go far to explain his art. This is essentially oriental ... Epstein is with us but not of us.'[48] During a visit to Paris in 1912, Epstein was greatly influenced by African and tribal art which he had the opportunity to see there, and thereafter incorporated elements of that work into his own sculpture. The identification of 'primitivism' in the work is not, therefore, in itself remarkable, though the almost universal, and highly vociferous, dismissal of the work is quite noteworthy. More disturbing is the tone of the critical discourse and, especially, the racialising of this discourse, which, as Barker shows, increased especially after 1917. The primitivism of the work was consistently identified with the primitivism of the man and of his ethnic group. The case of the response to his sculpture, *Risen Christ* (Figure 72), exhibited in 1920, is especially striking. This work was made as a private memorial to the First World War, and was intended as an allegorical representation of suffering.[49] Barker suggests that behind its hostile reception was the view that Jews had no right to portray Christ. She continues:

> Whether hostile or supportive, critics shared the opinion that Epstein's *Christ* was the expression of an alien mentality and constituted a direct challenge to the moral and aesthetic values native to contemporary Christian art. Their reviews were based on a common set of terms, such as 'archaic', 'barbaric', 'Oriental', 'Egyptian', 'aesthetic' and 'revolutionary', signifying the otherness of Epstein's *Christ* and offering a counter-image to the gentle divinity of Christian convention. Sensation-seeking press articles frequently combined assertions of the *Risen Christ*'s non-Western racial identity, with descriptions of his 'monstrous', 'revolutionary', 'insane', 'criminal', 'simian' and even 'Satanic' appearance.

One of the more exaggerated examples Barker cites is the following:

> Father Bernard Vaughan's diatribe was perhaps the most extreme in tone although the basic images he used were common to other hostile reviews. He described the 'degenerate' racial characteristics of Epstein's figure, which suggested 'some degraded Chaldean or African, which wore the appearance of an Asiatic-American or Hun-Jew, or a badly grown Egyptian swathed in the cerements of the grave'.[50]

72 Jacob Epstein, *Risen Christ*, 1917–19.

Later works, too, elicited the same hostility, and the same slippage from an objection to the primitivism of the object to prejudices about the ethnic origins of its producer.

The question of whether or not this critical discourse should be read in the context of the history of British anti-Semitism is a difficult one, and is not something I shall address here. Elizabeth Barker makes reference to this strand of political thought, and certainly there is plenty of evidence for a long-established (though always changing) tradition of anti-Semitic thought in Britain.[51] My task here is less ambitious, and is simply to draw out particular moments of art-critical writings which I want to suggest are indicative of the project of ethnic or racial exclusion which is the necessary correlate of the construction of 'Englishness'. No doubt the re-reading of these statements more systematically understood as part of another discourse – that of anti-Semitism – would provide a different, but, I assume, complementary, account of the construction of difference in this period. But I have to leave that to one side here. My primary and more limited intention is to demonstrate that 'Jewishness' is invoked in art criticism, often inappropriately, often gratuitously, and often negatively, in such a way as to reinforce, in this critical historical period, its obverse – namely 'Englishness'.

This discursive strategy works not only in relation to so-called 'primitivism' but also in relation to the negative response to modernism during the same period, both of which are entirely remote from that visual ideal of Englishness, the realist rural scene. As Juliet Steyn has shown, the equation of Jewish art with avant-garde art (for example, in the critical reception of the 1914 Whitechapel exhibition, *Twentieth Century Art*) was equally distorted (not all the Jewish artists represented were modernists, and not all the modernists were Jews), and equally designed to preserve the (non-modernist, non-'foreign', non-Jewish) category of 'Englishness' and 'English art'.[52] I take as an example of this the artist David Bomberg, the curator of the Jewish section of the Whitechapel exhibition. Bomberg (1890–1957) was born in Birmingham, the son of Jewish immigrants from Poland. The family moved to Whitechapel in 1895, and Bomberg later studied at the Slade School of Art. Like Gertler and Kramer, he included Jewish themes (in his case, biblical

themes as well as scenes from daily Jewish life) in his earliest work. His 1912 painting, *Vision of Ezekiel* (Figure 73), illustrates a story in the Book of Ezekiel in the Old Testament. The following year he painted *Jewish Theatre* (now in Leeds City Art Galleries). But his most radically innovative painting of that period, *Ju-Jitsu* (1913) (Figure 74), verges on the entirely abstract, the increasingly stylised figures of *Vision of Ezekiel* by now so deconstructed as to be virtually unreadable as figures.[53] In the 1914 exhibition, Bomberg exhibited in a group of his own work both *Vision of Ezekiel* and *Ju-Jitsu*, as well as an equally abstract work, *In the Hold* (1913–14, Tate Gallery, London). In his case, the hostile critical equation of modernist and Jewish had some foundation; indeed Juliet Steyn points out that Bomberg was the *only* Jewish artist in the exhibition whose art could have been characterised as Cubist or Futurist (the general categorisation of the Jewish section by some of the press).[54] But by now we have moved from an identification of the Jewish 'mark' with subject matter to the very different equation of Jewish-foreign (in this particular case, continental European)-modernist – a triple formulation which produced Englishness as both visual realism and ethnic purity.

My argument has been that the discourse of art criticism in the period 1910 to 1920 participated in the construction of the national ideology through the identification (and invention) of excluded entities. These entities were ostensibly particular works of art. In fact, they were particular artists and, through them, a particular ethnic minority. This ideological project was necessarily dependent on the manufacture of difference and its consequent and persistent reaffirmation. But I do not conclude from this either that difference is entirely mythical, or that work by

73 David Bomberg,
Vision of Ezekiel, 1912.

74 David Bomberg, *Ju-Jitsu*, c. 1913.

Jewish artists should not be approached in terms of the particular situation of those artists, including their ethnicity. Elsewhere, I have suggested that it is useful to consider Mark Gertler's work in terms of his ethnic background and his related ambivalence about both his own heritage and his relationship to British gentile society (and particularly to members of the Bloomsbury Group).[55] I will conclude with some suggestions of ways in which the specific situation of certain Jewish artists in early twentieth-century England may be relevant to the interpretation of their work. In 1966, Harold Rosenberg addressed the question, 'is there a Jewish art?' Having reviewed the possible ways in which we may speak of such an art (art produced by Jews, art depicting Jews or containing Jewish subject matter, the art of Jewish ceremonial objects, the art of Jewish mysticism, or metaphysical Judaica), he concludes that to speak of Jewish art is necessarily to speak of a specifically Jewish *style*. This, he argues, does not exist as a universal phenomenon, and hence 'we are obliged to conclude that there is no Jewish art in the sense of a Jewish style in painting and sculpture'.[56] However, he goes on to suggest that since art produced by Jews in the twentieth century is 'the closest expression of themselves as they are, including the fact that they are Jews', and since 'the most serious theme in Jewish life is the problem of identity', then 'this work inspired by the will to identity has constituted a new art by Jews which, though not a Jewish art, is a profound Jewish expression'. This formulation allows for the recognition of shared characteristics, which may include stylistic characteristics, in the work of Jewish artists, while at

the same time carefully historicising that commonality. That is, he makes it very clear that the concern with, and expression of, Jewish identity (and he is discussing specifically American Jewish identity) is very much a post-war twentieth-century matter, situated in a period of 'displaced persons, of people moving from one class into another, from one national context into another'.[57] It is this kind of social-historical exploration of 'Jewishness' which I believe is a potentially useful way to discuss the work; indeed, I would say this is also the only way in which it is legitimate to talk about such a thing as the 'Jewish mark'.

With regard to the four artists I have discussed in this essay, it is possible to map the outline of what such a sociological, or social-historical, interpretation might look like. To begin with, although as I pointed out earlier there is no necessary or invariable connection between the work of Jewish artists and the development of modernist and avant-garde art practices in England in this period, in fact these artists were all, at least for a time, in the forefront of such stylistic experimentation. Jacob Epstein was the leading modernist in the field of sculpture, and Bomberg, Kramer and Gertler were all strongly influenced by Cubism and Futurism, as well their English variant, Vorticism. (The fact that Gertler and Bomberg in particular reverted to pre-Cubist realism after the First World War is not relevant to the question of the nature of their work in the period under discussion.) There were, of course, many non-Jewish artists involved in modernist art practice and producing work informed by the most radical developments in Europe, and I am certainly not suggesting that modernism in England was somehow 'Jewish'. But what I am suggesting is that the active participation of certain Jewish artists in the English avant-garde was a function of their own particular social situation, central to which was their experience as Jewish men from immigrant, working-class or lower-middle-class backgrounds. A number of mediating factors help to explain their involvement in the avant-garde, these in turn the product of their ethnic and familial situations. Central among these mediating factors were a particular training in art; a relatively easy cosmopolitanism; and a clear position of marginality within contemporary British society, together with its correlate, a certain detachment from that sense of 'Englishness' which, as we have seen, was both long established and in process of reformulation. As I have suggested in the particular case of Mark Gertler, this detachment from the centre (manifest in his case especially in his ambivalent relationship with the Bloomsbury Group) allowed and perhaps even mandated a more radical aesthetic than that which was possible for those nearer to the centre.[58] Kramer, Bomberg and Gertler all studied at the Slade School of Fine Art, enabled to do so by scholarships or patronage, and there they were able to mix with many of those artists who were to build an avant-garde practice on the basis of their rejection of their training at the Slade. Epstein, whose early training was in the United States, studied at the Art Students' League, in many ways the nearest equivalent to the Slade in its student population, its openness to students without wealth, and its role as an incubator, within a strong 'Ashcan' tradition, of more radical artistic production. Finally, openness to artistic developments in continental Europe, beyond the

Post-Impressionism of Roger Fry, Vanessa Bell and Duncan Grant (the 'official' radicals in England in the pre-war period), depended on a certain cosmopolitanism which was still rare in England but which was far less problematic for artists who were themselves recent immigrants. All four of the Jewish artists under discussion visited Paris. Epstein studied there for two years before moving to England in 1905, and visited again in 1912 and 1913. Bomberg visited Paris in 1913, in connection with his task as curator of the 1914 Whitechapel exhibition. Jacob Kramer went to Paris to study in 1914. Mark Gertler visited Paris in 1912;[59] his work in the period 1912 to 1916, the most radical of his career, was influenced by Cubism (examples of which were also included in the second Post-Impressionist exhibition in London, in 1912) and by Vorticism, itself informed by European Futurism. Again, let me stress that I am not arguing that this particular conjunction of art-school contacts, European travel, and exclusion from dominant social and artistic circles applied only to Jewish artists (or, for that matter, to all of them). My point is that many Jewish artists shared these experiences, as well as the additional one of having to come to terms in some way with their own heritage, their relationship to their families of origin (with, in most cases, their continuing religious and traditional practices), and their changing attitudes to the role of Judaism in their own lives. In terms of the sociology of knowledge, it makes a good deal of sense to expect something of this confluence of influences to manifest itself in their work. And it is in this sense, and, I believe, *only* in this sense, that it may be possible to talk about something called 'Jewish art'. This would mean that not only could we continue to explore the various representations of Jewish family life, tradition and religious practice in the work of such artists; we could also examine, for example, the engagement in modernist art practice of particular Jewish artists in relation to their specific social situations and related aesthetic choices – situations which may include discussion of connection with family, connection with, or marginality to, the major cultural and social networks of the period, access to types of artistic training, access to foreign travel and so on.

From the point of view of the ideological construction of 'Englishness', my comments about the legitimate discussion of Jewish art are beside the point, however. For here the issue is the discursive construction of 'the Jew' and 'Jewishness' (and, as a sub-category in the visual field, 'Jewish art') in the service of the production of the ideology of the nation. Although a sociology of art which explores the work and conditions of production of Jewish artists in this process would be an interesting study, it would make little difference to that other task of critical deconstruction which has been the main theme of this chapter: namely, the examination of the function of the notion of 'the Jewish mark in English painting' which, despite its fundamentally mythical nature, had clear political and social effects in a period in which the meaning of 'Englishness' was at stake.

(Is)land narratives: Englishness, visuality and vanguard culture 1914–18

Jane Beckett

When in her short story 'Indissoluble matrimony' Rebecca West concluded of the infelicitous husband that 'bodies like his do not kill bodies like hers' she was concerned, in common with much contemporary writing, with conflicts of sexuality, desire and identity.[1] Written into this story, published in the first issue of *Blast* in the summer of 1914, are meditations on violence and power and on notions of Englishness, all of which were under pressure from the concepts of nation which were intensely debated at the outbreak of war.

This chapter focuses on the narratives of Englishness produced by the emergent avant-garde during the 1914–18 war. Its main concern is the positioning of women painters in the conflicting territories of early modernism, and the interconnectedness of these formations with the mutable conditions of the war. The urban fabric of London was transformed during the years 1914 to 1918, and the chapter explores the conjunctions between the formations of, and struggles over, sexual difference, the shattered fabric of the metropolis, and avant-garde formations and representations. Uneasy and unresolved, these forces collided in the crossing trajectories of early modernism.

The different avant-garde groupings in London and a prevailing Georgian aesthetic within English cultural life which were the focus of *Blast*'s opening salvos were radically altered by the political events of summer 1914, as Richard Cork and David Peters Corbett have discussed in both European and English contexts.[2] In these and earlier accounts, a set of common themes specific to the modernity of English painting and to war imagery recur: (1) the destruction of pre-war modernist syntaxes for painting and sculpture associated with new modes of perception; (2) violence and 'fables of aggression' (a term applied to Wyndham Lewis), mediated through individual subjects read onto the inter/national arena and linked to (3) nationalism and fascism, and (4) the problematic of the resolution of war, issues of memory, mourning and redemption against what has been perceived as a 'conservative' turn to figuration after 1920 and distinctly new forms of modernism to which English art cannot subscribe for at least a decade.[3] But curiously absent

are central themes from other cultural histories of the war: notions of national identity and, associated with this, patriotism and propaganda; gendered experiences and responses in and to war; the effects of trauma on wartime subjectivities and the interconnectedness of these themes.[4] War has been taken to mean either artists' engagement in armed conflict, or their observation of the fighting fronts as un/official war artists. Women are written in as assistants on an avant-garde stage, absent from any engagement in hostilities and thus absent from cultural production. To reinstate women as cultural producers is to engage with a rethinking of both the avant-garde and the war and to refigure the specifically gendered positionings of women during the war years. And it is to shift an attention mesmerisingly fixed on the artistic representation of trench warfare and an imagery of men in groups, in trenches, 'going over the top', wounded, in dressing stations, blinded by gas attacks, broken, dying, dead in fields of mud or as heroic images on war posters. While this focus on men's bodies is an integral part, perhaps the central drive of the war's narratives, it is, nevertheless, only a part.

Discussing women's writing about the war, Claire Tylee demonstrated that participation in military institutions, the martial zone, the professions, skilled industrial work and sexual adventure relocated the focus of women's writing.[5] While one concern in this chapter is therefore to attend to the links between war and the formation of the avant-garde – *Blast*, for instance, was published across the period 1914–15 which saw the early experiences of a highly mechanised trench warfare – another is to map the shifting relations between experiences and images of women in war with the visual representations made by vanguard women. Not all these issues can be explored in a study of this length, but I offer here three related themes – narratives of nation, the home front, and bodies of mud and of mechanisation – with which to begin an account of gendered experiences of the 1914–18 war and its avant-garde representation and the ways in which these shaped and were shaped by perceptions of Englishness, visuality and subjectivity.

'First (from politeness) England'[6]

An intense approbation of particular concepts of Englishness is threaded through the polemics of the *Blast* manifesto; an Englishness of music-hall humour, of stereotype, of popular mythologies, such as English 'politeness', at which the opening discharge is aimed. English cultural practice is plotted onto geographical location and climate, embracing customs, virtues, and the icons of London's new consumer and mercantile culture. Englishness is distinguished in its 'luxury, sport, the famous English "humour", the thrilling ascendancy and idée fix of Class', 'the most intense snobbery in the world – these phenomena give England', it is claimed, 'a peculiar distinction in the wrong sense, among the nations'.[7]

The inherent nationalism of *Blast*'s narratives is not my concern here. It is noted in most studies of modernist painting and sculpture of this period, the primary cue having been taken from Charles Harrison's *English Art and Modernism*.[8] Written,

and therefore positioned, within and against particular theoretical frameworks, this study reconceptualised 'Englishness', undisturbed as a category in art-historical texts since Pevsner's account of *The Englishness of English Art* published in 1956.[9] In addressing the problematics of 'national characteristics of art', Pevsner's analysis of the geography of art, framed as it partly was as a rejoinder to Dagobert Frey's *Englisches Wesen in der bildenden Kunst* (1942), raised significant issues within the ideological formations of British post-war reconstruction.[10] Pevsner's analysis of geographies of art was echoed by Harrison but reconfigured as Englishness and modernism, and glossed as a 'history of a history', that is to say a 'history of the modern in English art'.[11] But while modernism has been defined, Englishness, as in Peters Corbett (1997), has lain tantalisingly unexamined, other than as a teleology of art produced in England.[12] Harrison's acknowledgement that his study does not offer a 'radical revision of the history as it has been received' may be disingenuous when set beside other texts published in the early 1980s, such as Benedict Anderson's *Imagined Communities* which began to re-view assumptions of nation and nationhood.[13] Critical in Anderson's formulation is '*imagined*' (his italics). Communities he argues 'are to be distinguished, not by their falsity/genuineness, but by the style in which they are imagined'.[14]

Studies have shown that in its modern sense the concept of nation is relatively new. Whatever the tensions, the connectedness between emergent modernity in all its diversity and concepts of nation are close ones. Homi Bhabha perceptively argues that despite this closeness an ambivalence emerges in 'the certainty with which historians speak of the "origins" of nation as a sign of the "modernity" of society', something which for Bhabha demonstrates rather that 'the cultural temporality of the nation inscribes a much more transitional social reality'.[15] In the inscription of nation between 1914 and 1918 that 'cultural temporality' was acutely transitional, constantly displaced and deferred against the compressed social space and conditions of the war in which the British nation and sense of nationhood were imagined and reshaped.[16]

But how were visual culture and avant-garde practices intricated in the *Nation* processes of the narration of nation? A shift in the meaning of nation from a principally ethnic unit to a 'notion of political unity and independence', registered in the 1908 edition of the *Oxford English Dictionary*, signifies colonial interdependencies, crises in the nineteenth-century liberal state and new forms of modernity.[17] As much recent analysis has pointed out, there are intense difficulties not only in defining but also in analysing notions of nation, nationality and nationalism.[18] Anderson's exploration of nationality – or 'as one might prefer to put it in view of that word's multiple significations, nation-ness, as well as nationalism' – as 'cultural artefacts of a particular kind' opens distinct possibilities in shaping answers to this question. So, too, does his working hypothesis of nation as 'an imagined political community … imagined as both inherently limited and sovereign.'[19]

It is on the imagined terrain of a sovereign nation, defined, contained and limited by finite boundaries that the Blast/Bless disquisitions imag(in)e England.[20] If the

immediate borders of Wales and Scotland are invisible in *Blast*, the defining charac-
teristics of European nations are not. France, for example, was figured by familial
relations, alcohol, physical characteristics and canine behaviour, and, above all, as
'female'.[21] Water, most notably the sea, constitutes the defining, if elastic, limits of
England. And it is the sea and islandness which are characterised as 'the most funda-
mentally English'. With a litany of its ports and an emphasis on the conquering and
control of the sea, England is hailed as an 'Industrial Island machine, pyramidal
workshop, its apex at Shetland, discharging itself on the sea'.[22] Only from 'this lump
of compressed life' can a new movement in art arise.[23] Such representations of defen-
sive insularity, secure and inviolate borders and marine supremacy played into and
were part of contemporary imperialism, heightened in the Vorticist years of 1914 to
1918. While images of the sea have a long history in the British cultural imagination,
they were adroitly mobilised in the summer of 1914 and through the first months of
the war in the press and propaganda, so the strength of the nation was perceived in its
control of the sea. There had been considerable debate in the British polity, reported
widely in all sections of the press, over the reduction of government naval expendi-
ture during 1906–7 at the moment the German Dreadnought programme was
launched. During the next seven years, in reiterating the strength of German naval
power against the perceived weakness of the British fleets, the press fuelled a belief in
the inevitability of war, celebrating, among the multiplicity of images of the sea, the
new technologies of Dreadnoughts and U-boats and traditional state displays of
naval power. *Blast* dipped into this cultural baggage, taking over its signifiers of
Britons (at times the Royal Navy) as rulers of the waves, present intimations of war,
invocations of bravery and patriotism, and the cult of heroic individualism that sur-
rounded figures such as Horatio Nelson.[24] During 1914 rumours and rumblings of
war were accompanied in the press by images of the national fleet. The *Illustrated
London News*, for example, enumerated the national fleet at the annual Spithead
review in a four-page spread of photographs bearing the legend, 'the great display of
the World's Greatest Navy at Spithead: incidents at the assembly of war ships'.[25] If,
from the early images of 1914, the war was visualised at sea, a critical defining
moment in the nation's imagination came in February 1915, when nearly 1,200 pas-
sengers and crew died and a cargo of war munitions was lost in the German attack on
the S.S. *Lusitania* en route from New York.[26] While images of the sea retained an
imaginative hold in narratives of nation, they were renegotiated in the aftermath of
the German army's invasion of Belgium.[27]

Invocations of the sea are predicated on what it is not – namely land, and the fig-
uring of Eng*land* was critical to war propaganda. This is very marked in the shift
from the popular image of Jack Tar, the sailor boy, to the tin-helmeted Tommy as
representative of the nation during the first months of the war. If the Defence of the
Realm Act (DORA, 8 August 1914) invoked an abstract image of Britishness as the
domain of the nation, the introduction of recruitment poster campaigns gave a more
tangible image to Britain as land and sea. In the early stages of the war the abstract
concept of nation was figured as land, bounded by the safety of the sea, invoked in

political speeches, news reports, and pamphleteering and recruitment campaigns. War Office recruitment posters urged men to arms for 'King and Country', their images void of reference to the actual conditions of the war, which were displaced by heroic and glorious conditions or pastoral images of Britain. In contrast German armies were represented as wantonly invading the lands of 'Little Belgium', then of France. As Alex Potts has pointed out, figuring the English countryside as the essence of Englishness can be understood as a defence mechanism, incorporated and mobilised as a national mythology in times of political and national tension.[28] In the propaganda campaigns, voluntary and government-driven, surrounding the production and consumption of food, the land was presented as the territory of war on which 'victory – may be lost or won'.[29] The army was called up to defend this territory, and working as a land girl became the second highest area of employment for women after nursing. Like contemporary photographic representations, the textual injunctions in recruitment imagery to join the 'Women's Land Army' conjured up an eternal cycle of seasons and their activities, ploughing, harvesting and milking.[30] This vision of England was echoed in a pastoral mode which permeated the literary culture of the trenches and some, but by no means all, of women's war poetry.[31]

In visual culture, too, this was partly the case. If pastoral idioms persisted in vanguardist art they were modified and radically altered in confrontations with metropolitan modernity.[32] *Blast* celebrates contemporary metropolitan pleasures, popular heroes and heroines, aviators, music-hall artistes and boxers. It is the spirit and appearance of 'the Modern World' that is aggressively asserted in *Blast*. Its manifestos call up, elaborate and inhabit an Englishness on the new terrain of modernity, the modernity of experiences of war. Any link to a pastoral mode was explicitly repudiated in *Blast*'s polemic – 'incapable of anything but the song of a frog, in home counties: – these phenomena give England a peculiar distinction in the wrong sense, among the nations'.[33] The lingering pastoral evocations of Paul Nash's representations of the war zone, such as *Void of War* (Figure 75), or William Robert's lost oil *The Battalion Runner on the Duckboard Track*, are invaded by a vanguardist syntax of abstracted and mechanised imagery. Vorticism had developed a pre-war armoury, as Lewis pointed out, which framed and offered models for understanding the war zone: 'when Mars with his mailed finger showed me a shell-crater and a skeleton, with a couple of shivered tree-stumps behind it, I was still in my "abstract" element'.[34]

The concept of Britain as an inviolable island, running through the *Blast* manifesto as well as early press coverage of the war, was rudely shattered by Zeppelin raids over the east coast on 19 January 1915 in which four people were killed and property was destroyed.[35] The realisation that the aeroplane and airship could invade intensified anxieties about the insular vulnerability of Britain. As *The Times* remarked, Britain had lost 'the age old immunity at the heart of the British empire from the sight of a foe and the sound of an enemy missile'.[36] Gillian Beer has noted that the mythology of the island figured widely in writings about England, which was 'conflated with the island and perceived as the mythic centre of Empire'.[37] Yet, as Beer also shows, 'island' is a conjunction of land and water with permeable edges and

75 Paul Nash,
Void of War, 1918.

interiors traceried by lakes and rivers.[38] Helen Saunders' second contribution to
Blast, 2, 'Island of Laputa' (Figure 76), suggests both the island of its title and a
promontory, the crisp lines and rows of hatching signifying the waves of the sea and
doubling, in the hatched areas, to delineate land.[39] The mapped surface of the island
is made up of geometric forms deliberately not organised into a monocular perspec-

76 Helen Saunders, 'Island of Laputa', 1914–15.

tival system in order to inscribe as well as
constitute the new spatial geometries of
Vorticism. Constant changes of scale, inter-
actions between patterns and solids, ambi-
guities between negative and positive and,
particularly on the left hand side, between
figure and ground, suggest a flooding of the
boundaries and collapsing of distinctions
between land and water, island and sea. The
new uncertainties about the boundaries of
sea and land, and thus of nation and empire,
provoked by the war were characterised by
R. H. Tawney, writing anonymously in *The
Nation* on 21 October 1916, as 'the England
that's not an island or an Empire, but a wet
populous dyke stretching from Flanders to
the Somme'.[40]

In Saunders' drawing and woodcut the
island seems to move across from right to left

of the composition, to hover in an unfixed space. This sensation of movement is inevitably connected to the description in Swift's *Gulliver's Travels* of Laputa as a flying island, not fixed by space, time or dimension. The island is apparently seen from above, as if viewed from the shifting perspectives of an aeroplane, which had such profound effects on modern culture. Aeroplane travel, the *Daily Mail*'s prize for an Atlantic flight and the prospects of a Zeppelin Atlantic service, as well as air raids, offered a view from above, a perspective which had radical effects on vision and visuality. In addition these activities necessitated the mapping, charting and (particularly in wartime) the claiming of hitherto uninscribed territories.[41] Richard Cork argues that this was critical to the spatial configurations of early Vorticist work, avowed by Wadsworth's interest in flight and his two lost compositions *A Short Flight* and *Blackpool* (both 1914–15).[42] Aerial photography and land surveillance became increasingly important during the war. Reconnaissance flights made aerial views of war sites over 'No Man's Land', and other key locations such as Kutal-Amara, the site of a 147-day siege (7 December 1915–29 April 1916), were photographed from the air (Figure 77). These photographs enlarge on the idea of islandness, as sites of civilisation or destruction held within landmasses, and brought about the realisation that the aeroplane and airship could invade unseen from above, a fear which intensified anxieties about invasion. According to one contemporary observer, as early as autumn 1914 'people began to make preparations for Zeppelin raids'.[43]

77 'Kutal-Amara', c. 1915–16, aerial photograph.

Ruined sites and (s)crypts: capital war zones

Modernist polemicising flourished in metropolitan spaces and cultures, as *Blast* acknowledged in the opening salvos aimed at and framed by England.[44] As I have argued elsewhere, definitions of the modern were put in place and contested in the urban contexts of exhibitions, critical writings, magazines, journals under new editorial direction, lectures and performances as well as new, and often short-lived, venues like the Rebel Art Centre.[45] Shaped by and in the pressures of modernity, increasing industrialisation, mechanisation, technological change and financial expansion on a global scale, London was experienced in the first two decades of the twentieth century as changing from a sprawling Victorian city to a modern imperial metropolis or 'heart of empire'. 'LONDON', *Blast* proclaimed, 'IS NOT A PROVINCIAL TOWN – we do not want the GLOOMY VICTORIAN CIRCUS in Piccadilly Circus.'[46] At the centre of *Blast*'s vision of England, London, dubbed 'the Vortex' by Ezra Pound as early as December 1913, was represented in *Blast* by its central geography, and by its pleasures – the music halls and gaiety theatres of the West End, canals and the Serpentine.[47] Yet while the contests of the avant-garde took place in and over this metropolitan environment, that very territory itself was under siege and strangely altered following the outbreak of war. At once a centre for mobilisation, a fluid conduit between those moving to and from the front line, war zones and the 'home front', a site of military bombardment, supply shortages, new jobs and daily experiences of death, the urban environment gradually became dominated by diverse and intense experiences of war.

Adapting to the conditions of war involved radical changes to the social fabric and to social relations, changes which exerted extreme pressure on identities and subjectivities. The received account of the conditions of war as polarised gendered activities, men as the fighting force / women waiting at home, was not sustainable in the inevitable negotiation of pre-war social modes and the interchangeability between war and home zones for both men and women. The urban environment, particularly the inner city, operated as the site of interchange between these zones and as a space of slippage, contestation and reconfiguration of sexualities, subjectivities and identities.

At the outbreak of war, London was the largest urban conglomerate in the world, as well as the centre of British state, economic and imperial power. From August 1914 London, like other cities, became a centre for the recruitment and mobilisation of troops, riots for and against patriotic behaviour, marches by the unemployed and demonstrations for 'women's right to serve'.[48] Images of crowds of soldiers in khaki, squads of policeman and recruiting groups became familiar sights in the capital. Military centres, temporary field stations, interchange sites between civilian and military life for troop training and mobilisation, and temporary 'war' hospitals to deal with the huge scale of casualties were set up in schools, large private buildings and reused Poor Law buildings, often on the terrain in which avant-garde artistic identities were performed and staged.[49] Vorticist

imagery in many ways registers the reordering and disfiguration of this fluid terri-
tory of central London, notably in its representations of surging crowds and its
vision of a fragmented city turned inside out by bombing and mobilisation.

In the first eighteen months of the war, news reports, letters and memoirs, all
commented on the sheer masses of people who thronged the London streets. While
some were on political demonstrations or under mobilisation others were per-
forming a sense of community, the community of the British nation, manifest in the
massed bodies moving about the capital. The heterogeneity of these crowds figured
in vanguard writing. In Dismorr's 'London notes' in *Blast*, 2 (the 'War number'), 'a
dark agitated stream struggles turbulently along the channel bottom; clouds race
overhead./ Curiously exciting are so many perspective lines, withdrawing, con-
verging.'[50] Wyndham Lewis's prose piece published in the same issue, 'The crowd
master', identifies the crowd both as 'the first mobilisation of a country' and the
serpentine coils of Death: 'a fine dust of extinction, a grain or two for each man, is
scattered in any crowd like these black London war-crowds. Their pace is so
mournful. Wars begin with this huge indefinite Interment in the cities.'[51] 'The
crowd master' witnesses the spectacle of London, its thronging thoroughfares and
its crowds surging past the notable landmarks of an imperial city marked by the
new site of naval power: 'men drift in thrilling masses past the Admiralty, cold
night tide'.[52] Railway stations were key sites of interchange. Crowds are figured at
Charing Cross in Ford Madox Ford's 1915 poem *Antwerp*, which Lewis illustrated:

> This is Charing Cross;
> It is midnight
> There is a great crowd
> And no light.
> A great crowd, all black that hardly whispers aloud.[53]

Most soldiers going to and from the front went through Charing Cross, Waterloo
or Victoria stations. Mrs Elsie Knocker, returning to work as a front-line nurse,
wrote of the large crowds of 'heavily laden khaki lads' returning from their too brief
glimpse of 'other times' at Victoria station. She writes of the incoming stream of
men and the gradual dispersal as the trains depart. But like Lewis's 'The crowd
master' her pervading theme is Death and 'the ruthlessness of war' in which 'indi-
viduals cannot be considered'.[54] Lewis by contrast pitches the individual, 'The
crowd master', against the crowd, 'the multitude on the one hand, the Ego on the
other'.[55] There are uneasy tensions running through these passages from Lewis,
Dismorr and Knocker, flickering through their descriptions of the unstable crowds
and a presentiment of death. Yet in the combination of certainty and distance from
which 'The crowd master' views the rapid pace and volatility of the modern city
loiters a legacy from Baudelaire and Simmel which sees masculinity as the medium
through which the metropolis can be controlled.

In 'The crowd master' the 'closing of the Stock Exchange' initiates 'fascinating
and blood curdling changes in life', a 'Carnival of fear, psychologically'.[56] This

'Carnival of fear' was marked in multiple ways on the civilian front. There were the mobilised men – healthy, shell-shocked or convalescent – and the civilian population both moving through the familiar terrain of the city now made unfamiliar by the state of war. The endemic fear prompted by the closing of the economic centre of London, the signifier of Britain's wealth, was also noted by Dorothy Shakespear. Her watercolour 'War Scare, July 1914' was inscribed 'done when the Stock Exchange shut, before war was declared'.[57] A vortex implodes: arcing and angular forms converge on a displaced centre, which oscillates from concave to convex. As in her 'Snow Scene', reproduced in *Blast*, 2 (Figure 78), or 'Pyrenees: Design for a woodcut' (c. 1919), the forms are tightly held together within a broad panoramic view which does not radically depart from Albertian perspective. The economic anxiety palpable in 'War Scare' had multiple effects in wartime British cities: food and supply shortages, new employment patterns, unemployment and that new fear – the threat from the sky.

78 Dorothy Shakespear, 'Snow Scene', 1914–15.

The introduction of regulations in 1914 by DORA to secure public safety and the defence of the realm authorised the regulation surveillance and control of British citizens, curtailed after-dark lighting, and introduced trial and punishment for their contravention. Safety regulations also changed the structure of the city, in which the display of wealth and the sites of leisure and consumption were contrasted with the darkened streets. If visitors to London recalled with astonishment the groups of marching soldiers on their way to and from the front, they also commented on the intensity of visits to restaurants and cafés in which 'the illuminations inside made up for the darkness of the streets'.[58] This too was the urban territory of the avant-garde. Vorticist imagery was produced within the fragmented spaces, fractured lighting and disjointed perceptions of wartime London. Lawrence Atkinson's 'Study – Café Tables' of c. 1914–18 (Figure 79), Helen Saunders' drawing 'Cabaret',[59] and the first-floor dining-room at the Restaurant de la Tour Eiffel in Percy Street, a popular meeting-place for Vorticists, which

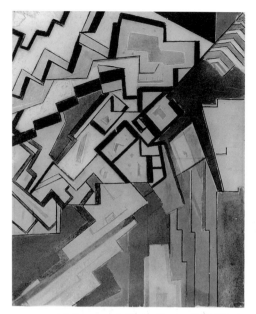

79 Lawrence Atkinson, 'Study - Café Tables', c. 1914–18.

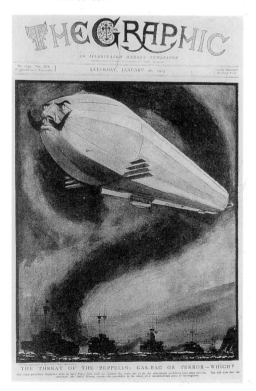

Saunders decorated with Wyndham Lewis in the second half of 1915, are located in these contrasting experiences of war.[60]

Zeppelin raids transformed London's sights and spaces. On the night of 31 May–1 June 1915, 120 bombs were dropped onto London's East End, and in September further airship raids were carried out over Essex. In the press coverage these events were figured by fragmented, shattered buildings; in the ruins civilians and territorial soldiers held displaced household goods. Buildings, bodies and lives: sliced through. Although, as Paul Wombell has pointed out, the imagery of ruins was a key propagandist visual trope, standing for 'German atrocities' and for the violation of nations. Such images precipitated anxieties about the invasion of Britain.[61] Fears of invasion from the sea were added to the threat by bombing from above. Attempts to diffuse the fear through graphic satire appeared in the press, such as the caption – 'Gas-bag or Terror – Which?' – beneath the image of a Zeppelin with the Kaiser's head on the cover of *The Graphic* in January 1915 (Figure 80).

Nevertheless imaged on this cover are those very elements which generated the nation's anxieties – gas, smoke, a Zeppelin hovering over the German High Seas Fleet. These elements transformed perceptions of London both imaginatively and in the daily experiences of its citizens. Although preparations for Zeppelin raids had been made in some areas, Harriet Shaw Weaver noted London's unpreparedness for air attacks as well as the shock of a German Zeppelin hanging over the National Gallery and the Admiralty in October 1915

80 'The Threat of the Zeppelin: Gas-bag or Terror – Which?', *The Graphic*, 16 January 1915.

(it bombed The Strand, causing casualties).[62] The ruins, as much as the constant demolition, building, and rebuilding, rendered the city, uncanny, unhomely, unrecognisable. It is this transformation of the familiar into the unfamiliar that Freud emphasised in his account of the uncanny, written over this period.[63] It was in relation to death and dead bodies, Freud argued, that many experience 'das unheimlich', the familiar alienated through the processes of repression by fear, and he drew out themes of the uncanny in 'literature, stories and imaginative productions'.[64] His observations on the significance of the processes of modification for writers in giving formal representation to the feared experiences may usefully be drawn into a discussion of visual imagery produced during the war in London. Helen Saunders' 'Atlantic City' in *Blast*, 2 (Figure 81), provides an image of the fragmentation, dispersal and non-unitary nature of the wartime city, echoing and playing with repeated

81 Helen Saunders, 'Atlantic City', 1914–15.

media images of sliced-through, shattered buildings and indeterminate household objects (Figure 82).[65] In common with other Vorticist artists, Saunders breaks with two late nineteenth-century paradigms for the representation of the modern city

82 'We bombed the Fortress of London Successfully', *Daily Express*, c. 1915.

which were retained in some early modernist practice: the framing of a view from the threshold of a window and the depiction of urban interiors.[66] Sight-lines converge and depart, sights and sites collide. In 'Atlantic City' the image seems to explode outwards from the centre. Broken shards of urban architecture are lit by arrows of brilliant light. The incisive glare of electric light (or explosion?) breaks up surfaces (as in her 'Vorticist Composition in Green and Yellow', c. 1915), highlights facades of buildings, glows from illuminated windows and borders deep caverns.[67]

In a brilliant and witty analysis of architecture and the text and architecture as text, Jennifer Bloomer has proposed, in contrast to conventional architectural drawing in which line delimits space, '*scrypt*', which she defines as 'a writing that is other than transparent, a writing that is illegible in the conventional sense'. She describes it as 'this writing of something that is empty space, where something secret and sacred – something unspeakable or unrepresentable – is kept, a holey space'.[68] For Bloomer, *scrypt* doubles upon *crypt*, a cavernous void hewn into solid material. Crypts and caves are omni-present in Saunders' drawings, from the cavities of 'Untitled Gouache: Female Figures Imprisoned' (c. 1913), which shape and are formed by the figures within, to the internal depths of 'Composition with Figures in Black and White', c. 1914–15.[69] Voids are visible within the 'slicing through', as in Jessica Dismorr's 'Abstract Composition' of 1914–15 (Figure 83). *Scrypt* delineates the *crypt*, but lends it a spatial uncertainty: as the cave is hollowed out, so the cavity may cave in.

Richard Cork has remarked upon the lack of internal coherence in Saunders' compositions which indeed do lack the logical variation of those by contemporaries such as Lewis, whose canvases like *Workshop* of 1914–15 employ different spatial configurations.[70] Analytical geometries of space (referenced by Ezra Pound in his

83 Jessica Dismorr, 'Abstract Composition', c. 1914–15.

account of Vorticism published in *The Fortnightly Review* in 1914) displaced the viewing subject and the plenary view by setting aside Albertian one-point perspective. Vorticist geometries drew on a range of new imag(in)ings of space and spatial ordering, and I have suggested that land and air ordinances, reanimated in war cartographies, may be important for this reordering. Significantly, although in common with other Vorticists, Saunders attended the Slade School, her interest in perspectival systems was animated through friendship with the artist Rosa Waugh. According to Waugh, from c. 1908, the impact of passages in Joseph Conrad's *Mirror of the Sea* (1906) had stimulated her development of a theory of 'natural perspective'.[71] Waugh refined her theories through analysis of astronomical maps. Critical to her account was the making of plans and elevations of figures, a feature of Saunders' Vorticist work. In 'Atlantic City' the view is everywhere and nowhere; it is not fixed at any point which can be granted to the spectator who is precipitated into its unhomely/*unheimlich* spaces, into a disorientating vision of metropolitan spaces transfigured by war.

Bodies, mechanisation, mud

When George Silverton opened the front door he found that the house was not empty for all its darkness. The spitting noise of the striking of damp matches and mild, growling exclamations of annoyance told him his wife was trying to light the dining-room gas.[72]

My niche in nonentity still grins –
I lay knees, elbows pinioned, my sleep mutterings blunted against a wall.[73]

There is mud all around.
This is favourable to the eclosion of mighty life: thank God for small mercies! How is it that if you struggle you sink?[74]

With these words, published in *Blast* 1914 and 1915, three women, Rebecca West, Jessie Dismorr and Helen Saunders, one writer and two painters, publicly entered the unstable territories of an English avant-garde. This ground was radically altered in the economics of war. The mobilisation of men as an active fighting force was one trajectory of the initial stages of the war; engagement of the civilian population and mobilisation of civilian morale, considered as critical factors to the outcome of the war, was another.[75] While the variable economic circumstances of the middle classes during the war profoundly altered the structure of art institutions, dealer activities and, inevitably, the livelihoods of artists, it also had a transformative impact on the gendered formations of identity and experience.[76] Men involved in vanguard artistic production enlisted or were conscripted and later commissioned by the British or Canadian War Memorials committees, joined the peace corps as ambulance orderlies, were conscientious objectors or worked on the home front in ordinance and military depots.[77] The conditions of modern warfare, its uncertainties, violence and displacement onto unfamiliar territories, exerted

immense pressure on the production, maintenance and management of modern identities, not least in the circulation of contradictory and, in avant-garde terms, conservative new images of patriotism and heroism.

The new perceptions of self as soldier or sailor, enlisting, training and on the fighting fronts have been outlined in recent studies, although the interchanges between soldier/artist still remain shadowy.[78] The connective ties between martial aggressiveness and certain forms of avant-garde masculinities were, however, unavailable to women.[79] While some women like Jessie Dismorr, who became a Voluntary Aid Detachment nurse, moved between the war and civilian zones, many women lived out the war in the home zone. This was not, as Cork suggests, a passive period of waiting, disconnected from the war, but an active engagement in a multiplicity of experiences. The immediate effect of the outbreak of war was intense unemployment for women, but by 1915 women began to find work in industrial and non-industrial areas that had previously been open only to men, as clerks, van drivers, shop assistants in offices and across the transport system, and after March 1915 in the munitions industries, engineering and producing explosives.[80] For women, there were numerous, and often specifically gendered crossings between the war and civilian zones, as in Helen Saunders' experiences in typing manuscripts and letters for Lewis from the front, her work in the censor's office, and her social relations with friends and family coming and going to the front (her sister was a VAD nurse in France). Active experiences on the home front effected 'radical change' in the representations of the 'symbolic field' for both women and men, shaping and rearticulating gendered vanguard subjectivities.[81]

The opening words of the texts quoted above place women in expected terrains – at home, performing wifely tasks (West), asleep perhaps (Dismorr) or taking a mud bath (Saunders). As West's narrative enticingly lays out, Evadne did not find the role of wife to George Silverton particularly conducive, as the sounds, the metaphors, of damp matches and darkened house and the failed gaslight convey.[82] As the narrative unfolds, in contrast to Silverton's pusillanimous misogyny, Evadne is presented as a vital sensual woman, a sought-after and skilled public speaker on socialist platforms. The story ends with George's attempt to drown his wife, in the belief that she is meeting a lover at the 'Petrick reservoirs, two untamed lakes', only to find her soundly asleep at home.[83] Silverton's perception of marriage is embodied in his fantasy of Evadne: 'there was something', he ponders 'about the fantastic figure that made him feel as though they were not properly married'.[84] West locates his conception of marriage both in descriptions of the house/home and in the readings of his wife's body. The absurdity of marriage is figured through various metaphors, most ironically through Silverton's failure either to drown his wife or to commit suicide. But it is different images of the body which carry and develop the narrative. His body exhausted, distressed, 'as though [its] walls – had fallen in at death', hers warm, heavy, asleep. Silverton's conclusion is that 'bodies like his do not kill bodies like hers'.[85] When its juxtaposition with the outbreak of war in 1914 is considered, the intensity of that

realisation takes on a different resonance from the 'sexual war' proposed by the literary critics, Sandra Gilbert and Susan Gubar.[86] The poems by Dismorr and Saunders also present the body, in their case as circumscribed, positioned, held in sleep, struggling, or slipping in mud. But then that strange word 'eclosion' – in Saunders, a naturalisation of the French word *éclosion*, describing the blooming of a flower – suggests to an English ear exclusion or occlusion, a shutting out or closing down of something, as well as seclusion.

In 'A vision of mud' the stifling, sucking property of mud is elaborated:

> I lie quite still: hands are spreading mud everywhere: they plaster it on what should
> be a body.
> They fill my mouth with it. I am sick. They shovel it all back again.
> My eyes are full of it; nose and ears, too.
> I wish I could feel or hear …
> A giant cloud like a black bladder with holes in it hovers overhead.
> Out of the holes stream incessant cataracts of the same black mud that I am lying in.
> Here is a little red in the mud …
> I have just discovered with what I think is disgust, that there are hundreds of other
> bodies bobbing about against me.[87]

In parenthesis at the conclusion of the poem Saunders indicates that these are bodies lying in 'hydro' 'medicinal' mud. But do Derridean strategies of reading and deferred meaning offer different, perhaps doubled readings for the poem? In the multiplicity of images of war circulating on the civilian front in the first eighteen months of hostilities there is a gradual redistribution of heroic images of troops in uniforms imaged in the press, on posters, in letters and dispatches, or of ships static on the high seas, to include representations of conflict, of bodies engaged in battle. Sparingly described in letters home, newspapers and the illustrated press slowly included images of the dug-out trenches of the Western front, of dead bodies or body parts mired in mud. In 'A vision of mud', the body slips and slides, the delineations and boundaries indecipherable, unresolved. Mud fills orifices of sight, sound and smell. But the mud is also likened to excreted bodily substances streaming incessantly from a 'black bladder'. There is furthermore red in the mud. While the poem is in one reading formulated around the corporeal experiences of women, at another it conjures dying and petrified images of the dismembered masculine bodies of trench warfare, its narrating subject masquerading as feminine and as masculine. Evading any resolution, haunted by the trauma of war in which gendered identities fragmented with diagnoses of male hysteria, the poem ends with an image of the disturbed body slithering in the mud's slime, amoeba-like bumping against unknown bodies.

The image of the body perceived as disconnected parts of a 'vision of mud', is also figured in Jessie Dismorr's poem 'Monologue'. Here body pieces converge to present an image of a body fragmented into grotesque parts, with 'stretched ears', fingers 'tipped with horn', dilating and bulging eyes, loose tongue. While the poem

elaborates the sense of sight, the bulging eyes that 'dismember live anatomies innocently', the body is also presented as machine:

> I admire my arrogant spiked tresses, the disposition of my perpetually foreshortened limbs
> Also the new machinery that wields the chains of muscles fitted beneath my close coat of skin'.[88]

This interplay of body and machinery, a familiar trope in avant-garde war writing, inflected here onto the feminine body, evokes both the contemporary imagery and the experience of women munitions workers. The main work in the munitions industries, in which there was a major increase of women employees between 1915 and 1917, was the manufacture and filling of shells with high explosive trinitro-toluene (TNT), which stained women's hair and skin yellow, earning them the name of 'canaries' and engendering a variety of conflicting responses.[89] In a recruitment poster headlined 'These women are doing their bit', women working with shells are depicted standing in a light, clean atmosphere, a young fashionably dressed woman drawing on protective clothing and headgear. The language and the image put in place good, well-paid employment for women. In the background a soldier waves at the doorway, stepping into an unspecified front but supported by the women of Britain. Numerous photographs depicted women, standing or sitting, in heavy industrial wear, handling machinery, their bodies connected with different elements of the machine, the limits between body and machinery often blurred and indistinct.

In two works by Saunders of c. 1915, the watercolour, 'Vorticist Composition' (private collection) and 'Abstract Multicoloured Design' (Plate 7), architectural forms pierce and fragment the body, and in the interplay between interiors and exteriors of body and machinery, the body reshapes the architectural spaces. In both, the corporeal/architectural forms hover, indeterminately, between two and three dimensions. Two striking elements in each of these works link them to contemporary photographic representations of industrial women workers. Brigid Peppin suggests that 'Vorticist Composition' may be a study for the lost painting *Cannon*, and points out the representation of an angular figure 'simultaneously as gunfire and victim'.[90] This may be displaced by a reading of the whole as mechanical forms (or conceivably fins), indicating an interest in Vorticist preoccupations with the body as machine, so prevalent as I indicated above in contemporary imagery of women munitions workers, actively producing the explosives; the dominant use of yellow ochre in the image is indelibly linked to their street visibility. But a photograph of a woman textile worker offers provoking clues to the interplay of body/space in Saunders' watercolours and gouaches (Figure 84). In the photograph a woman worker sits on a machine separating strands of what is probably cotton, the skeins of which, like sinews, construct and are entangled with body and space. Saunders employed a similar device in 'Abstract Multicoloured Design' in which strings from a large hand, on the left of the composition, confuse the inter-delineation of body and space.

The intertwined narratives of nationality, identity and cultural representation were fragmented and changed during the war and the English avant-garde was caught up in the formations of a modernity shaped by the transformative processes of war. It was within this mutable territory that some avant-garde posturings were played out, that gendered identities collided and elided as sexual difference was re-formed both in terms of polarities and of slippery irresolutions. I have argued that this reformulation was neither straightforward nor ordered, but that it can be understood through the strategies and responses traceable in the work of women artists and writers in the avant-garde of wartime.

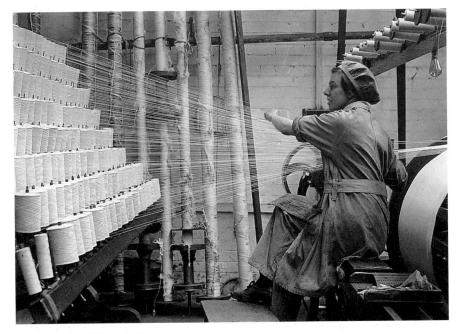

84 'Woman Textile Worker', photograph.

Notes

Notes to Introduction

1 C. Harrison, 'England's climate', in B. Allen (ed.), *Towards a Modern Art World* (New Haven and London, Yale University Press, 1995), p. 223.

2 See C. Harrison, '"Englishness" and "Modernism" revisited', *Modernism/Modernity*, 6:1 (1999) 75–90. There is a perennial difficulty with terminology. It is our conviction that the cultural circumstances of England are specific and different to those of Scotland, Wales or (Northern) Ireland. To write 'British' when we mean 'English' is a form of cultural imperialism. We accordingly use 'Britain' and 'British' only when we intend to refer to the British Isles. It is perhaps worth pointing out that 'English' refers to the conditions of production, not necessarily to the artist.

3 This is effectively the view taken by Harrison in *English Art and Modernism, 1900–1939* (London and Bloomington, Ind., Allen Lane and Indiana University Press, 1981).

4 Paul Barlow in chapter 3 of this volume shows that despite some recent attempts to define new relationships between English art and modernity, this strand of scholarship and its attendant dismissal of the English product is still widely influential.

5 See David Peters Corbett, *The Modernity of English Art, 1914–30* (Manchester and New York, Manchester University Press, 1997), for a fuller discussion of these issues.

6 Inherited largely from Clement Greenberg, of course. For an account of this position and its influence, see F. Frascina and C. Harrison with the assistance of D. Paul (eds), *Modern Art and Modernism: A Critical Anthology* (London, Harper and Row in association with the Open University, 1982).

7 See, for instance, M. Berman, *All That Is Solid Melts Into Air: The Experience of Modernity* (London, Verso, 1983). The most influential example of this reading is T. J. Clark, *The Painting of Modern Life: Paris in the Art of Manet and his Followers* (London, Thames and Hudson, 1985). See the discussions in F. Franscina, N. Blake, B. Fer, T. Garb and C. Harrison, *Modernity and Modernism: French Painting in the Nineteenth Century* (New Haven and London, Yale University Press in association with the Open University, 1993), and, for a recent example of this approach, R. Hobbs (ed.), *Impressions of French Modernity: Art and Literature in France 1850–1900* (Manchester, Manchester University Press, 1998).

8 See, for example, T. J. Clark, *Farewell to an Idea: Episodes from a History of Modernism* (New Haven and London, Yale University Press, 1999), Chapter 1, where Clark discusses David's *Death of Marat* (1793) as a founding moment of modernism.

9 There is a vast literature on modernity as social and cultural process. For a recent survey, see Corbett, *The Modernity of English Art*, Chapter 1.

10 See Berman's use of these terms in *All That Is Solid Melts Into Air*.

11 Historians have for some time seen the need to address the history of industrialisation (modernisation in our terminology) as a process which varied in character and chronology in different regions of Britain; see, for instance, P. Hudson, *The Industrial Revolution* (London, Edward Arnold, 1992), or F. M. L. Thompson (ed.), *The Cambridge Social History of Britain, 1750–1950* (Cambridge, Cambridge University Press, 1990), which exemplify the approach to historical narratives we are arguing for.

12 Influential and recent work on Englishness and national identity includes R. Samuel (ed.), *Patriotism* (London, Routledge and Kegan Paul), R. Colls and P. Dodd (eds.), *Englishness: Politics and Culture, 1880–1920* (London, Croom Helm, 1986), L. Colley, *Britons: Forging the Nation, 1707–1837* (New Haven and London, Yale University Press, 1992), D. Matless, *Landscape and Englishness* (London, Reaktion, 1998), G. Cubitt (ed.), *Imaging Nations* (Manchester and New York, Manchester University Press, 1998) and, most recently, A. Easthope, *Englishness and National Culture* (London and New York, Routledge, 1999).

13 Janet Wolff's chapter was not presented at 'Rethinking Englishness', and Kenneth McConkey and David Peters Corbett gave papers there on different subjects to those dealt with in their chapters here. All the remaining chapters are derived from the papers delivered at the conference.

14 The issues of landscape and national identity are dealt with in another volume which had its inception at the conference, *The Geography of Englishness: English Art and National Identity, 1880–1940*, ed. D. Peters Corbett, Y. Holt and F. Russell (New Haven and London, Yale University Press, forthcoming from the Paul Mellon Centre for Studies in British Art and the Yale Center for British Art).

15 See Andrew Stephenson's chapter in this volume (chapter 8) for the recent literature on questions of identity.

16 On the concept of conservative modernity generally, see the special issue of *New Formations*, 28 (1996).

17 P. Gillett, *The Victorian Painter's World* (Gloucester, Sutton, 1990), D. S. Macleod, *Art and the Victorian Middle Class: Money and the Making of Cultural Identity* (Cambridge, Cambridge University Press, 1996), S. P. Casteras and C. Denney, *The Grosvenor Gallery: A Palace of Art in Victorian England*, exhib. cat. (New Haven and London, Yale University Press for the Yale Center for British Art, 1996).

Notes to Chapter 1

1 I should explain two things here. First, that I have kept 'English' for consistency; neither 'English' nor 'British', narrowly defined, does justice to the cosmopolitan nature of pre-war modernism (Augustus and Gwen John were Welsh, Fergusson was Scottish, Lewis was half Canadian, Epstein, Pound and Eliot were American, Yeats and Joyce were Irish, Gaudier-Brzeska was French, and Bomberg and Gertler were the Yiddish-speaking children of East European immigrants). Second, that this chapter is substantially as given at the conference 'Rethinking Englishness: English Art, 1880–1940', in 1997, and I have been encouraged to preserve its informal and somewhat polemical tone. My aim for the purposes of plenary scene-setting was to consider some of the options for a revisionist history of English modernism or, in Charles Harrison's phrase, for a study 'not subject to the traditional closures on art historical writing'. (This quotation provided an

epigraph for the conference; I had already used it in the introduction to my 1996, Mellon lectures, published as *Modern Life and Modern Subjects: British Art in the Early Twentieth Century*, New Haven and London; Yale University Press, 2000.) See C. Harrison, *English Art and Modernism, 1900–1939* (London and Bloomington, Ind., Allen Lane and Indiana University Press, 1981), p. 7.

2 E. Said, *Beginnings: Intention and Method* (Baltimore, Johns Hopkins University Press, 1975), p. 50.

3 W. K. Rose (ed.), *The Letters of Wyndham Lewis* (London, Methuen, 1963), p. 12. Rose suggests 1904 but the date is more likely 1905; at the end of April or beginning of May, John and his wife Ida joined Dorelia in the caravan on Dartmoor where she had given birth to his son Pyramus. They remained there for two months with John's children by Ida.

4 Quoted in Michael Holroyd, *Augustus John: A Biography* (Harmondsworth, Penguin, 1976), p.186. This is a revised, paperback, edition of the two volumes published by William Heinemann in 1974 and 1975. There is substantial new material in Holroyd's *Augustus John: The New Biography* (London, Chatto and Windus, 1996), but there are also cuts, so that I am obliged to quote from more than one edition.

5 *Burlington Magazine*, 15 (1909) 17.

6 John's obituary notice for Lady (Matthew) Smith, née Gwen Salmond, *The Times* (1 February 1958), quoted in Holroyd, *Augustus John* (1976), pp. 81–2.

7 Ida John to Mary Dowdall ('the Rani'), undated, quoted in Holroyd, *Augustus John* (1996), p. 192.

8 C. Holland, 'Lady art students' life in Paris', *Studio*, 30 (1903) 225–31.

9 W. Lewis, *Rude Assignment* (Santa Barbara, Cal., Black Sparrow Press, [1950] 1984), p. 127.

10 V. Bell, 'Notes on Bloomsbury' (1951), repr. in S. P. Rosenbaum (ed.), *The Bloomsbury Group: A Collection of Memoirs. Commentary and Criticism* (Toronto, Toronto University Press, 1975), p. 75.

11 'Genius and women painters', *The Common Cause* (17 April 1914) 31.

12 A. John, *Chiaroscuro: Fragments of an Autobiography* (London, Jonathan Cape, 1952), p. 73.

13 W. Lewis, *Blasting and Bombardiering* (London, Calder and Boyars, [1937] 1967), pp. 32, 36, 46–7.

14 The 'round-robin' letter sent to Omega shareholders and the press, October 1913, is reprinted in Rose, *Letters of Wyndham Lewis*, pp. 47–50. (I have reversed the order of the sentences.)

15 *Blast*, 1 (1914) 30, 33.

16 Quoted in R. Cork, *Vorticism and Abstract Art in the First Machine Age* (London, Gordon Fraser, 1976), vol. 1, p.182.

17 In D. D. Paige (ed.), *Selected Letters of Ezra Pound, 1907–1941* (London, Faber and Faber, 1971), p.74. See also Ezra Pound quoted in H. Brodzky, *Henri Gaudier-Brzeska* (London, Faber and Faber, 1933), p. 62: 'Brzeska is immortalising me in a phallic column.'

18 'Vital English Art' was published in the *Observer* (7 June 1914), *The Times* and the *Daily Mail*; it is reproduced in C. R. W. Nevinson, *Paint and Prejudice* (London, Methuen, 1937), pp. 58–60. On Marinetti and the Futurist 'scorn for women' (but also their ambiguous support for women's suffrage as likely to destroy the hoax of modern democracy), see 'Against *Amore* and parliamentarianism', reprinted in R. W. Flint (ed.), *Marinetti: Selected Writings* (New York, Farrar, Strauss and Giroux, 1972), p. 75.

19 From a paper read to the Memoir Club, c. 1922, quoted in Q. Bell, *Virginia Woolf: A Biography* (London, Hogarth Press, 1972), vol. 1, p. 124.

20 R. Marler (ed.), *Selected Letters of Vanessa Bell* (London, Bloomsbury, 1993), pp. 153–4.

21 *A Room at the Second Post-Impressionist Exhibition* has been attributed to both Bell and Fry. I believe it to be by Bell: on stylistic grounds; because Duncan Grant was confident that it was by her (remembering the occasion, and that he was the seated figure); and because she refers to it in a letter to Fry. 'I enjoyed painting at the Grafton though I think my painting is very dull, but the colour was so lovely and I had a really good look at the pictures. You must come one Sunday. It is wonderful to be there alone and see the things in peace.' Bell to Fry, 17 November [1912], Tate Gallery Archives, Charleston Papers 8010.8.78. It is true that there is another letter from Vanessa to Clive Bell, 31 December [1912], indicating that Fry had also 'been off at 8 to do a sketch at the Grafton of the Matisses before they go!' (8010.2.102), but see Grant's recollections in 'Duncan Grant to 1920. The Basic Outline', D. Brown, Tate Gallery Archives, 724.1, p. 5, and also Grant's interview with Sarah Whitfield, 1970–71, TAV 1A/B.

22 F. Rutter, *Revolution in Art* (London, Art News Press, 1910). Rutter was an art critic, founder and secretary of the Allied Artists' Association, Director of Leeds City Art Gallery and honorary treasurer of the Men's Political Union for Women's Enfranchisement. In 1913 Rutter was suspected of complicity in the escape of the suffragette arsonist Lilian Lenton (blessed in *Blast*), who had been on temporary release from Armley Jail, recuperating from hunger strike under the terms of the 'Cat and Mouse' Act.

23 V. Bell, Memoir VI, quoted in F. Spalding, *Vanessa Bell* (London, Macmillan, [1983] 1984), p. 92.

24 *Morning Post* (16 November 1910) 5, repr. in J. B. Bullen (ed.), *Post-Impressionists in England: The Critical Reception* (London, Routledge, 1988), p. 6.

25 C. Lewis (ed.), *Self Portrait: Taken from the Letters and Journals of Charles Ricketts RA* (1939), pp. 189–90, quoted in J. Christian (ed.), *The Last Romantics: The Romantic Tradition in British Art: Burne-Jones to Stanley Spencer*, exhib. cat. (London, Lund Humphries in association with the Barbican Art Gallery, 1989), p. 20.

26 C. Bell, *Art* (London: Chatto and Windus, [1914] 1949), p. 25.

27 Harrison, *English Art and Modernism*, p. 7. There is a new preface to the second edition (New Haven and London, Yale University Press for the Paul Mellon Centre for Studies in British Art, 1994). On 'Of' see M. Baldwin, C. Harrison and M. Ramsden, 'Art history, art criticism and explanation', *Art History* (December 1981) 432–56, esp. 433–6. A more detailed discussion can be found in Art & Language, 'A portrait of V. I. Lenin', *Art-Language*, 4 (June 1980) 26–62.

28 Baldwin *et al.*, 'Art history, art criticism and explanation', 433, 444.

29 M. Baxandall, *Painting and Experience in Fifteenth-Century Italy: A Primer in the Social History of Pictorial Style* (Oxford, Oxford University Press, 1972), p. 1.

30 *Blast*, 1 blasted 'First (from politeness) ENGLAND', the 'Britannic Aesthete' and 'Tonks' (p. 11), 'good-for-nothing Guineveres' and 'SNOBBISH BORROVIAN running after GIPSY KINGS' (a dig at John) (p. 19). The Omega round robin detected in Bloomsbury Post-Impressionism 'a mid-Victorian languish of the neck' and a 'greenery-yallery' skin (a reference to the Grosvenor Gallery and work such as Burne-Jones's which was regularly shown there). But *Blast* also blessed England, 'Industrial Island machine',

chiefly for its 'PORTS, RESTLESS MACHINES of scooped out basins/heavy insect dredgers/monotonous cranes/stations … steep walls of factories' (p. 23). 'England is just now the most favourable country for the appearance of a great art' (p. 33). On 'The Englishness of British Art', see William Vaughan in the *Oxford Art Journal*, 13 (1990) 11–23. A progressive naturalism, consolidated in the late nineteenth century as the chief characteristic of 'Englishness' in art, together with an insular confidence in the native tradition, hindered the development of internationalism and formalism as these were espoused by modernist artists and critics. But increasingly from the 1880s progressive writers employed a Darwinian, evolutionary discourse to argue for less didactic, more expressive art forms appropriate to the changing conditions of modernity.

31 See, for a selection, Bullen (ed.), *Post-Impressionists in England*.

32 See N. Pevsner, *The Englishness of English Art* (London, The Architectural Press, 1956), p. 60: 'a decent home, a temperate climate, and a moderate nation. It has its disadvantages in art. There is no Bach, no Beethoven, no Brahms. There is no Michelangelo, no Titian, no Rembrandt [but] a nice crop of amateur painters from maiden aunts to Prime Ministers.' It is a familiar trope in relation to women's supposed lack of cultural (as opposed to reproductive) capacities. Elisabeth Bronfen takes her epitaph for *Over Her Dead Body: Death, Femininity and the Aesthetic* (Manchester, Manchester University Press, 1992) from Thomas de Quincy, 'Joan of Arc', *The Collected Writings*, ed. D. Masson (London, A. and C. Black, 1897), p. 406: 'yet, sister woman, though I cannot consent to find a Mozart or a Michael Angelo in your sex, cheerfully, and with the love that burns in depths of admiration, I acknowledge that you can do one thing as well as the best of us men – a greater thing than even Milton is known to have done, or Michael Angelo: you can die grandly, and as goddesses would die, were goddesses mortal'.

33 See L. Tickner, 'Men's work? Masculinity and modernism', in N. Bryson, M. A. Holly and K. Moxey (eds.), *Visual Culture: Images and Interpretations* (Hanover, N.H., and London, Wesleyan University Press, 1994), pp. 42–82; and 'Now and then: the Hieratic Head of Ezra Pound', *Oxford Art Journal*, 16:2 (1993) 55–61.

34 'I might have been at the head of a social revolution, instead of merely being the prophet of a new fashion in art': Lewis, *Blasting and Bombardiering*, p. 35.

35 R. S. Nelson and R. Shiff (eds.), *Critical Terms for Art History* (Chicago, University of Chicago Press, 1996). Phenomenology and the physiology and psychology of perception, which have also informed some recent art-historical writing, are not discussed in this volume.

36 R. Fry, 'The artist in the great state' (1912), quoted in R. Jensen, *Marketing Modernism in Fin-de-Siècle Europe* (Princeton, Princeton University Press, 1994), p. 36.

37 This is not to suggest, of course, that photography is a socially and technically unmediated practice.

38 See, in particular, P. Bourdieu, *The Rules of Art: Genesis and Structure of the Literary Field*, trans. S. Emanuel (Cambridge, Polity Press, [1992] 1996); and *The Field of Cultural Production: Essays on Art and Literature*, a collection of previously translated essays by Bourdieu edited by R. Johnson (Cambridge, Polity Press, 1993). Bourdieu argues that (in the French context) the Salon des Refusés of 1863 triggered the rupture with the whole hierarchical apparatus secured by the Academy's monopoly, which was slowly transformed 'into a *field* of competition for the monopoly of artistic legitimation' (*The Field of Cultural Production*, pp. 251–2).

39 P. Bourdieu, *Questions de Sociologie* (Paris, Minuit, 1984), p. 197, quoted in T. Moi, 'Appropriating Bourdieu: feminist theory and Pierre Bourdieu's theory of culture', *New Literary History*, 22 (1991) 1017–49 (p. 1021).

40 Paul Edwards reproduces a number of photographs of Lewis in *Wyndham Lewis: Art and War*, exhib. cat. (London, The Wyndham Lewis Memorial Trust in association with Lund Humphries, 1992); see esp. pp. 13–15. The 1911 *Self-Portrait* is reproduced with others in W. Michel, *Wyndham Lewis: Paintings and Drawings* (London, Thames and Hudson, 1971) (Plate 4). The V of the frowning eyebrows repeats those in Lewis's sketch of himself in his new hat, in a letter to his mother c. 1907. The original is in the Lewis papers in the Rare and Manuscript Collections, Carl A. Kroch Library, Cornell University (Box 62). The letter is reproduced in Rose, *Letters of Wyndham Lewis*, pp. 32–3, but without the sketch.

41 See Michel, *Wyndham Lewis*, cat. P4.

42 Virginia Woolf, *Three Guineas* (London, Penguin, [1938] 1977), pp. 73–4: the 'battle of the Royal Academy' was one among many – the battle of Westminster, the battle of Whitehall, the battle of Harley Street – all fought by the same combatants: 'that is by professional men v. their sisters and daughters'.

43 Lewis remarked that 'artificial floating' was essential for the modern artist: 'I could not have lived, only paid for hair-cuts and cigarettes, with any money I made up to autumn 1913' (he was floated by his obliging mother who also brought up two of his illegitimate children): *Rude Assignment*, p. 135. Sophie Brzeska's 'diaries', much of them in reported speech and headed intermittently 'Notes for Matka' (a novel) are in the archives of the Universities of Cambridge (to c. 1915) and Essex (c. 1915 and after). The Jewish Education Aid Society sponsored a number of art students from immigrant families between 1908 and 1914, including David Bomberg, Mark Gertler, Jacob Kramer, Bernard Meninsky and Isaac Rosenberg, all of whom went to the Slade. On Omega, see J. Collins, *The Omega Workshops* (London, Secker and Warburg, 1984).

44 Jensen, *Marketing Modernism*, p. 3. Also of interest here are D. S. Macleod, *Art and the Victorian Middle Class: Money and the Making of Cultural Identity* (Cambridge, Cambridge University Press, 1996); and J. Codell, 'Artists' professional societies: production, consumption, and aesthetics', in B. Allen (ed.), *Towards a Modern Art World* (New Haven and London, Yale University Press for the Paul Mellon Centre for Studies in British Art, 1995), pp. 169–87.

45 See M. Ward, 'What's important about the history of modern art exhibitions?', in R. Greenberg, B. Ferguson and S. Nairne (eds.), *Thinking About Exhibitions* (London, Routledge, 1996), pp. 451–64. See also Codell, 'Artists' professional societies'.

46 Durand-Ruel, Bernheim-Jeune, Ambroise Vollard, the Druet Gallery, Clovis Sagot and Daniel Kahnweiler lent works to *Manet and the Post-Impressionists* in 1910, as did private collectors including Leo Stein.

47 The local audience for art declined as the national academies lost their power and established criteria of competence were breached. But the international audience for new art expanded as secessionists linked up in a plethora of small magazines and exhibiting spaces across the West. Lewis was reproduced in Russia and Vorticist work was shown in New York. Fifteen countries were represented in the Berlin Autumn Salon of 1913. The exhibition of Futurist painting at the Sackville Gallery in March 1912 had begun in Paris, and travelled on to Berlin, Brussels, Hamburg, Amsterdam, The Hague, Frankfurt, Breslau, Dresden, Zurich, Munich and Vienna.

48 I have taken the quotation from 'The language of art', *New Age* (28 July 1910), repr. in O. Sitwell (ed.), *A Free House! Or the Artist as Craftsman: Being the Writings of Walter Richard Sickert* (London, Macmillan, 1947), p. 89; but see *ibid.*, p. 74, apropos the Millet painting: 'Millet was giving here just that something that only the pencil or the brush can give, an emotion whose bouquet will not survive decanting from the skin of painting into that of letters.'

49 'The New English and after', *New Age* (2 June 1910), quoted in J. Rothenstein, *Modern English Painters*, 1, *Sickert to Smith* (London, Macdonald and Jane's, [1952] 1976), p. 47.

50 M. Barrett, 'The concept of difference', *Feminist Review*, 26 (Summer 1987) 29–41. I develop the implications of her article for art history in 'Feminism, art history and sexual difference', *Genders*, 3 (Fall 1988) 92–128.

51 See A. Callen, *The Spectacular Body: Science, Method and Meaning in the Work of Degas* (New Haven and London, Yale University Press, 1995), pp. 21–8.

52 See G. Pollock, most recently in *Differencing the Canon: Feminist Desire and the Writing of Art's Histories* (London, Routledge, 1999) and *Mary Cassatt: Painter of Modern Women* (London, Thames and Hudson, 1998).

53 A. M. Wagner, *Three Artists (Three Women): Modernism and the Art of Hesse, Krasner, and O'Keeffe* (Berkeley, University of California Press, 1996). The quotations are from pp. 13, 17, 27.

54 *Ibid.* pp. 183–4. Poussin was a great admirer of Domenichino. Henry James considered his reputation inflated. Francis Haskell discusses James's puzzlement that the Brownings burnt incense to Domenichino, and his apparent indifference to the possibility that their tastes might be vindicated, in *Rediscoveries in Art: Some Aspects of Taste, Fashion and Collecting in England and France* (London, Phaidon, 1976), p. 8.

55 Wagner, *Three Artists*, p. 25; alluding to Michael Baxandall's suggestion that art historians can 'point' productively, like tour guides, at works others can see too. See Baxandall, 'The language of art history', *New Literary History*, 10 (1978–79) 454–5.

56 See P. Bourdieu, *Distinction: A Social Critique of the Judgement of Taste*, trans. R. Nice (Cambridge, Mass., Harvard University Press, 1984).

57 T. Eagleton, *The Ideology of the Aesthetic* (Oxford, Blackwell, 1990), p. 13.

58 These are among Bourdieu's examples in *Distinction*.

59 B. Herrnstein Smith, 'Contingencies of value', *Critical Inquiry*, 10 (September 1983) 1–35 (p. 24). See also her subsequent volume, *Contingencies of Value: Alternative Perspectives for Critical Theory* (Cambridge, Mass., Harvard University Press, 1988).

60 'Contingencies of Value', pp. 11–12, 26, 27.

61 See Charles Harrison, '"Englishness" and "Modernism" revisited', the published version of a paper delivered at the 'Rethinking Englishness' conference, University of York, 1997, *Modernism/Modernity*, 6:1 (1999) 75–90: 'let me come clean, though I risk a certain loss of face in doing so. An interest in the art of Ben Nicholson was the principal motivating force for the work that led to *English Art and Modernism*. He played a central role in the story it was written to tell. The painter Gwen John, on the other hand, is not even mentioned in the book. Yet if I were now required to choose a work by one or the other – let us say to live with – it is the picture by Gwen John that I would take' (84). (I cut the quotation here for brevity, but Harrison goes on to consider a number of possible determinants on this change of heart.)

62 Lewis, *Blasting and Bombardiering*, p. 46.

63 B. Collins (ed.), *12 Views of Manet's Bar* (Princeton, Princeton University Press, 1996). This does not reprint N. Ross's *Manet's Bar at the Folies-Bergère and the Myths of Popular Illustration* (1982) or T. J. Clark's 'A Bar at the Folies-Bergère', Chapter 4 of *The Painting of Modern Life: Paris in the Art of Manet and his Followers* (London, Thames and Hudson, 1985), and a recent addition is T. de Duve, 'How Manet's *A Bar at the Folies-Bergère* is constructed', *Critical Inquiry*, 25 (Autumn 1998) 136–68.

64 The catalogue offers a detailed account of the exhibitions that introduced continental modernism to the British public, from Fry's 'Manet and the Post-Impressionists' of 1910 to 1919. See A. Gruetzner Robins, *Modern Art in Britain 1910–1914* (London, Merell Holberton in association with the Barbican Art Gallery, 1997).

65 John Rothenstein puts this well in the case of Mark Gertler: 'two contradictory views prevail about Gertler: the one held by those disposed to favour art that is produced near the centre from which the dominant style of the time radiates; to the other incline those who are disposed to believe that the only way for an art to be universal is to be local and particular … To some, therefore, Gertler was a gifted provincial whose art ripened as it moved ever nearer to the Parisian sun; to others he seemed an inspired provincial whose art lost its savour as it became more metropolitan'; *Modern Painters*, 2, *Lewis to Moore* (London, Macdonald and Jane's, [1956] 1976), p. 200. See also Peter Fuller's argument that 'the best British art of this century has, in fact, adopted a stance of informed resistance towards Modernity' (and by implication modernism); and Philip Dodd's response that the career of David Bomberg, one of Fuller's heroes, 'shows that an artist can be simultaneously "localist" and cosmopolitan' and that 'the artistic category that must be dispensed with now is the national'. Fuller, 'British art: an alternative view', *Art and Design*, 3:1–2 (1987) 55–66 (p. 57); 'An open letter from Philip Dodd: art, history and Englishness', *Modern Painters*, 1:4 (Winter 1988–89), 40–1 (p. 41).

66 A positive, revisionist account of British modernism has to avoid the trap of underplaying continental influence (Bell and Grant believed, after all, that there was no one in England 'even with whom it's worth discussing one's business'), but also of overplaying it (neither Picasso nor Braque made the same move to abstraction in their collages around 1913–14 or adopted the vivid colouring of Omega's decorative aesthetic). On 'no one with whom', see A. O. Bell (ed.), *The Diary of Virginia Woolf* (London: Hogarth Press, 1977), vol. 1 (1915–19), p. 120, entry for 2 March 1918; and on Omega as a compromise formation drawing on the British Arts and Crafts tradition and the French avant-garde, see P. Wollen, 'Hitting the buffers', a review of C. Butler, *Early Modernism: Literature, Music and Painting in Europe 1900–1916* (Oxford, Oxford University Press, 1994), in *London Review of Books* (8 September 1994) 10–11. There are also local variations in the relations of 'modernisms' to 'modernity'. David Peters Corbett puts it very well: 'once we are prepared to see modernity as a changing complex of processes which take on a particular colouring in certain places and at certain times, then the way is open to shift attention from the suspect history of modernism in England to an interpretative description of its place within a more generously drawn historical situation'. D. Peters Corbett, *The Modernity of English Art 1914–30* (Manchester, Manchester University Press, 1997), p. 16.

67 Harrison, '"Englishness" and "Modernism" revisited', 79.

68 M. A. Holly, *Panofsky and the Foundations of Art History* (Ithaca, Cornell University Press, 1984), p. 165. The reference is to W. Heckscher, *Erwin Panofsky: A Curriculum Vitae* (Princeton, New Jersey, Princeton University Press, 1969), p. 14. Perhaps there is another parallel here with Bourdieu, whose concept of 'field' was intended 'to bypass the

opposition between internal reading and external analysis without losing any of the benefits and exigencies of these two approaches'; the point was always *to do both* (*The Rules of Art,*) p. 205).

69 E. Barrett Browning, *Aurora Leigh* (London, Women's Press, [1853–56] 1978), pp. 200–1.

Notes to Chapter 2

I would like to thank Henri Zerner, whose teaching inspired my interest in nineteenth-century art; John House for many discussions on academic art; John Betts for illumination about Greek art; and Charles Martindale for inspiration and encouragement.

1 For the term 'licked surface', see C. Rosen and H. Zerner, *Romanticism and Realism: The Mythology of Nineteenth Century Art* (London and Boston, Faber and Faber, 1984), pp. 203–32.

2 C. Greenberg, 'Towards a newer Laocoön' (1940), repr. in *Clement Greenberg: The Collected Essays and Criticism*, ed. J. O'Brian (Chicago and London, University of Chicago Press, 1986–93), vol. 1, p. 27: 'the name of this low is Vernet, Gérome [sic], Leighton, Watts, Moreau, Böcklin, the Pre-Raphaelites, etc., etc.'

3 The chronological boundaries of this periodisation vary in different accounts; David Peters Corbett describes 'processes of change which have been operating since the sixteenth century', while Charles Harrison speaks of 'Western culture from the mid-nineteenth century at least until the mid-twentieth: a culture in which processes of industrialization and urbanization are conceived of as the principal mechanisms of transformations in human experience'. See D. Peters Corbett, *The Modernity of English Art, 1914–30* (Manchester and New York, Manchester University Press, 1997), p. 11; C. Harrison, 'Modernism', in R. S. Nelson and R. Shiff (eds.), *Critical Terms for Art History* (Chicago and London, University of Chicago Press, 1996), p. 143.

4 For Harrison, 'the intentional rejection of classical precedent and classical style' is basic to modernism even on the broadest definition; see Harrison, 'Modernism', p. 142. See also B. H. D. Buchloh, 'Figures of authority, ciphers of regression', *October*, 16 (Spring 1981) 39–68, where twentieth-century returns to classicism are presented as betrayals of modernism, inherently authoritarian and regressive.

5 P. de Man, 'Literary history and literary modernity' (1969), in *Blindness and Insight: Essays in the Rhetoric of Contemporary Criticism* (Minneapolis, University of Minnesota Press, second edition, 1983), p. 142.

6 See *ibid.*, pp. 156–61.

7 F. Leighton, Notebook XV, Royal Academy of Arts, possibly c. 1880; see L. and R. Ormond, *Lord Leighton* (New Haven and London, Yale University Press, 1975), p. 83. Leighton's Academy Addresses are largely devoted to a survey of the art of the past.

8 F. Leighton, Address delivered 10 December 1879, repr. in *Addresses Delivered to the Students of the Royal Academy by the late Lord Leighton* (London, Kegan Paul, Trench, Trübner, 1896), p. 11. Compare Walter Pater on literary modernity in the Antonine period: 'How had the burden of precedent laid upon every artist increased since [the Homeric age]!' Yet Pater was willing to contemplate the possibility that Homer's age might have been another such 'modernity'; see W. Pater, *Marius the Epicurean* (Oxford and New York, Oxford University Press, [1885] 1986), pp. 57–8.

9 See C. Arscott, 'Leighton: the artist as artificer', in T. Barringer and E. Prettejohn (eds.), *Frederic Leighton: Antiquity, Renaissance, Modernity* (published for the Paul Mellon Centre for Studies in British Art and the Yale Center for British Art, New Haven and London, Yale University Press, 1999), pp. 5–9, 15.

10 For example, Horace, *Odes* 2.20; see N. Rudd, 'Daedalus and Icarus (i) from Rome to the end of the Middle Ages', in C. Martindale (ed.), *Ovid Renewed: Ovidian Influences on Literature and Art from the Middle Ages to the Twentieth Century* (Cambridge, Cambridge University Press, 1988), p. 22.

11 See S. Jones, catalogue entry in S. Jones *et al.*, *Frederic Leighton*, exhib. cat. (London, Royal Academy of Arts, 1996), p. 165; Arscott, 'Leighton: the artist as artificer', p. 8. For the comparison to the *Hermes*, see R. Barrow, 'Drapery, sculpture and the Praxitelean ideal', in Barringer and Prettejohn (eds), *Frederic Leighton*, p. 59. The association with the *Hermes* is not less relevant because the statue was not unearthed until 1877 (eight years after the first exhibition of Leighton's picture); the attribution of the statue to Praxiteles depended on resemblance to a type of male beauty already associated with Praxiteles and crucial to Leighton's painting. The statue is not now ascribed to the ancient sculptor but it continues to appear Praxitelean to most scholars. Like the Praxitelean male nudes, the so-called *Castor and Pollux* of the Prado has figured in homo-erotic writing on art; see, for example, J. A. Symonds, *Sketches and Studies in Italy* (London, Smith, Elder, 1879), pp. 84–8.

12 C. Greenberg, 'Modernist painting' (1960), repr. in *Clement Greenberg*, ed. O'Brian, 4, p. 85.

13 See N. McWilliam, 'Limited revisions: academic art history confronts academic art', *Oxford Art Journal*, 12:2 (1989) 71–86.

14 See Greenberg, 'Towards a newer Laocoon', pp. 24–30.

15 A. Gruetzner Robins, 'Leighton: a promoter of the new painting', in Barringer and Prettejohn (eds), *Frederic Leighton*, pp. 323–9.

16 See E. Prettejohn, 'Leighton: the aesthete as academic', in R. C. Denis and C. Trodd (eds.), *Art and the Academy in the Nineteenth Century* (Manchester, Manchester University Press, 2000), pp. 34–42.

17 See Greenberg, 'Towards a newer Laocoon', pp. 24, 27.

18 Rosen and Zerner, *Romanticism and Realism*, pp. 221–2.

19 See *ibid.*, pp. 222–32.

20 'Exhibition of the Royal Academy. Third Article', *The Times* (15 May 1869) 12.

21 'The Royal Academy', *Art-Journal* (1 July 1869) 199; 'The London art-season', *Blackwood's Edinburgh Magazine*, 106 (August 1869) 224.

22 See E. Prettejohn, 'Aesthetic value and the professionalization of Victorian art criticism, 1837–78', *Journal of Victorian Culture*, 2:1 (1997) 80–3.

23 E. Prettejohn, 'Morality versus aesthetics in critical interpretations of Frederic Leighton, 1855–75', *Burlington Magazine*, 138 (1996) 79–84.

24 This is already evident in 'Towards a newer Laocoon', pp. 34–5, and becomes more pronounced in 'Modernist painting', p. 87.

25 See Greenberg, 'Modernist painting', p. 90.

26 Repr. in C. Reed (ed.), *A Roger Fry Reader* (Chicago and London, University of Chicago Press, 1996), pp. 12–20. For Fry's later emphasis on volume and the 'plastic' in painting, see C. Reed, 'Refining and defining: the Post-Impressionist era', *ibid.*, pp. 121–3.

27 G. W. F. Hegel, *Introductory Lectures on Aesthetics*, trans. B. Bosanquet (1886; repr. London, Penguin, 1993), pp. 94, 92.

28 See, for example, F. G. Stephens, 'The Royal Academy', *Athenaeum*, 2584 (5 May 1877) 580–1; W. M. Rossetti, 'The Royal Academy exhibition', *Academy* (16 June 1877) 539–40.

29 Sir Joshua Reynolds, Discourse X (1780), *Discourses on Art*, ed. R. R. Wark (published for the Paul Mellon Centre for Studies in British Art, New Haven and London, Yale University Press, 1975), pp. 187–8.

30 See E. Gosse, 'The New Sculpture', *Art Journal* (1894) 138–42; Leighton's modelling in clay was the subject of the first article in the first number of *The Studio* (1893). On the New Sculpture, see S. Beattie, *The New Sculpture* (published for the Paul Mellon Centre for Studies in British Art, New Haven and London, Yale University Press, 1983).

31 M. H. Spielmann, *British Sculpture and Sculptors of To-Day* (London, Paris, New York and Melbourne, Cassell, 1901), pp. 1–12.

32 Greenberg, 'Towards a newer Laocoon', p. 23.

33 R. Fry, 'Introduction to the Tenth Discourse', in *Discourses Delivered to the Students of the Royal Academy by Sir Joshua Reynolds. Kt.*, ed. R. Fry (London, Seeley, 1905), p. 265.

34 Reynolds, Discourse X, p. 177.

35 The article responds to another exploration of the problem, Irving Babbitt's *The New Laokoön: An Essay on the Confusion of the Arts* of 1910; see Greenberg, 'Towards a newer Laocoon', p. 30.

36 Oscar Wilde immediately recognised the connection, noting that Leighton's sculpture 'may be thought worthy of being looked at side by side with the Laocoon of the Vatican'; see O. Wilde, 'The Grosvenor Gallery', *Dublin University Magazine*, 90 (July 1877) 126.

37 See G. E. Lessing, *Laocoon*, trans. R. Phillimore (London, Macmillan, 1874). Lessing's two basic categories, space and time, gained still more philosophical significance when Kant made them the two *a priori* categories by means of which the mind represents to itself all experience, whether of the external world or of its internal state, in the *Critique of Pure Reason* of 1781. Read alongside Kant, Lessing's binary division might be taken to imply that the arts concretely, and comprehensively, realise the basic conditions of human subjectivity.

38 See, for example, Stephens, 'The Royal Academy', 581; Rossetti, 'The Royal Academy exhibition', 539. However, Tom Taylor predicted a victory for the snake: 'the man has been ill-advised to attempt resistance with an arm held behind him'; see 'The Royal Academy', *The Times* (5 May 1877) 12.

39 H. H. Statham, 'At the Royal Academy', *Fortnightly Review*, 28 (July 1877) 72.

40 H. James, 'The picture season in London' (1877), repr. in H. James, *The Painter's Eye: Notes and Essays on the Pictorial Arts*, ed. J. L. Sweeney (Madison, Wisc., and London, University of Wisconsin Press, 1989), p. 149.

41 Greenberg, 'Towards a newer Laocoon', p. 34.

42 W. Pater, *The Renaissance: Studies in Art and Poetry*, ed. D. L. Hill (Berkeley and Los Angeles, University of California Press, 1980), p. 164.

43 Greenberg, 'Towards a newer Laocoon', p. 34.

44 See, for example, F. C. McGrath, *The Sensible Spirit: Walter Pater and the Modernist Paradigm* (Tampa, University of South Florida Press, 1986); D. Carrier, 'Baudelaire,

Pater and the origins of modernism', *Comparative Criticism*, 17 (1995) 109–21; D. Donoghue, *Walter Pater: Lover of Strange Souls* (New York, Alfred A. Knopf, 1995), pp. 1–9.

45 Robin Spencer proposes an analogous role for Swinburne and Whistler; see R. Spencer, 'Whistler, Swinburne, and art for art's sake', in E. Prettejohn (ed.), *After the Pre-Raphaelites: Art and Aestheticism in Victorian England* (Manchester, Manchester University Press, 1999), pp. 59–89.

46 Pater, *The Renaissance*, p. 102.

47 *Ibid.*, p. 103.

48 *Ibid.*, p. 105.

49 W. Pater, 'The beginnings of Greek sculpture' (1880), repr. in *Greek Studies: A Series of Essays* (London, Macmillan, [1895] 1901), p. 189.

50 Hegel, *Introductory Lectures*, p. 91.

51 J. J. Winckelmann, *The History of Ancient Art* (1764), trans. G. Henry Lodge, 2 vols (London, Sampson Low, Marston, Searle and Rivington, 1881), vol.2, p. 58.

52 Pater, *The Renaissance*, p. 173.

53 For a recent analysis of Winckelmann's history of Greek art, see A. Potts, *Flesh and the Ideal: Winckelmann and the Origins of Art History* (New Haven and London, Yale University Press, 1994).

54 W. Pater, 'The age of athletic prizemen' (1890), repr. in W. Pater, *Greek Studies*, p. 284.

55 *Ibid.*, p. 285, on Myron's cow, and p. 294, where the word 'academic' is used of the Polycleitan canon.

56 I. Kant, *The Critique of Judgement* (1790), trans. J. C. Meredith (Oxford, Clarendon Press, [1911] 1952), para. 17, p. 79.

57 Pater, 'The age of athletic prizemen', p. 282.

58 Fry, 'The philosophy of Impressionism', p. 16.

59 *The Elder Pliny's Chapters on the History of Art*, trans. K. Jex-Blake, commentary by E. Sellers (London, Macmillan, 1896), XXXIV.58, pp. 46–7.

60 Pater, 'The age of athletic prizemen', p. 286.

61 *Ibid.*, p. 287.

62 See L. Dowling, *Hellenism and Homosexuality in Victorian Oxford* (Ithaca and London, Cornell University Press, 1994).

63 J. Loesberg, *Aestheticism and Deconstruction: Pater, Derrida, and De Man* (Princeton, N.J., Princeton University Press, 1991), pp. 185–9.

64 See Barringer and Prettejohn (eds), *Frederic Leighton*, pp. xiv–xv.

65 I have argued elsewhere that the 'feminine' gendering of aestheticist art may also be seen as an exploration of aesthetic purity in the visual arts, following Lessing's gendered distinction between the (masculine) temporal arts and the (feminine) spatial arts; see E. Prettejohn, 'Aestheticising history painting', in Barringer and Prettejohn (eds), *Frederic Leighton*, p. 102. Loesberg notes the parallel between Victorian constructions of sexual 'inversion' and negative critical characterisations of Aestheticism; he offers a powerful critique of the ideological 'common ground holding together aestheticism, homosexuality, and an unnatural writing that reproduces through the sterile proliferation of signs'; Loesberg, *Aestheticism and Deconstruction*, p. 187.

66 McWilliam, 'Limited revisions', esp. 81–2.

67 *Ibid.*, 82–3.

68 *Ibid.*, 71.

69 Rosen and Zerner, *Romanticism and Realism*, p. 215.

70 *Ibid.*, p. 216.

71 Pater, *The Renaissance*, p. 48.

72 *Ibid.*, pp. xix–xxii.

73 Kant, *Critique of Judgement*, para. 8, p. 55.

74 Greenberg, 'Towards a newer Laocoon', p. 37.

75 Kant, *Critique of Judgement*, para. 16, pp. 72–4.

Notes to Chapter 3

1 J. Treuherz, *Pre-Raphaelite Paintings from Manchester City Art Galleries* (Manchester, Manchester City Art Gallery, 1993), p. 107.

2 K. Flint, 'Portraits of women: on display', in P. Funnell *et al.* (eds.), *Millais: Portraits*, exhib. cat. (London, National Portrait Gallery, 1999), p. 200.

3 See *ibid.*, p. 185, where the author writes of Sargent in comparison to Millais that there is 'less of a sense that the artist is colluding in the predictable routines of a social ritual'.

4 *Ibid.*, p. 184. The fact that Sargent almost certainly imitated Millais' painting goes unmentioned, though Flint is quick to claim that in the one portrait (*Kate Perugini*) of which she seems unable to disapprove Millais has used a 'common enough' pose. She cites Whistler's *Louise Jopling* as Millais' source – presumably the explanation for an otherwise inexplicable effect of 'strength of mind and personality'.

5 For the history of the Vickers portrait and its sitters, see J. Hamilton, *The Misses Vickers: The Centenary of the Painting by John Singer Sargent*, exhib. cat. (Sheffield, Sheffield Arts Department, 1984).

6 Critics such as T. J. Clark and Charles Harrison are the principal exponents of this view. In a recent television programme for the Open University Harrison, with co-presenter Trish Evans, claims that 'advanced artists', by which he means Impressionists, questioned stereotyped portrayals of women. Like Flint he conflates 'advanced' social attitudes with stylistic innovations. The very style of Impressionist painting is *inherently* egalitarian, as opposed to the 'dramatised manner' of pre-modern artists such as Vigée-Lebrun and Joseph Wright, both of whom are blamed for their reactionary portrayal of women. The fact that 'the whole surface is given equal weight' in Impressionism is apparently connected to its liberating images of women. C. Harrison, and T. Evans, 'Picturing the genders', A103, 'Introduction to the Humanities', Open University, 1997. Television programme.

7 See Andrew Graham-Dixon, *A History of British Art* (London, BBC Books, 1996), p. 115. For Graham-Dixon, Gainsborough's 'breathtakingly original' late work *Diana and Actaeon* (c. 1785) has 'the frail, flickering loveliness of a Cézanne painted 100 years *avant la lettre*'. Graham-Dixon's following chapter is entitled 'Modern Art'. He contrasts Turner who 'looked the future full in the face' with the hapless W. P. Frith, who depicts 'society as the bourgeois conservative Victorian mind thought of it' (p. 162). See also Kenneth McConkey's chapter in the present book (chapter 6) for a discussion of British Impressionism's response to Gainsborough.

8 W. H. Hunt, *Pre-Raphaelitism and the Pre-Raphaelite Brotherhood* (London, Macmillan, 1905), vol. 2, p. 372. Similar ideas are expressed by Millais in notes written in the 1870s. See G. H. Fleming, *John Everett Millais* (London, Constable, 1998), p. 200.

9 Millais' controversial *Christ in the House of his Parents* was exhibited in 1850. It is contemporaneous with other instances of confrontational realism such as Watts's *The Irish Famine* (1849) and Courbet's *The Stone Breakers* (1849).

10 This claim is made by Clement Greenberg in his essay 'Modernist painting'. It is repeated by Greenbergian critics such as T. J. Clark, Charles Harrison and Paul Wood. See T. J. Clark, 'Clement Greenberg's theory of art, in F. Frascina (ed.), *Pollock and After, the Critical Debate*, London, Harper and Row, 1985, pp. 47–63; Clark, *The Painting of Modern Life: Paris in the Art of Manet and his Followers* (London, Thames and Hudson, 1985); C. Harrison, P. Wood and J. Gaiger, *Art in Theory, 1815–1900* (Oxford, Blackwell, 1998), pp. 314, 530–1.

11 See Briony Fer's introduction to F. Frascina *et al.*, *Modernity and Modernism: French Painting in the Nineteenth Century* (New Haven and London, Yale University Press, 1993). There is also a genre of literature which construes Manet's art as a manifestation of Profound Philosophical Truths; see J. H. Rubin, *Manet's Silence and the Poetics of Bouquets* (London, Reaktion, 1994), in which we learn that 'Manet's blatant display of manual physicality implies a renewal of contact with the material continuum (necessitated by accepting the human condition as materially grounded) … It confirms our sense of purpose in the world', p. 221. Rubin also repeats the standard claim that 'Manet's brushstrokes run against the grain of the professional academic work-ethic signified by smooth and careful finish', p. 221.

12 Whistler was accused of 'flinging a pot of paint in the public's face', Millais of 'scornful flinging of unfinished work'. J. Ruskin, *Works*, ed. E. T. Cook and A. Wedderburn (London, George Allen, 1903–12), vol. 14, p. 496; vol. 29, p. 160.

13 J. G. Millais, *The Life and Letters of Sir John Everett Millais* (London, Methuen, 1899). The information comes from M. H. Spielmann's biography, *Millais and his Works* (Edinburgh and London, Blackwoods, 1898), p. 137.

14 The Resplendent Quetzal, which lies on the lap of the girl at the left, was a prominent feature of the gallery's ornithological collection, reproduced in the guidebook. It is now in store. Only British birds are now displayed, including the Barn Owl and Kingfisher, both depicted in the painting.

15 Ruskin, *Works*, vol. 14, p. 496.

16 A. L. Baldry, *Sir John Everett Millais: His Art and Influence* (London, Bell, 1899), p. 67.

17 The birds have been kindly identified for me by Michael Waters, Mark Adams and Cyril Walker of the Natural History Museum's Bird Group. I am grateful to Dr Robert Prys-Jones for his help in arranging this. Those beside the children are a Scarlet Ibis, a Great Bird of Paradise (with the yellow tail feathers) and a Blue-Backed Fairy Bluebird. Slightly lower down is a Regent Bowerbird (yellow and black) and a Magnificent Bird of Paradise (thin curving tail-feathers). The prominent 'm'-shaped feathers of the last bird resembles Millais' customary monogram-signature, which appears with the date on the label of the draw containing the Heron. All the birds were from the collection of Millais' son, John Guille, who was himself an ornithologist. The painting was suggested by a visit to the famous ornithologist John Gould, by then a 'confirmed invalid', who died shortly afterwards. Millais, *The Life and Letters of Sir John Everett Millais*, vol. 2, pp. 170–3.

18 Such as a cover of the French periodical *Le Monde Illustré* in which the disembodied face of a mother appears reflected in a mirror above a fireplace in which children are placing

boots and shoes on Christmas Eve; M. Vierge, 'Moeurs parisiennes: la Noël des petits enfants', *Monde Illustré* (26 December 1874).

19 Notable examples of this would be in *Effie Deans* (1877) and *An Idyll: 1745* (1844). It can be traced to *Trust Me* (1862). In each case the illegibility of the emotional responses of the characters is marked by multiple, conflicting cues. This is most evident in *An Idyll: 1745*, in which three Scots girls, drawn to the edge of Cumberland's camp, are depicted as both frightened and entranced by two flute-playing soldier boys, whose own poses and expressions can be read as both threateningly 'leering' and as innocently child-like.

20 This story is widely repeated – as a legend – in popular natural-history books at the time. Even Linnaeus thought that the birds may have spent their whole time in the air, as the specimens he saw were without feet (their Latin name is *apodia*). These myths are all debunked by Alfred Russel Wallace in *The Malay Archipelago* (1869). Wallace himself, however, indulged in an extraordinary romantic description of the King Bird of Paradise, which symbolised for him the whole paradox of 'civilisation' as a simultaneously destructive and enlightening force, bringing to visibility the full beauty of the birds hidden in the jungle, only to destroy the habitats which brought them into being; A. R. Wallace, *The Malay Archipelago, the Land of the Orang-Utan, and the Bird of Paradise: A Narrative of Travel, with Studies of Man and Nature* (New York, Dover Reprint, [1869] 1962), pp. 338–40.

21 According to Ruskin, the word 'menial' refers to tasks performed by the masses, or 'the many'. Ruskin. *Works*, vol. 25, p. 13.

22 S. Wilson, 'Monsters and monstrosities: grotesque taste and Victorian design', in C. Trodd *et al.* (eds) *Victorian Culture and the Idea of the Grotesque* (London, Ashgate, 1999), pp. 143–62. The Royal Society for the Protection of Birds was founded in 1889 (initially as the 'Fur and Feather Group'), because of fears about the misuse of birds for these purposes. See also L. Barber, *The Heyday of Natural History* (London, Jonathan Cape, 1980), p. 19. Jonathan Smith is currently working on a book to be entitled *Seeing Things: Darwin, Ruskin, and Victorian Visual Culture*, in which he discusses Victorian artists' responses to Darwinism. In particular, he explores the elements of natural theology in the work of John Gould, the ornithologist who had inspired Millais's painting. Gould's influence on Ruskin's *Love Meinie*, and both Gould's and Ruskin's resistance to Darwinism are examined in relation to the depiction of bird behaviour in ornithological literature.

23 This painting is discussed by Charles Harrison in 'Picturing the genders'. The pose of the 'thinker' contemplating the dying man probably comes from the figure of the philosophical Indian in Benjamin West's *Death of Wolfe* (1770). Millais recommends contemporary subjects for narrative painting in notes written in the early 1870s, in which he claims that 'splendour' may be found in the shape of a nose rather more than in generalised ideal beauty, or portentous narratives. These views are typical of Pre-Raphaelite complaints against Reynolds – themselves derived from Hazlitt. Millais clearly holds to these ideas long after his abandonment of 'Pre-Raphaelite' high finish; see Fleming, *John Everett Millais*, p. 200.

24 It is impossible to 'fix' a meaning for these, but it is difficult to dismiss as coincidence the role of the Quetzal as a sign of proto-redemptive pagan ideas supplanted by Christianity, and of the King Bird of Paradise as a reference to Christ as King of Paradise – reinforced by its deployment as a Sacred Heart. Other birds may also be significant. The owl trapped in its glass jar is juxtaposed with the figure of the teenage girl, suggesting that the

new-found 'wisdom' of the girl may be symbolised. The ibis was also a sacred bird in Ancient Egypt.

25 This belief is central to Mormonism, providing the narrative of pre-conquest Christian history in the Americas. It dates back to seventeenth-century Catholic commentary on the conquest. Cortez was supposed to have been mistaken for the returning Quetzal-feathered god-king Quetzalcoatl, a story used by Christian apologists as evidence of providential provision for Christian conquest of South America. A rationalised variant of this argument was the idea that the original Quetzalcoatl (said to be 'white-faced') was a European – possibly a Christian Roman or Viking – who had somehow found his way to the Americas and had spread the Christian message, which was later corrupted. Such fantasies of ancient proto-imperial explorations were common during the nineteenth century, as were attempts to demonstrate that other religions were confused or degenerate versions of Judaeo-Christian truth. See B. A. Gardner, 'The Christianizing of Quetzalcoatl', *Sunstone*, 11 (1986) 6–10.

26 Wallace, *The Malay Archipelago*, p. 339.

27 Millais was a keen student of Tennyson's *In Memoriam*; see Fleming, *John Everett Millais*, pp. 107–8. The doubt/faith problem is connected in art with the deliberate use of 'possible' iconography in Pre-Raphaelitism (is an object mere 'fact' or 'sign'?), an idea derived from Carlyle's *Sartor Resartus* and much used by Hunt; see C. Brooks, *Signs for the Times: Symbolic Realism in the Mid-Victorian World* (London, Allen and Unwin, 1984).

28 Ruskin, *Works*, vol. 34, p. 670.

29 For a claim that Manet seeks to modernise *Las Meninas* in the palace of consumerism that is *The Bar at the Folies-Bergères* (1882), see V. Perutz, *Edouard Manet* (London and Toronto, Lewisburg, Bucknell University Press, 1993), p. 203.

30 Leonée Ormond argues that Millais' *An Idyll: 1745* (1884) is a realist reply to Leighton's classical *Idyll* (1881). Alison Smith makes the same point about Millais' only nude, *A Night Errant* (1870), arguing that its physicality was a challenge to the 'chaste' nudes exhibited by Leighton; L. Ormond, 'Leighton and Millais', *Apollo* (Feb. 1996) 40–4; A. Smith, *The Victorian Nude: Sexuality, Morality and Art* (Manchester, Manchester University Press, 1996); For Millais' 'humanist' replies to Whistler, see Funnell *et al.*, (eds) *Millais: Portraits*, pp. 58, 102.

Notes to Chapter 4

I would like to thank David Peters Corbett and Lara Perry for their helpful editorial suggestions. The essay has also benefited from the comments of John Wells and, in an earlier draft, of Rebecca Virag.

Although he would perhaps have had little time for its method or arguments, this essay is affectionately dedicated to the memory of James Byam Shaw, distinguished historian of old master drawings and a generous friend to many young scholars.

1 See A. Gruetzner Robins, *Modern Art in Britain, 1910–14*, exhib. cat. (London, Barbican Art Gallery, 1997), p. 8.

2 This phrase derives from Rossetti's description of Edward Burne-Jones as 'one of the nicest young fellows in Dreamland', quoted, for example, by C. Wood in *The Pre-Raphaelites* (London, Weidenfeld and Nicholson, 1984), p. 114. The most recent

example of this categorisation is the title of the exhibition of 1998 held at the Metropolitan Museum, New York, and in Birmingham and Paris: *Edward Burne-Jones: Artist-Dreamer*. See S. Wildman and J. Christian, *Edward Burne-Jones: Artist-Dreamer*, exhib. cat. (New York, Metropolitan Museum and Harry N Abrams, 1998).

3 F. Rutter, 'Byam Shaw', *Sunday Times* (23 March 1919), quoted R. V. Cole, *The Art and Life of Byam Shaw* (London, Seeley Service, 1932), p. 205.

4 *Ibid.*

5 *Observer* (10 February 1933).

6 C. Harrison, 'Abstraction', Chapter 3 of *Primitivism, Cubism, Abstraction: The Early Twentieth Century* (New Haven, Yale University Press, 1993), pp. 200–1.

7 See for example, Wood, *The Pre-Raphaelites*; T. Barringer, *Reading the Pre-Raphaelites* (New Haven, Yale University Press, 1999); J. Marsh and P. G. Nunn, *Pre-Raphaelite Women Painters*, exhib. cat. (Manchester, Manchester University Press, 1997).

8 J. Christian, (ed.), *The Last Romantics* (London, Lund Humphries, 1989).

9 *Ibid.*, p. 18.

10 J. Fabian, *Time and the Other: How Anthropology Creates its Object* (New York, Columbia University Press, 1983).

11 The remark was included in Charles Harrison's discussion of *Boer War 1900* in a plenary session at the 'Rethinking Englishness' conference, University of York, in 1997.

12 H. Perkin, *The Rise of Professional Society* (London, Routledge, 1989).

13 Cole, *The Art and Life of Byam Shaw*, p. 19. Cole's account of Shaw's origins and background is replicated in all later sources.

14 Perkin, *The Rise of Professional Society*, p. 4.

15 Perkin underestimates the extent to which the culture he describes is bound up with the administration, economic functioning and ideological promotion of the British Empire. On this, see P. O. Cain and P. J. Hopkins, *British Imperialism: Innovation and Expansion, 1688– 1914* (London, Longman, 1993), pp. 23–37. On the cult of imperial manliness, see *inter alia* J. A. Mangan, *The Games Ethic and Imperialism* (London, F. Cass, 1998).

16 Cole, *The Art and Life of Byam Shaw*, p. 135.

17 See for example, Cole, *The Art and Life of Byam Shaw*, p. 58. 'I have been terribly depressed about my work lately … I do not seem to be able to get up any fire about it.'

18 L. Tickner, 'Men's work? Masculinity and modernism', in N. Bryson, M. A. Holly and K. Moxey (eds.), *Visual Culture: Images and Interpretations* (Hanover, N.H., and London, Wesleyan University Press, 1994), pp. 42–82.

19 For a discussion, see M. Wheeler, *Death and Future Life in Victorian Literature and Theology* (Cambridge, Cambridge University Press, 1990), pp. 33–5 and Plate 12.

20 See for comparison Hans Thoma, *Christ and the Woman of Samaria* (1881, Staatliche Kunsthalle, Karlsruhe). Reproduced and discussed in G. Schiff, *German Masters of the Nineteenth Century*, exhib. cat. (New York, Metropolitan Museum of Art, 1981), pp. 233–4.

21 Quoted Cole, *The Art and Life of Byam Shaw*, p. 66.

22 *Ibid.*, p. 66.

23 *Ibid.*, p. 133.

24 As Glen Byam Shaw he was to become a leading Shakespearian actor, and director of the Royal Shakespeare Company and English National Opera, noted for his pioneering production of Wagner's Ring Cycle.

25 For a significant analysis of the dynamics of the upper-middle-class Edwardian household, see P. Thompson, *The Edwardians: The Re-Making of British Society* (London, Weidenfeld and Nicholson, 1975), pp. 92–9. The text is based on an oral history project, and although there are inherent problems in generalising on the basis of such evidence, the recollections of Grace Fulford, quoted extensively by Thompson, resonate with the class relations depicted in Byam Shaw's painting.

26 Cole, *The Art and Life of Byam Shaw*, p. 79.

27 See D. Cherry, *Painting Women: Victorian Women Artists* (London, Routledge, 1993), pp. 120–40.

28 Cole, *The Art and Life of Byam Shaw*, p. 110.

29 *Ibid.*, pp. 86–8.

30 *Pre-Raphaelite Women Painters*, pp. 85–98 and 152–6. Byam Shaw is acknowledged in the same authors' earlier treatment of Brickdale, see J. Marsh and P. G. Nunn, *Women Artists and the Pre-Raphaelite Movement* (London, Virago, 1989), pp. 145–9.

31 Cole, *The Art and Life of Byam Shaw*, p. 94.

32 The composition was possibly also a self-conscious emulation of the frescoes by Gozzoli from the Palazzo Medici-Riccardi a colour reproduction of which hung on the wall of Shaw's Warwick Road studio. See Cole, *The Art and Life of Byam Shaw*, p. 78.

33 See E. Prettejohn, 'Painting indoors: Leighton and his studio', *Apollo* (February 1996).

34 Quoted Cole, *The Art and Life of Byam Shaw*, p. 102.

35 G. Dawson, *Soldier Heroes: British Adventure, Empire and the Imagining of Masculinities* (London, Routledge, 1994), p. 1.

36 T. Carlyle, *On Heroes, Hero-Worship and the Heroic in History* (London, Chapman, Hall, [1840] 1889), pp. 10–11.

37 Dawson, *Soldier Heroes*, p. 148.

38 *The Times* (14 November 1857), quoted in Dawson, *Soldier Heroes*, p. 107.

39 A. Haddon, *The Story of the Music Hall: From Cave of Harmony to Cabaret* (London, Fleetway, 1935), p. 121; see also W. MacQueen-Pope, *The Melodies Linger On: The Story of Music-Hall* (London, W. Allen, 1950); and most recently the discussion in R. Rainey, *Institutions of Modernism: Literary Elites and Public Culture* (New Haven and London, Yale University Press, 1998), pp. 33–5.

40 See K. Gänzl, *The British Musical Theatre*, vol. 1: *1865–1914* (Basingstoke, Macmillan, 1986), p. 876. See also J. P. Wearing, *The London Stage: A Calendar of Plays and Players*, vol. 1, p. 338. Despite his prominence in Byam Shaw's Coliseum act drop, the dog Toby was not one of Stoll's attractions but appeared at the rival Garrick Theatre.

41 See J. N. Moore, *Edward Elgar: A Creative Life* (Oxford, Oxford University Press, 1984), pp. 627–30.

42 See J. M. MacKenzie (ed.), *Popular Imperialism and the Military, 1850–1950* (Manchester, Manchester University Press, 1992); J. M. MacKenzie, *Imperialism and Popular Culture* (Manchester, Manchester University Press, 1984).

43 Cole, *The Art and Life of Byam Shaw*, p. 20.

44 J. F. Codell, 'The artist colonized: Holman Hunt's bio-history, masculinity, nationalism and the English School', in E. Harding (ed.), *Re-Framing the Pre-Raphaelites* (Aldershot, Scolar, 1996), p. 212.

45 W. H. Hunt, *The Obligations of the Universities towards Art* (London, H. Frowde, 1895), pp. 14–16, quoted in Codell, 'The artist colonized', p. 212.

46 See Robins, *Modern Art in Britain*.

47 E. Chesneau, *The English School of Painting* (1885), p. ix, quoted in K. McConkey (ed.), *Impressionism in Britain*, exhib. cat. (London, Yale University Press in association with Barbican Art Gallery, 1995), p. 30.

48 K. McConkey, *British Impressionism* (New York, Harry N Abrams, 1989), p. 51.

49 See L. Merrill, *A Pot of Paint: Aesthetics on Trial in Ruskin v Whistler* (Washington D.C., Smithsonian Institution Press, 1992).

50 M. Pointon, 'The artist as ethnographer: Holman Hunt in the Holy Land', in M. Pointon (ed.), *Pre-Raphaelites Re-Viewed* (Manchester, Manchester University Press, 1989), pp. 22–44. The quotation is taken from p. 37.

51 Cole, *The Art and Life of Byam Shaw*, p. 53.

52 Quoted *ibid.*, p. 70.

53 For Burne-Jones's Perseus series, see Wildman and Christian, *Edward Burne-Jones*, pp. 221–34. Byam Shaw's comments on Madox Brown are found in Cole, *The Art and Life of Byam Shaw*, p. 53. He considered Rossetti to be, by comparison, 'insipid'.

54 Cole, *The Art and Life of Byam Shaw*, p. 119.

55 *Ibid.*

56 Quoted in P. Summerfield, 'Patriotism and empire: music-hall entertainment, 1870–1914', in MacKenzie, *Imperialism and Popular Culture*, p. 36.

57 Summerfield, 'Patriotism and empire', p. 37. I am grateful to John Wells for his advice on Kipling's text, which is taken here from *Rudyard Kipling's Verse: Inclusive Edition 1885–1932* (London, Hodder and Stoughton, 1933).

58 Cole, *The Art and Life of Byam Shaw*, p. 119.

59 On the Boer War, see especially T. Pakenham, *The Boer War* (London, Weidenfeld and Nicholson, 1979). The illustrated edition (New York, Random House, 1983), contains a great deal of interesting visual material, as does E. Lee, *To the Bitter End: A Photographic History of the Boer War, 1899–1902* (New York, Viking, 1985).

60 See G. W. Joy, *The Work of George William Joy, with an Autobiographical Sketch* (London, Cassell, 1904), p. 54. The work is reproduced in colour in this publication (n. p.).

61 *Ibid.*

62 The separate spheres of man and woman are treated in separate chapters, 'Of Kings' Treasuries' and 'Of Queens' Gardens'. See J. Ruskin, *Sesame and Lilies* (London, Blackie, [1865] 1910).

63 D. Judd, *The Victorian Empire* (New York, Prager, 1970), p. 160.

64 F. Young, report in the *Manchester Guardian*, quoted in F. Young, *The Relief of Mafeking* (London, Methuen, 1900). Quoted in Lee, *To the Bitter End*, p. 172.

65 Untraced, reproduced in Cole, *The Art and Life of Byam Shaw*, p. 196.

66 *1916*, watercolour, exhibited at the Royal Watercolour Society in 1916. Present whereabouts unknown. Reproduced in Cole, *The Art and Life of Byam Shaw*, p. 194.

67 Peyton Skipwith, 'Byam Shaw: a pictorial storyteller, *Connoisseur*, 191 (March 1976) 197.

Notes to Chapter 5

I would like to thank Allen Staley, Natalie Kampen, Maria Ruvoldt, Senta German, Judith Mayne, Lara Perry, and David Peters Corbett for their helpful comments on various drafts

of this chapter. The research for it was supported in part by a grant from the Center for Advanced Studies in the Visual Arts in 1995–96.

1 'Indeterminacy' is, of course, a term with many meanings in literary criticism. I use the term in Iser's sense, as a property of texts – the gaps and blanks that must be filled in by the reader in the process of interpretation – rather than in the sense of a condition for all interpretation. W. Iser, *The Act of Reading: A Theory of Aesthetic Response,* trans. T. Bahti (Minneapolis, University of Minnesota Press, 1989). See also: T. Bahti, 'Ambiguity and indeterminacy: the juncture', *Comparative Literature,* 38:3 (1986) 209–33.

2 The term 'problem picture' has been the subject of some confusion in art-historical scholarship, used at times to refer to almost any narrative painting. In fact, the problem picture was a very specific form of ambiguous narrative painting, popularised by John Collier at the Royal Academy between 1895 and 1914. The term was coined in the early twentieth century to describe these particular works. See my dissertation for a discussion of the type and its history: P. M. Fletcher, 'Narrating modernity: the problem picture, 1895–1914', unpublished Ph.D. dissertation, Columbia University, 1998.

3 'Problem and story pictures from the Royal Academy', *Illustrated London News* (9 May 1908) iv–v.

4 On the fallen woman in Victorian art, see L. Nead, 'The Magdalen in modern times', *Oxford Art Journal,* 5:3 (1984) 26–37.

5 'Art Notes: The Royal Academy: first notice', *Truth* (6 May 1908) 1164.

6 The critic is referring to *The Cheat* (1905) and *Mariage de convenance* (1907), both popular problem pictures by Collier.

7 For a different reading of these pictures and their representation of masculinity, see J. A. Kestner, *Masculinities in Victorian Painting* (Aldershot, Scolar Press, 1995), p. 166.

8 See, for example, E. Showalter, *Sexual Anarchy: Gender and Culture at the Fin de Siècle* (New York, Viking, 1990; London, Bloomsbury, 1991); Kestner, *Masculinities in Victorian Painting*; and J. Tosh, 'The making of masculinities: the middle class in late nineteenth-century Britain', in A. V. John and C. Eustance (eds.), *The Men's Share? Masculinities, Male Support, and Women's Suffrage in Britain, 1890–1920* (London and New York, Routledge, 1997), pp. 38–61.

9 Tosh, 'The making of masculinities', p. 45.

10 *Ibid.*, p. 55; Showalter, *Sexual Anarchy*, pp. 9–15.

11 Tosh, 'The making of masculinities', pp. 39–40.

12 L. Tickner, 'Men's work? Masculinity and modernism', in N. Bryson, M. A. Holly and K. Moxey (eds.), *Visual Culture: Images and Interpretations* (Hanover, N.H., and London, Wesleyan University Press, 1994), pp. 42–82.

13 'Problem and story pictures'.

14 'Royal Academy', *Reynolds's Newspaper* (3 May 1908) 1.

15 There is a vast literature on turn-of-the-century fears of degeneration. For its specifically Edwardian manifestations, in particular as they relate to the Boer War, see S. Hynes, *The Edwardian Turn of Mind* (London, Oxford University Press, 1968); M. Rosenthal, *The Character Factory* (New York, Pantheon Books, 1984); and J. Nauright, 'Colonial manhood and imperial race virility: British responses to post-Boer War colonial rugby tours', in J. Nauright and T. J. L. Chandler (eds.), *Making Men: Rugby and Masculine Identity* (London and Portland, Oregon, Frank Cass, 1996), pp. 121–39.

16 Rosenthal, *The Character Factory*, pp. 135–6. As Rosenthal demonstrates, this figure was greatly exaggerated.

17 V. Berridge, 'Popular Sunday papers and mid-Victorian society', in G. Boyce, J. Curran and P. Wingate (eds.), *Newspaper History: From the Seventeenth Century to the Present* (London, Constable, 1978), pp. 247–64.

18 Gracchus, 'The birth rate: its international aspects', *Reynolds's Newspaper* (17 May 1908) 2.

19 J. A. Mangan, 'Social Darwinism and upper-class education in late Victorian and Edwardian England', in J. A. Mangan and J. Walvin (eds.), *Manliness and Morality: Middle-Class Masculinity in Britain and America, 1800–1940* (Manchester, Manchester University Press, 1987), pp. 135–59; R. Holt, *Sport and the British: A Modern History* (Oxford, Clarendon Press, 1989); and J. Lowerson, *Sport and the English Middle Classes, 1870–1914* (Manchester and New York, Manchester University Press, 1993).

20 'The Royal Academy: the decline of the subject picture', *Morning Post* (4 May 1908) 4; Atlas, 'What the world says', *The World* (20 May 1908) 913.

21 'The Royal Academy (first notice)', *The Times* (4 May 1903) 13.

22 E. A. Bryant, 'After dinner', *The Sketch* (13 May 1908) 144.

23 'This year's art at the Royal Academy', *Daily Mirror* (4 May 1908) 3.

24 'Passing events', *Art Journal* (May 1908) 157; 'The Royal Academy: the decline of the subject picture'; 'The Sentence of Death', *Daily Mirror* (4 May 1908) 9.

25 M. H. Spielmann, 'The Royal Academy I', *Daily Graphic* (9 May 1908) 646.

26 'Sentence of Death'; 'This year's art at the Royal Academy'.

27 See S. Cherry, *Medical Services and Hospitals in Britain, 1860–1939* (Cambridge, Cambridge University Press, 1996); N. Parry and J. Parry, *The Rise of the Medical Profession: A Study of Collective Social Mobility* (London, Croom Helm, 1976).

28 A. Conan Doyle, *Memories and Adventures* (London, Hodder and Stoughton, 1924), p. 23, cited in R. Boxill, *Shaw and the Doctors* (New York and London, Basic Books, 1969), pp. 7–8.

29 Boxill, *Shaw and the Doctors*, p. 19.

30 On the changing doctor–patient relationship, see I. Waddington, *The Medical Profession in the Industrial Revolution* (Dublin, Gill and Macmillan, 1984); I. Waddington, 'The role of the hospital in the development of modern medicine', *Sociology*, 4:2 (1973) 211–24; and Boxill, *Shaw and the Doctors*.

31 See G. B. Shaw, *The Doctor's Dilemma* (Harmondsworth and New York, Penguin Books, 1957).

32 'What the world says', *The World* (13 May 1908) 862.

33 A Family Doctor, 'Doctors' dilemmas', *Daily Mail* (14 May 1908) 6.

34 'The Royal Academy: the decline of the subject picture'. For another example, see 'Royal Academy: second notice', *Daily Telegraph* (15 May 1908) 7.

35 Atlas, 'What the world says'; 'Art notes: the Royal Academy: second notice', *Truth* (13 May 1908) 1231.

36 R. Ohmann, *Selling Culture: Magazines, Markets and Mass Culture at the Turn of the Century* (New York, Verso, 1996), p. 199.

37 R. Bowlby, *Just Looking: Consumer Culture in Dreiser, Gissing, and Zola* (London and New York, Methuen, 1985).

38 'Art', *Truth* (4 May 1910) 1167; P. G. Konody, 'Pictures you cannot help seeing', *Daily Mail* (5 May 1906) 6.

Notes to Chapter 6

1 G. Moore, 'Impressions in St James's Park', *Speaker* (30 September, 1893), 352.

2 Moore is probably referring to *Gathering in the Park with a Flautist*, 1717, a picture which entered the Louvre as part of the La Caze collection in 1869. It was still a comparatively recent acquisition at the time of his arrival in Paris in 1873.

3 Consumption as a reformulation is widely debated by cultural theorists. For a succinct discussion in relation to the history of *mentalités*, see R. Chartier, *Cultural History*, trans. L. G. Cochrane (Cambridge, Polity Press, 1988), pp. 40–2. The processes of remaking alluded to here have a specialist meaning, albeit described in different language by art historians.

4 For a summary of recent work in this field, see D. Peters Corbett, Y. Holt and F. Russell (eds), *The Geography of Englishness: English Art and National Identity, 1880–1940* (New Haven and London, Yale University Press, forthcoming for the Paul Mellon Centre for Studies in British Art and the Yale Center for British Art).

5 J. Hone, *The Life of Henry Tonks* (London and Toronto, Heinemann, 1939), p. 271. Tonks and Furse knew one another from c. 1890 up until the latter's death in 1904.

6 The idea of the 'living picture' was not so extraordinary at the period. 'Living pictures', tableaux vivants, in which famous paintings would be re-enacted upon the stage, were a familiar music-hall turn in the nineties. Since they often involved veiled nudity, they were vilified by suffragists and purity crusaders, although defended by writers like Shaw; see K. Beckson, *London in the 1890s: A Cultural History* (New York and London, Norton, 1992), pp. 119–25.

7 For reference to Monet's reaction to the London parks, see K. McConkey (ed.), *Impressionism in Britain*, exhib. cat. (London, Yale University Press in association with Barbican Art Gallery, 1995), p. 161.

8 *Ibid.*; see also G. Moore, *Confessions of a Young Man* (London, Heinemann, [1886] 1928), p. 189.

9 See D. Donoghue, *Walter Pater: Lover of Strange Souls* (New York, Knopf, 1995), p. 199.

10 W. Pater, *Imaginary Portraits* (London, [1887] 1905), pp. 26–7.

11 *Ibid.*, p. 16.

12 Jules and Edmond de Goncourt's *L'Art du dixhuitième siècle* was completed and published in Paris in 1875, although it had been appearing in twelve separate parts since 1856; see E. and J. de Goncourt, *French XVIII Century Painters*, trans. Robin Ironside (London, Phaidon, 1948). The Watteau essay which opens the book is to some extent least typical since it largely consists of a transcript of *La Vie d'Antoine Watteau*, by the Comte de Caylus, a lost manuscript, read at the Academie Royale de Peinture et de Sculpture in 1748. For a discussion of the antiquarian pursuits of the Comte de Caylus, see F. Haskell, *History and its Images: Art and the Interpretation of the Past* (New Haven and London, Yale University Press, 1993), pp. 180–6. The Goncourts' catalogue raisonné on Watteau also appeared in 1875 and of relevance to the social construction of style and the contemporary ethos of collecting is their *La Maison d'un artiste* (Paris, G. Charpentier, 1881), 2 vols. For a discussion of the Goncourts' house at Auteuil, see D. L. Silverman in *Art Nouveau in Fin-de-Siècle France: Politics, Psychology and Style* (Berkeley, University of California Press, 1989), pp. 20–4.

13 See, for instance, S. O. Simches, *Le Romanticisme et le goût esthetique du XVIIIe siècle* (Paris, Presses Universitaires de France, 1964); A. Brookner, *The Genius of the Future:*

Studies in French Art Criticism (London and New York, Phaidon, 1971), pp. 121–44; C. Duncan, *The Pursuit of Pleasure: The Rococo Revival in French Romantic Art* (New York, Garland, 1976). In addition to George Moore, the dissemination of the fascination for the age of the rococo, specifically fixed to the Goncourts was taken up by John Gray, Charles Ricketts and the *Dial* circle in the late 1880s. Ricketts records his continuing enthusiasm for the Goncourts in his diary for 13 September 1900 when he notes, 'have been consoled during a bloody cold by Goncourt's *Eighteenth Century Masters*', and comments on 'the daintiness and seriousness of most of the essays'; C. Lewis (ed.), *Self-Portrait: Taken from the Letters and Journals of Charles Ricketts RA* (London, Peter Davies, 1939), p. 44; see also 'A note on the art of Watteau,' in C. Ricketts, *Pages on Art* (London, Constable, 1909), pp. 35–44.

14 Anon., 'Afternoons in studios – a chat with Mr Whistler', *Studio*, 4 (1894) 116–21. Whistler's importance in this regard has been underestimated. The significance of his return to Paris in March 1892 has not received the attention it deserves. The writer in *The Studio* comments upon his affectation, 'his sprightly daintiness of manner that the Faubourg St Germain has always prized so highly'.

15 W. Rothenstein, *Men and Memories* (London, Faber and Faber, 1931), vol. 1, pp. 158–62. Heinemann hoped to publish an English edition of the Goncourt *Journal*.

16 C. Phillips, 'The Wallace Collection: the French pictures', *Art Journal* (1901) 257–63; M. H. Spielmann, 'Gems of the Wallace Collection', *Magazine of Art* (1901) 63, 168, 224. Additionally Claude Phillips's 'Portfolio' monograph on *Watteau* (London, George Bell and Sons, 1895) is heavily reliant upon research conducted by the Goncourts. See also Lady Dilke, *French XVIII Century Painters* (London, George Bell and Sons, 1899), and her companion volume on draughtsmen and engravers, which attempts to draw together the Goncourts with other recent French scholarship.

17 C. L. Hind, *Watteau* (London, T. C. and E. C. Jack; New York, Stokes [n.d., c. 1910]), p. 71; C. Mauclair's *Antoine Watteau (1684–1721)* (London, Duckworth [n.d., c. 1905]) was published as part of the Popular Library of Art. Hind omits to mention Claude Phillips's 'Portfolio' monograph.

18 During his Paris years, Moore visited the Goncourts and was sent copies of their books; see J. Hone, *The Life of George Moore* (London, Gollancz, 1936), pp. 74, 159, 427. Like Zola, Edmond de Goncourt distanced himself from Moore after the publication of *Confessions of a Young Man*, in which there were critical comments about naturalism and the penchant for note-taking (London, Heineman, [1886] 1928), p. 104.

19 G. Moore, *Modern Painting* (1893), p. 206, quoted in McConkey (ed.), *Impressionism in Britain*, pp. 134–5.

20 K. McConkey, *Sir John Lavery RA, 1856–1941*, exhib. cat. (Belfast, Ulster Museum and Fine Art Society, 1984), pp. 28–30.

21 Goncourt, *French XVIII Century Painters*, p. 68.

22 See G. Moore, *Modern Painting* (London, W. Scott, [1893] 1898), p. 247: 'Monet sees clearly, and he sees truly, but does he see beautifully? Is his an enchanted vision? And is not every picture that fails to move, to transport, to enchant, a mistake?'

23 Anon., 'Afternoons in studios', 116.

24 Moore, *Modern Painting*, p. 261: 'it was no part of their scheme to compete with nature, so it could not occur to them to cover one side of a face with shadow'.

25 C. H. Collins Baker, 'Philip Wilson Steer, President of the New English Art Club', *Studio*, 46 (1909) 259–66. In this 2000-word article, Watteau is mentioned four times in different contexts, Turner three times and Constable two.

26 C. H. Collins Baker, 'The paintings of Professor Henry Tonks', *Studio*, 49 (1910) 4, refers to the eighteenth-century precedents quoted in Tonks's teaching; see also Collins Baker's 'Henry Tonks as artist', in Hone, *Life of Tonks*, pp. 324–5. Direct evidence of this aspect of Tonks's teaching is found in the early sketchbooks and studies of William Orpen; see for instance *William Orpen, 1878–1931: Early Work*, exhib. cat. (London, Pyms Gallery, 1981), catalogue nos. 4, 5, 23–32.

27 *The Pastoral Play* was shown at the New English Art Club in 1899 (spring, no. 65). Now lost, it was thought in 1939 to be in the collection of Nelson Ward. A study for the picture, formerly coll. Frederick Brown, was illustrated in *Artwork*, 5 (1929) 218.

28 At this period, for instance, conversation in the *faubourg Saint-Germain* was peppered with English phrases – *le skating, le footing*. Odette de Crecy invites her visitors to 'tea' and the hostesses of the faubourg had their hair fringed in emulation of the Princess of Wales. In the fine arts, *le style anglais* was practised by fashionable portraitists like Blanche and La Gandara who looked to Gainsborough and Romney.

29 See, for instance, B. Bosanquet, *A History of Aesthetic* (London, S. Sonnenschein; New York, Macmillan, [1892] 1910), in which writers so socially attuned to the modes of their day as Voltaire and Diderot only merit passing mention.

30 J. Meier-Graefe, *Modern Art: Being a Contribution to a New System of Aesthetics*, trans. F. Simmonds and G. W. Chrystal (London, Heineman; New York, Putnam's, 1908), vol. 2, p. 269.

31 Lavery, Orpen and Shepherd in the 1920s painted interiors of 25 Park Lane. For reference to that by Lavery, see K. McConkey, *Sir John Lavery* (Edinburgh, Canongate, 1993), p. 171.

32 T. M. Wood, 'The Paintings of Wilfrid G. von Glehn', *Studio*, 56 (June 1912) 8.

33 D. S. MacColl, *The Life, Work and Setting of Philip Wilson Steer* (London, Faber and Faber, 1945), p. 27.

34 Moore, *Modern Painting*, p. 238.

35 *Barbizon House: An Illustrated Record* (London, D. C. Thomson, 1937), no. 12.

36 See MacColl, *Philip Wilson Steer*, p. 108; Bruce Laughton, *Philip Wilson Steer* (Oxford, Clarendon Press, 1971), p. 77; Laughton lists the decorations as one large grisaille overmantle (see his note 36) and four grisaille canvases let into the walls.

37 His Francophile credentials were as impeccable as those of Moore himself. A friend of Lautrec and Anquetin, he had frequented all the right bars and brothels in Paris, had visited the choice watering holes along the Seine and imbibed the charms of Dieppe.

38 It has been noted that Sickert at this point affected an interest in the crinolines of the 1860s, referring as much to English illustrators as to a painter like Boudin; see W. Baron, *Sickert* (Oxford, Phaidon, 1973), p. 39.

39 G. Moore, 'The New English Art Club', *Speaker* (25 November 1893) 581.

40 Baron, *Sickert*, p. 309 (nos. 67 and 68); see also McConkey, *Impressionism in Britain*, p. 56. Not only did Blanche acquire one of Sickert's *L'Hotel Royal* sequence, and was given a related drawing by the artist, but he referred to him as the 'Canaletto of Dieppe'.

41 M. Chamot, D. Farr and M. Butlin, *Tate Gallery Catalogues: Modern British Paintings, Drawings and Sculpture* (London, Tate Gallery, 1964), vol. 1, p. 34. Studies of Beardsley

confirm the degree to which he conformed to the craze for Watteau; see M. Sturgis, *Aubrey Beardsley: A Biography* (Woodstock, N.Y., Overlook Press, 1999), pp. 164–5; S. Calloway, *Aubrey Beardsley* (London, V&A Publications, 1998), p. 157; S. Weintraub, *Beardsley* (Harmondsworth, Penguin, [1967] 1972), p. 207.

42 Moore, *Modern Painting*, p. 582.

43 Moore transposed this sentence from his Conder review to the review of Steer's solo exhibition as published in the enlarged edition of *Modern Painting* (p. 238), perhaps unintentionally indicating the degree to which, in his mind, the work of the two artists had become interchangeable.

44 Conder exhibited two works, *Design for a Fan* (13) and *Landscape* (110) at the New English spring exhibition and *Vétheuil* (63) in the winter of 1893.

45 Rothenstein, *The Life and Death of Conder* (London, Dent, 1938), p. 147. Rothenstein notes that 'in conversation he [Conder] alluded constantly to Watteau; his own thumbed copy of Claude Phillips's monograph (which he recovered the better to stand constant use) he ornamented with Watteauesque designs, and favourite passages he marked with rose leaves' (p. 73).

46 At a personal level the Conder/Beardsley relationship is described in Rothenstein, *The Life and Death of Conder*, pp. 135–41. Much of this material with embellishments is repeated in the modern biographies of Beardsley; see, for instance, Sturgis, *Aubrey Beardsley*, p. 335.

47 Ricketts summed up Conder's artistic lineage: 'some of Watteau's mastery had to pass through the facile hands of Fragonard and became coloured by a more worldly vision; the glamour of the *Fêtes Galantes* had to be morseled up in the fantastic art of Monticelli before the convention could be taken up by Conder', *Pages on Art*, pp. 5–6.

48 The early biographies of Conder contain sundry references to his patrons; see F. Gibson, *Charles Conder, His Life and Work* (London and New York, John Lane, 1914), and Rothenstein, *The Life and Death of Conder*; see also D. Rodgers, *Charles Conder, 1868–1909*, exhib. cat. (Sheffield, Graves Art Gallery, 1967); D. Rodgers, *Charles Conder*, exhib. cat. (London, Fine Art Society and Piccadilly Gallery, 1969); and U. Hoff, *Charles Conder* (Melbourne, Landsdowne Australian Art Library, 1972). J. McKenzie, 'Charles Conder', in *High Art and Low Life: The Studio and the Fin de Siècle*, exhib. cat. (London, Victoria and Albert Museum, 1993), pp. 42–7, does not explicitly engage with issues of patronage.

49 Recent accounts of Art Nouveau have tended to neglect Conder's work partly because uncertainty surrounds his contributions to the Maison de l'Art Nouveau, and his contributions were not commented upon in press reports of the opening of the shop – unlike, for instance, the murals of Brangwyn; see G. P. Weisberg (ed.), *L'Art Nouveau:-Bing, Paris Style 1900*, exhib. cat. (New York, Abrams; Washington D.C., Smithsonian Institution, 1986), p. 66, and Silverman, *Art Nouveau*, p. 275. Rothenstein, *Men and Memories*, pp. 133–4, provides details of the commission which came via Fritz Thaulow. Meier-Graefe, *Modern Art*, vol. 2, p. 262, provides one of the few accessible accounts of the Conder boudoir, 'where silk displayed its sheen between white Louis Seize panels'.

50 These items were sold by Thaulow's descendants at Christie's South Kensington, *Charles Conder's Hangings for the Villa des Orchides, Dieppe*, 27 October 1987. Unsold lots from this sale were offered at Christie's London on 21 September 1989. Rothenstein states that the Bing silks were purchased by Thaulow when a series of others were commissioned; *Men and Memories*, vol. 1, p. 106.

51 D. S. MacColl, 'The paintings on silk of Charles Conder', *Studio*, 13 (1898) 238. MacColl's article functions as a prose correlative to Conder's paintings rather than as a reasoned case or critical essay in the conventional sense. It commences with a rich description of the landscape of Conder's imagination which only tangentially is derived from actual places.

52 Conder's commission from Edmund Davis, the millionaire owner of South African and Rhodesian mines, owes something to his friendship with Ricketts, Shannon and the Vale circle; see S. Reynolds, 'Sir Edmund Davis: collector and patron of the arts', *Apollo* (June 1980) 459–63. For Davis's taste, see Anon., 'A bedroom decorated by Mr Frank Brangwyn', *Studio*, 19 (1900) 173–80; T. M. Wood, 'The Edmund Davis collection', *Studio*, 64 (1914) 79–95, 229–45; 65 (1915) 3–17.

53 T. M. Wood, 'A room decorated by Charles Conder', *Studio*, 34 (1905) 205. In essence, Davis had commissioned from Conder a *Gesamtkunstwerk* in the sense then being articulated by Meier-Graefe.

54 *Ibid.*, p. 201.

55 See Silverman, *Art Nouveau*, p. 90.

56 We gain some sense of the appearance of such an interior in William Nicholson's *The Conder Room*, 1910 (sold Christie's, 5 June 1992, lot 31), a double portrait of Pickford and Sybil Waller in a room entirely hung with Conders at their house in St George Road; see A. Nicholson (ed.), *Sir William Nicholson, Painter: Painting, Woodcuts, Writings, Photography* (London, Giles de la Mare, 1996), p. 106.

57 *Ibid.*, p. 206. This analogy was echoed by Meier-Graefe *(Modern Art*, p. 261) who considered Conder 'the reincarnation of some delicate eighteenth century painter, who first adorned the fans of the ladies in the park at Versailles'.

58 R. Ironside, *Philip Wilson Steer* (Oxford and London, Phaidon, 1943), p. 15.

59 Y. Holt, *Philip Wilson Steer* (Bridgend, Seren, 1993), pp. 79–104; see also Holt, 'Nature and nostalgia: Philip Wilson Steer and Edwardian landscapes', *Oxford Art Journal*, 19:2 (1996) 28–45.

60 Coll. Hugh Lane, Municipal Art Gallery, Dublin (Bruce Laughton, *Philip Wilson Steer*, no. 237); *The Picnic (Little Dean)* was sold at Christie's South Kensington, 16 June 1988, lot 125 (Laughton, *Philip Wilson Steer*, no. 429).

61 Dowdeswell staged an exhibition of his work in 1888; he was paired with Degas in an exhibition at Mr Collie's rooms in Bond Street in 1892 and a further solo exhibition was staged at the Goupil Gallery in 1900. By this stage the artist's work was identified with a strand of 'decadent' taste, the most obvious expression of which was found in R. de Montesquiou, 'Monticelli', *Gazette des Beaux Arts*, 3rd series, 25 (1901) 89–104; see also Meier-Graefe, *Modern Art*, pp. 90–2. For reference to the 'Monticelli mania' in Scotland, see B. Smith, *Hornel: The Life and Work of Edward Atkinson Hornel* (Edinburgh, Atelier, 1997), pp. 42–4. For more general consideration of Monticelli's influence, see A. Sheon and H. Wytenhove, *Adolphe Monticelli, 1824–1886* (Marseille, Editions Jeanne Lafitte, sous la direction des Musées de Marseille, 1986), pp. 117–22.

62 M. H. Dixon, 'Monticelli', *Art Journal* (1895) 212.

63 AE (George Russell), quoted in *Illustrated Catalogue* (Dublin, Municipal Gallery of Modern Art, 1908), p. 34.

64 J. Munro (ed.), *Philip Wilson Steer*, exhib. cat. (London, Arts Council, 1985), p. 45; Laughton, *Philip Wilson Steer*, pp. 73–4.

65 Goncourt, *French XVIII Century Painters*, p. 88.

66 Collins Baker, 'Philip Wilson Steer, President of the New English Art Club', 262.

67 H. Bergson, *Matter and Memory*, trans. N. M. Paul and W S. Palmer (London, Swan Sonnenschein; New York, Macmillan, [1896] 1911). Silverman's discussion in *Art Nouveau* is again relevant, as is the general cultural context in which Bergson's ideas operated, i.e. that of *psychologie nouvelle*, the 'new' woman, the writings of William James and Havelock Ellis, the dramas of Maeterlinck and the music of Debussy. The most obvious expression of Bergson's ideas in the artistic context occurs of course in Proust.

68 The training of visual memory for art students had expanded in the late nineteenth century with the spread of the pupils of Horace Lecoq de Boisbaudran, the most influential of whom, Alphonse Legros was Slade Professor of Fine Art from 1876. Lecoq's treatise, *L'Education de la memoire pittoresque et la formation de l'artiste* (1862), was translated as *Training of the Memory in Art*, by L. D. Luard in 1911. For a discussion of Lecoq's ideas, see P. ten-Doesschate Chu, 'Lecoq de Boisbaudran and memory drawing, a teaching course between Idealism and Naturalism', in G. P. Weisberg (ed.), *The European Realist Tradition*, (Bloomington, In., Indiana University Press, 1983), pp. 242–89.

69 Bergson, *Matter and Memory*, p. 72.

70 Moore, *Modern Painting*, p. 353.

71 *Ibid.*, p. 74.

72 *Ibid.*, p. 82.

73 For reference to the growing popularity of Corot's work in Britain, see K. McConkey, 'Silver twilights and rose-pink dawns, British collectors and critics of Corot at the turn of the century', in G. P. Weisberg (ed.), *J.-B. Camille Corot 1796–1875*, exhib. cat. (Tokyo, Osaka and Yokohama, Art Life, 1989–90), pp. 30–3. I list over a dozen important Corot collectors active in Britain from the 1870s. The first and in some ways most unusual of these was Frederic Leighton who acquired a series of *The Four Times of the Day*, painted originally for Alexandre-Gabriel Decamps, presently in the Loyd collection and on loan to the National Gallery, London; see C. L. Loyd, *The Loyd Collection of Paintings and Drawings at Betterton House, Lockinge near Wantage, Berkshire* (London and Banbury, Agnew Press, 1967), nos. 10–14. For a general survey of Corot collecting, with brief mention of key British collectors, see M. Pantazzi, 'Corot and his collectors', in G. Tinterow, M. Pantazzi and V. Pomarede, *Corot*, exhib. cat. (Metropolitan Museum of Art, New York, 1996–97), pp. 397–407.

74 M. Holland, introd., *The Complete Works of Oscar Wilde* (Glasgow, Harper Collins, 1994), p. 526.

75 Lavery for instance recalled that the attraction of Grez-sur-Loing for young painters of the early 1880s was that it held 'as a talisman the debonair spirit of Corot', quoted in McConkey, 'Silver twilights', p. 31.

76 W. Armstrong, 'Alfred East RI', *Magazine of Art* (1895), 81; quoted from D. C. Thomson, *The Barbizon School of Painters: Corot, Rousseau, Diaz, Millet, Daubigny* (London, Chapman and Hall, 1890), pp. 75–8.

77 Thomson, *The Barbizon School*, p. 82.

78 *Ibid.*, p. 83.

79 It was clear by 1895 that East was identified in his mind along with Bouguereau, Herkomer and Dagnan-Bouveret as 'stockbroker' taste; see Moore, *Modern Painting*, p. 154.

80 In later years, he recalled, 'a young fellow came to me and said he was in great distress. I asked what was the matter, and he said he was bothered about style. When he went out on a breezy morning, he thought of Constable, and would paint more or less like Constable; and on a dewy morning he would think of Corot, and would paint more or less like Corot. I told him not to bother his head about style, but to try to tell his own story, and to tell it strongly and confidently, then he would form his own style'; A. East, 'On sketching from nature, a few words to students', *Studio*, 37 (1906) 98.

81 G. Moore, 'The New English Art Club', *Speaker* (25 November 1893) 582.

82 Moore identifies one of these works more precisely in *Modern Painting*, p. 75, as *Ravine* (coll. Sir John Day), and refers to two others, a landscape (coll. G. N. Stevens) and *The Lake* (coll. J. S. Forbes). All of these, along with *Le Lac de Garde* and *By the Side of the Water* are reproduced in Thomson *The Barbizon School*, pp. xi, 7, 13, 16, 29. It is obvious that in writing his essays on Corot, Moore referred to this source.

83 Moore, *Modern Painting*, p. 583.

84 J. M. Whistler, *The Gentle Art of Making Enemies* (New York, Dover, [1892] 1967), p. 143.

Notes to Chapter 7

This essay is an account of one of the more significant themes of my doctoral thesis, 'Facing femininities: women in the National Portrait Gallery 1856–1899', unpublished D.Phil. thesis, University of York, 1998), to which I would refer any interested reader for a fuller development of the argument. I gratefully acknowledge the support of the Social Sciences and Humanities Research Council of Canada, and the Association of Commonwealth Universities, UK, for supporting my research.

1 The history of the National Portrait Gallery, and its roots in established forms of collecting and representation, are investigated in 'Saved from the housekeeper's room', the epilogue to M. Pointon, *Hanging the Head: Portraiture and Social Formation in Eighteenth Century England* (New Haven and London, Yale University Press for the Paul Mellon Centre for Studies in British Art, 1993), and in P. Barlow, 'The imagined hero as incarnate sign: Thomas Carlyle and the mythology of the "national portrait" in Victorian Britain', *Art History*, 17:4 (1994) 517–45.

2 Historians of museums have interested themselves in the ways that exhibiting institutions encourage certain viewing practices, for instance Tony Bennett's sociological study *The Birth of the Museum: History, Theory, Politics* (London, Routledge, 1995), although this and other examples are usually fairly generalised. Jonathan Crary's *Techniques of the Observer: On Vision and Modernity in the Nineteenth Century* (London and Cambridge, Mass., MIT Press, 1992) is a short and focused study of how technical and scientific discourses produced 'modern' forms of spectatorship.

3 Barlow, 'The imagined hero as incarnate sign', 517. The generic problems and interest of portraiture are helpfully surveyed by J. Woodall (ed.) in her introduction to *Portraiture: Facing the Subject* (Manchester, Manchester University Press, 1997), pp. 1–25.

4 C. McKay, 'Museums, curators and the mere "snapper up of unconsidered trifles": some nineteenth-century debates', MS. I would like to take this opportunity to thank Carol McKay for sharing this very perceptive essay with me.

5 This was quoted widely from one of Carlyle's letters; most importantly in this context, it was quoted by Earl Stanhope in his 1856 speech to the House of Lords proposing the Gallery. *Hansard*, 3d series, vol. 140, col. 1772.

6 Paul Barlow explores the use (and problems) of authenticity in the Portrait Gallery in somewhat more detail in 'Facing the past and present: the National Portrait Gallery and the search for "authentic" portraiture', in Woodall (ed.), *Portraiture*, pp. 219–38. He argues that the acquisition of copies and studio portraits reflects an anxiety to collect certain figures whose original portraits might not have been available; I would suggest that the contemporary sense of what constituted an 'original' artwork is not as exacting as late twentieth-century definitions, and would have included multiple copies which were commonly made by portraitists and often by subject painters as well.

7 NPG 64 was acquired in 1859 as a portrait of Mary Sidney, but was reidentified in the 1950s as Mary Scudamore.

8 See the entry for Mary Sidney in the *Historical and Descriptive Catalogue of the Pictures, Busts and c. in the National Portrait Gallery*, for example, no. 44 in the 1860 edition.

9 W. H. Carpenter, *Pictorial Notices of Van Dyke and his Contemporaries* (London, James Carpenter, 1844), p. 47.

10 See notes on a portrait of the Duchess by Gascar which was offered to, and rejected by, the Portrait Gallery in early 1878. George Scharf, Trustees Sketch Book, XXIII, p. 8. Later in 1878 the Gallery purchased a portrait of the Duchess by Mignard (NPG 497).

11 George Scharf, who was employed by the Gallery as its chief administrator from 1857 until he retired, a bachelor aged 75, in 1895, dedicated most of his adult life to the pursuit of authentic portraits and the means of authenticating them. Scharf and many of the Trustees were members of the Society of Antiquaries, whose minutes from one meeting concerning a portrait offered for sale to the Society, include the note that 'various observations were made on the literary and artistic frauds of the present time, and regret expressed that no effectual means of checking or punishing such malpractices could be found'; *Proceedings of the Society of Antiquaries*, 2nd series, 5:4 (1859) 250.

12 Ann Bermingham writes interestingly and authoritatively on the history of this construction of the feminine gaze. See her 'The aesthetics of ignorance: the accomplished woman in the culture of connoisseurship', *Oxford Art Journal*, 16:2 (1993) 3–20, and 'The Picturesque and ready-to-wear femininity', in S. Copley and P. Garside (eds) *The Politics of the Picturesque*, (Cambridge, Cambridge University Press, 1994), pp. 81–119. Elizabeth Wilson's *Adorned in Dreams: Fashion and Modernity* (Berkeley and Los Angeles, University of California Press, 1985) is a study of the relationship between modern art, fashion and femininity.

13 The best illustration of Horsley's conservatism is his position in the debate over students' access to nude models, cogently discussed by Alison Smith in *The Victorian Nude: Sexuality, Morality and Art* (Manchester, Manchester University Press, 1996), pp. 227–9. I would like to thank Paul Barlow for sharing with me his 1995 correspondence with Nicola Watson of Northwestern University about this painting, to which much of my discussion of it is owed.

14 Highly aestheticised and apparently eroticised portraits of women were also produced during the Regency; a portrait by Romney of Emma Hamilton acquired in 1870 was the first and only portrait of this type and period to be collected by the National Portrait Gallery before the twentieth century.

15 This was Lord Elcho, whose dissatisfaction with the arrangements was communicated by fellow Trustee William Smith privately to the Board's Secretary in 1863. Elcho was removed from the Board in 1867, along with Francis Grant. Trustees' letters to Scharf, NPG.

16 Although he never practised architecture, Beresford-Hope held the presidency of the Royal Institute of British Architects at the time of his appointment to the Portrait Gallery's Board. On Coutts Lindsay and his circle, see S. P. Casteras and C. Denney (eds.), *The Grosvenor Gallery: A Palace of Art in Victorian England* (London and New Haven, Yale University Press, 1996), and C. Newall, *The Grosvenor Gallery Exhibitions.* (Cambridge, Cambridge University Press, 1995). Viscount Hardinge's drawings of India, lithographed by J. D. Harding, were published as *Recollections of India* (London, Thomas McLean, 1847); four of his landscape watercolours are held by the South London Gallery (acc. 511–13 and 516).

17 See Smith, *The Victorian Nude*, pp. 99–111. The conflation of Frenchness and idealism in mid-century is also discussed by A. Bermingham, 'System, order, and abstraction: the politics of English landscape drawing around 1795', in W. J. T. Mitchell (ed.), *Landscape and Power* (London and Chicago, University of Chicago Press, 1994), pp. 77–101, and by Barlow in 'The imagined hero as incarnate sign', esp. 523–4 and 542.

18 E. Prettejohn, 'Aesthetic value and the professionalization of Victorian art criticism 1837–78', *Journal of Victorian Culture*, 2:1 (Spring 1997) 71–94.

19 See, for example, L. Nead, *The Female Nude* (London, Routledge, 1992), and P. G. Nunn, 'In Venus' train', in Nunn, *Problem Pictures: Women and Men in Victorian Painting* (Aldershot, Scolar, 1995), pp. 139–58.

20 Anon., *Engravings from the Choicest Works of Sir Thomas Lawrence, PRA* (London, Henry Graves [n.d., c. 1872]).

21 In a letter to Scharf dated 7 February 1879 Hardinge expressed his wish to have Frederic Leighton appointed to the Board to act as an authority on 'artistic merit'. Trustees' letters to Scharf, NPG.

22 For examples see the minutes of the Board of Trustees meeting for 10 May 1879; 23 February 1893; 26 January, 1899; the minutes of the meeting held 4 June 1887 record that the Trustees accepted a portrait because they were 'impressed with its high merit as a work of art'.

23 This includes the practice of artists who held appointments on the Board of Trustees of the National Portrait Gallery during the later nineteenth century, particularly Leighton, Poynter, and G. F. Watts who are generally included in groupings of nineteenth-century neo-classicists.

24 Hardinge, letter to Scharf, 3 April 1879. Trustees' correspondence, NPG.

25 *New Building 1889–1896*, NPG.

26 'Thirty-third Annual Report of the Trustees of the National Portrait Gallery', 1895.

27 See for instance C. Hall, *White, Male, Middle Class: Explorations in Feminism and History* (Cambridge, Polity Press, 1992). For an informed study of gender and art practice during this period see Nunn, *Problem Pictures*.

28 See L. Tickner, 'Men's Work? masculinity and modernism', in N. Bryson, M. A. Holly and K. Moxey (eds.), *Visual Culture: Images and Interpretations* (Hanover, N.H., and London, Wesleyan University Press, 1994), pp. 42–82. C. S. Blum's *The Other*

Modernism: F. T. Marinetti's Futurist Fiction of Power, (Berkeley, Los Angeles, London, University of California Press, 1996) is an excellent study of the central role of gender in the formation of Italian modernism.

Notes to Chapter 8

References to material held in the Whistler Collection, Special Collections, Glasgow University Library are given in the form GUL PC. The volumes of press cuttings are identified by number.

1 Ezra Pound, 'Patria mia', *The New Age* (24 October 1912), repr. in R. Spencer (ed.), *Whistler: A Retrospective* (New York, Hugh Lauter Levin, 1989), p. 368.

2 For the interrelations between modernism and sexual difference, see L. Tickner, 'Men's Work? Masculinity and modernism', in N. Bryson, M. A. Holly and K. Moxey (eds.), *Visual Culture: Images and Interpretations* (Hanover, N.H., and London, Wesleyan University Press, 1994), pp. 42–9. For wider socio-cultural shifts, see E. Showalter, *Sexual Anarchy: Gender and Culture at the Fin de Siècle* (New York, Viking, 1990; London, Bloomsbury, 1991), and S. Ledger and S. McCracken (eds.), *Cultural Politics at the Fin de Siècle* (Cambridge, Cambridge University Press, 1995).

3 See R. Dellamora, *Masculine Desire: The Sexual Politics of Victorian Aestheticism* (Chapel Hill, University of North Carolina Press, 1990), pp. 1–8, and E. Cohen, *Talk on the Wilde Side: Towards a Genealogy of a Discourse on Male Sexualities* (London and New York, Routledge, 1993), pp. 1–2.

4 Showalter and Ledger see the 'New Woman' as the other main protagonist in challenging sexual codes and redefining 'femininity' and 'masculinity'. See Showalter, *Sexual Anarchy*, p. 3, and S. Ledger, 'The New Woman and the crisis of Victorianism', in Ledger and McCracken, *Cultural Politics at the Fin de Siècle*, pp. 22–4.

5 See H. Brod, 'Masculinity as masquerade' in A. Perchuk and H. Posner (eds.), *The Masculine Masquerade: Masculinity and Representation* (Cambridge, Mass., MIT List Visual Arts Center, MIT Press, 1995), pp. 13–15.

6 'What is a gentleman?', *The World: A Journal for Men and Women* (22 May 1878) 8.

7 'Celebrities at home: no. XCII. Mr. Whistler at Cheyne Walk', *ibid.*, 4–5.

8 This periodisation of c. 1865–95 follows L. Dowling, *The Vulgarization of Art: The Victorians and Aesthetic Democracy* (Charlottesville and London, University Press of Virginia, 1996), p. 1.

9 See Peter Wollen's arguments about the sexual politics of Decadence in 'Out of the past: fashion/Orientalism/the body', in Wollen, *Raiding the Icebox: Reflections on Twentieth-century Culture* (London and New York, Verso, 1993), p. 12.

10 For mid-Victorian tropings from the 1850s to the 1860s, see H. Sussman, *Victorian Masculinities: Manhood and Masculine Poetics in Early Victorian Literature and Art* (Cambridge, Cambridge University Press, 1995).

11 See N. Vance, *The Sinews of the Spirit: The Ideal of Christian Manliness in Victorian Literature and Religious Thought* (Cambridge, Cambridge University Press, 1985), pp. 1–8.

12 For 'performative' and its theorisation, see J. Butler, *Gender Trouble: Feminism and the Subversion of Identity* (London and New York, Routledge, 1990), pp. 134–41, and P. Phelan, *Unmarked: The Politics of Performance* (London and New York, Routledge,

[1992] 1993). My reading is indebted to A. Jones, 'Clothes make the man: the male artist as a performative function', *Oxford Art Journal*, 18:2 (1995) 18–22.

13 See Butler, *Gender Trouble*, p. 139, and J. E. Adams, *Dandies and Desert Saints: Styles of Victorian Masculinity* (Ithaca and London, Cornell University Press, 1995), pp. 11–13.

14 Butler, *Gender Trouble*, p. 139.

15 For the relevance of Joan Rivière's 'Womanliness as masquerade' (1929), see S. Heath, 'Joan Rivière and the masquerade', in V. Burgin, J. Donald and C. Caplin (eds.), *Formations of Fantasy* (London, Methuen, 1986), and Tickner, 'Mens work?', 53–5.

16 See P. Gillett, *The Victorian Painter's World* (Gloucester, Sutton, 1990), esp. 'Art publics in late-Victorian England', pp. 192–241; for shifts in art patronage, see D. S. Macleod, *Art and the Victorian Middle Class: Money and the Making of a Cultural Identity* (Cambridge, Cambridge University Press, 1996); for the growth in women artists, see D. Cherry, *Painting Women: Victorian Women Artists* (London, Routledge, 1993).

17 Quote from F. Leighton, 'Presidential Address at the Art Congress, Liverpool, 3 December 1888', repr. in E. [Mrs Russell] Barrington, *Life, Letters and Work of Frederic Leighton* (London, G. Allen, 1906), vol. 2, p. 342. For the growth of artists' professional societies, see J. F. Codell, 'Artists' professional societies: production, consumption and aesthetics', in B. Allen (ed.), *Towards a Modern Art World* (New Haven and London, Yale University Press, 1995), pp. 169–83. For changes in career hierarchies, see H. Perkin, *The Rise of Professional Society: England since 1880* (London, Routledge, 1989), pp. 3–7.

18 See Tickner, 'Men's work?', pp. 46–7, 70–1.

19 See Dellamora, *Masculine Desire*, pp. 204–7.

20 For trends in French art journalism in the period, see M. Ward, 'From art criticism to art news – journalistic reviewing in late nineteenth century Paris', in M. R. Orwicz (ed.), *Art Criticism and its Institutions in Nineteenth-century France* (Manchester, Manchester University Press, 1994), pp. 162–81.

21 Whilst the 'New Journalism' of the 1890s represented a watershed in British journalism, it is important to note the wide range and diversity of art journalism and the speed and effectiveness of its distribution throughout the second half of the nineteenth century. See H. E. Roberts, 'Exhibition and review: the periodical press and the Victorian art exhibition system', in J. Shattock and M. Wolffe (eds.), *The Victorian Periodical Press: Samplings and Soundings* (Leicester, Leicester University Press, 1982), pp. 79–107.

22 For reserve and manliness, see Adams, *Dandies and Desert Saints*, pp. 188–91. For reserve in male dress, see J. Harvey, *Men in Black* (London, Reaktion, 1995) pp. 146–7.

23 T. Duret, *Histoire de J. McN. Whistler et de son oeuvre* (Paris, H. Floury, 1904), p. 73. Quote from English translation by Frank Rutter (London, Grant Richards, 1917), p. 73.

24 H. Fantin-Latour, letter to O. Scholderer [Paris], 23 January 1873, originally in Brame and Lorenceau Archive, Paris. The original French is reprinted in R. Spencer, 'Whistler, Manet and the tradition of the avant-garde', in R. E. Fine (ed.), *James McNeill Whistler: A Reexamination*, Studies in the History of Art, 19, Center for Advanced Study in the Visual Arts, Symposium Papers VI (Washington, D.C., National Gallery of Art; Hanover, N.H., and London, distributed by University Press, 1987), p. 56 (English translation: note 41, p. 63).

25 Fantin-Latour, letter to O. Scholderer, [Paris] 10 March 1873, originally in Brame and Lorenceau Archive, Paris, quoted by Spencer in French, *ibid.*, p. 57 (English translation: note 43, p. 63).

26 Fantin-Latour, letter to O. Scholderer, [Paris] 22 June 1873, originally in Brame and Lorenceau Archive, Paris, quoted by Spencer in French, *ibid.*, p. 57 (English translation: note 44, p. 63).

27 O. Scholderer, letter to Fantin-Latour, Putney, 19 May 1876, originally in Brame and Lorenceau Archive, Paris, quoted by Spencer in French, *ibid.*, p. 59 (English translation: note 53, p. 63).

28 C. Pissarro, letter to Lucien Pissarro, Osny, 28 February 1883, quoted in Spencer (ed.), *Whistler: A Retrospective*, p. 198.

29 For the growing tendency to celebrate 'temperament' in contemporary art marketing, see N. Green, 'Dealing in temperaments. economic transformation of the artistic field in France during the second half of the nineteenth century', *Art History*, 10 (March 1987) 59-78. For an overview, see R. Jensen, *Marketing Modernism in Fin-de-Siècle Europe* (Princeton, N.J., Princeton University Press, 1994). Whilst Jensen argues convincingly for the significance of Paris *and* Berlin as important late nineteenth- and early twentieth-century art centres, I think there is a need to acknowledge London as an influential international art market with strong links to the United States and a growing demand for modern art from the expanding number of overseas dependencies, protectorates and colonies of the Empire.

30 For a theory of trans-national exchanges, see E. Said, 'Travelling theory', in *The World, the Text and the Critic* (London, Vintage, 1991), pp. 226–7.

31 Duret, *Histoire de J. McN. Whistler et de son oeuvre*, p. 25.

32 For how Walter Sickert and Mortimer Menpes as 'followers' copied Whistler's dandyism, see M. Menpes, *Whistler as I Knew Him* (London, Adam and Charles Black, 1904), p. 29.

33 For the dynamics of the French art system, see P. Mainardi, *Art and Politics of the Second Empire* (New Haven and London, Yale University Press, 1987), and *The End of the Salon* (Cambridge, Cambridge University Press, 1993).

34 See Roberts, 'Exhibition and review', pp. 79–80 and Tickner, 'Men's work?', p. 47.

35 Whistler employed press clippings agencies, notably the London firms of Durrant's Press Cuttings and Romeike and Curtice's Press Cutting Agency, to collate newspaper reports and exhibition reviews and forward them to him either in Britain or in Paris. The existing files are now held in the Special Collections of Glasgow University Library, which kindly allowed me access to them.

36 See R. Spencer, 'Whistler's *The White Girl*: painting, poetry and meaning', *Burlington Magazine*, 140 (May 1998) 300–11.

37 C. Baudelaire, 'L'eau forte est à la mode', *Boulevard*, (Paris, 14 September 1862), reprinted and translated in Spencer (ed.), *Whistler: A Retrospective*, p. 60.

38 P. Burty, 'Salon de 1863: la gravure et la lithographie', *Gazette des Beaux Arts*, 15:2 (1863) 153. Translated and quoted by K. A. Lochnan, *The Etchings of James McNeill Whistler*, exhib. cat. (New Haven and London, Yale University Press in association with the Art Gallery of Ontario, 1984), p. 91.

39 Unidentified source marked in Whistler's hand as 'Wapping', GUL PC1, p. 6.

40 See R. Rees, 'Under the weather: climate and disease, 1700-1900', *History Today* (January 1996) 35–41, which illustrates an 1858 *Punch* cartoon showing 'Father Thames

introducing his offspring [Diphtheria, Scrofula and Cholera] to the Fair City of London', p. 35.

41 See L. Nead, *Myths of Sexuality: Representations of Women in Victorian Britain* (Oxford, Basil Blackwell, 1988), and C. Gallagher, 'The Body versus the social body in the work of Thomas Malthus and Henry Mayhew', in C. Gallagher and T. Laquer (eds.), *The Making of the Modern Body: Sexuality and Society in the Nineteenth Century* (Berkeley and London, University of California Press, 1987), p. 90.

42 See R. Spencer, 'Whistler's subject matter: *Wapping*, 1860–64', *Gazette des Beaux-Arts*, 134 (October 1982) 131–42, for Armstrong's advice to Whistler.

43 For prostitution within dock towns and ports, see Cohen, *Talk on the Wilde Side*, pp. 70–86.

44 *The Realm* (4 May 1864), GUL PC1, p. 13.

45 *The Times*, 5 May 1864, GUL PC1, p. 14.

46 F. Leyland, letter to Whistler, 6 and 24 July 1877, GUL Whistler Correspondence L117 and L128.

47 Duret, *Histoire de J. McN. Whistler et de son oeuvre*, p. 98

48 For Whistler as a generator of publicity in America, see S. Burns, *Inventing the Modern Artist: Art and Culture in Gilded Age America* (New Haven and London, Yale University Press, 1996), Chapter 7, 'Performing the Self', pp. 221–46.

49 I am grateful to Elizabeth Prettejohn for discussing these points with me and for her comments on an earlier draft of this chapter.

50 Quote from G. Du Maurier, letter to T. Armstrong, 11 October 1863, in D. Du Maurier (ed.), *The Young George Du Maurier: A Selection of his Letters, 1860–1867* (London, Peter Davies, 1951), p. 216.

51 For these Pre-Raphaelite avant-garde codings, see H. L. Sussman, *Victorian Masculinities: Manhood and Masculine Poetics in Early Victorian Literature and Art* (Cambridge, Cambridge University Press, 1995), pp. 111–14, 140, and for Rossetti as a distinctive typology, see pp. 166–9.

52 'Some pictures at the Artists Fund Exhibition', undated presscutting, GUL PC1, p. 5.

53 Spencer, 'Whistler's *The White Girl*', 310–11 notes that Whistler and Swinburne were on intimate terms before and during a trip to Paris in March 1863, and that Whistler pasted Swinburne's verse, 'Before the Mirror', to the frame of *The Little White Girl* when it was exhibited at the Royal Academy in 1865. Just prior to this, Swinburne was writing his review of Baudelaire's *Fleurs du Mal* which was the earliest article on the poet in English. Published in *The Spectator* (6 September 1862), p. 998, it set out the basic tenets of Aestheticism.

54 R. Browning, 19 June 1870, quoted in Dellamora, *Masculine Desire*, p. 71.

55 See R. Dorment and M. Macdonald, *James McNeill Whistler* (New York, N. H. Abrams, 1995), pp. 111–14. It is important to note that the critical reception of Courbet in England distinguished between his practice as a landscape painter and his role as a figure painter. As Courbet recognised there were important distinctions to be drawn between the two art economies and between the tastes of the dealers and art-buying publics of France and England. In a later letter to Castagnary, dated 22 February 1873, Courbet instructed him to bear in mind that in any selection of his work for a London audience 'the theme is more important than the technique … You know as well as I what will suit … pleasant subjects for London'; quoted in P. ten-Doesschate Chu (ed.),

The Letters of Gustave Courbet (Chicago and London, University of Chicago Press, 1992), p. 487.

56 Whistler, letter to Fantin-Latour, c. August 1867, quoted in L. Bénédite, 'Artistes contemporains: Whistler', *Gazette des Beaux Arts*, 34 (1905), pp. 232–4.

57 See E. Denker, *In Pursuit of the Butterfly: Portraits of James McNeill Whistler*, exhib. cat. (Washington, D.C., National Portrait Gallery, 1995), pp. 59–61.

58 Quote from 'Winter exhibition of cabinet pictures in oil', *Athenaeum* (2 November 1872), GUL PC1, p. 58.

59 'Dudley Gallery', *The Times* (11 November 1872), GUL PC1, pp. 61–2.

60 For a full account of this show, see R. Spencer, 'Whistler's first one-man exhibition reconstructed', in G. Weisburg and L. Dixon (eds), *The Documented Image: Visions in Art History* (Syracuse, Syracuse University Press, 1987), pp. 27–49.

61 For these gender codings, see A. Higonnet, 'Imaging gender', in Orwicz (ed.), *Art Criticism and its Institutions*, pp. 146–61. Although her arguments are based on French art debates, they are extremely relevant to English discussions in the 1860s and 1870s.

62 Whistler, letter to Fantin-Latour, [n.d., September?] 1867, reprinted in a different translation in Spencer (ed.), *Whistler: A Retrospective*, pp. 82–4.

63 For a fuller account of Blanc's ideas, see J. L. Shaw, 'The figure of the Venus: rhetoric of the ideal and the Salon of 1863', *Art History*, 14:4 (December 1991) 549–51.

64 These investigations are discussed in my 'Leighton and the shifting repertoires of "masculine" artistic identity in the late Victorian period', in T. Barringer and E. Prettejohn (eds), *Frederic Leighton: Antiquity, Renaissance, Modernity* (New Haven and London, Yale University Press published for the Paul Mellon Centre for Studies in British Art and the Yale Center for British Art, 1999), pp. 231–2.

65 These were subsequently published as E. J. Poynter, *Ten Lectures on Art* (London, Chapman and Hall, [1879] second edition 1880); the quotes are from 'Lecture III: systems of education', pp. 106–7.

66 Poynter, 'Lecture IV: notes on the formation of a style', p. 117.

67 *Ibid.*, pp. 117, 119.

68 *Ibid.*, pp. 155, 157.

69 'Winter exhibition of cabinet pictures in oil, Dudley Gallery', *Athenaeum* (2 November 1872), GUL PC1, p. 57.

70 Dudley Gallery exhibition', *Graphic* (2 November 1872), GUL PC2, p. 1.

71 The history of Cremorne Gardens is given in D. P. Curry, *James McNeill Whistler at the Freer Gallery of Art*, exhib. cat. (New York and London, Smithsonian Institution in association with Norton, 1984), pp. 74–87.

72 Cited by L. Merrill, *A Pot of Paint: Aesthetics on Trial in 'Whistler v. Ruskin'* (Washington and London, 1992), p. 167.

73 Consider, for example, P. G. Hamerton's review published in the *Fine Arts Quarterly* that as 'a representative of Realism in France … it is difficult to speak of Courbet without losing patience. Everything he touches becomes unpleasant'; reprinted in J. A. M. Whistler, *The Gentle Art of Making Enemies* (New York, Dover, [1892] 1967), p. 80.

74 'Mr. Whistler's Venice pastels', *Pan* (5 February 1881), GUL PC4, p. 53.

75 See M. Ward, 'Impressionist installations and private exhibitions', *Art Bulletin*, 73:4 (December 1991) 610–13.

76 'Mr. Whistler's latest "arrangement"', *The Times* (1 March 1883), GUL PC6, p. 46. For a full account of the installation, see D. M. Bendix, *Diabolical Designs: Paintings,*

Interiors, and Exhibitions of James McNeill Whistler (Washington and London, Smithsonian Institution, 1995), pp. 224–31.

77 The fine arts: Mr. Whistler's Venice pastels', *The World: A Journal for Men and Women* (2 February 1881), GUL PC4, p. 49.

78 C. Pissaro, letter to Lucien Pissarro, 28 February 1883, quoted in Spencer (ed.), *Whistler: A Retrospective*, p. 198.

79 W. Sickert, 'The Whistler exhibition' [a review of an exhibition at Colnaghi and Obach for the Professional Classes War Relief Fund], *Burlington Magazine*, 27 (July 1915) 169–70.

80 See M. G. H. Pittock, *Spectrum of Decadence: The Literature of the 1890s* (London and New York, Routledge, 1992), pp. 15–17.

81 These responses taken from GUL PC files are quoted in Bendix, *Diabolical Designs*, pp. 228–9.

82 The *Times* review is reprinted in 'The Grosvenor Gallery', *Bazaar*, 14 May [1882?], GUL PC3, p. 85.

83 For the identification of mass culture with the 'feminine', see A. Huyssen, 'Mass culture as woman: modernism's other', in Huyssen, *After the Great Divide: Modernism, Mass Culture and Postmodernism* (Basingstoke and London, Macmillan, 1986), pp. 44–62.

84 Gissing quoted in Showalter, *Sexual Anarchy*, p. 3.

85 'Mr. Whistler's pictures', *The Hour* (18 March 1876), GUL PC1, p. 71. Huyssen, 'Mass culture as woman', p. 51, points out that for Nietzsche, Wagner and Wagnerian signalled the ultimate 'feminisation' of culture.

86 C. Marriott, *The Modern Movement in Painting* (London, Chapman and Hall, 1920) p. 82.

87 See W. Rothenstein, *Men and Memories: Recollections, 1872–1900* (London, Faber and Faber, 1931), where he notes that in the 1890s Whistler 'was generally considered as … something of a *poseur*, in fact, as Wilde was, in England', vol. 1, p. 85.

88 See L. Tickner, 'Now and then: the *Hieratic Head of Ezra Pound*', *Oxford Art Journal*, 16:2 (1993) 55–61.

89 'The Grosvenor Gallery', *Daily Telegraph* [May 1877], GUL PC1, p. 85.

Notes to Chapter 9

References to material held in the Sickert archive in Islington Libraries Local History Collection are given in the form IC. The volumes of press cuttings are identified as PCB followed by the dates covered by the volume and, where one exists, by the folio number.

1 For a recent discussion of some of the implications of this situation for Sickert's graphic works see A. Gruetzner Robins, *Walter Sickert: Drawings, Theory and Practice, Word and Image* (Aldershot, Scolar, 1996).

2 V. Woolf, *Walter Sickert: A Conversation*, introduction by R. Shone (London, Bloomsbury Workshop, 1992), p. 17. For a reading of Sickert as painter of modern life, see A. Gruetzner Robins 'The London Impressionists at the Goupil Gallery', in K. McConkey, *Impressionism in Britain*, exhib. cat. (London, Yale University press in association with Barbican Art Gallery, 1995).

3 W. Sickert, 'Idealism', *Art News* (12 May 1910) 217.

4 I don't mean to suggest by this that Sickert explores these themes only in the music-hall series. I have chosen to concentrate on them here partly for reasons of space, but also because they formulate the issues with particular clarity over a number of different works.

5 Held in December 1889. The exhibitors were Francis Bate, Fred Brown, Francis James, Paul Maitland, Theodore Roussel, Bernhard Sickert, Walter Sickert, Sidney Starr, Philip Wilson Steer and George Thompson; see Robins, 'The London Impressionists at the Goupil Gallery', and Robins, 'The London Impressionists', unpublished Ph.D. dissertation, Courtauld Institute of Art, 1988; see also W. Baron, *Walter Sickert* (London, Phaidon, 1973), Chapter 3; W. Baron, *The Camden Town Group* (London, Scolar, 1979), pp. 4–6; and D. Sutton, *Walter Sickert* (London, Michael Joseph, 1976), pp. 62–70.

6 See T. J. Clark, *The Painting of Modern Life: Paris in the Art of Manet and his Followers* (London, Thames and Hudson, 1984), for the most influential version of this reading of the relations between art and modernity.

7 W. Sickert, 'Introduction to the catalogue of the "London Impressionists" exhibition', Goupil Gallery, December 1889, reproduced in D. S. MacColl, *Life, Work and Setting of Phillip Wilson Steer* (London, Faber and Faber, 1945), p. 176.

8 See K. McConkey, *British Impressionism* (Oxford, Phaidon, 1989), pp. 85, 88. But also see Baron, *Sickert*, for identification of this as a Symbolist influence.

9 Sickert, 'Introduction to the "London Impressionists"', p. 176.

10 See Baron, *Sickert*, pp. 23–4 for her association of this passage with Whistler's 'Ten o'clock' lecture and more general refusals of content in painting in favour of its visual qualities.

11 For a recent attempt to use Symbolism as a catch-all term, see *The Age of Rossetti, Burne-Jones and Watts: Symbolism in Britain, 1860–1910*, exhib. cat. (London, Tate Gallery, 1997).

12 See McConkey, *Impressionism in Britain*, for a recent and comprehensive survey.

13 See, for instance, R. Anderson and A. Koval, *James McNeill Whistler: Beyond the Myth* (London, John Murray, 1994), pp. 187–8, 243.

14 *The Age of Rossetti*, p. 207.

15 James McN. Whistler, 'The ten o'clock' lecture, in E. Warner and G. Hough (eds.), *Strangeness and Beauty: An Anthology of Aesthetic Criticism 1840–1910* (Cambridge, Cambridge University Press, 1983), vol. 2, p. 81.

16 See, for example, *Whistler*, exhib. cat. (London, Tate Gallery, 1995), cat. nos. 46 and 49 for instances of this modernity of subject matter.

17 Cited in *The Age of Rossetti*, p. 169.

18 See McConkey, *Impressionism in Britain* for a discussion of the aesthetics of Realism in this period.

19 Sickert made the argument for Realism in art in a chapter, 'Modern Realism in painting', he contributed to A. Theuriet, *Jules Bastien-Lepage and his Art: A Memoir* (London, T. Fisher Unwin, 1892), pp. 133–43; Sickert wrote there that 'the important fact about Millet is not that he struggled with poverty, or that he expressed on canvas the dignity of labour, but that he was a great artist' and was able 'to render' his motifs 'in fitting terms in accordance with the tradition which governs the use of each material', pp. 133, 134.

20 For contemporary comments on some of the music-hall works, see Anna Gruetzner Robins, 'Sickert "painter-in-ordinary" to the music-hall', in W. Baron and R. Shone (eds.), *Sickert: Paintings*, exhib. cat. (London, Royal Academy of Arts, 1992), p. 13.

21 *Pall Mall Gazette*, IC, PCB 1906–9 [n. p.].

22 W. H. Meyers, *Onlooker* (22 July 1911), IC, PCB 1906–9: 2.

23 *Saturday Review* (1 December 1906), IC, PCB 1906–9 [n. p.].

24 C. Phillips, 'Goupil Gallery: Contemporary Art Society', *Daily Telegraph* (7 April 1913), IC, PCB 1908–14: 102.

25 Two of the most sophisticated and developed attempts to do so work by defining Sickert as a wholly Realist painter, unresponsive to the mediating function of the painter; see R. Ross, 'The Stafford Gallery: paintings by Mr Walter Sickert', *Morning Post* (19 July 1911), and R. Fry, 'Mr Walter Sickert's pictures at the Stafford Gallery', *Nation* (8 July 1911), both of which were provoked by a successful one-man show. For Fry, Sickert's 'vision is curiously detached … Things for him have only their visual values, they are not symbols, they contain no key to unlock the secrets of the heart and spirit'; for Ross, Sickert's subjects 'must … satisfy a severe aesthetic formula which admits nothing so artificial as poetry, nothing so obvious as physical beauty, to disturb the functions of paint'. The point for both critics is that Sickert is a creature of the visual only and that his subject matter is accordingly inconsequential for him.

26 *Observer* (28 November 1909), IC, PCB 1906–9 [n. p.].

27 See B. Laughton, *Philip Wilson Steer, 1860–1942* (Oxford, Clarendon Press, 1971) (and Y. Holt, *Philip Wilson Steer* (Bridgend, Seren, 1992).

28 For an extended discussion of this claim, see my book, *Visuality and English Painting, 1850–1914*, in progress for Yale University Press.

29 See, for an analysis of late Victorian anxieties about the capacity of language to give an authentic account of the world, L. Dowling, *Language and Decadence in the Victorian Fin-de-Siècle* (Princeton, N.J., Princeton University Press, 1986); see also G. Budge, 'Poverty and the picture gallery: the social project of Victorian aesthetics', unpublished paper given at Trinity and All Saints College, Leeds, July 1999.

30 For a very clear exposition of this and associated paradoxes, see C. Rosen and H. Zerner's essay 'The ideology of the licked surface, official art' in their *Romanticism and Realism: The Mythology of Nineteenth Century Art* (London, Faber and Faber, 1984).

31 On Sickert's graphic works, see A. Troyen, *Walter Sickert as Printmaker*, exhib. cat. (New Haven, Yale Center for British Art, 1979).

32 On the significance and history of music halls, see D. Howard, *London Theatres and Music-Halls, 1850-1950* (London, Routledge, 1970); P. Bailey, *Leisure and Class in Victorian England* (London, 1978); Bailey (ed.), *Music Hall: The Business of Pleasure* (Milton Keynes, Open University, 1986); and J. S. Bratton, *Music Hall: Performance and the Popular Dramatic Tradition in England* (Milton Keynes, Open University, 1986). On Sickert, see John Stokes's chapter 'Prudes on the prowl' in his *In the Nineties* (New York and London, Harvester Wheatsheaf, 1989); Robins, 'Sickert "painter-in-ordinary"'; and R. Emmons, *The Life and Opinions of Walter Richard Sickert* (London, Faber and Faber, 1941), Chapter 5.

33 For a reproduction of Sickert's first music-hall painting, now destroyed, *Collins Music Hall, Islington Green*, c. 1887–88, see F. Wedmore, *Some of the Moderns* (London, Virtue, 1909) (n. p., plates after p. 50); see also on this painting, Baron, *Sickert*, cat. 50 and pp. 24, 29.

34 See Baron, *Sickert*, pp. 24–5, for a discussion of the appeal of the halls to Sickert and possible influences. See also, Robins, 'Sickert "painter in ordinary"'.

35 Discussed in D. Peters Corbett, '"Gross material facts": sexuality, identity and the city in Walter Sickert, 1905–1910', *Art History*, 21:1 (March 1998) 45–64; see also Lisa Tickner *Modern Life and Modern Subjects*, 2000 (New Haven and London, Yale University Press).

36 See Baron, *Sickert*, pp. 22–30, and Robins, 'The London Impressionists'.

37 Sickert, *The Scotsman*, 24 April 1889, cited in Baron, *Sickert*, p. 24. The influence of Degas has been a strong concern of the literature; on the question of the influence of Whistler and Degas, see *ibid.*, p. 24, and R. Pickvance, 'The magic of the halls and Sickert', *Apollo* (April 1962) 107–15.

38 Sickert was adamant in print that Degas's Realism had not influenced his choice of music-hall subjects or their composition. He wrote that 'it is surely unnecessary to go so far afield as Paris to find an explanation of the fact that a Londoner should seek to render on canvas a familiar and striking scene in the midst of the town in which he lives', and he goes on to describe *Collins Music Hall, Islington Green* (see *ibid.*, note 33); quoted *ibid.*, p. 109, from *The Scotsman* (24 April 1889).

39 Anna Gruetzner Robins discusses the spatial ambiguity in these paintings in 'Sickert "painter-in-ordinary"', pp. 16–17.

40 E. Bagnold, *Autobiography* (London, Heinemann, 1969), p. 73. Bagnold describes Sickert's fascination with 'the abated light that got muffled in the glass' of mirrors. She goes on, 'he had his own term for this effect, '"blonde", he would mutter. It was a love-word. The folds of a dirty sheet in shadow, the model's naked body on the bed, her flesh, green-shadowed, melting into the surrounding wood, rep, leather, reverberating, softly in a splendour of unspoiled light'.

41 See the discussion in Robins, 'Sickert "painter-in-ordinary"', pp. 13–16. Robins discusses the version of the painting in the Art Gallery of New South Wales in Sydney, which is the one shown at the New English Art Club. *Gatti*'s has a complicated history; see Baron, *Sickert*, cat. no. 42, p. 302, and Baron and Shone (eds), *Sickert: Paintings*, p. 70.

42 This version of *Gatti's* was also known as *Ta-Ra-Ra-Boom-De-Ay* according to Wendy Baron, telephone conversation with the author, 1999, and *Sickert*, cat. no. 42., pp. 302–3. In the catalogue Baron quotes Sickert's recollection of painting this version 'from drawings executed on the spot in 1888'.

43 The existence of multiple versions of this painting suggests the continuing fascination of the challenge to Sickert. Baron lists the evidence in *Sickert*, cat. no. 42.

44 This is evident from the fact that the cartouches in the 'rear wall' with the figures of the dancing women both reappear reflected at an angle between the columns.

45 In a short essay on 'Sickert's late work' in *Late Sickert*, exhib. cat. (London, Arts Council, 1981), Helen Lessore described the ways in which 'one of the most striking characteristics of Sickert's late pictures is the consistent treatment of the canvas as a surface, with an all-over equality of tension between the flat shapes into which it is divided, irrespective of what they represent' (p. 22). She adduces *Temple Bar* (c. 1941, private collection), which has some claim to be the last picture Sickert ever painted, as evidence that 'he did also eventually notice that the grid of squares on the canvas itself in some mysterious way contributed something to the painting' so that 'he actually re-painted the squaring-up lines after their original purpose has been served'. She comments, 'part of the magic lay in seeming to bring everything up to the surface' (p. 22). This technique clearly has a longer history in Sickert's oeuvre than Lessore remembered.

46 Perhaps, since the description and technique here is a mixture of wet on wet and heavy black outline (that is, mixes Degas and Whistler), then this, too, inscribing a broken grid pattern over wet-on-wet painting, declares Sickert is using Degas as well as Whistler. See Wendy Baron's comments on the impact of Degas on Sickert's technique in 'Sickert's links with French painting', *Apollo* (March 1970) 186–97. Baron argues that Sickert derived the use of squaring-up procedures, utterly alien to the technique of Whistler, from Degas; pp. 188–9; on Sickert's technical practice and squaring up, see the memoir by Clifford Hall, who was Sickert's pupil in the 1920s, printed in M. Lillie, *Sickert: The Painter and his Circle* (London, Elek, 1971), pp. 71–4, esp., pp. 72–3.

47 Sickert made drawings during performances directly into notebooks which he carried with him on his nocturnal visits to the music halls; see Emmons, *Life and Opinions*, p. 48.

48 See G. Didi-Huberman, 'The art of not describing: Vermeer – the detail and the patch', *History of the Human Sciences*, 2:2 (June 1989) 135–69, and my essay 'The aesthetics of materiality: avant-garde painting in London before 1914', in P. Edwards (ed.), *The Great English Vortex: Modernist London* (forthcoming, Bath, 1999). I owe my introduction to Didi-Huberman to M. A. Holly, *Past Looking* (Ithaca, N.Y., Cornell University Press, 1996).

49 Sickert wrote in a letter to *The Times* that 'the great painters painted from drawings that remained stable, and not in the presence of the "movie" that is nature. To the extent that the moderns have not forgotten this, have they succeeded in doing work that could hang beside that of their predecessors and masters?'; W. Sickert, 'Whistler: the artist in practice' [letter], *The Times* [no date or issue given], IC, PCB 1906–9, June 1934–38 [n. p.]. This argument is part of his repudiation of Whistler; see also *A Free House! or The Artist as Craftsman: Being the Writings of Walter Richard Sickert*, ed. O. Sitwell (London, Macmillan, 1947), p. 15.

50 As is its capacity to act as an unmediated presentation of knowledge about the circumstances and conditions of experience.

51 W. J. T. Mitchell, *Iconology, Image, Text, Ideology* (Chicago and London, University of Chicago Press, 1986), p. 5. See also the related concept of the 'metapicture' which Mitchell elaborates in *Picture Theory* (Chicago and London, University of Chicago Press, 1994), pp. 35–82, and which he describes as 'a kind of summary image … that encapsulates an entire episteme, a theory of knowledge' (p. 49). The founding discussion of the hypericon and its relevance for understandings of modernity is Foucault's discussion of Velásquez's *Las Meninas* in *The Order of Things: An Archaeology of the Human Sciences* (London, Tavistock, 1970); see, for a discussion of Sickert's use of mirrors and a comparison with *Las Meninas*, Baron, *Sickert*, pp. 29–31; see, also, for a useful history of modern critical responses to the idea of the hypericon, James Elkins, *Why are our Pictures Puzzles?* (London and New York, Routledge, 1999).

52 I rely on Baron's definition of the 'Camden Town period' as 1905–1914, 'Introduction', *Sickert: Paintings, Drawings and Prints of Walter Richard Sickert, 1860–1942*, exhib. cat. (London, Arts Council, 1977–78), p. 21. See also Baron on the dating of *Studio* in Baron and Shone (eds), *Sickert: Paintings*, p. 182. I am also indebted to comments on the spatial setting by these authors.

53 See Baron and Shone (eds), *Sickert: Paintings*, cat. no. 56, p. 182, on the spatial complexities of this picture.

54 The works based on photographs Sickert produced later in his career make sense in the context of this argument; see *Late Sickert* and Baron and Shone (eds), *Sickert: Paintings,* for discussion of these paintings.

Notes to Chapter 10

 1 *The Quarto* was published from 1896 to 1898.
 2 J. Fothergill, *The Slade* (London, Richard Clay, 1907).
 3 Augustus John wrote of the careful contrivance of his image in his autobiography: 'if my shoes were unpolished, they were specially made to my own design. If I abjured a collar, the black silk scarf that took its place was attached with an antique silver brooch ... The velvet additions to my coat were no tailor's but my own afterthought, nor were my gold earrings heirlooms, for I bought them myself: the hat I wore ... might have been borrowed from one of Callot's gypsies, and was ... a gift from one of their descendants. My abundant hair and virgin beard completed an ensemble'; A. John, *Chiaroscuro: Fragments of an Autobiography* (London, Grey Arrow [1952], 1962), p. 243.
 4 W. George, Diary for 1896–97, entry for 26 October 1896, University College Archives.
 5 University College London, Session Books 1895–96, list 310 students in the Department of Fine Art, 206 of whom were women. University College Archive.
 6 M. Foucault, 'Space, knowledge and power', in P. Rabinow (ed.), *The Foucault Reader* (Harmondsworth, Penguin, 1984).
 7 See M. Foucault, *Discipline and Punish* (Harmondsworth, Penguin, 1991).
 8 University College Calendar, 1895–96, University College Archive.
 9 While the first names of male students are represented by their initials, those of female students are recorded in full in Slade registers. University College London, Faculty of Arts and Laws Register, 1895–96, University College Archive.
10 According to Wyn George's diary, Miss Elder gave lessons in the antique room as well as tutorials. Miss Elder's responsibility for the antique room (a less important area of study) and her absence from the literature on the school and its formal records are explained by the unequal status of many women lecturers in higher education during this period. See D. Cherry, *Painting Women: Victorian Women Artists* (London and New York, Routledge, 1993), p. 62. The University College Faculty of Arts and Laws Registers, 1893–96, list two Miss Elders living at the same London address, both registering in 1893 to study Fine Art. Louise Alice Elder studied at the Slade from 1893 until 1894, exhibiting work at the New English Art Club in 1894 and 1897. As she was twenty-four at the time of her registration, it seems that she could well have been the Miss Elder who taught Wyn George. Ethel Harriet Elder was seventeen when she registered, and studied at the Slade between 1893 and 1896; *The Royal Society of British Artists 1824–1893 and the NEAC 1888–1917* (Woodbridge, [1975] 1984), p. 563.
11 Wyn George, diary entry, 15 May 1897.
12 Foucault, 'Space, knowledge and power', p. 245.
13 T. de Lauretis, 'The technology of gender', in *Technologies of Gender: Essays on Theory, Film and Fiction* (London, Macmillan, 1987), p. 26.
14 Here I disagree with Hilary Taylor's argument that 'a feminine temperament could not be compatible with an artistic one' at the Slade during the 1890s; see H. Taylor, '"If a young painter be not fierce and arrogant God ... help him": some women art students at the Slade, c. 1895–9', *Art History* 9:2 (1986) 232–44 (p. 243).

15 The written documents include, in addition to Wyn George's diary for 1896–97, the unpublished memoir of Edna Waugh (better known under her married name of Clarke-Hall).

16 See C. Weeks, 'Women at work: the Slade girls', *Magazine of Art* (1883) 325.

17 T. Mackenzie, *The Art Schools of London* (London, Chapman and Hall, 1895), p. 73.

18 By the 1890s the provision of life study for women had become more commonplace. However as Tessa Mackenzie's guide lists, there were still seven London art schools which forbade women from working from the model.

19 The stippling process was attacked by Edward Poynter, the first Slade Professor, who instituted the practice of direct drawing from the life in the French style; see S. Macdonald, *The History and Philosophy of Art Education* (London, University of London Press, 1970), p. 263.

20 S. Hutchinson, *The History of the Royal Academy 1768–1968* (London, Chapman and Hall, 1968), p. 143.

21 Tessa Mackenzie describes the 'previous careful art training' necessary to enter the Royal Academy Schools and listed the rigorous entry requirements, which included life drawing and detailed anatomical drawings. Mackenzie, *Art Schools*, pp. 1–3.

22 Of course, not all women would have been able to consider embarking on a Slade studentship and becoming a fine artist, the cost would have made it prohibitive to the working class, who would have been steered towards vocational design-based training; see Cherry, *Painting Women*, pp. 58–60.

23 University College London, *Prospectus and Calendar,* 1894, p. 30, University College Archive.

24 In his memoirs Augustus John gave a definition of his relationship with the female nude: 'beauty at its highest is of course sexual and can be calculated. The Pretty Girl is the supreme criterion.' John, *Chiaroscuro*, p. 66. Numerous writers have chronicled John's affairs with his models, while Bruce Arnold gives an account of Slade student William Orpen's affair with a life model at the School, Emily Scobel; B. Arnold, *Orpen: Mirror to an Age* (London, Jonathan Cape, 1981), p. 77.

25 George, diary entry, 15 October 1896.

26 George, diary entry, 17 November 1896. *A Lady Undressing* was cat. no. 35 in the winter 1896 exhibition.

27 George, diary entry, 25 January 1897.

28 As Anna Gruetzner Robins has shown, during the 1890s French art was often perceived in these terms in Britain, the critic George Moore describing it as 'a ruined garden' in 1892; A. Gruetzner Robins, 'The London Impressionists', unpublished Ph.D. dissertation, Courtauld Institute of Art, 1988, pp. 219; 259–60.

29 George, diary entry, 21 March 1897.

30 George, diary entry, 30 November 1896.

31 George's diary constantly stresses the attractiveness of the life models, 'new girl model – very nice – looks rather shy – slim – a treat after the fat one'; 'went into the Life Room for short poses. Lovely girl model about 17 I should think'; 'lovely man model. Young fellow … splendid muscles'; diary entries, 20 October 1896, 25 November 1896 and 1 December 1896.

32 *Prospectus and Calendar*, 1894, p. 188.

33 Waugh, unpublished memoir (n. p.).

34 Other Slade competition entries in which the figures were fully clothed were well known at the time for having used students as models, for example William Orpen's *The Play Scene from Hamlet*, of 1899, which is peopled by, among others, Ida Nettleship and Augustus John. Arnold, *Orpen*, pp. 75–80.

35 *The Quarto*, 4 (1898) 8.

36 University College London, *Calendar and Session Book*, 1896–97 and 1898–99, University College Archive.

37 University College London, Annual Reports, Expenditure Accounts 1891–1900, University College Archive.

38 George, diary entry, 6 November 1896.

39 The Executive Committee and the Hanging Committee of the NEAC were all male enclaves during the 1890s, and remained so into the 1900s. Between the spring of 1895 and winter 1897 there was one woman artist among the approximately forty male members of the NEAC, between the latter date and spring 1900 there were no women members. Between 1895 and 1900 the highest number of female artists exhibiting at the NEAC was 16 in spring 1900; they showed 23 works, compared to the 75 male artists who showed 122 works.

40 *The Studio*, 25 (1902), p. 175.

41 George wrote of visiting the National Gallery, the British Museum, the South Kensington Museum and the National Portrait Gallery, diary, 1896–97.

42 George, diary entry, 10 November 1896.

43 Waugh, unpublished memoir (n. p.).

44 *Ibid.* (n. p.).

45 George, diary entry, 12 December 1896.

46 *University College Gazette* (20 May 1896) 24, University College Archive. Miss Oliver may have been the Slade student Madge Oliver, who won a Slade Scholarship in 1896–97. Madge Oliver was still known to Gwen John in the 1930s. See C. Lloyd Morgan, *Gwen John Papers at the National Library of Wales* (Aberystwyth, National Library of Wales, 1988), p. 21.

47 V. Gardner and S. Rutherford (eds.), *The New Woman and her Sisters* (London, Harvester, 1992), pp. 4, 41.

48 V. Gardner, 'Introduction', *ibid.*, p. 2.

49 Letter from Ida Nettleship to Ethel Nettleship [1897]. NLW MS 22798, National Library of Wales Archive.

50 D. Mitchell, 'The New Woman as Prometheus: women artists depict women smoking', *Women's Art Journal* 12 (1991) 3–9.

51 George, diary entry, 6 October 1896.

52 S. M. Newton, *Health, Art and Reason: Dress Reformers of the 19th Century* (London, John Murray, 1974), p. 162.

53 Waugh, unpublished memoir (n. p.).

54 National Portrait Gallery Conservation Record. The National Portrait Gallery have photographed the slightly blurred stamp which seems to read Paul Foinet. Paul Foinet was an artists' colourman and dealer used by British artists in Paris and based in Montparnasse, where Gwen John lived in 1898–99.

55 Letter from Ida Nettleship to Ada Nettleship [1898–9] NLW MS 22798, National Library of Wales Archive.

56 *Interior with Figures*, 1898–99, National Gallery of Victoria, Melbourne.

57 *Self-Portrait in a Green Dress*, 1898, watercolour, size and location unknown, *Self-Portrait with Grace Westray*, watercolour, size and location unknown. Listed in the catalogue of a later exhibition (under the artist's married name) are a self-portrait drawing of 1899 and a self-portrait oil of 1900; *Drawings by Edna Clarke-Hall* (Manchester, City of Manchester Art Gallery, 1939), pp. 22–3.

58 There still exists a copy made by Gwen John of *The Duet* by Gabriel Metsu which is part of the National Gallery Collection. Gwen John is listed in the National Gallery's *Copyists Register 1901–1946* on 13 February 1902 as renewing an earlier registration (the earlier registration books are missing from the archive). Many of the other copyists who registered gave Frederick Brown of the Slade School as their reference.

59 M. Maynard, 'A dream of fair women: revival dress and the formation of late Victorian images of femininity', *Art History* 12:3 (1989) 322–41.

60 Maynard, 'A dream of fair women', p. 324.

61 *The Times* (13 November 1901).

62 Henry Tonks was a particular admirer of Whistler's work. See L. Moms, *Henry Tonks and the Art of Pure Drawing* (Norwich, Norwich School of Art, 1985), p. 23. Augustus John's memoirs give an account of Whistler's visit to the Slade School in the late 1890s, and the excitement it aroused among the students. John, *Chiaroscuro*, pp. 42–3.

63 J. Rivière, 'Womanliness as masquerade' (1929), repr. in V. Burgin, J. Donald and C. Kaplan (eds.), *Formations of Fantasy* (London, Methuen, 1986), pp. 35–44.

64 *Ibid.*, p. 38.

65 T. Garb, 'Unpicking the seams of her disguise: self-representation in the case of Marie Bashkirtseff', *Block*, 13 (1987–88) 79–86.

66 *Ibid.*, p. 84.

67 A. Heilman, 'Masquerade, sisterhood and the dilemma of the feminist as artist and woman in late nineteenth-century British women's writing', *Journal of Gender Studies*, 3 (1994) 155–63.

68 For example *The Queen* of 18 January 1896 carried numerous illustrations of this style, p. 110.

69 *University College Gazette* (22 March 1897) 70–1.

70 H. Postlethwaite, 'Some noted women painters', *Magazine of Art* (1895) 17–22.

71 The Victoria and Albert Museum houses a beautifully cut woman's suit and blouse with full sleeves and embroidered lapels by the Parisian house Doucet of c. 1895; cat. No. T.15 V&A, 1979.

72 *The Catalogue of the Twenty-Fourth Exhibition of Modern Pictures Held at the New English Art Club*, Spring 1900; cat. no. 104, Miss G. M. John, *Portrait of the Artist*.

73 *Twenty-Fourth Exhibition of the New English Art Club*; cat. no. 115, W. Holman Hunt, *Portrait of Dante Gabriel Rossetti*; cat. no. 118.

Notes to Chapter 11

1 R. Gathorne-Hardy (ed.), *Ottoline: The Early Memoirs of Lady Ottoline Morrell* (London, Faber and Faber, 1963), p. 253. Thanks to Ben Harvey for bringing this text to my attention.

2 See, for example, P. Dodd, 'Englishness and the national culture', in R. Colls and P. Dodd (eds.), *Englishness: Politics and Culture 1880–1920* (London, Croom Helm, 1986), as well as other examples discussed in this essay.

3 N. Pevsner, *The Englishness of English Art* (London, Penguin Books, [1956] 1993).

4 Colls and Dodd (eds.), 'Preface', in *Englishness* (n. p).

5 *Ibid.*, (n. p).

6 Bill Schwarz, in a sympathetic review, has faulted the book for its inadequate attention to this dimension, arguing that the 'modern symbolic unities of England can make no historical sense unless the imperial determinations are painstakingly reconstructed'; B. Schwarz, 'Englishness and the paradox of modernity', *New Formations*, 1 (Spring 1987) 149.

7 T. Davies, 'Education, ideology and literature', *Red Letters*, 7 (1978) 251–60. Reprinted in T. Bennett, G. Martin, C. Mercer and J. Woollacott (eds.), *Culture, Ideology and Social Process* (London, The Open University Press, 1981).

8 R. Samuel (ed.), *Patriotism: The Making and Unmaking of British National Identity*, 3 vols (London and New York, Routledge, 1989).

9 S. Daniels, 'Envisioning England', *Journal of Historical Geography*, 17:1 (1991) 98. Actually, Daniels here means 'terrain' rather literally, referring to the physical co-ordinates of 'Englishness' at different moments – the village, the monument, parkland, the factory town – but makes clear throughout that this is only one aspect of the changing meaning of 'Englishness' across time.

10 R. Samuel, 'Introduction: exciting to be English', in Samuel (ed.), *Patriotism*, vol. 1, pp. xxii–xxviii.

11 And its persistence can be noted at the end of the twentieth century. As preparations for the World Cup soccer tournament were finalised in France, British tabloids referred to 'France's slimy Continental ways', and carried headlines like 'Frogs need a good kicking'; *New York Times* (3 June 1998). David Lowenthal, 'British national identity and the English Landscape', *Rural History* 2:2 (1991) 205–30.

12 Dodd, 'Englishness and the national culture'.

13 *Ibid.*, p. 12.

14 R. Samuel, 'Introduction: the "little platoons"', in Samuel (ed.), *Patriotism*, vol. 2, *Minorities and Outsiders*, p. xviii.

15 Discussing the fiction of the 1930s writer, Mary Butts, Patrick Wright argues that here 'the Jew is actively given a meaning which is culturally *necessary* to the valued England which he contaminates'; P. Wright, *On Living in an Old Country: The National Past in Contemporary Britain* (London, Verso, 1985), p. 122; italics in the original.

16 D. Feldman, 'The importance of being English: Jewish immigration and the decay of liberal England', in D. Feldman and G. Stedman Jones (eds.), *Metropolis-London: Histories and Representations since 1800* (London and New York, Routledge, 1989), p. 56. The following discussion of anti-alienism is greatly indebted to this article, as well as to Feldman's book, *Englishmen and Jews: Social Relations and Political Culture 1840–1914* (New Haven and London, Yale University Press, 1994), and his article 'Jews in London, 1880–1914', in Samuel (ed.), *Patriotism*, vol. 2, pp. 207–29.

17 Feldman, 'Jews in London', p. 207.

18 My discussion (and Feldman's) of this production of the non-English other is obviously at the level of social history, and in terms of discourses and social institutions. For a fascinating, and important, exploration of the same issues in psychoanalytic terms, see J. Donald, 'How English is it? Popular literature and national culture', in E. Carter, J. Donald and J. Squires (eds.), *Space and Place: Theories of Identity and Location* (London, Lawrence and Wishart, 1993).

19 B. Cheyette, *Constructions of 'the Jew' in English Literature and Society: Racial Representations, 1875–1945* (Cambridge, Cambridge University Press, 1993), p. 8.

20 *Ibid.*, p. 204.

21 D. Glover, 'Aliens, anarchists and detectives: legislating the immigrant body', *New Formations*, 32 (Autumn/Winter 1997). Indeed Glover points out the irony of Conrad's focus on Italians, rather than Jews, as figuring in the 'phobic imaginary' of the anti-alien movement: p. 30.

22 See, for example, M. J. Metzger, '"Now by my hood, a gentle and no Jew": Jessica, *The Merchant of Venice*, and the discourse of early modern English identity', *Publications of the Modern Language Association of America*, 113:1 (January 1998) 52–63; and J. Shapiro, *Shakespeare and the Jews* (New York, Columbia University Press, 1996).

23 J. Giles and T. Middleton, 'Introduction', *Writing Englishness 1900–1950: An Introductory Sourcebook on National Identity* (London and New York, Routledge, 1995), p. 6.

24 K. Adler, 'John Singer Sargent's portraits of the Wertheimer family', in L. Nochlin and T. Garb (eds.), *The Jew in the Text: Modernity and the Construction of Identity* (London, Thames and Hudson, 1995).

25 Pevsner, *The Englishness of English Art*.

26 See W. Vaughan, 'The Englishness of British art', *Oxford Art Journal*, 13:2 (1990) 22–3.

27 D. Piper, 'Introduction', *The Genius of British Painting* (London, Weidenfeld and Nicolson, 1975), p. 8.

28 *Ibid.*, p. 9.

29 J. Barrell, 'Sir Joshua Reynolds and the Englishness of English art', in H. K. Bhabha (ed.), *Nation and Narration* (London and New York, Routledge, 1990). Barrell's argument is that for a brief period in the late eighteenth century there flourished (particularly in the writings of Sir Joshua Reynolds) a 'discourse of custom', which focused on the local and ornamental, as opposed to the dominant discourse of civic humanism, whose focus was the universal. His suggestion is that the discourse of custom, which ultimately failed to establish itself in the Academy, might have opened the way for very different theories of art and culture in the nineteenth century.

30 P. Dodd, 'An open letter from Philip Dodd: art, history and Englishness', *Modern Painters*, 1:4 (Winter 1988–99) 41.

31 For detailed discussion of this visual ideology, see W. Vaughan, 'The Englishness of British art'; also his 'Constable's Englishness', *The Oxford Art Journal*, 19:2 (1996) 17–27; T. Barringer, ' Landscapes of association', *Art History*, 16:4 (December 1993) 668–72; D. Lowenthal, 'British national identity and the English landscape'.

32 Barringer ('Landscapes of association') in particular makes this argument; It has its correlate in T. J. Clark's essay on the Impressionists' displacement of urban experience onto representations of apparently rural scenes which are in fact images of the suburbs whose traces of the city, though energetically marginalised, appear in attenuated form; T. J. Clark, 'The environs of Paris', in *The Painting of Modern Life: Paris in the Art of Manet and his Followers* (New York, Alfred A. Knopf, 1985).

33 An early, and famous, example of this was Lawrence Gowing's response to John Berger's interpretation of a painting by Gainsborough; see J. Berger, *Ways of Seeing* (Harmondsworth, Penguin Books, 1992), p. 106. A decade later, the critical response to David Solkin's reading of the landscapes of Richard Wilson, in an exhibition and

catalogue in 1982, replayed this ideological battle. See D. H. Solkin, *Richard Wilson: The Landscape of Reaction*, exhib. cat. (London, Tate Gallery, 1982), and, for the debate on this, N. McWilliam and A. Potts, 'The landscape of reaction: Richard Wilson (1713?–1782) and his critics', *History Workshop Journal*, 16 (Autumn 1983) 171–5.

34 'The definition of the Englishness of English art is always attended … by the definition of what was seen to be "unenglish" and alien'; Dodd, 'An open letter from Philip Dodd', 40.

35 See J. Steyn, 'Inside-out: assumptions of "English" modernism in the Whitechapel Art Gallery, London, 1914', in M. Pointon (ed.), *Art Apart: Art Institutions and Ideology Across England and North America* (Manchester and New York, Manchester University Press, 1994), pp. 212–30.

36 Letter to Gertler, 9 October 1916, repr. in *Mark Gertler, Paintings and Drawings*, exhib. cat. (London, Camden Arts Centre, 1992), p. 11. At least, I have not come across any objection to the letter in Gertler's published correspondence and other commentary on his work and life.

37 S. D., 'Jacob Epstein's sculptures: some impressions of a layman', *Jewish Chronicle*, 27 April 1917.

38 Elizabeth Barker, 'The primitive within: the question of race in Epstein's career 1917–1929', in *Jacob Epstein: Sculpture and Drawings*, exhib. cat. (London and Leeds, W. S. Maney in association with The Henry Moore Centre for the Study of Sculpture, 1989). This catalogue was for an exhibition at Leeds City Art Galleries and the Whitechapel Art Gallery, London, in 1987.

39 F. Gore, 'The resilient figure: Mark Gertler and Matthew Smith', in S. Compton (ed.), *British Art in the 20th Century: The Modern Movement*, exhib. cat. (Munich, Prestel, and London, Royal Academy of Arts, 1986), p. 172.

40 A. Kampf, 'The quest for a Jewish style', Chapter 1 of *Chagall to Kitaj: Jewish Experience in 20th Century Art*, exhib. cat. (London, Barbican Art Galleries, Lund Humphries, 1990).

41 *Ibid.*, p. 25. The authors of the article Kampf refers to are Issachar Ryback and Boris Aronson.

42 M. Heyd and E. Mendelsohn, '"Jewish" art? The case of the Soyer brothers', *Jewish Art*, 19-20 (1993–4) 196.

43 *The Immigrant Generations: Jewish Artists in Britain 1900–1945* (New York, The Jewish Museum, 1983), p. 60.

44 For a discussion of Gertler's changing, and conflicted, relationship with his Jewish heritage and with the artists and intellectuals of the Bloomsbury Group, see J. Wolff, 'The failure of a hard sponge: class, ethnicity, and the art of Mark Gertler', *New Formations*, 28 (Spring 1996) 46–64.

45 She does not refer to these particular works, but mentions a work which she describes as 'a fruit stall with pyramids of oranges and apples', and another of the birth of Eve, which is almost certainly the 1914 painting, *The Creation of Eve*, now in a private collection. Gathorne-Hardy, *Ottoline*, p. 253.

46 See note 36. The fact that Gertler sent Lawrence a photograph of the work is confirmed by Gertler's biographer: J. Woodeson, *Mark Gertler: Biography of a Painter, 1891–1939* (Toronto, University of Toronto Press, 1973), p. 226.

47 Barker, 'The primitive within'.

48 Both cited *ibid.*, p. 44.

49 See E. Silber and T. Friedman, 'Epstein in the public eye', in *Jacob Epstein: Sculpture and Drawings*, for a discussion of the making of this work and critical responses to it.

50 Barker, 'The primitive within', p. 46.

51 See, for example, G. C. Lebzelter, *Political Anti-Semitism in England 1918–1939* (New York, Holmes and Meier, 1978); C. Holmes, *Anti-Semitism in British Society 1876–1939* (London, Edward Arnold, 1979); T. Kushner, *The Persistence of Prejudice: Antisemitism in British Society during the Second World War* (Manchester, Manchester University Press, 1989). For a discussion of the relevance of anti-Semitism to the reception of R. B. Kitaj's work in the 1990s, see my article, 'The imperfect guest: "diasporist" art and its critical response', in J. Aulich and J. Lynch (eds), *Critical Kitaj: A Critical Anthology of Essays on the Work of R. B. Kitaj* (Manchester, Manchester University Press, forthcoming).

52 Steyn, 'Inside-out'.

53 Richard Cork has shown how the initial study for *Ju-Jitsu* was far less radical aesthetically than the final version of the painting; at the same time, it can act as a guide to the painting, since the figures in the study are not yet so dramatically fragmented. R. Cork, *David Bomberg* (New Haven and London, Yale University Press, 1987), pp. 48–52.

54 Steyn, 'Inside-out', p. 222.

55 Wolff, 'The failure of a hard sponge'.

56 Harold Rosenberg, 'Is there a Jewish art?', *Commentary*, 42:1 (July 1966) 59.

57 *Ibid.*, 60.

58 This is argued more fully in my article, 'The failure of a hard sponge', where I also adopt Fredric Jameson's argument about Wyndham Lewis, that exclusions of class operate in much the same way, enabling radically innovative work (though obviously not, in the case of Lewis, politically progressive ideology); see F. Jameson, *Fables of Aggression: Wyndham Lewis, the Modernist as Fascist* (New Haven and London, Yale University Press, 1979).

59 Woodeson, *Mark Gertler*, p. 82. On a later visit, in 1920, he records the 'enormous impression' made on him by Renoir's work, at the same time saying (in a letter to a friend) 'about the more modern stuff I am really not at all sure'; Woodeson, p. 268.

Notes to Chapter 12

Part of this paper was originally presented at the conference, 'Rethinking Englishness' held at the University of York in 1997. I am indebted to David Peters Corbett and the conference participants for analysis and debate of the issues of visuality and Englishness.

1 *Blast*, 1 (June 1914) 116–17.

2 R. Cork, *Vorticism and Abstract Art in the First Machine Age* (London, Gordon Fraser, 1976); R. Cork, *A Bitter Truth: Avant-Garde Art and the Great War* (New Haven and London, Yale University Press, 1994); D. Peters Corbett, *The Modernity of English Art, 1914–30* (Manchester and New York, Manchester University Press, 1997); and D. Peters Corbett (ed.), *Wyndham Lewis and the Art of Modern War* (Cambridge, Cambridge University Press, 1998); see also Tim Cross (ed.), *The Fallen: An Exhibition of Nine Artists who Lost their Lives in World War One*, exhib. cat. (Oxford, Museum of Modern Art, 1988).

3 On aggression and violence in Lewis, see Peters Corbett (ed.), *Wyndham Lewis*; on the 'conservative' turn, see A. Light, *Forever England: Femininity, Literature and Conservatism between the Wars* (London, Routledge, 1991), and 'Conservative Modernism', special issue of *New Formations*, 28 (Spring, 1996).

4 M. R. Higonnet *et al.* (eds), *Behind the Lines: Gender and the Two World Wars* (New Haven and London, Yale University Press, 1987); C. Tylee, *The Great War and Women's Consciousness: Images of Militarism and Women's Writings, 1914–64* (London, Macmillan, 1990); S. Ouditt, *Fighting Forces, Writing Women: Identity and Ideology in the First World War* (London, Routledge, 1994); J. Winter, *Sites of Memory, Sites of Mourning: The Great War in European Cultural History* (Cambridge, Cambridge University Press, 1995); J. Bourke, *Dismembering the Male: Men's Bodies, Britain, and the Great War* (London, Reaktion, 1996); T. Tate, *Modernism, History and the First World War* (Manchester and New York, Manchester University Press, 1998), pp. 20–32.

5 See Tylee, *The Great War and Women's Consciousness*.

6 *Blast*, 1 (June 1914), 11.

7 *Ibid.*, 32.

8 C. Harrison, *English Art and Modernism, 1900–1939* (London, Allen Lane, 1981); Peters Corbett *The Modernity of English Art*.

9 N. Pevsner *The Englishness of English Art* (London, Architectural Press, 1956). On Pevsner and Frey, see W. Vaughan, 'Behind Pevsner: Englishness as an art historical category', in D. Peters Corbett, Y. Holt and F. Russell (eds.), *The Geography of Englishness: National Identity and English Art, 1880–1940* (New Haven and London, Yale University Press, forthcoming).

10 Pevsner, *The Englishness of English Art*, p. 9.

11 Harrison, *English Art and Modernism*, p. 6.

12 *Ibid.*, p. 75. The interface between 'the imagination and the material world' remains tantalisingly referenced in Harrison's text in the rampant character ascribed to 'the ideology of liberalism-plus-utilitarianism' in 'British culture'.

13 B. Anderson, *Imagined Communities: Reflections on the Origin and Spread of Nationalism* (London, Verso. 1983); C. Tilly (ed.), *The Formation of National States in Western Europe* (Princeton, N.J., and London, Princeton University Press, 1975); E. Hobsbawm, *Nations and Nationalism since 1780* (Cambridge, Cambridge University Press, 1989), see esp. p. 4.

14 Anderson, *Imagined Communities*, p. 6.

15 H. K. Bhabha (ed.), *Nation and Narration* (London, Routledge, 1990), p. 1.

16 There has been no comparable study of the reinventions of Britishness or the reforging of the nation for the period following Linda Colley's cogent and insightful investigations of the long eighteenth century, Colley argues that the elements out of, and the manner in, which the British nation was forged between 1707 and 1837 shaped the quality of a particular 'sense of nationhood and belonging ever since.' L. Colley, *Britons: Forging the Nation 1707–1837* (New Haven and London, Yale University Press, 1992), p. 1.

17 Noted in Hobsbawm, *Nations and Nationalism*, p. 18.

18 E. J. Hobsbawm and T. Ranger (eds.), *The Invention of Tradition* (Cambridge, Cambridge, University Press, 1983); A. D. Smith, *Theories of Nationalism* (London, Duckworth, 1983); Hobsbawm, *Nations and Nationalism*; Bhabha, *Nation and Narration*.

19 B. Anderson, *Imagined Communities*, rev. edn. (London, Verso, 1991), p. 7.

20 *Blast*, 1 (June 14), 11–42.

21 See *ibid.*, 13, 27.

22 The ports listed are Liverpool, Hull, Port of London, Newcastle, Bristol, Glasgow; see *ibid.*, 23.

23 *Ibid.*, 23–4, 32.

24 On these issues see Colley, *Britons*, particularly Chapter 4, 'Dominance', pp. 147–93.

25 *Illustrated London News* (25 July 1914) 130–33.

26 For discussion of the reverberations of the sinking of the *Lusitania* on contemporary literature, see Tate, *Modernism, History and the First World War*.

27 See C. Haste, *Keep the Home Fires Burning: Propaganda in the First World War* (London, Penguin, 1977), Chapter 1.

28 A. Potts '"Constable country" between the wars', in R. Samuel (ed.), *Patriotism: The Making and Unmaking of British National Identity* (London, Routledge, 1989), pp. 160–88.

29 Rowland Prothero, Minister of Agriculture, 26 December 1916, reported in M. MacDonagh, *London During the Great War* (London, Eyre and Spottiswood, 1935), p. 164.

30 See the collection of Land Army recruitment posters and photographs held in the Imperial War Museum.

31 See P. Fussell, *The Great War and Modern Memory* (New York and London, Oxford University Press, 1975); N. Khan, *Women's Poetry of the First World War* (Brighton, Sussex, Harvester Press, 1988); J. Montefiore, 'Shining pins and wailing shells', in D. Goldman (ed.), *Women and World War I: The Written Response* (London, Macmillan, 1993), pp. 51–72.

32 Consider in this context Edward Wadsworth's woodcuts *Landscape* and *Little London City*, both of 1914–15.

33 *Blast*, 1 (June 1914), 32. This can also be read as a repudiation of Bloomsbury aesthetics built on French cultural preoccupations.

34 W. Lewis, *Rude Assignment: A Narrative of my Career Up-to-date*, ed., T. Foshay (Santa Barbara, Cal. Black Sparrow Press, [1950] 1984), p. 138.

35 There were raids on Great Yarmouth, Sheringham and King's Lynn in Norfolk. These and German naval bombardments of Scarborough and Hartlepool in December 1916 were mobilised in national propaganda campaigns; see Haste, *Keep the Home Fires Burning*.

36 *The Times* (20 January 1915) 1.

37 G. Beer, 'The island and the aeroplane: the case of Virginia Woolf', in R. Bowlby (ed.), *Virginia Woolf* (London, Longman, 1992), p. 137.

38 *Ibid.* As Beer says, while England has often been seen as an island, the term the 'British Isles' is used to include Scotland, Wales and Northern Ireland.

39 A squared-up study survives (reproduced in Cork, *Vorticism*, p. 425); a drawing so titled was shown at the Vorticist exhibition of 1915 and in New York in 1917 where it was dated 1915. The size, 25.5 x 21.5 cm, was given in the Quinn sale catalogue of 1927.

40 *The Nation* (21 October 1916).

41 *Blast*, 1 (June 1914), 22; on Atlantic flights, see *The Times* (9 July, 1914) 9; *The Times* (February 1915) 10.; *Illustrated London News* (11 July 1914) 51.

42 See Cork, *Vorticism*, pp. 370–2.

43 Ms Winifred Tower, 'Recollections', Imperial War Museum, quoted in M. Brown, *The Imperial War Museum Book of the First World War: A Great Conflict Recalled in Previously Unpublished Letters, Diaries, Documents and Memoirs* (London, Sidgwick and Jackson, Imperial War Museum, 1991), p. 220.

44 *Blast*, 1 (June 1914), 11.

45 See J. Beckett and, D. Cherry, 'Modern women, modern spaces: women metropolitan culture and Vorticism', in K. Deepwell (ed.), *Women Artists and Modernism* (Manchester, Manchester University Press, 1998), pp. 36–54.

46 *Blast*, 1 (June 1914), 19.

47 D. D. Paige, *Letters of Ezra Pound. 1907–1941* (New York, Haskell House, 1951), p. 28.

48 Discussed in L. Tickner, *The Spectacle of Women: Imagery of the Suffrage Campaigns, 1907–1914* (London, Chatto and Windus, 1989); see esp. Chapter 5, 'Epilogue'.

49 W. G. MacPherson, *Official History of the Medical Services*, 4 vols (London, 1921); Adrian Gregory has suggested that approximately 1,050,000 men from Greater London served in the British forces during the First World War of whom approx. 130,000 died on active service; see A. Gregory, 'Lost generations: the impact of military casualties on Paris, London and Berlin', in J. Winter and J.-L. Robert (eds.), *Capital Cities at War: Paris, London, Berlin, 1914–1919*, Studies in the Social and Cultural History of Modern Warfare Series (Cambridge, Cambridge University Press, 1997).

50 J. Dismorr, 'London notes', *Blast*, 2 (1915) 66.

51 W. Lewis, 'The crowd master', *ibid.*, 94. 'The crowd master' is discussed in P. Peppis, 'Surrounded by a multitude of other blasts: Vorticism in the Great War', *Modernism/Modernity*, 4:2 (1997) 39–66.

52 *Ibid.*, 94.

53 Ford Madox Ford, *Antwerp* (London, 1915); cover design by W. Lewis, printed paper, Anthony D'Offay Gallery, London; Lewis's drawing 'Before Antwerp' appeared on the cover of *Blast*, 2.

54 Cited in Brown, *Imperial War Museum Book of the First World War*, pp. 218–19; Elsie Knocker served as a nurse on the Belgian front line.

55 'The crowd master', 99.

56 *Ibid.*, 95.

57 The full inscription begins, 'Not to be shown to anyone'.

58 Elsie Grey, letter to her parents, Autumn 1916, quoted in Brown, *Imperial War Museum Book of the First World War*, p. 218.

59 'Cabaret' (private collection) was probably executed in 1913–14; irregularly squared up, it may be a preparatory study for a decorative scheme; see B. Peppin, *Helen Saunders, 1885–1963*, exhib. cat. (Oxford, Ashmolean Museum and Graves Art Gallery, 1996), p. 45.

60 See 'Restaurant art', *Colour Magazine* (April 1916) xiv; 'Futurism in furnishing', *Colour Magazine* (May 1916), discussed in Beckett and Cherry, 'Modern women, modern spaces', p. 40.

61 Paul Wombell, 'Face to face with themselves: photography and the First World War', in P. Holland, F. Spence, S. Watney (eds.), *Photography Politics: two* (London, Comedia, 1986), pp. 74–81.

62 See J. Lidderdale and M. Nicholson (eds.), *Dear Miss Weaver: Harriet Shaw Weaver, 1876–1961* (London, Faber and Faber, 1970), p. 107; and Tate, *Modernism, History and the First World War*, pp. 20–32.

63 S. Freud, 'The "uncanny"' ('Das unheimlich') (1919), in *Art and Literature*, Penguin Freud Library (Harmondsworth, Penguin, 1985), vol. 14, pp. 336–76, 372.

64 *Ibid.*

65 'Atlantic City' was shown at the Vorticist exhibition.

66 City views out of windows include V. Bell, *46 Gordon Square,* c. 1909–10 (private collection), and the Camden Town painters who depicted urban interiors; for a detailed study of Sickert's imagery of Camden Town, see J. Beckett and D. Cherry, 'Painting is/as murder: Walter Sickert and the Camden Town murder', forthcoming.

67 'Vorticist Composition in Green and Yellow' is reproduced in Cork, *Vorticism*, p. 424.

68 J. Bloomer, *Architecture and the Text: The (S)crypts of Joyce and Piranesi* (New Haven and London, Yale University Press, 1993), pp. 11, 48.

69 Taking Cork's title, Lisa Tickner has argued that in this untitled watercolour 'Saunders probably comes closer than anyone else in the pre-war avant-garde to producing an overtly feminist painting'; see L. Tickner, 'Men's work? Masculinity and modernism', in N. Bryson, M. A. Holly and K. Moxey (eds.), *Visual Culture: Images and Interpretations* (Hanover, N.H., and London, Wesleyan University, 1994), p. 22; see also Cork, *Vorticism*, p. 150.

70 Cork, *Vorticism*, pp. 419–24; compare Lewis's *New York* 1914, *Workshop,* 1914–15, and *The Crowd,* 1914–15, neither of which have the complex perspectival experimentation of Saunders.

71 See R. Waugh, unpublished typescript, where she cites the following passage from Conrad's *Mirror of the Sea*: 'the man who has looked upon his ship going over too far is made aware of the preposterous tallness of a ship's spars. It seems impossible but that those gilt trucks, which one had to tilt one's head back to see, now falling into the lower plane of vision, must perforce hit the very edge of the horizon'; cited in Peppin, *Helen Saunders*, p. 61.

72 West, 'Indissoluble matrimony', 98.

73 J. Dismorr 'Monologue', *Blast,* 2 (1915), 65.

74 H. Saunders 'A vision of mud', *Blast,* 2 (1915), 73.

75 See J. Turner (ed.), *Britain and the First World War* (London, Unwin Hyman, 1988).

76 J. Lawrence 'Material pressure on the middle classes', in Winter and Robert (eds), *Capital Cities at War*, pp. 229–54. Cork, *A Bitter Truth*, refers to the problems of selling images of the war during 1915–19; see also Peters Corbett (ed.) *Wyndham Lewis*.

77 See Cork, *Vorticism*, Chapter 18, and *A Bitter Truth*.

78 Of the signatories to the *Blast* manifesto whose war service is known, Richard Aldington served on the Western front; Gaudier-Brzeska was conscripted in September 1914 and killed at the front in June 1915; William Roberts was in the Royal Field Artillery as a gunner between March 1916 and 1918; Edward Wadsworth was in the Royal Navy Volunteer Reserve from 1914 to 1917; Wyndham Lewis was a gunner from March 1916 to May 1917 and was commissioned in June 1916, serving at the front from June to November 1917; Jacob Epstein was in the Artists Rifles between 1917 and 1918, T. E. Hulme enlisted in September 1914, was wounded in spring 1915 and killed September 1917.

79 R. Poggioli, *The Theory of the Avant-Garde*, trans. G. Fitzgerald (Cambridge, Mass., Harvard University Press, 1968); Tickner, 'Men's Work?'; J. Lyon, 'Militant discourses: strange bedfellows', *differences: journal of feminist cultural studies*, 4:2 (1992) 100–33.

80 Through the winter and spring of 1914–16 unemployed women from the cotton, linen, silk and lace-making industries, the dressmaking trades and domestic service were redeployed in the production of equipment for the troops.

81 Susan Sulieman has persuasively argued that critical to concepts of an avant-garde are attempts to effect 'radical change and innovation *both* in the symbolic field (including what has been called the aesthetic realm) and in the social and political field of everyday life'; S. Sulieman, *Subversive Intent: Gender Politics and the Avant-Garde* (Cambridge, Mass., Harvard University Press), 1990, p. xv.

82 Marriage, as many accounts have pointed out, was the typical experience of most middle-class women at the beginning of the twentieth century although this was a role under tremendous pressure from 1900; see J. Lewis, *Women in England 1870–1950* (Brighton, Sussex, Wheatsheaf Books, 1984).

83 West, 'Indissoluble matrimony', 106.

84 *Ibid.*, 99.

85 *Ibid.*, 116–17.

86 S. M. Gilbert and S. Gubar, *No Man's Land: The Place of the Woman Writer in the Twentieth Century*, 1, *The War of the Words* (New Haven and London, Yale University Press, 1988), in which they characterise West's 'Indissoluble matrimony' as part of a war conducted through a confrontation of words; see pp. 96–100.

87 Saunders, 'A vision of mud', 73.

88 *Ibid.*, 65.

89 See T. Bonzon, 'The labour market and industrial mobilization', in Winter and Robert (eds), *Capital Cities at War*.

90 *Cannon*, one of three drawings by Saunders purchased by John Quinn; see Peppin, *Helen Saunders*, p. 46, no. 16.

Index

Note: Page numbers given in *italic* refer to illustrations.